AUTOTHEORY AS FEMINIST PRACTICE IN ART, WRITING, AND CRITICISM

AUTOTHEORY AS FEMINIST PRACTICE IN ART, WRITING, AND CRITICISM

LAUREN FOURNIER

THE MIT PRESS
CAMBRIDGE, MASSACHUSETTS
LONDON, ENGLAND

This book was set in Arnhem Pro and Frank New by Westchester Publishing Services. Printed and bound in the United States of America.

Library of Congress Cataloging-in-Publication Data

Names: Fournier, Lauren, author.
Title: Autotheory as feminist practice in art, writing, and criticism / Lauren Fournier.
Description: Cambridge, Massachusetts : The MIT Press, 2021. | Includes
 bibliographical references and index.
Identifiers: LCCN 2020013894 | ISBN 9780262045568 (hardcover)
Subjects: LCSH: Feminism and the arts. | Autobiography in art. | Arts,
 Modern—Philosophy.
Classification: LCC NX180.F4 F68 2021 | DDC 700.82—dc23
LC record available at https://lccn.loc.gov/2020013894

10 9 8 7 6 5 4 3 2 1

CONTENTS

ACKNOWLEDGMENTS

Writing this book would not have been possible without the love and support of my family and friends, as well as the rich, dynamic communities that I am humbled to be a part of—the literary communities, art communities, feminist communities, queer communities, and academic communities. Thank you to Marcus Boon, Darren Gobert, and Shannon Bell for your sustained and sustaining work with me as I developed this research during my time as a doctoral candidate at York University. It was there, at that post-Marxist haven on the moon, where this research began.

A big thank you to Suzanne Zelazo and Jonathan Adjemian for your thoughtful editorial eyes, as well as Victoria Hindley, Gabriela Bueno Gibbs, and Deborah Cantor-Adams at the MIT Press for your keen editorial support.

Thank you to David Chariandy, Gabrielle Civil, Hazel Meyer, Letitia Calin, Annie Jael Kwan, Stacey Young, Alex Brostoff, Emily LaBarge, Justin Wolfers, Luce Irigaray, Valerie Walkerdine, Sarah Sharma, Jennifer Fisher, Erin Wunker, and many others, for our conversations in and around autotheory, and all of the artists and writers in this book for allowing me to write about and include gorgeous images of your work: including Sona Safaei-Sooreh, Cauleen Smith, Johanna Hedva, Moyra Davey, and Thirza Cuthand.

Thank you to Lisa Steele, Kim Tomczak, Rachelle Viader-Knowles, David Garneau, Sylvia Ziemann, Jeannie Mah, Ian-Carr Harris, Yvonne Lammerich, and Jeanne Randolph, for being some of my dearest mentors in the arts, with whom I spoke about this research and writing at different stages and whose company I cherish.

Thank you to MLA Chernoff, Eric Schmaltz, Christine Tran, Kaitlyn Boulding, Julia Polyck O'Neill, Lucia Lorenzi, and a great many others, who build me up as part of my community of poets and literati misfits, and who inspire me to keep writing and reading my work aloud.

Special shout-outs also to Andrea Creamer, Chief Lady Bird, Jaclyn Bruneau, Daniella Sanader, Amber Christensen, Allyson Mitchell, Deirdre

Logue, Jen Macdonald, Ted Whittall, Gabe Levine, Sarah Brophy, Roc Han, and John G. Hampton. To my family, biological and chosen: Sara Mulligan, Ryan Mulligan, Nora Mulligan, Ray Fournier, Lori Fournier, Bernie Bey, Melodie Kline, and Robin Low.

Thank you, finally, to Lee Henderson, who was my rock and confidante during my entire journey with this book, and who continues to be closer-than-family-forever. I love you. And to everyone else, who I could not include in this limited space: thank you. For all the ostensibly solo time it takes to write a book, authorship is by no means an isolated pursuit. A big thank you to the Social Sciences and Humanities Research Council (SSHRC) for funding this research and to the American Comparative Literature Association, the Modern Language Association, and the Royal College of Art in London for hosting me at your conferences—where I refined these ideas on the autotheoretical impulse in dialogue with others.

I would like to acknowledge the very specific places where I wrote this book, embodied as I am in a particular space and time, and living as a white settler on colonized lands. I began writing this book on the traditional, ancestral territories of many nations including the Mississaugas of the Credit, the Anishnabeg, the Chippewa, the Haudenosaunee, and the Wendat peoples, writing in a shared studio apartment right on Yonge Street in downtown Toronto, just on the edges of the Church-Wellesley Village—a queer (in many senses of the term) context that indelibly shaped this work. I continued to write and finish this book while living back home on Treaty 4 lands, Saskatchewan, in a small prairie city called Regina—a place that the nêhiyawak have referred to as oskana kâ-asastêki, Cree for "the place where bones are piled up" ("pile o' bones"). These lands, to which I am the most tied and with which I am the most familiar at this point in history, are the territories of the nêhiyawak (Cree), Anihšināpēk (Saulteaux), Dakota, Lakota, and Nakota (Assiniboine), and the Métis/Michif.

AUTOTHEORY AS FEMINIST PRACTICE

History, Theory, Art, Life

Theory itself is often assumed to be abstract: something is more theoretical the more abstract it is, the more it is abstracted from everyday life. To abstract is to drag away, detach, pull away, or divert. We might then have to drag theory back, to bring theory back to life.
—Sara Ahmed, *Living a Feminist Life*

My whole problem with theoretical structures has to do with their displacement of physicality, as if there is a seepage or a toxicity from the experience of the body that is going to invade language and invalidate theory.
—Carolee Schneemann, *Imaging Her Erotics*

THE PROJECT OF THE BOOK

This book offers an interdisciplinary historical framework for understanding autotheory, one attuned to its long-standing ties in feminist practices across media and form. With an approach that is itself at times autotheoretical, I provide a working history and theory of the autotheoretical impulse—moving among close reading, feminist analysis, self-reflective anecdotes, and reparative forms of critique. I consider the present-day politics, aesthetics, and ethics of the autotheoretical turn in culture, looking at the tensions that arise between intersectional, transnational feminisms, on the one hand, and advanced late capitalism and neoliberal imperatives

surrounding the "self" on the other. Extra-institutional and, perhaps, extradiscursive, autotheory has the potential to become the "next big turn" in visual culture and literary studies. But why autotheory, and why now?

Even in its literary and text-based forms, autotheory draws much from histories of contemporary art, including conceptual art, video, film, and performance. Terms like "performative philosophy" and "conceptual criticism" point to a grounding in transmedial art histories, while "fictocriticism" and "autofiction" point to the literary histories of the autotheoretical impulse. Other terms, such as "performative autoethnography," point, curiously, to roots in anthropology. In this book, I extend the emergent notion of autotheory to a consideration of contemporary art across media, looking to a longer history of post-1960s practices, including conceptual art, video art, body art, film, and performance, along with experimental writing, literary art, and criticism. From this perspective, autotheory is transmedial, taking shape across forms—from the personal essay, new journalism, and creative nonfiction to the expanded field of art writing and criticism, confessional feminist memes and performance for the camera, and film and television.

As a way of describing an artist's or writer's way of working, autotheory seems a particularly appropriate term for works that exceed existing genre categories and disciplinary bounds, that flourish in the liminal spaces between categories, that reveal the entanglement of research and creation, and that fuse seemingly disparate modes to fresh effects. By approaching autotheory through the varied perspectives of contemporary art histories and feminisms, this book provides crucial insight into how autotheory might best be understood as fundamentally transdisciplinary and how it differs from such genres as autobiography and memoir, while also remaining tied to them in supple ways.

This book considers the ways in which artists and writers wrestle with the place of theory and autobiography in their many lived and artistic practices—often to ambivalent effect. Artists turn to autotheory both for its innate troubling of dominant epistemologies and approaches to philosophizing and theorizing and for its capacity to make space for new ways of theorizing and understanding their lives. Through their practices, artists and writers shed light on theory and philosophy as ambivalent sites of desire and difficulty, attraction and frustration, stubborn ossification and malleable, iterative transformation. Autotheory reveals the tenuousness

of maintaining illusory separations between art and life, theory and practice, work and the self, research and motivation, just as feminist artists and scholars have long argued.

But while I present the autotheoretical impulse as characteristic of feminisms' histories broadly understood, at the same time I argue for the unique history of autotheory as a contemporary, post-1960s mode of artistic practice that is indebted to histories of feminist writing and activism. Understanding autotheory as encompassing a spectrum of para-art and paraliterary practices, I contextualize the autotheoretical turn in relation to ongoing issues in art, philosophy and theory, and intersectional feminisms. Specific topics broached here include: the place of the autobiographical in the history of philosophy, the gendered politics of narcissism and the continued hold of the "narcissist" critique, the shift from philosophy to theory in the twentieth century as part of the shift from modernism to postmodernism, discussions around "posttheory" and "antitheory," the cultural capital of theory and the power of its circulation, the limits and possibilities of autotheory as a subversive or transformative mode of critiquing institutional power, and the place of theory as specialized discourse and framework in the humanities and the arts—in which I include visual art and the expanded field of multisensorial arts that mobilize ideas of accessibility in a shift from the ocularcentrism of "visual art."

As I discuss the simultaneous turn to the self and theory, I consider the limits and possibilities of an autotheoretical mode in light of the present-day context of advanced global capitalism and neoliberalism; the circulation of Trump-style descriptors like "fake news" and "post-fact," or the idea that "my truth is truth"; the pervasive postconfessional technologies of social media, #MeToo, and related fourth-wave feminist movements; the rise of so-called woke politics (and its varied backlashes); and the concomitant calls for decolonization of land, language, and institutions taking place across North America or Turtle Island, the responses to which are especially visible in art and the humanities, with their concerted efforts at indigenization. Throughout this book, I consider where the autotheoretical impulse fits into all of this. Is autotheory a viable or productive way of working in the arts and academia today? What are the possibilities offered by autotheoretical modes, and what are their challenges and limitations?

To consider the valences of "autotheory," I must consider the politics and aesthetics of both "auto" and "theory," and I do so throughout the book. In these chapters, I think through the ways theory is mobilized in artistic practices as a means of garnering social, political, cultural, and institutional capital and knowledge from lived experience. I consider the ways identity is performed in relation to theory. How does this complicate autotheory's capacity to function as a means of critique? In a context in which women, queers, people of color, and other historically marginalized groups represent large markets with consumerist agency and in which theory as a learned discourse with niche appeal signifies its own cachet with its own classist implications, how can we understand autotheory as a means of resistance, transgression, or dissent? What is the relationship between autotheory and artistic agency and becoming? What place does philosophizing and theorizing have—if we are being honest with ourselves—in today's publics, including artistic and academic ones, and how might we approach this question intersectionally? What might these autotheoretical practices reveal to us about the transformative possibilities of reflection—including, but not limited to, self-reflection—particularly in a post-pandemic era where both personal and collective priorities are being widely questioned in increasingly public ways? I also consider how autotheoretical practices shed light on unexpected affinities and points of connection across communities, opening up space for reparative relationships—even between feminists and those subjects/objects which they (we) critique, and whom have critiqued them (us) in turn.

In writing this book, I have drawn from an archive of works and practices chosen for a variety of reasons; my relationship to each of them arose from the specificities of my own lived, embodied experience in a particular place and time. This archive is open-ended and intuitive, scrupulous and rooted as much in scholarly research and sober reflection as in gut-based understanding and critico-synchronistic happenstance. In the early stages of research, while I was reading about narcissism in the British Library and applying an Irigarayan lens to my reading of Chris Kraus as "philosopher's wife,"[1] I took a break at the Tate Modern and was struck by Adrian Piper's *Food for the Spirit* photographs in the group show "Performing for the Camera." Later that week, by chance, I would be

invited to join Luce Irigaray's seminar for PhD students, which was taking place a bus ride away in Bristol; there I would workshop my earliest ideas about autotheory and feminist philosophical history at afternoon seminars and evening dinners with Irigaray and the PhD students, Luce feeding me bites of her poached pear while she told me quite candidly, over wine, firsthand stories about Jacques Lacan (against whom she seemed to be still harboring frustrations, him having fired her from her teaching post in Paris following the publication of her too-feminist-to-be-rigorous *Speculum*) and Jacques Derrida ("We all thought he was so handsome," Luce recalled winsomely. "A good man").

My methodological approach is grounded in the personal-theoretical, incidental, gut-centered nature of autotheoretical research. I write about works I have encountered in the places where I've lived, art scenes I am in close contact with in my capacities as an artist and a curator (and art writer and 'critic' and scholar), works I've encountered through gallery exhibitions and museum retrospectives and performances and screenings, online content that I have access to, book clubs and reading groups and working groups I am a part of, conferences I've attended, and conversations I've had over email and in libraries and coffee shops and bars. In writing this book, I have attempted to provide a rigorous overview and historical contextualization of autotheory as a contemporary mode of artistic practice across media that is driven by concerns of interest to intersectional feminisms. The book is transnational in scope, but connected most intimately to my home context of Turtle Island/North America, where I live as a settler on colonized lands.

I have found energy in books like Sohrab Mohebbi and Ruth Estévez's *Hotel Theory Reader* (a title borrowed from Wayne Koestenbaum's phenomenological novel of the same name) and Jody Berland and Will Straw's *Theory Rules*,[2] which both take up theory as an artist's material—though neither work, perhaps by virtue of their focus on other questions related to theory and art, addresses autotheory. My hope for this book is that it extends and gives new direction to the still nascent but rapidly growing conversations around the relationship between theory and artistic practice, paying attention to the problematics of the "auto" in relation to "theory" and feminisms and to the longer histories of the autotheoretical (and

autophilosophical) impulse in philosophy, art, and activism. I also hope to show the significance of the turn to autotheory for understanding the place that theory holds in contemporary art and writing.

Although I offer a provisional definition of autotheory, I hold space for the term's possibilities as it is reworked, reimagined, and reiterated in different ways by artists, writers, scholars, educators, activists, and practitioners who draw from different archives. Most simply, autotheory is the integration of the *auto* or "self" with philosophy or theory, often in ways that are direct, performative, or self-aware—especially so in those practices that emerge with postmodernism. This leads to the complicated questions of what constitutes philosophy and theory—the stakes of the term "autotheory" and its histories appear in the politics of who has access to writing in ways considered theoretical and critical—and of what kinds of knowledge are understood as legitimately critical or rigorous, and by whom. These questions are entangled in colonial, white-centric, and patriarchal histories, and I return to them throughout the book, looking at the ways artists process the master discourses of theory and philosophy and at their new conceptions of what it means to produce theory or to *theorize* as part of living in the contemporary world.

Finally, I approach autotheory as a provocation. The very integration of *auto* or *autos,* the self, with *theory* into a single term is contentious, especially in light of the historical disparagement of self-reflective work as a supposedly narcissistic and therefore nonintellectual or fundamentally uncritical mode—and especially when the work is made by women and people of color. I suggest that autotheory can be approached as a practice that artists, writers, critics, curators, activists, and others tend toward as a way of coming to terms with "theory"—whether as the "master discourse(s)"[3] of theory and philosophy, to take the words of Luce Irigaray, or as the work of making theories—in relation to their experiential, affective lives and embodied, relational practices as human beings in the world. In this book, I look at several works by artists and writers to consider the politics, aesthetics, and ethics of autotheory in relation to pressing contemporary issues, from the gendered and racialized politics of self-imaging and who has access to the "I" to whether and how this thing called theory might be decolonized.

DEFINING AUTOTHEORY

I don't make a big distinction between writing about "myself" and writing about "larger issues." (Maybe I'm Emersonian in that way, or just feminist.)
—Maggie Nelson, in conversation with Micah McCrary

The term "autotheory" emerged in the early part of the twenty-first century to describe works of literature, writing, and criticism that integrate autobiography with theory and philosophy in ways that are direct and self-aware. The "memoir with footnotes" would be one example. Most simply, the term refers to the integration of theory and philosophy with autobiography, the body, and other so-called personal and explicitly subjective modes. It is a term that describes a self-conscious way of engaging with theory—as a discourse, frame, or mode of thinking and practice—alongside lived experience and subjective embodiment, something very much in the *Zeitgeist* of cultural production today—especially in feminist, queer, and BIPOC—Black, Indigenous, and people of color—spaces that live on the edges of art and academia.

The term began to trend after the publication of American writer Maggie Nelson's 2015 book *The Argonauts*, where Nelson, riffing on Spanish writer and curator Paul B. Preciado's use of the term in *Testo Yonqui (Testo Junkie)* (2008/2013),[4] inscribes a performative mode of citation alongside a postmemoir, queer feminist life-writing text. Previously, texts that might be termed autotheoretical were referred to as "critical memoir," "theoretical fiction," "life-thinking," or "fiction-theory,"[5] with terms like autofiction emerging alongside. Along with other terms—such as creative criticism, conceptual criticism, theoretical fiction, biofiction, fictocriticism, critical memoir, queer phenomenology, queer feminist affect theory, philosophical novels and novels in essay form, essayistic films, performance philosophy, and performative autoethnography—autotheory points to modes of working that integrate the personal and the conceptual, the theoretical and the autobiographical, the creative and the critical, in ways attuned to interdisciplinary, feminist histories.

In the mid- to late 2000s and 2010s, the term "autotheory" gained traction in both academic and art world contexts. Across art, literary, and academic scenes there has been a groundswell of interest in such

recent works as Preciado's *Testo Yonqui (Testo Junkie)* (2008/2013), Claudia Rankine's *Citizen: An American Lyric* (2014), Moyra Davey's *Les Goddesses* (2011), and Nelson's *The Argonauts* (2015), and renewed interest in older works, such as Clarice Lispector's *Água Viva* (1973), Gloria E. Anzaldúa's *Borderlands/La Frontera: The New Mestiza* (1987), and Chris Kraus's *I Love Dick* (1997).[6] Autotheory seems to best describe the practices of artists, writers, and other art and culture workers who move between the worlds of contemporary art, literature, and academia, in spaces where practice and research, writing and studio art, self-reflection and philosophical study meet. Those working autotheoretically might move, for example, between experimental writing and conceptual art, filmmaking and art writing, performance art and philosophical fiction; their studio practice might incorporate diaristic journaling and the expanded field of photography, juxtaposing critical research with autobiographical reflection. Works like Barbara Browning's *The Gift* (2017) and her exploration of what she calls the "performative novel" demonstrate an autotheoretical impulse in practices that span performance, music, writing, collaboration, and parafiction. Tisa Bryant's *Unexplained Presence* (2007), Gillian Rose's *Love's Work* (1995), Julietta Singh's *No Archive Will Restore You* (2018), and McKenzie Wark's *Reverse Cowgirl* (2020) also bear mentioning.[7]

The present-day turn to autotheory owes a great deal to transnational feminist histories of art, literature, criticism, and activism. Indeed, the history of feminism is, in a sense, a history of autotheory—one that actively seeks to bridge theory and practice and upholds tenets like "the personal is political." As an impulse, autotheory can be traced through early feminist conceptual art, video art, performance, and body art, as well as cross-genre writings by women of color, such as Audre Lorde, Gloria E. Anzaldúa, Cherríe Moraga, Sylvia Wynter, and bell hooks. Certainly, the practice of theorizing from the first person is well established within the genealogies of feminism, and after the 1960s it takes on a particularly conceptual and performative valence.

Since the beginning of the feminist movement as understood in the West, feminist philosophers have worked from an autotheoretical place: from Mary Wollstonecraft's *A Vindication of the Rights of Woman* (1792) and Sojourner Truth's *Ain't I A Woman?* (1851) to Shulamith Firestone's *A Dialectic of Sex* (1970), the topic of theoretical reflection is catalyzed by their

lived experience as women in patriarchal and colonial societies.[8] The texts themselves are rooted firmly in clearly rigorous, intellectual argumentation, drawing from existing theory and discourse to make shifts—some more reformist, some more revolutionary—based in a certain feminist politics. In the 1970s and 1980s, women were more able to explicitly incorporate the autobiographical or the personal in their "intellectual" work, even as they continued to negotiate such experimental moves with the more conservative demands of their institutions and livelihoods as academics, for example.[9] In the 1980s through the mid-1990s, a lot of feminist theory continued to obscure the line between theory or philosophy and autobiography through such genres as nonfiction and essay collections, with works like Lorde's *A Burst of Light* (1988) and hooks's *Killing Rage* (1995) among the notable examples.[10]

The act of disclosing to other women what was once private was central to the formation of the women's liberation movement in the 1960s,

Lisa Steele, *A Very Personal Story*, 1974, single-channel video (still). Courtesy of the artist and Vtape.

where "consciousness-raising" came to describe practices of disclosing lived experience as a means of becoming conscious of the ways in which so-called personal issues were, in fact, structural and systemic. The revolution of the everyday that took place in the 1960s led to a recognition of daily and domestic life as political: feminist writers, artists, scholars, and activists came to see that, as the slogan had it, "the personal is political," and that their practices (as artists, activists, educators, caretakers) could and should engage with the particularities of their lived experience as women, as queer, as racialized, and so on. This continued through to the third wave, with hooks grounding her antiracist feminist theory in the conviction that "the enemy within must be transformed before we can confront the enemy outside,"[11] a sentiment aligned with the logic of second-wave consciousness-raising.

In the 1970s, the feminist art movement in America foregrounded women's bodies as active and conceptual, while feminist poets and philosophers working in France sought ways to express the female body and subjectivity through writing. Artwork by feminist conceptualists, body artists, postmodern dancers, and performance artists working in the mid to latter half of the twentieth century, among them Piper, Valie Export, Lisa Steele, Howardena Pindell, Shigeko Kubota, Louise Bourgeois, Yoko Ono, Trisha Brown, Martha Rosler, Mary Kelly, Andrea Fraser, and Mona Hatoum, contributes to a rich history of feminist art attuned to autotheory as an embodied, critical stance in art-making. Kelly's *Post-Partum Document* (1973–1977) and Rosler's *Semiotics of the Kitchen* (1974), with accompanying texts, such as Helen Molesworth's *House Work and Art Work* (2000), took up motherhood and labor from autotheoretical perspectives that address the materials and sign systems of their lives, with more recent texts, such as British novelist Joanna Walsh's *#TheoryPlusHouseworkTheory* (2019), in which Walsh relays her experience "listening to or watching works relating

Andrea Fraser, *Museum Highlights: A Gallery Talk*, 1989, performance (photographic documentation). Photo: Kelly & Massa Photography. Courtesy of the artist.

to theory and theorists that are freely available online" while "carrying out a household or personal care task."[12] Walsh's work extends an exploration of theory's relationship to forms of labor—including menial labor—as a way of discussing both self-care and "the growing poor" into a Fluxus-style script that the artist has already performed herself.

The 1980s saw the development of women's studies departments and women's studies (later, feminist and gender studies; still later, sexual diversity studies) as a discipline; with these changes, the number of feminist scholars incorporating personal experience into their theoretical and academic writing increased substantially. "If one of the original premises of seventies feminism (emerging out of sixties slogans) was that 'the personal is the political,'" Nancy K. Miller explains, "eighties feminism has made it possible to see that the personal is also theoretical: the personal is part of theory's material." This came from a larger shift, driven by movements such as critical race studies, to reconfigure what constitutes legitimate knowledge in the academy.[13]

While some scholars—including hooks, Miller, Eve Kosofsky Sedgwick, and Jane Gallop—found it useful to directly incorporate personal experience in their theoretical writings, others decried the impulse as "narcissistic," charged it was lacking sufficient critical distance, or avoided it as professionally risky. In *Getting Personal: Feminist Occasions and Other Autobiographical Acts*, Miller describes how the modes of "personal criticism" and "narrative criticism" that developed during the 1980s were nevertheless "occasional writing" practices, meaning they took place in a marginal time frame in comparison to the more established modes of theorizing. A feminist-inclined scholar might write personal criticism for a low-stakes conference or a newsletter while carrying out the rest of her writing in the supposedly objective style of conventional scholarly writing with its "critical plausibility" upheld by her primarily white, male counterparts—all in the hope of securing a well-paid, tenure-track position.[14] I say this not to entrench a falsely dualistic gender binary but to acknowledge the historical context of division between a Euro-American, male-centric academic culture of scholarship (which tended to obscure its subjective inclinations and investments) and a burgeoning feminist mode that tended to highlight the extant place of subjectivity and the body in theoretical writing.

The mid- to late 1990s saw the publication of scholarly anthologies, for example Sedonie Smith and Julia Watson's *Women, Autobiography, Theory: A Reader*, in which the authors traced the development of autobiography studies and criticism since 1980. They used language from the performative turn to describe what they called "autobiographical acts," and looked to cross-medial and postdigital spaces as contexts in which "self-presentation and self-narration" featured widely, including "Autographics. Installations. Performance art. Blogs. StoryCorps. Facebook. MySpace. PostSecret. LiveJournal. YouTube. 'This I Believe.' SecondLife. OpenSocial. Web cam documentaries."[15] Yet the term autotheory is absent from these texts. Does the invocation of theory lead to the work being perceived as more critically legitimate than if it had softer designations? If the word is coded as male or masculine—a coding that is compounded when compared in oppositional ways to the "feminized" genres of lifewriting and memoir—then it is not surprising that the notion of autotheory is gendered, too.

In the 2000s, writings by American and European feminists activated autotheory as a way of working through contemporaneous issues related to gender, sexuality, and the body. Works such as Preciado's *Testo Yonqui* and the French artist and writer Virginie Despentes's *King Kong Theory* (2006) took up issues related to trans and gender-nonconforming bodies and subjectivities, radical sexuality (or those that existed on the margins of the existing queer discourses), and the politics of sex work and fucking.[16] Preciado's and Despentes's work both marked a shift in the tenor of autotheoretical writing, with Preciado enacting the kind of autotheoretical project that their work calls for: "The philosophy of the pharmacopornographic regime has been reduced to an enormous, dripping butt-plug camera. In such circumstances, the philosophy of such high-punk modernity can only be autotheory, autoexperimentation, auto-techno-penetration, pornology."[17] If the prevailing ideology of the status quo is akin to the abject butt-plug camera, then the philosophical practices required for such an age are ones of autotheory and autoexperimentation—a queered, phenomenological response to the creeping acceleration of theory and culture, one that both affirms and rejects accelerationism through its unique, transmasc enacting of auto-techno-penetration-pornology.

Autotheoretical works move between theory and philosophy—these master discourses, with their status as intellectually rigorous and critical modes that thrive, most often, in academic and para-academic contexts—and the experiential and embodied. The questions of what constitutes theory and who constitutes a theorist are certainly intersectional feminist ones, and are further complicated when approached with an actively anticolonial lens. In what ways and to what extent can a theorist engage "the personal," or can the personal be properly or legitimately theoretical—and how does this question shift when we think about it intersectionally? How personal can one get without sacrificing rigor, and by what—or whose—terms do we define said rigor? Are theory and the personal opposed, or are they inextricably enmeshed, as so many feminist texts intimate? An exploration of these questions and the stakes therein will help us trace the emergence and use of the term autotheory over the last decades.

NOT A MEMOIR: AUTOTHEORY AS PERFORMATIVE LIFE-THINKING

Many artists and writers who work autotheoretically have articulated their desire to differentiate, even distance, what they are doing from memoir or autobiography. Nelson distinguishes memoir from autotheory and supplants "memoir" with "life-writing," where life-writing is distinguished by its ontology as a practice—something active that one does in the present—rather than a genre, which is more static and fixed, shaped by preexisting categories and generic expectations.[18] "It couldn't be called memoir or nonfiction or autobiography," Sheila Heti says of first reading Chris Kraus's *I Love Dick*, "but it wasn't an essay, nor was it fiction. It seemed to be a form I hadn't encountered before, and a persona I hadn't encountered before."[19] The author echoes this sentiment: "*I Love Dick* happened in real life," Kraus explains in her 2016 article for the *Guardian,* "but it's not a memoir."[20]

The act of aligning theory and the self, discourse and life, raises issues when it comes to the question of critical legitimacy—a matter that is complicated further for women and femmes (and others whose subjectivities do not fit into the category of white and male) working in this mode. In 1985, the American literary critic Barbara Johnson wrote, "Not only has

personal experience tended to be excluded from the discourse of knowledge, but the realm of the personal itself has been coded as female and devalued for that reason."[21] Sweeping generic terms like "women's writing" tend to be associated with personal content and are therefore seen as soft or limited in relevance to critical conversations. For example, women's writing might be more readily taken up in relation to the domestic sphere as the site of the personal and the private, rather than the public sphere as the site where real politics and thinking take place—a configuration that was, of course, troubled by the onset of second-wave feminism, but persists today.

On October 1, 2015, the British Indian writer Bhanu Kapil tweeted: "This is the year I heard the words 'autotheory' and now, from Sofia Samatar, 'life-thinking'—for the first time."[22] Kapil was retweeting the Somali American writer Sofia Samatar, who describes the blogs of Kapil and Gukira as "a kind of life-thinking." Autotheory, Samatar explains, is "a word for writing that integrates autobiography and social criticism."[23] One could make the case that much of the work that falls under the categories of philosophy, theory, literature, and art are modes of life-thinking. But terms like autotheory and life-thinking underline the relationship between criticality and the personal in ways that are self-aware. Highlighting words like *critical, theory,* and *thinking* in texts that resemble preexisting genres, such as memoir and autobiography, emphasizes their intellectual aspect, raising interesting questions about the perceived lack of "thinking" in these genres. The term life-thinking shifts attention away from the perhaps more writerly concerns of memoir and "life-writing," where attention might be placed on literary form and the knotty problematics of memory, in contrast to questions of criticism.

Autotheory is as much a wrestling with, and a processing of, discourses and material realities of theory that pervade contemporary art and literature as it is an invoking of one's self as an integral part of theorizing. The term "critical memoir" has been used to describe autotheoretical works from Nelson's *The Argonauts* and Lorde's *The Cancer Journals* to Kate Zambreno's *Heroines* and Ann Cvetkovich's *Depression: A Public Feeling.*[24] The question of whether the memoir is a critical form has been taken up by such scholars as Marlene Kadar, who anticipated the shift from the genre of memoir to the critical practice of life-writing in the period during which

forms like Miller's "personal criticism" and Gallop's "anecdotal theory" were revolutionizing approaches to scholarship in feminist and women's studies programs in Canada and the United States.[25]

Emerging in different ways and to different effects over the past century, autotheory has been shaped on the one hand by the discursive shift toward affect and performativity and on the other by the shifting place of the personal in relation to social media technologies and the more widespread cultural tendency to overshare. Attention to the ways that performativity shapes contemporary practices better equips us for a consideration of autotheory, where performativity and a kind of postmodern self-awareness mark certain shifts from preceding modes of writing the self in a manner that might be described as "postconfessional." Guided by Sedgwick's elucidation of Judith Butler, as well as writings by other queer feminist affect theorists such as Sara Ahmed and Sianne Ngai, Anna Poletti theorizes life narrative as performative (in the Butlerian sense)—as constituting that life *through* the act of writing—rather than as expressive (describing a life that exists prior to the act of writing about it).[26] Poletti's argument is shaped by the performative turn—having inherited the poststructural lineage of performativity from Butler, who articulates the mechanisms of gender performativity that structure the subject in discourse—and predicated on the notion that one's life and identity do not preexist their constitution through a mode of *doing*.

For Nelson, reflecting on her process of writing *The Argonauts*, the distinction between memoir and performative writing comes down to a question of memory. Memory is associated with the genre of memoir, while performative writing approaches memory with a reflexive sense of instability and play. In performative writing, the writer's memory of their lived experience is one material among others, like the theory and artworks and literary texts they reference:

For a lot of people who write autobiographically, memory becomes the main subject, rather than actions. I don't mean that in a derogatory way. It's just that memory is not very interesting to me as a subject. I'm interested in performative writing, I guess—I like it to have heat, or to feel like you're moving with something. ... It's like, let the writing perform that the memory is false, but I don't need to tell you that in words.[27]

Tied to this distinction between a writer approaching their work from an interest in memory and performativity is a distinction between being driven by psychology—a characteristic of many psychoanalytically informed innovations of the early to mid-twentieth century—and being driven by aesthetics, politics, and philosophy. "I focus on aesthetic problems as I work, rather than on psychological ones. Because in my experience, if you resolve the aesthetic issues in any given piece, you've also worked out the psychological ones," Nelson notes.[28] The performative function of memoir as explored in autotheoretical texts comes to a head with Nelson's description of herself as being "in drag as a 'memoirist'" from time to time.[29]

Mieke Bal recently defined autotheory as both a "practice" and an "ongoing, spiralling form of analysis-theory dialectic" that she turned to after being "confronted with the shortcomings of written documentation, especially for the understanding of contemporary culture, which is by definition still 'in becoming.'"[30] For Bal, the practice of making documentary film and then approaching these films "as *theoretical objects*" in their own right is necessary for her to be able to adequately understand and theorize what she has been calling migratory aesthetics as a filmmaker. Autotheory, for Bal, is ultimately "a form of thinking that integrates my own practice of art making as a form of thinking and reflecting on which I have made as a continuation of the making," recuperating the visual and audial back into the theoretical-critical, and back again, through the process of thinking about the work that she made.[31] In this way, Bal's practice as an artist and filmmaker is integral to her capacity to theorize documentary film as a scholar: there is a fluid movement between the two.

In the work of Shannon Bell, filmmaking practices function as philosophical practices that shape and are shaped by theorizing political and aesthetic issues. Bell's method of "shooting theory," which she defines as "theory in action," involves her imaging theoretical concepts by "shooting" video and sound footage and editing it into short videos. She developed this practice between 2007 and 2013 and has "shot" the works of Georges Bataille, Alain Badiou, and Emmanuel Levinas, among others. Bell came to this visualizing practice because of the limitations of the written word in the face of sweeping, abstract concepts: "you can't think political theory simply within language."[32]

In her 1992 elucidation of performance-based philosophy, the start of her autotheoretical deep dive into the politics and aesthetics of female ejaculation, Bell writes: "Performance art is at the forefront of postmodern theorizing. Artists are performing theory: acting out theory. Performance art destabilizes the established conception of what is considered theoretical engagement and broadens the concept of theory to include new areas of life and new political subjects."[33] Bell's work engaged the growing idea that performance, and performance art specifically, is a way of embodying theory. This idea made its way through art and academic practices in the 1970s and 1980s, with the discipline of performance studies, grounded in New York City's experimental theater scene and NYU's performance studies department through the Tisch School of the Arts serving as the institutionalized face of such an impulse. Now well established in academic and art world spaces, performance foregrounds ideas of liveness and the artist's body, iterability and citation, the body in research and documentation.

The practice of embodying and acting out theory converges in interesting ways with late twentieth-century art practices. In the 1980s and 1990s the V-Girls, a feminist art collective comprising Andrea Fraser, Jessica Peri Chalmers, Marianne Weems, Erin Cramer, and Martha Baer, used collective performance as a means to humorously critique academic discourse. Initially formed as a study group to read feminist psychoanalytic theory in earnest, their gatherings soon evolved into discussions of their art practices, as well as the politics of canonization and professionalized language. In their performances, they used the form of the scholarly panel discussion to recast psychoanalytic theory in performative ways. As Becky Bivens writes, "Their works satirize academic egotism and critical theory, with special attention to deconstructionist, psychoanalytic, post-structuralist, and feminist thought."[34] By reiterating the discourse and rituals of feminist psychoanalytic theory and its academicization through their speech and other performative elements as performance artists—including the images in their PowerPoint presentations, the staging and props, and their stern style of dress—they parodied the theory that held a hegemonic place in contemporaneous feminist theorizing and art-making.

Jeanne Randolph coined the term "fictocriticism" in the 1980s—a flexible term that continues to shape present-day autotheoretical practices—when

she was writing art criticism in Toronto. At the time, the term referred to a mode of art criticism that activates fictionalization as a strategy for writing about, and around, the works of artists with whom Randolph might be in close relation—living, as she did, as part of the tight-knit, downtown community of artists in the Queen West scene of Toronto. Now based in Winnipeg, Randolph is a contemporary artist, cultural theorist, and practicing psychoanalyst whose performances and photographic interventions engage ideas from theory and psychoanalysis in ways resonant with the V-Girls' performances. Randolph's extradisciplinary and paradiscursive work enlivens the frameworks of this thing called "theory," often evading scholars (a deliberate move on Randolph's part). In her 2012 performance lecture "Freud's Mummy Bandages: Theory as Melodrama,"

Jeanne Randolph, *Museum of Discarded Ideas*, 2014, photograph. Photo: William Eakin. Courtesy of the artist and William Eakin.

Jeanne Randolph, *Circus of Objects* evening
with pole performer Virginia Draghi-Ranson,
2019, performance. Photo: Alexis Kinloch.
Courtesy of the artist and Alexis Kinloch.

Randolph extended the parafictional, fictocritical experiments around theory and psychoanalysis that she began in the 1980s; she engaged such psychoanalytic methods as free association and stream of consciousness, as well as humor, allegory, and metaphor, and her characteristic commingling of a range of rhetorical registers. In her "Is Ficto-Criticism an Invasive Species?," Randolph writes: "I mention performance to suggest ficto-criticism's unmistakable pliability—handy for perversions of the dominant form (of consumerism, performance, criticism, lectures, research). Ficto-criticism is like an amoeba. It's got no boss."[35]

Roni Horn, *Rings of Lispector (Agua Viva)*, 2004, ochre-colored rubber tiles with orange rubber text inserts (installation view, exhibition documentation). Photo: Stefan Altenburger. Courtesy of the artist and Hauser & Wirth.

A great deal of autotheoretical work exists in the liminal spaces between contemporary art, writing, and criticism. To be sure, many of the autotheoretical writings I've encountered are intermingled, in ways I find curious, with art writing, itself an expanded field of inquiry and practice that exists in close proximity to theory and discursive programming in art galleries, public museums, and artist-run centers. This is a trait not only of recent autotheory. Take, for example, the innovative poetic-philosophical-musical texts of Brazilian writer Clarice Lispector in the 1940s–1970s, which "evaded description": Lispector's *Água Viva*, written in Portuguese, did not "resemble anything written at the time, in Brazil or anywhere else. Its closest cousins are visual or musical," as Benjamin Moser explains.[36] *Água Viva* exceeds preexisting genres and incorporates a self-aware subjectivity alongside citations of French existentialism and French feminism—the relevant philosophy and theory of her context—which is perhaps one of the reasons why Lispector's work has seen a resurgence of interest in recent years as part of the growing trend toward work that is autotheoretical and autofictional.

Autotheoretical texts can give rise to more autotheoretical texts and, sometimes, direct responses. Hélène Cixous has written of her experience of reading Lispector; later, conceptual artist Roni Horn engaged autotheoretically with Lispector's text as translated by Cixous in her 2004 exhibition *Rings of Lispector* (*Água Viva*) at Hauser & Wirth in London. In an elegantly ouroboric loop, Cixous was commissioned to write the exhibition catalogue essay.[37]

In the exhibition, Horn referenced Lispector's *Água Viva* as a core material and point of reference in the work, using it as artist's material within the larger installation and activating the text to new effect through the use of liquid and aqueous imagery. Horn assembled interlocked rubber floor tiles that featured passages excerpted from *Água Viva*. As viewers looked at them, they felt the haptic gush beneath their feet—and were literally grounded on the texts they read. Through her material decisions, Horn makes visible what is implicit in the practices of so many contemporary artists: the haptic processing of theory through the body, and the rumination and fluids that go into making art.

Before autotheory's 2015 surge into contemporary art and literary discourse, the term appeared in Stacey Young's *Changing the Wor(l)d:*

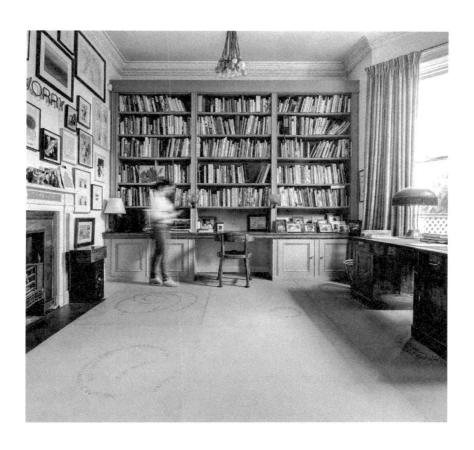

Roni Horn, *Rings of Lispector (Agua Viva)*, 2004, ochre colored rubber tiles with orange rubber text inserts (installation view, exhibition documentation). Photo: Alex Delfanne. Courtesy of the artist and Hauser & Wirth.

Discourse, Politics, and the Feminist Movement (1997), a work of feminist social movements theory grounded in social science methodology. Young uses the word "autotheory," which she is sometimes credited with having coined, to describe a genre of writing that emerges from the women's liberation and civil rights movements: she states that autotheory "combine[s] autobiography with theoretical reflection and the author's insistence on situating themselves within histories of oppression and resistance"; in this way it resembles autoethnography.[38] Methods such as autoethnography and performative ethnography are other antecedents to autotheory: both engage the experience of the subjective self as part of the process of gathering knowledge. In autoethnography, one "seeks to describe and systematically analyze (*graphy*) personal experiences (*auto*) in order to understand cultural experiences (*ethno*),"[39] turning necessary critical attention to oneself and one's own position, while performative ethnography adds an awareness of embodiment learned in performance studies.

Young approaches feminist publishing as discursive politics, reading autotheoretical texts as "counterdiscourses" and as the "embodiment of a discursive type of political action, which decenters the hegemonic subject of feminism": the "hegemonic subject" here is the white heterosexual cisgender woman with class privilege.[40] Focusing on the field of American feminist publishing between 1970 and 1990, Young cites Minnie Bruce Pratt's *Rebellion: Essays 1980–1991,* Rosario Morales and Aurora Morales's *Getting Home Alive* (1986), and the 1981 anthology *This Bridge Called My Back: Writings by Radical Women of Color*, edited by Gloria Anzaldúa and Cherríe Moraga, as originary examples of autotheoretical texts.[41] Young maintains that it is because women of color and lesbian women wrote theory from the perspective of their lived experience that the women's movement began to address intersectionality as a feminist imperative. For Young, autotheory emerges at this point of meeting between third-wave feminism, with its moves toward intersectionality, and second-wave feminism, with its lodestar of "the personal is political." The period in North American feminism between 1970 and 1990 is one in which scholars and writers, including Indigenous and Métis women, were more empowered to use their positioning and life experience as a basis from which to theorize publicly; notable examples include hooks's 1981 *Ain't I a Woman? Black*

Women and Feminism, Maria Campbell's 1973 *Halfbreed,* and Lee Maracle's 1988 *I Am Woman: A Native Perspective on Sociology and Feminism.*[42]

Young's reading of autotheory is based in an analysis of the output of four small presses—Aunt Lute Books, South End Press, Firebrand, and Kitchen Table Women of Color Press—and a consideration of how their publishing of this dawning genre shaped changes in American feminism between 1980 and 1990. Today as well, certain presses shape the texts that I read as autotheoretical: these include a handful of alternative presses, such as Semiotext(e), Graywolf, and Autonomedia, and a few academic presses, notably Duke University Press, which has staked out ground in the subfield of queer feminist affect. These presses tend to publish works that approach theory, literature, and scholarship in exploratory ways and that show explicit or tacit support for progressive feminist politics.

Aside from Young's coining of the term, the only other definitions of "autotheory" appear not in peer-reviewed or professionally published academic sources but in personal blogs. In a post from April 2017, the artist Valeria Radchenko cites Young and Preciado alongside her own definition, in which "writing autotheory is a method of using the body's experience to develop knowledge."[43] In April 2016, a writer named kc, who self-describes as "a white, able-bodied, queer/trans/non-binary person, as a survivor, as a person navigating mental health issues, and as a person with a deep commitment to critical analysis and political revolution," wrote a blog post titled "the academy, autotheory, and the argonauts," which opens with an anecdote from the writer's experience in a seminar class on queer affect theory at a university in the United States. The post becomes kc account of "quit(ting) the academy," or opting out of university training. Yet kc still cherishes certain theory, noting that "there was a particular genre of work that i craved … testo junkie, ann cvetkovich's depression, s. lochlann jain's malignant, audre lorde's zami. … "[44] Autotheory is what marks kc's point of affinity with theory, even as their politics and access needs drive them to exit the neoliberal university and what Jessica Yee calls the "academic industrial complex of feminism."[45]

Theory, here, is a discourse embedded in academic institutions that might be seen as inaccessible—at best daunting, at worst hostile and violent—to certain publics, including those that are neurodivergent, are living with mental illness, are survivors of sexual violence, or are unable to

access higher education due to class- and race-based discrimination. And yet, like Young, kc understands autotheory—a different way of practicing *theory* in para-institutional and embodied ways—to be a fundamentally politicized mode of feminist writing that makes space for those who have been inordinately marginalized to engage in the practice of theorizing and to redefine what it means to theorize. On their blog, kc asks who has access to writing texts like *The Argonauts*, and answers that it is those who have already established themselves as legitimate within the terms of academia (or, relatedly, of contemporary art). For whom is autotheory a truly reparative practice? Sedgwick had to be established in a canonical field—nineteenth-century literature—before being supported institutionally in writing about her identification as a "gay man," her experience

lo bil, 2016, performance (photographic documentation). Photo: Dahlia Katz. Courtesy of the artist and Dahlia Katz.

with breast cancer, and how queer configurations of pleasure drive her choices about what to theorize. To consider autotheory as feminist, one must consider the politics of access and power around the production of theory and the reinscription of what constitutes acceptable knowledge in spaces of higher learning.

The approach an artist takes when working autotheoretically also varies across media and form: personal installations bookended by human-sized reproductions of feminist and queer theory texts made of gluten-free papier-mâché, as seen in Allyson Mitchell's and Deirdre Logue's work; or, in Nelson's or Joanna Walsh's work, names of philosophers and theorists populating the margins and footnotes of what first read like a memoir but now, with its citations, seems more akin to a scholarly project. At other times the references to theory are gestural: the artist-slash-PhD candidate pronouncing their frustration with *reading* as they throw down their notes and a disheveled backpack and speak about bodily discomfort while moving around the room, twisting their body to wring out the sexual trauma that vibrates in them on a cellular level, in lo bil's performance artworks around the conceit of *Moving Weirdly*: *Performance Methods for Researching Trauma*; bil's work that calls to mind the work of earlier feminist performers like Trisha Brown of the Judson Dance Theater, whose *Accumulation with Talking* introduces everyday movement and speech as part of the postmodern dance philosophy that every movement can be an expressive dance movement and that every person can be a dancer.[46]

Or it might be performance for the camera, where the young In-digiqueer[47] artist, feeling isolated in their identity on the Canadian prairies, turns away from books about lesbians to go out and try to cultivate relationships with other real-life queers, as seen in Thirza Cuthand's work; later in their practice, Cuthand uses these same aesthetic strategies and tongue-in-cheek performance-for-video to cultivate and nurture two-spirit communities and intimacies across borders, where two-spirit denotes Indigenous folks for whom both the genders male and female are present within one person.[48] Other times, autotheory might look like an artist literalizing, through their body, a representation of a theory book, as in Madelyne Beckles's *This Bridge Called My Back*, where the artist's physical enacting of the "bridge" posture on her hands and knees— connoting the provision of support, the exertion of labour, and the

Thirza Cuthand, *Thirza Cuthand Is an Indian
Within the Meaning of the Indian Act*,
2017, single-channel video (still). Courtesy
of the artist.

Thirza Cuthand, *2 Spirit Dreamcatcher Dot
Com*, 2017, single-channel video (still).
Courtesy of the artist.

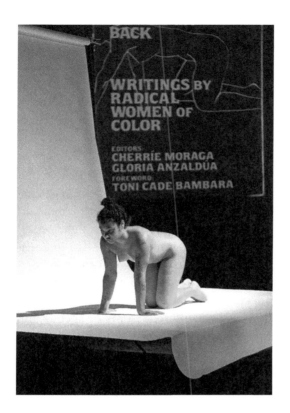

possibility (and refusal) of exploitation—re-signifies the book's iconic title before a live audience. With these practices in view, autotheory is theory and performance, autobiography and philosophy, research and creation, knowledge that emerges from lived experience and material-conceptual experiments in the studio and the classroom.

Madelyne Beckles, *This Bridge Called My Back*, 2017, performance (photographic documentation). Photo: The Art Gallery of Ontario. Courtesy of the artist and The Art Gallery of Ontario.

Increasingly, these artists' and writers' composite ways of working have begun to be recognized by academic institutions as valuable, even necessary, and departments have formed in response to the shifts in culture: programs with names like Creative and Critical Studies, for example, and writing-based programs at universities of art and design, that are necessarily transdisciplinary and recognize the legitimacy of theory and practice as twinned, perhaps even inseparable.

Autotheory is a mode of theorizing that draws attention to itself as such. Take, for example, Audrey Wollen's "Sad Girl Theory" (2016), Johanna Hedva's *Sick Woman Theory* (2016), or Virginie Despentes's *King Kong Theory* (2006).[49] Hedva's *Sick Woman Theory* is an essayistic text accompanied by self-images of the artist lying on their bed and sitting in their wheelchair surrounded by pill bottles and books. It has a manifesto-like reasoning and tone: it is directly tied to social justice activism and rooted in lived experience, and it is disseminated online to promote wider accessibility of information, as a manifesto is wont to do. It advances certain calls to action, advocating for understanding different forms of agency and political participation from the perspective of a sick person. Yet Hedva does not call the work a manifesto but a "theory." In similar fashion, *King Kong Theory* reads as a manifesto for the decriminalization of sex work, rooted in the writer-filmmaker's experience, yet Despentes, too, frames her text as a "theory."

In *Sick Woman Theory,* Hedva places their ongoing experience of living with chronic illness as the basis from which to write a new, intersectional feminist theory that upholds the lives, agency, and limits of those who are experiencing illness and disability. They ground their theory in contemporaneous political contexts, specifically the Black Lives Matter protests in Los Angeles in 2014 and their inability to participate on the streets. Citing the work of Arendt, Butler, Cvetkovich, Lorde, and Starhawk, and placing their theories alongside their gendered, racialized, and class-based experiences as someone living with an autoimmune disease, Hedva engenders a space that resonates with the second-wave, the-"personal-is-political" mantra and with a more intersectional, explicitly queered twenty-first-century feminism. Hedva explains their use of the term "woman" in the sense of a Spivakian strategic essentialism,

emphasizing the long-standing feminist imperative of making one's subject position known while at the same time queering the label of "woman" through trans, nonbinary, and genderqueer subjectivities.

By invoking theory to describe itself, late twentieth-century and early twenty-first-century autotheory marks a shift from work by feminist precursors. Hélène Cixous's *écriture féminine* approached theory as "an essentially masculine enterprise of 'power through knowledge,'"[50] and used the practice of women's writing as a way of distancing itself from that masculinity logic and signification. Other French feminists, such as Monique Wittig, followed suit, marking a point of connection with later Québécois precursors of autotheory, such as the lesbian feminist Nicole Brossard. Brossard's *fiction théorique* is an experimental writing practice that found community with other Québécois feminist writers in the collectively authored text *Theory, A Sunday* (1988).[51] Brossard's writing has been described as *fiction théorique* because of the ways in which it integrates philosophy and feminist theory with autobiography and fictionalization. Theorizing Brossard's writing, critic and translator Barbara Godard describes fiction-theory as follows:

Presented as women's words and put on the page, however, such memories become *fiction-theory,* fiction deployed as thought experiment or hypothesis ("if … then") to rework the social imaginary or as a writing-machine producing forms to … ["resolve problems of sense"] and … ["subject" reality "to transformation" (149)]. Such intercepting the real is performed through language and its image or figures in their function as *relays* to *transmission devices.* The dynamic linkages render reality proximate and so facilitate transference, with a consequent transformation in consciousness and motivation.[52]

Godard argues that Brossard's mode of writing fiction-theory is practiced by the writer "to shift our perceptions" and rupture "what we understand as reality"; she links Brossard's fiction-theory to the related practice of "writing as research" throughout the 1970s.[53]

Just as autotheory has ties to practices of performance and poetry, so too it has ties to the history of the essay and essayistic practices, which span twentieth-century movements such as new journalism. As the

Johanna Hedva, *Sick Woman Theory*, 2016,
photographs. Photos: Pamila Payne. Courtesy
of the artist and Pamila Payne.

autotheoretical impulse moves through contemporary cultural production, it continues to take the essay form, as well as related forms, such as the video essay and the film essay. The essay is a form accustomed to living in the place where criticism and autobiography meet—where one can write about philosophical, cultural, aesthetic, and political ideas along with one's lived experience. Discussing Dodie Bellamy's 2015 collection *When the Sick Rule the World* on KCRW's *Bookworm*, radio host Michael Silverblatt noted that "these pieces use 'theory,' in quotes—as you say, it is an objective correlative: that's the language of literary criticism—and at the same time it goes beyond it. We discover that what we know about the world, *theoretically*, is also manifested in the world, *actually*. And ... that's what makes the best of these essays so very strong."[54] The New Narrative movement, from which Bellamy's work emerged, and related mid- to late twentieth-century writing practices are conditions of possibility for autotheory: with its radical approaches to literary nonfiction that tune in to theory as part of practice and that attempt to honestly or "authentically" represent the writer's lived experience, however tenuous a term like "authenticity" might be in a late postmodern context of reception.[55] New Narrative extends Language poetry's interest in theory and the material qualities of language and selfhood to "a representation of the author as theory-based," as well as indubitably physical.[56]

The essay is often described as a form that *thinks*. Writing in the form of the lyric essay, Claudia Rankine's autotheoretical texts *Citizen* and *Don't Let Me Be Lonely* have the same subtitle (*An American Lyric*), and similarly move between personal narrative, social criticism, and insightful discussions of contemporary art by such artists as Glenn Ligon, whose work is reincorporated into the larger autotheoretical narrative of *Citizen*.[57] Notably, in that book Rankine writes her autotheory in the second person, a rhetorical embodiment of the structural racism her book takes up and her own distantiation from the privileged positioning of the historically whitened "I." Other poets, including Bhanu Kapil, Anne Carson, Eileen Myles, and Leah Piepzna-Samarasinha, have written the lyric essay in ways that might be described as autotheoretical. As I discuss in the next section, the history of the essay, as well as the history of philosophy, are precursors to the development of autotheory—as is, most important for this book, the history of feminisms across disciplinary, medial, and national borders.

While autotheory as a post-1960s mode bears newness, it is tied to these longer histories of aesthetic experimentation and activism.

In a review titled "Is Radical Queerness Possible Anymore?," the critic Christian Lorentzen describes the moment of encountering a new genre as he read *The Argonauts*:

Two words stick out on the back of *The Argonauts*, and I'm not talking about fierce or intrepid. ... The first word is autotheory. Not quite a neologism, it doesn't have much of a life outside of academic writing. At first glance you might assume it refers to building a theory of the self, but what Nelson's up to is something more like deploying her own experience as an engine for thinking that spins out into the world and backwards and forwards in time.[58]

According to Lorentzen, "autotheory" does not refer to a "theory of the self" so much as to theory that emerges from the self. The autotheorist shuttles between self and theory—political theory, linguistics, poststructuralism, affect theory, performance theory, aesthetics, gender—using firsthand experience as a person living in the world as the ground for developing and honing theoretical arguments and theses. In addition to being a site of feminist engagement with the discourses of theory and philosophy, autotheory is also the site of engagement with the materials of the writer's or artist's life: embodied experience can become another text, framework, or catalyst through which to think through aesthetic, social, cultural, moral, and political issues. Entailed in the use of the self (*auto*) as material alongside theory comes a degree of self-analysis and criticality about one's own life as part of the practice of autotheory.

In his blog post "*The Argonauts* is a Direct Descendant of Anzaldúa's *Borderlands/La Frontera* and No One is Talking About It," Daniel Peña laments the tendency for white writers to be credited with the coining of "new genres" that BIPOC writers and artists contributed to developing. While Nelson's work is often described as charting the path for the emerging term "autotheory"—perhaps because her book was one of the first to have the word "autotheory" explicitly printed on it—Peña makes the case that *The Argonauts* is heavily indebted to Anzaldúa's *Borderlands*, something that he argues continues to go unacknowledged in most current conversations around Nelson's work. As Chicana feminist scholars Norma E. Cantú and

Aída Hurtado describe in their introduction to the twenty-fifth anniversary edition of *Borderlands,* "Anzaldúa uses the geographical location of her birth as the source of her theorizing";[59] Anzaldúa extends W. E. B. Du Bois's theory of double consciousness to her experience as a lesbian Chicana woman who grew up in Texas in order to theorize borders, translation, and the phenomenology of living in the "borderlands" in relation to the ever-charged geographic space of the "Texas-U.S. Southwest/Mexican border" where she grew up.[60] Just as Cantú and Hurtado emphasize "the philosophical conceptual significance" of Anzaldúa's writings, so too Peña stresses the violence of erasing Chicana literature from the lineage of American writing that Nelson's "autotheory" draws from.

AUTOTHEORY'S HISTORICAL ROOTS

Interest in autotheory is growing rapidly. Even though it is a recent term, only really taking off in the late 2010s, nearly two decades after Stacey Young is said to have coined it in 1997, "autotheory" embodies centuries-long problems within philosophy. One could in fact speak of an autotheoretical impulse that moves through the larger history of philosophy (from one of the earliest, perhaps most fundamental philosophical yearnings, to "know thyself")—an impulse brought into sharper view by contemporary feminists who are more vocally and, following the changes brought by postmodernism, self-reflexively coming to terms with theory as a system of discourse that structures art and academic life in ways that need to be considered intersectionally.

We can find a tendency toward working autotheoretically in the sixteenth century, with the work of philosophers and essayists like Michel de Montaigne bringing a clarity of focus to the autobiographical in philosophizing projects, a tendency continued later by Jean-Jacques Rousseau, Immanuel Kant, Karl Marx, Friedrich Nietzsche, Sigmund Freud, Søren Kierkegaard, W. E. B. Du Bois, and Frantz Fanon. It is most certainly found earlier, too—think Plato's writing of Socrates, or, as I'll discuss later in this section, St. Augustine's *Confessions.* After World War II and the many social, political, cultural, aesthetic, technological, and discursive shifts

brought on by the post-1945–1950s era and cohering in the 1960s–1970s, autotheory takes shape more clearly. These changes contributed to autotheory's emergence in the so-called West, with the interrelated contexts of a dematerialized, intermedial art scene, decolonization movements, and a burgeoning feminist movement in art and academia.

The idea that the three big patriarchs of this thing we now call "theory" (with a capital "*T*" implied, at least in the "West")—namely, Marx, Nietzsche, and Freud—all worked in somewhat autotheoretical ways complicates the project of historicizing autotheory in a way I find compelling. These three worked autotheoretically in the sense that, to varying degrees, they philosophized and theorized from their lived experiences, sometimes acknowledging this as such, at other times suppressing it. Freud analyzed his own dreams and psychoanalyzed his family members. Nietzsche concluded his oeuvre with a hyperreflective autobiographical treatise, and Marx, the least autotheoretical of the three, wrote about labor from his personal observations, using the first-person plural in *Das Kapital*.

Many of the changes taking shape in the 1960s were bubbling up in the avant-garde of the early 1900s too, with the dynamic experimentation of modernist women and gender-nonconforming artists, writers, and filmmakers like Zora Neale Hurston, the Baroness Elsa von Freytag-Loringhoven, Claude Cahun, and Gertrude Stein marking ruptures in existing genre and media designations. These figures can each rightly be called proto-postmodernists, and their approach to representing oneself and transmuting autobiographical materials in their work resonates with the autotheoretical tendencies found in cultural production today, from Stein's play with the materiality of language and the signification-in-language of domestic objects, to the Baroness's boundary-obfuscating Dada performances of everyday life, to Neale Hurston's shuttling from writer to filmmaker to anthropologist, writing from the first person in reflexively embodied and critical ways in such works as "How It Feels to Be Colored Me" (1928).[61]

The focus of this book is on post-1960s feminist experimentation, and I acknowledge with a keen curiosity these historical precursors and antecedents—be they feminist or otherwise—to autotheory, which would warrant a separate book. For now, I maintain that autotheory has a much

longer lineage than the 1998–2015 context within which the term itself has surfaced, and that this current can be traced not only through earlier feminist art, literature, criticism, and activism as it developed through the nineteenth century and into the twentieth and twenty-first centuries, often in response to hostile situations, but also further back, in the development of the theoretical and autobiographical modes of writing that inform contemporary autotheory. The rigorous writings by feminists such as Luce Irigaray, as well as the apprehension of prescient work that most male theorists dismissed (including her mentor, Jacques Lacan), bears underlining, particularly when it comes to feminists' contributions to foregrounding the self—as embodied in specific ways—in relation to theory. Autotheory is tied to a politics of radical self-reflection, embodied knowledge, and sustained, literary nonfictional writing through the self that has been, and continues to be, suppressed and repressed by certain patriarchal and colonial contexts.

Autotheory exists in the place between criticism and autobiography, which might be why it is so enmeshed, in different ways and to different effects, depending on the practice at hand, with the essay. "I would rather be an expert on me than on Cicero," Michel de Montaigne wrote in his *Essais*, a collection of the French magistrate and philosopher's writings published in the latter part of the sixteenth century.[62] Pointed to as an originator of the modern essay, Montaigne wrote in ways that directly considered the inner workings of his mind and that engaged the personal as a way of thinking through larger ideas. Sarah Bakewell, one of Montaigne's biographers, describes Montaigne as "the first blogger," noting that his favorite subject "was himself."[63] Montaigne assembled his writings, which have been described as "meandering collections of thoughts," under the title *Essais*, which means "trials" or "attempts," where the word "essay" comes from the French verb *essayer*, "to try." Essaying and experimenting are both at the heart of autotheory as an aesthetic mode, where there are active and ongoing attempts being made to understand oneself and one's life in relation to others.

"If you go back to Montaigne, the essay was a very open form that examined the workings of his [the writer's] mind, so it could go anywhere. I think the essay is, in some senses, the closest prose comes to poetry,"

Bellamy notes.[64] In the essay form—which is also often, as history shows, a *personal* essay—the writer can move adeptly between different registers, topics, methods, and modes of argument, including the anecdotal. Some of Montaigne's contemporaries accused him of what we would now call oversharing. It was seen as unseemly—both improper by the standards of the time and also fundamentally nonintellectual and unliterary—for Montaigne to describe in his essays personal details from his life, such as the kinds of wine he preferred to drink or the small size of his penis. *Essais* would ultimately be placed on the Vatican's list of banned books from 1676 to 1854, with Montaigne accused by Vatican theologians of "showing too little shame for his vices" and displaying "a ridiculous vanity" in his essayistic writings, the personal nature of which was seemingly at odds with the public, intellectual standing of a man like Montaigne.[65] But was it the personal nature of the work, or how direct he was about the incorporation of the personal—seemingly without shame, or at least the level of shame expected in that time and place—that made his writing contentious to the patriarchy?

Like Montaigne's personal essays, Augustine's autobiographical writings, published as the *Confessions,* are notable premodern precursors to contemporary autotheory. Written in Latin between AD 397 and 400, Augustine's *Confessions* has been recognized as a formidable, critical work that contributes to histories of religion and culture and "carries harmonics of deeper meaning" that extend beyond its "apparently simple autobiographical narrative." As Henry Chadwick writes in his introduction to his translation, "The work is a major source for social history as well as for religion. ... This work is far from being a simple autobiography of a sensitive man. ... It is a work of rare sophistication and intricacy, in which even the apparently simple autobiographical narrative often carries harmonics of deeper meaning."[66] Of course, the question of whose work gets this kind of consideration and reception—treated as more than *just* an autobiography—is at the core of the autotheoretical impulse and its varied intersectional and feminist politics. Rousseau's writings, also titled *Confessions* (1782) and written in the latter part of the eighteenth century, would influence philosophers like Kant and Marx—philosophers whose work shaped the modes of critical writing and thought known as contemporary theory.

Curiously, there are also notable antecedents to autotheory within the very philosophical and theoretical canons that contemporary artists autotheoretically confront and subvert in their work. This includes thinkers like Jacques Derrida, Friedrich Nietzsche, Immanuel Kant, Sigmund Freud, and René Descartes. While I invoke Cartesian dualism in my discussion of the role that the mind/body opposition has historically played in disregarding more explicitly embodied work by women, for example, when discussing the philosophical efficacy of feminist body art, it is worth noting that Descartes's own work from which I draw and critique is grounded in the *autos*. His philosophical revelation of *cogito ergo sum* ("I think therefore I am"), for one, is predicated on the self-conscious existence of the philosopher as the "I," upon which the philosopher reflexively self-reflects. Indeed, the work of Descartes and Kant is often too easily cited as being in opposition to phenomenological, embodied, and poststructuralist feminist modes of philosophizing—the modes that are directly related to autotheory—which, while making sense in terms of their political views, obfuscates the presence of an autotheoretical impulse in the history of philosophy more broadly. I take this up in chapter 1, where I discuss the trailblazing feminist conceptual artist Adrian Piper's nuanced, decades-long work with Kant.

Autotheoretical writings often make use of illustrative examples, including anecdotes taken from life or from the lives of others from history, to concretize an abstract idea or to work through a philosophical concept. This practice can be found in the history of philosophy, theory, and the essay more broadly—in Freud, for example, or in Jean-Paul Sartre or Barthes (take, for example, Sartre's setting out of daily situations like waiting for the bus to illustrate abstract notions of his existential philosophy in his *Critique of Dialectical Reason*). The particularly self-reflexive charge of certain autotheory texts comes from the use of examples that are explicitly or transparently from the writer's personal life—or the lives of those they identify with—in a way that foregrounds the specificity of the selves alongside theory.

In *The Ear of the Other* (1985), Derrida identifies Freud and Nietzsche as exceptions to the seeming rule in philosophy that one must maintain a separation between the self (auto) and the work (philosophy, theory). Derrida deconstructs philosophy's supposed preclusion of the "I" through

a reading of Nietzsche's *Ecce Homo*, a text that integrates autobiography and philosophy through what Derrida calls "auto-engendering."[67] Derrida takes up the role "autoanalysis" plays in Freudian psychoanalysis, considering the place of Freud's family in his work and how *The Interpretation of Dreams* and similar works are, at root, autobiographical.[68] Nietzsche too incorporates his "I" and his autobiographical experiences in his philosophy in ways that transgress what had heretofore been understood as properly philosophical. Derrida rightly acknowledges that such blurring of Nietzsche's "self" and Nietzsche's philosophy could have precluded him from being recognized as a philosopher, scholar, or scientist in his time, which might in part be why the tendency largely remains latent in Nietzsche's work.[69]

Like Chadwick's reading of Augustine's *Confessions*, Derrida's reading of Nietzsche's *Ecce Homo* sees within it something that exceeds the autobiographical genre: "The utterances I have just read or translated do not belong to the genre of autobiography in the strict sense of the term. To be sure, it is not wrong to say that Nietzsche speaks of his 'real' father and mother. But he speaks of them 'in Ratselform,' symbolically, by way of a riddle ... in the form of a proverbial legend, and as a story that has a lot to teach."[70] He emphasizes that, while autobiography is very much present in *Ecce Homo*, "we would again be mistaken if we understood it as a simple presentation of identity, assuming that we already know what is involved in self-presentation and a statement of identity."[71] In doing so, Derrida apprehends the performative impulse found so reflexively in postmodern conceptions of subjectivity and productions of the self. Derrida is careful not to disregard the more straightforward presentations of the self as constituted through Nietzsche's philosophical writings, even as he acknowledges the different charge that the autobiographical takes on when contextualized within the philosophical or when understood in more performative and conceptual ways.

This approach to practicing philosophy brings to mind Lorde's inventive mode of "biomythography," demonstrated in her 1982 *Zami: A New Spelling of My Name*.[72] Described as a work of "collaged self construction," *Zami* transmutes the autobiographical into the mythological. Like a *bricoleur*, Lorde freely borrows from different genres "according to how well they help tell the story of a particular African-American woman's

life."[73] By elevating her autobiography and family stories to the status of myth, Lorde reframes her experience and distances it from the perceived aesthetic and critical stasis of memoir. Of course, there remain pertinent intersectional feminist questions around the distinctions and power differentials between and among autobiography, fiction, theory, and even myth, and how works that engage the "self" in performative ways are received—issues I return to frequently in this book.

Derrida acknowledges the presence of the autobiographical in the philosophy of Nietzsche and Freud, pointing to possible autotheoretical roots in the history of philosophy broadly understood, and Derrida's own work has autotheoretical bubblings.[74] Yet Irigaray is swift to point out that *her* "autobiography" or self is nowhere to be found in Western philosophy—at least not before the 1960s. This is, in her view, because she is a woman, and the "auto" of Western philosophy is that of a European man.[75] Written in France in the early 1970s, Irigaray's contributions to continental philosophy and French theory function as a feminist counterpoint to Derrida's theses, revealing the need to acknowledge the role that "sexuate difference"— what we in anglicized departments of Gender, Feminist, and Women's Studies today would typically refer to as gender—plays in the relationship between philosophy/theory and the autobiographical self, or "I." Irigaray describes the impulse that drove her to write her 1974 work *Speculum of the Other Woman* in autotheoretical terms: "I wrote *Speculum* because I was a woman and the Western story of philosophy did not correspond to my autobiography or lived experience. Obviously myself-as-woman has been woven into the fabric of *Speculum*."[76] Until then, Irigaray argues, her self was precluded from accessing philosophy; she could enter it if she were to shroud her identity as a woman or, at least discursively, become like a man.[77] Pointing out the precursors to autotheory in male-authored philosophy of the continental philosophy canon does not refute Irigaray's argument about the suppression of the "auto" so much as it reveals the need to more sufficiently consider the ways the "auto" figures in even the most seemingly "objective" philosophical texts: texts that, for all their latent autophilosophical charge, continued to dismiss philosophical work that was more outrightly personal.

"AUTO" (NARCISSISM AND THEORY)

The ease with which the label "narcissistic" is deployed to condemn a particular cultural practice relates to its conventional link to a specifically feminine degradation of the self.
—Amelia Jones, *Body Art: Performing the Subject*

"If you are going to represent physicality and carnality, we cannot give you intellectual authority," Carolee Schneemann relays as she reflects on the reception of her performance art and experimental films in the 1960s-70s.[78] In performances like *Interior Scroll*, Schneemann references directly the reception of her art by the prevailing male-led avant-garde scenes of the time, quoting an unnamed male "structuralist filmmaker" who gives a list of reasons why Schneemann's film work cannot be viewed; the list includes "the personal clutter; the persistence of feelings; the hand-touch sensibility; the diaristic indulgence."[79] The ongoing division between what is properly understood as philosophy and theory—with their intellectual authority—and the autobiographical is one of the key stakes of autotheory as a feminist mode of art practice. It is also one reason why autotheory is itself a provocation. Not everyone has had access to working in a mode that bridges this chasm (a chasm wrought by certain assumptions in the texts constituting "Western philosophy") between autobiography and theory, the body and the mind.

One of the most noticeable ways in which the autotheoretical turn is tied to histories of feminist practice is the simple fact that feminist artists continually face the charge of narcissism when they incorporate themselves in direct ways into their work (and feminists themselves are not immune from launching such critiques). One of the reasons why work by women and artists of color is particularly vulnerable to charges of narcissism is that women and racialized people have been historically overdetermined by their bodies—in contrast, always, to the supposedly neutral standard of the white, cisgender man. With the leftover hold of Cartesian dualisms, this tends to lead to the bias (unconscious or otherwise) that women are *either* intelligent and critical *or* embodied and sexual; philosophically savvy *or* naively navel-gazing. This has led to the creation of autotheoretical work by feminists that responds to such oppositions, integrating their

"personal" with theory in ways that commingle and transform each; at the same time, feminists have also called out their male contemporaries for working in ways that are just as personal while pretending their subjective work is, in fact, neutral or objective.

The association between narcissism and femininity is long-standing, and has roots in psychoanalytic theory. In Freudian psychoanalysis, for example, narcissism and femininity are integrally linked. To call someone "narcissistic" is to pathologize that person as passive, ignorant, and stunted in emotional development. Freud sees female narcissism as "self-contentment and inaccessibility," structured like an ouroboros that renders woman self-contained and impenetrable to the outside world.[80] Since she is characterized by her childlike naïveté, the narcissist is precluded from participating in critical thought. Yet there remains an unresolved paradox in the psychoanalytic theory on narcissism and women: Freud associates women with narcissism by virtue of their gender, and yet women are distanced from the very possibility of *being* narcissistic by not having access to subjectivity through discourse, in the Lacanian sense of subject-formation through the Symbolic Order of signification. This is the argument Irigaray puts forward in "An Ex-Orbitant Narcissism," where she notes that women are not given the freedom to actually *be* narcissistic in the context of a phallocentric economy of signification (she points to Freud's theory of penis envy to drive her point home).[81]

Simone de Beauvoir's *The Second Sex* shows a different kind of feminist approach to the question of narcissism in the history of philosophy: women are, in fact, narcissistic, but this performance or "staging" of oneself comes not from something inherent in women but from the material circumstances that perpetuate women's subjugation. In this mid-twentieth-century, existential feminist view, women's status in the world leads them to see themselves more readily as objects than as subjects, and as such they gravitate to doubling mechanisms—such as gazing at themselves in the reflective surface of a mirror—that split them into subject-object. This provides a woman with a false sense of coherence as a subject. Men, on the other hand, do not see themselves in their "immobile image" because they are always already subjective and active. Like the mirror, the self-portrait and the "selfie" are "instrument(s) of doubling" that women might use—allowing someone to see herself as something outside herself.[82]

While Freud and de Beauvoir conceive of narcissism as feminine, Irigaray understands it as a masculine way of being in the world. It is the male philosopher who is narcissistic, Irigaray argues—and this narcissism undergirds the production of philosophy as we know it.[83] In her critique of Freud's and Lacan's subordination of women and the feminine in their philosophy, Irigaray writes: "The feminine is defined as the necessary complement to the operation of male sexuality, and, more often, as a negative image that provides male sexuality with an unfailingly phallic self-representation."[84] Woman is like the photographic negative to man's positive; woman is the speculative mirror on which the male depends in order for him to have a sense of self. In her later work, Irigaray develops

Gabrielle Civil, *Fugue—Dissolution, Accra,* 2013, performance (photographic documentation). Photo: Fungai Machirori. Courtesy of the artist.

the notion of self-affection as a way of moving away from the masculine ocularcentrism that theories of narcissism are predicated on and toward other sensorial experiences, such as breathing and haptic touch.

Similar to Irigaray's critique of narcissism, other feminists have critiqued the canon of male-authored philosophy and theory for failing to acknowledge the role that a specific thinking, embodied person plays in the creation of philosophical work. From Lorde's and hooks's theorizing of a politics of difference, to Cixous's writing of the body and the self through a poetic-theoretical practice of *écriture féminine*, to Adrienne Rich and Donna Haraway engaging a "politics of location" and positioning, the history of feminist thought emphasizes the role of a specifically racialized, gendered, and otherwise "marked"—to use the now-dated language of feminist performance scholar Peggy Phelan—subject in the production of that thought, and the politics therein.[85] Of course, this move risks being disregarded by the less sympathetic (or the outright antifeminist) as being *only* about "identity politics," and therefore less "purely" rigorous or critical than more serious, and seemingly less narcissistic, thinkers. This is one of the stakes of autotheory: it addresses the unchecked biases behind the charges of narcissism-as-uncritical. Through its fundamental shuttling between the autobiographical and the theoretical, the self-reflective and the critical, and through its knowing complication of the lines dividing "theory" from "autobiography" and both from "fiction," autotheory provides new insight into these long-standing and ongoing problems related to narcissism and the *autos* in theory and philosophy.

"THEORY" (WITH A CAPITAL "T")

Diagnosis: colonialism.
—Lindsay Nixon (@notvanishing)

What does the invocation of "theory" do in contrast to the more militant "manifesto," or the more feminized "memoir"? One answer might be the naming and claiming of intellectual credibility, which is part of the turn toward autotheory today. There is a historical tie between the intellectual authority of "theory" and the devaluing of those who are other than the

intellectual standard of that time. Part of the politics of this autotheoretical turn in culture may well be that BIPOC, women, femme, trans, and gender-nonconforming folks align their work with theory to underline its critical potency and import. To consider the drive behind artists and writers choosing to frame their personal-critical work as theory, one must consider the history of this word *"theory,"* the politics of the term, and who has had access to the title of "theorist."

Today, many artists maintain adjacent professional practices as scholars and educators, curators, writers and critics, editors, directors, and community organizers, and the question of the role philosophy and theory play in the production and reception of their work is one they must consider at some point. Theory's place in academia and the art world continues to be contended, and the politics of theory becomes particularly charged in relation to intersectional and decolonial feminisms—which might question the politics of legibility and intelligibility in "theory" as a historically Eurocentric, American-centric, masculinist, and colonial discourse. While some contemporary artists and feminists approach theory with wariness and caution, others readily invoke it to describe their way of working. The rising trend for artists and writers to align their politicized and personal work as *theory* is worthy of consideration in light of the larger autotheoretical turn.

Historically, for one's work to be considered intellectual and critical, as a philosopher, historian, critic, or professor, one had to have an air of objective authority. Men who are Euro-American, upper class, not racialized, and at least heterosexual-passing tended to be granted the kinds of "objective" authority required for their work to be considered critical and intellectual, while women, people of color, Indigenous people, poor and working-class people, non-university- or college-educated people, and others were historically abjected from that realm because of their assumedly uncritical hypersubjectivity and embodiment—a problem that continues through to the present day in mobilizations of the notion of identity politics. The very notion of theoretical abstraction, or a vacuumed *rigor* that exists for its own ends and apart from any particular body, is a masculine—even macho—and white, colonialist ideal.

Sometimes autotheoretical work is heavily citational of more canonically philosophical and academic materials, with the artist drawing attention to those references by rendering them visual and material, sculptural

and poetic, in otherwise self-reflective work. At other times, as is often in the case for those artists and writers who find the given philosophical systems violent or exclusionary, the work eschews such explicit referencing of canonically philosophical or theoretical work. Instead it focuses primarily on engendering theory from the artists' and writers' lived, experiential perspective as people integrated into a particular community or ancestral context, or referencing those forms of knowledge that are passed on by means other than peer-reviewed publications or white-cube gallery shows—including long-existing Indigenous knowledge systems grounded in specific land and cosmological contexts that are cognizant and attuned as such, with place-based knowledge shared orally in relationship with an elder, for example.

What are the criteria when it comes to understanding work *as* "theory" and "philosophy"? Who gets to define what constitutes theory, who constitutes a theorist? Whose theories are valuable or valued in a given institution or discursive space? What modes of making work are understood as legitimately critical or sufficiently rigorous for academia and the contemporary art world? Who can write or make work in ways that are understood *as* theory? The autotheoretical impulse, tied up as it is with intersectional feminist histories of bridging theory and practice, art and life, is entwined in these questions. To respond to these questions, I consider autotheory as practiced by a range of working artists looking to contested meanings of theory across contexts. I draw from long-standing feminist and BIPOC traditions of critiquing the politics of these often Euro-American-centric discourses called "theory" and "philosophy," from Irigaray's critiques of the gendered blind spots of theory, to hooks's critiques of the hegemonies within feminist theory itself, to Zoe Todd's Métis feminist critique of ontology as fundamentally colonialist.[86]

In "An Indigenous Feminist's Take on the Ontological Turn: 'Ontology' Is Just Another Word for Colonialism," Métis scholar Zoe Todd presents a convincing argument—which went viral online—that the so-called "ontological turn" in contemporary theory is simply appropriating and reiterating Indigenous ways of knowledge. "Personal paradigm shifts have a way of sneaking up on you," Todd writes in the opening line of her essay, going on to describe her moment of revelation in 2013 that came when hearing Bruno Latour, one of her theory "heroes," speak on climate, and

perceiving his view as an iteration, in slightly different terms, of the long-existing Inuit cosmopolitical thought that had been passed on to Todd from her Inuit friends—but without a recognition of that source.[87] Writing from the disciplinary context of anthropology, Todd confronts the "epistemic violence" toward, and erasures of, Indigenous knowledges in larger conversations around ontology; she does so by writing autotheoretical vignettes that move between anecdotal reflections and citations of those Indigenous thinkers who are "discussing the same topics" that theorists are but in ways that might not be clearly apparent *as* theoretical based on the colonialist biases that writers in the West are entrenched in.

The question of who has access to theoretical discourse, as well as who has access to the "I"—an "I" that can speak with agency and be heard—is central in Hiba Ali's *Postcolonial Language*.[88] Using performance for the camera and the form of the performance lecture, or what Ali refers to more specifically here as the "thesis performance" (made, as it was, in the context of her MFA program), Ali embodies ideas from postmodern feminist theory and so-called postcolonial theory, including Judith Butler's work on the politics of whose lives are *livable* and whose lives are mourned.[89] Ali translates this theory into practice through the deliberate, repetitive act of naming in lengthy parts of the video, mourning those who might have gone unmourned in the context of American drone warfare in the Middle East. Through the media of video art and performance with other POC collaborators, she processes postcolonial theory and language through her experience as an Arab woman living in North America in the twenty-first century.

"Do 'I' have the right to enunciate this term? Do 'I' have the privilege, prestige, political authority or affiliation?" are questions that Ali and the other performers return to over the course of the work. Ali's statement that "the experience of the immigrant is deemed as either too personal or too political" strikes a nerve, functioning as a commentary on the limitations of feminism historically and perhaps naïve assumptions of the inclusivity of feminist mantras, like "the personal is political," that developed during the 1960s second wave of feminism. She posits the racialized immigrant as that who exceeds the limits of such feminist discourse—that who is abjected from understandings of the personal-as-political.

Decolonizing theory is an imperative tied to larger movements, some of them here on the colonized lands of North America/Turtle Island, to

decolonize academic and art world institutions. Part of the move toward decolonizing theory is the turn toward restoring and bringing back to life forms of knowledge and language that colonial forces have attempted to extinguish. The artist Joi T. Arcand works with Plains Cree syllabics to create site-responsive works of art that draw attention to the politics of intelligibility and communication on the colonized lands known as Canada, where the colonizer's languages, English and French, exerted themselves with a certain force. Indigenous autotheoretical practices present ripe possibilities for both resisting and subverting colonialist ideologies—including the neocolonial moves of superficial indigenization—and serving as self-determining sites of cultural, epistemological, and linguistic resurgence. Indigenous and Black artists and writers work autotheoretically as a means of questioning the parameters of "the theoretical"—or what constitutes theory: rigor, but by what standard?—in light of pressing questions around subjectivity, colonialism, structural racism, and who is precluded access to self-determination, collective mobilization, agency, and autonomy in spaces of art and culture, and in universities and colleges.

The move toward decolonizing theory, and engendering theory from embodied experience, is coming into clear view across a range of Indigenous and Métis feminist, queer, and two-spirit artists' practices, with notable examples including Thirza Cuthand's performances for video, Lindsay Nixon's book *nîtisânak,*[90] and David Garneau's series of symbolic, trenchant still-life paintings on Indigenous and Métis research methodologies and intertextualities—which shirk settler-colonial influences such as Catholicism and recenter kinship systems and land-based modes of thought. In Cuthand's *Working Baby Dyke Theory: The Diasporic Impact of Cross-Generational Barriers*, one of Cuthand's earliest works of video art, the artist makes theory from their lived experience as a queer, Indigenous artist growing up on Treaty 6 lands, Saskatchewan, in the 1990s. Cuthand continues their long and rich practice of performance for the camera, as they find it an efficacious way to foreground their particular body and the ways in which it is "marked" both in the world and in the work. During a studio visit with Cuthand, I listened to the artist describe being drawn to video art as a medium because it allowed them to accessibly represent their own body—the site of various forms of violence and oppression in the context of colonialist Canada, but also the site of pleasure and agency

and joyful and mad subjectivity, and of aspects that exceed the thinking of colonial history. Through video art, they can subvert discourses and systems *through* the specificities of their performing, speaking, joking body-self, sometimes performing alone and other times alongside Indigenous, two-spirit, and queer settler friends. The immediacy of their body and personality, expressed on-screen, is transformative for the ideas and discourses at play in the work.

In *Working Baby Dyke Theory*, the artist wrestles with questions related to identity and community, diaristically using performance for the camera to voice their desires for love and belonging as a young, Indigenous queer person. Coming out as a lesbian on the Saskatchewan prairies, in a city with little queer visibility, Thirza found themself turning to books as a source of understanding. But books could only go so far: Thirza narrates, in a voice-over accompanying a visual shot of a pile of scattered books on their floor, "I'd gotten tired of just reading about lesbians, so I thought maybe I should go out to meet other ones." Thirza confesses their experiences, as they hungrily sought out community, of being tokenized and mistreated in a small lesbian scene that, in their view, was centered on an older queer community and its needs. With the teenage artist self-positioned as a "Baby Dyke," an identification that comes perhaps as much from their context as from their desire, this video work becomes a "Working Baby Dyke Theory" that represents Cuthand's desires and frustrations living as queer and Indigenous in a particular time and place in Canada's history. This is a philosophical approach to queer living and self-determination in which the artist critiques aspects of the community as it currently exists while affirming the possibility of another way of being in relation *as* Indigenous and queer. Echoing the fluidity of other feminists who have worked autotheoretically, and like Sedgwick, Cuthand has moved in and out of different gender identifications and orientations, shifting language from "lesbian" to "boi" to "2 Spirit" and back again.

To understand contemporary artists' recent engagement with theory through autotheoretical practices, the history of this thing called "theory" must be considered at least briefly. Theory is associated with the tripartite lineages of "Marxism, psychoanalysis, and structuralism," as well as with the poststructuralist work of Barthes, Derrida, Foucault, Althusser, Baudrillard, and others.[91] Fredric Jameson locates the discursive shift from

"philosophy" to "theory" in the 1960s, when postmodernism wrought its many ontological and epistemological changes. Historicizing the waning of philosophy and the waxing of theory over the course of the twentieth century, Jameson moves from Sartrean existentialism as the peak of high modernism and the last notable example of "philosophy" to structuralism and poststructuralism as the beginning of theory; he highlights the influence of such factors as the linguistic turn, Barthes's "The Death of the Author," and the emergent, small *"p"* politics of the personal in this evolution.[92] That existential phenomenology, embodied in Sartre, as well as in de Beauvoir, Husserl, Kierkegaard, is a precursor to autotheory—by way of writing philosophy through an attention to embodied experience as such—bears mention.

As the authority of philosophy wanes, theory emerges as a form of "metaphilosophy," or what Jameson describes as "the transformation of philosophy into a material practice." He defines theory as a fundamentally postmodern form that is intertextual, citational, and appropriative in its references and materials. In contrast, philosophy generates its own monolithic and authoritative "truths" that are not dependent on referencing other texts.[93] For Jameson, the crisis of philosophy was spurred by the so-called "death of the subject," a death of not only "the individual ego or personality, but also the supreme philosophical subject, the cogito but also the *auteur* of the great philosophical *system*." The philosophizing subject is displaced by ideology, and the discipline of philosophy is displaced by "praxis and terror."[94] It is a bleak representation of critical life after philosophy—and characterizes Jameson's cynicism toward postmodern cultural production.

In this Jamesonian view of history, Sartrean existentialism in the 1940s and 1950s marks the climax of philosophy before the dawn of theory; others, such as Arkady Plotnitsky, point to earlier shifts, such as that prompted by Nietzsche, as having led to "the death of philosophy, at least as hitherto understood." Curiously, while Jameson posits Sartrean existentialism as the end of philosophy, Plotnitsky credits de Beauvoir's feminist existentialism in *The Second Sex* as "the first sign of the second death of philosophy," after Nietzsche.[95] If Jameson is skeptical about the value of post-1950s intellectual shifts, he still posits the 1960s as "a moment of a universal liberation, a global unbinding of energies" that had

consequential effects on the ontology and practice of theory and art.[96] This globalized "unbinding of energies" politically and socially could also be felt across the fields of literature and academia. Autobiography and life-writing, for example, did not emerge as an area of serious academic study until the 1960s.[97]

In "Deleuze in the Age of Posttheory," the literary scholar Jeffrey R. Di Leo describes "the alleged 'posttheoretical turn'" in academia, where "theory" means French poststructuralist theory that is, presumably, written by men (or that does not position itself as explicitly feminist), whereas "cultural studies" is something else entirely. Di Leo describes the shift in the 1980s as a time when "theory came to encompass a widening of perspectives": as such, the so-called "low theory" of feminisms, postcolonial theory, and so on, began to supplant so-called "high theory." Looking to the 1990s, Di Leo writes that "the *high* theory of the '70s which was coming to acquire a timeless, ahistorical, permanence in the '80s through its codi-fication in *method* was giving way to the *low theory* of cultural studies which re-emphasized the contingent, local, historical, and contextual character of all cultural artifacts. ... By the '90s, cultural studies had broadened to include postcolonial, queer, and media studies, while theory was showing only the faintest signs of development." In this view, critical race, femi-nist, and queer theory are something ontologically different from "theory" properly understood: they are posited as a form of "cultural studies" that, at best, is a kind of "low theory."[98] Di Leo's emphasis on the place of "the contingent, local" in rendering so-called low theory *low* is significant when one considers the development of autotheory as a feminist mode. Such an oppositional understanding of "cultural studies" and "high theory" sets the stage for a better understanding of the intersectional feminist politics of theory that autotheoretical practices set in motion.

The misguided division between identity politics and "theory" is a thinly veiled racist and sexist configuration of what kinds of knowledge are critically upheld. As David Chariandy puts it, "Theory, real theory, will appear to be white," and the more opaque it is, the better: "like be-ing an asshole."[99] Even today, scholars seem to know well the white- and male-dominated nature of "true" or "real" theory and philosophy—at least as it is historically canonized. I have heard from women and gender-nonconforming scholars that, when they presented their work at

philosophy conferences, they were the only women or non-men there, and when they went to women's studies and gender studies conferences, what they were doing was no longer considered "philosophy" but something else (as if working from a discipline like gender studies precluded one from ascending to the supposedly more intellectually pure realm of philosophy). Autotheory reanimates "subject-centered inquiry"[100] in a way that rigorously engages the "master discourse(s)" of theory. If theory via Kant, Nietzsche, Marx, Freud, 1970s poststructuralism, and Di Leo's "high theory" (which ostensibly disclaims subjectivity and contingency for something universal) is at odds with an intersectional feminist politics of subjectivity and locatedness, then autotheory provides contemporary artists and writers with a way to work through this difference, process these tensions, and generate different ways of thinking about, and being with, theory. Feminist autotheory positions subject-centered work *as* theory using a range of tactics and strategies.

In a contemporary climate in which terms like "posttheory," "antitheory," and "the death of theory" circulate, I consider how autotheory offers up different ways of approaching the work of theorizing, and the relationship between the rise of autotheory, the institutional encouragement of integrating theory and practice, and recent discourses of us being in a "posttheory" time. Indeed, like BIPOC feminist critiques of the so-called "death of the avant-garde" in the 1960s—at the very time when more kinds of people were able to access avant-garde spaces and ways of working (or be recognized as such)—the claim that we are now "post theory," or living in the wake of theory's proverbial "death," needs to be considered in relation to the rapid rise of autotheory and the feminist, antiracist, and anticolonial or decolonial politics therein.

THE GENDER TROUBLE OF AUTOTHEORY: SEMIOTEXT(E) AS A CASE STUDY

In their autohistory of the New Narrative movement, Bellamy and husband Kevin Killian write that Chris Kraus's *I Love Dick* in 1997 marked a shift—an end of New Narrative and the beginning of something else.[101] This something else, I think, is autotheory, in its late 1990s to present mode

of explicitness—or the emergence of something even more performatively autotheoretical than the already theoretically informed, reflexively subjective writings of New Narrative. Kraus's writings were my initial guiding thread through autotheory, and she is a significant figure throughout this book. In contextualizing her autotheoretical work, the focus of chapter 5, I consider the ontological and epistemological power differential among the terms "theory," "autobiography," and "fiction" as they persist in culture. This is a problem even in the most leftist-leaning, experimental modes of theory and writing (one ought not equate *experimental* with *progressive*—something I often forget) in the late twentieth century, embodied in the case of Semiotext(e), the press that published Kraus's work and that she co-ran as an editor for some time with Sylvère Lotringer and, later, with Hedi El Kholti.

The actions of male editors and writers precluding women, in different ways, from the terrain of "theory" have been ongoing. The case of Jacques Lacan banning Luce Irigaray from her teaching post in post-1968 Paris owing to her integration of feminism with philosophy in *Speculum* serves as a notable example of the feminist problems in contemporary theory. In the early 1970s, Semiotext(e) brought French poststructuralism in all its post-1968 politicized, subversive, countercultural fervor to the United States, manifesting as schizo-abject, quintessentially postmodern theory and writing. Semiotext(e) played a role in publishing work that I find especially pertinent to the autotheoretical impulse, and yet the press's history and catalogue also show how stark gender divides persisted through poststructuralist and postmodern theory: even the theory that purported to destabilize power hierarchies and to queer gender nonetheless remained dominated by cis male voices in ways that excluded others. I take Semiotext(e) as my case study, here, because I see them as a leading edge of contemporary theory, and I approach with a curiosity more than anything this historical gender trouble in relation to autotheory's tensions between writing the self, theorizing, and fictionalizing.

In 1974, Lotringer founded Semiotext(e) as "a vehicle for introducing French theory into the United States." Lotringer had been a student of Roland Barthes and, like Barthes, had shifted from an interest in structuralism and semiotics to an interest in poststructuralism. In 1972, when

Lotringer was hired by Columbia University in New York City to teach structuralism, he found he was more passionate about the possibility of "engineering a nonacademic intellectual movement" and "reinvent(ing) the concept of revolution in America" through post-1968 French poststructuralist theory. What resulted was Semiotext(e), a press that would soon become the cutting-edge cult space for critical theory that embodied "the interface between the globally dominant American culture industry and the French theorization of the post-1968 experience."[102] It was and continues to be a hub for vanguard critical texts that straddle the line between art and literature, criticism and activism, philosophy and theory.

Semiotext(e) primarily published theory and art by European and American men, with the one oft-cited female exception to the rule being Kathy Acker—a woman with whom Lotringer was romantically and sexually involved. In 1990, Semiotext(e) bifurcated into two subpresses: one focused on male-authored "theory" and the other focused mostly on female-authored "fiction," with some exceptions, such as David Rattray. Kraus curated the latter in the Native Agents series, which she founded to showcase autofiction written by theoretically inclined women and queers, with writers like Ann Rower, Lynne Tillman, Barbara Barg, Cookie Mueller, Myles, publishing works that activated a newly performative, postmemoiristic "I."[103] Many of these writers emerged from subcultural scenes in which performance featured heavily.

Under Kraus's direction, Native Agents established itself as a space for an exciting, experimental feminist literary counterculture. While it made space for working-class and lesbian women exploring transgressive themes around sexuality and identity, it remained predominantly white, a matter that has been addressed in Semiotext(e)'s more recent subseries, which publish cutting-edge work by writers like Jackie Wang and Veronica Gonzalez Peña. Native Agents galvanized forces that had been latent or disconnected from each other, including third-wave feminisms. Yet the feminist politics of Semiotext(e) remain curiously untapped in scholarly communities. Why was Semiotext(e) not publishing theory by women?

In a 1994 interview conducted by Henry Schwarz and Anne Balsamo with the then couple, Kraus explains how Lotringer was comfortable publishing work by women when it was *fiction,* but not so much when it was theory. This was because of the "psychoanalytic bent" of feminist theory,

which was seen as being wrapped up in psychoanalysis. Semiotext(e) aligned itself with the Deleuze-Guattrian strain of theorizing, which ran counter to Freud.

LOTRINGER: So the idea was instead of criticizing or being criticized, [quietly we issued the point of view series], and we start going the other way. So that basically we balance things out and go on.

KRAUS: Sylvère's idea about this was that it was acceptable in the fiction series to publish only women, but he never wanted women in the theory series because the only women he knew writing theory were doing psychoanalytic theory, which he wasn't so interested in. And then the fiction series wasn't introspective or psychoanalytic at all in that way. It was a very public "I." The same public "I" that gets expressed in these other French theories.[104]

Lotringer's comments here imply that being self-critical and introspective is antithetical to being theoretical, a view that stands in contrast to the promise of autotheory: in the world of Semiotext(e) in the mid-1990s, "feminism" was associated with psychoanalysis, particularly feminist critiques of psychoanalytic theory as seen in the work of Irigaray, Cixous, and Kristeva. The late twentieth century saw theory and art-making that came, in a sense, after psychoanalysis—distanced from the kinds of discursive epistemologies that the well-entrenched Freudian and Lacanian modes represented, and located somewhere "after" psychoanalysis, confession, and philosophy. In the case of the Native Agents scenes of the early 1990s—found in the liminal space where literature, visual art and performance, and music and sound meet—this was tied to the perceived association between second-wave feminist theory (emerging from a French tradition) and psychoanalytic theory.

Lotringer's resistance to "auto-critique" in his role as a literary critic and editor problematizes the seemingly unchecked gender problematics within Semiotext(e) as a twentieth-century space for experimental, seemingly progressive and even queer modes of practicing theory. In the interview Lotringer describes the act of "self critique" as "useless," entrenching the divide between disclosure and "personal" modes (coded as feminine, or perhaps feminist here), and concealment and the properly *theoretical* (coded as masculine, or male).

The conversation with Lotringer and Kraus presupposes a false dichotomy between the self-analyzing and the polemical or public, a dichotomy that seems particularly disingenuous in light of the kinds of work Native Agents published. That women and queers are given space to write fiction but not theory demonstrates one of the stakes of autotheory. It also provides insight into the growing tendency for women, trans, and gender-nonconforming writers and artists to explicitly frame their work *as* theory—even works that move across genres and could be described using different terms, such as manifesto or memoir. Theory has excluded them, even when it could serve as a useful or apt descriptor of their work, so now they invoke it, with a wary pride, describing their work as *theory*.

CONCEPTUAL ART: ART AFTER PHILOSOPHY

One of the challenges and pleasures of watching Annie [Sprinkle]'s work, I think, is that it is theoretically sophisticated without appearing to be. She literally embodies theory.
—Gabrielle Cody, *Hardcore from the Heart*

Just as the 1960s saw a move from high modernist "philosophy" to postmodern "theory," so too did this period bring a revolution in the relationship between philosophy and art. In "Art after Philosophy," the conceptual artist Joseph Kosuth argues that "the twentieth century brought in a time that could be called 'the end of philosophy and the beginning of art.'"[105] Put simply, conceptual art is art in which the idea or concept behind the work takes precedence, often over the physical art object. In conceptual art, it is the framework that the artist establishes for the work rather than any particular formal style or set of materials that in many ways defines the piece as a work of art. Through being framed as art, it becomes art.

Conceptualism developed alongside the proliferation of other intermedial practices in the 1960s, including video art, installation art, body art, the making of multiples and artist's books, Fluxus, happenings, and the newly cohering black arts movement and feminist art movement.

Conceptual art takes shape across media, with conceptual artists working freely across different materials and forms, choosing whichever is most conducive to the concept or idea they are working with at the time. Feminist conceptual art and body art practices brought politicized stances into play with self-referential, theoretical critiques. In addition to bringing together the conceptual and the political in a given work, feminist conceptualists revealed the potential to incorporate "subject-centered inquiry" into idea-based art—which had, in the hands of male artists, prohibited such blending, at least in theory.[106] Women and artists of color resisted the poststructuralist notion of the death of the author that began to circulate post 1968, just as they were beginning to gain entrance to these scenes. Through the 1960s and 1970s, such women artists as Adrian Piper, Eleanor Antin, and Martha Rosler were also increasingly skeptical of conceptual art's "insular focus on aesthetic debate," interested instead in articulating "their emerging concerns with problematic social relations" connected to everyday life, gender, and race.[107]

The paradox of narcissism is as much a problem in the fields of theory and scholarly writing as it is in contemporary art. Certain practices, among them video art and performance for the camera, are especially conducive to an autotheoretical impulse, enmeshed as they are in conceptualism, self-imaging, and reflection. In her 1976 essay "Video: The Aesthetics of Narcissism," the art historian Rosalind Krauss proffers a convincing Greenbergian argument that the medium of video art is not a particular material (in the way we would typically understand medium—where the medium of painting is, it figures, *paint*), but is the psychic mechanism of narcissism itself. In this view, video art—a practice that emerged with a DIY force in the 1960s and 1970s as the technology, relatively affordable and handheld, became accessible to artists—works with the literal self-looking made possible by those technologies. As they perform in front of the camera, the artist sees themself in the monitor—peering into the camera's lens, the artist's image is reflected back to themself, the monitor providing a mirrorlike feedback, specular and reflexive, as it records.[108]

While a characteristic of the feminist movements especially, this turn to self-reflection in conceptual art practices of the 1960s to 1970s was not limited to women. Joan Jonas reflects on the period of the 1970s when she was making performance for video work, a literally self-looking practice

made possible by the Sony Portapak and its capacity for transmitting the moving image on a monitor, simultaneously, as the artist records. She describes how self-reflection was a big concern for artists like herself, which the video camera made space to delve into: "I was very involved with self-examination and looking at myself and my relationships with friends. How women relate to each other. And men were also going through these same changes, and they were very concerned with these questions as well. So politically it was a very exciting time."[109]

The rich history of "self-imaging" practices in feminist art has been extensively written about by scholars of performance, visual culture, and art history, among them Amelia Jones, who offers a reading that reclaims narcissism as a self-aware stance with the potential for art world subversion. Looking to the history of 1960s–1970s feminist body art, Jones considers Hannah Wilke's "embodied narcissistic subjectivity"; she proposes that, as a self-reflexive feminist approach, narcissism can destabilize the terms and valuations of a patriarchal, mid-century modernist art world—specifically the high modernist approach to aesthetic "disinterest" espoused by Greenberg via Kant.[110] Jones's feminist reclamation of narcissism through her art historical readings of feminist body artworks informs my thinking about autotheory: I extend her research as I consider how artists and writers transmute the self through imaging and other modes of representation and inscription.

Those working autotheoretically seem to share certain critical and aesthetic investments and fixations. Like Jones, Kraus repeatedly turns to Wilke as exemplary of a feminist artist who used her body in her own work in ways that were perceived as too transgressive—unintelligible in their supposedly uncritical narcissism—by both male critics and feminists. Kraus proclaims, "Hannah Wilke is a model for everything that I hope to do," positioning *I Love Dick* as an extension of the theoretically informed work begun by feminist conceptual artists and body artists before her.[111] Here the turn to "the canon" is more a turn to those marginalized in the canon—the paracanonical artists who slip through the cracks of history, or who deserve more consideration in light of emergent notions of practice that might adequately describe how they were working.

As discussed earlier, under the logics of philosophy as historically understood, which include Descartes's dualism and Aristotle's chain of

being, women's bodies have been irreconcilable with the rational mind. Jones argues that feminist body art and performance art of the 1960s on is a condition of possibility for the female artist to be "both body and mind, subverting the Cartesian separation of *cogito* and *corpus* that sustains the masculinist myth of male transcendence," which becomes the basis for her argument for the "radical" possibilities of so-called "narcissistic" feminist practices in the 1970s.[112] As Schneemann writes, "To deal with actual lived experience—that's a heroic position for a male and a trivial exposure for a woman. … A woman exploring lived experience occupies an area that men want to denigrate as domestic, to encapsulate as erotic, arousing, or supporting their own position."[113]

In the San Francisco–based American artist Christine Tien Wang's *I'm Too Self-Aware to Be a Narcissist* (2019), the titular words are written in all caps in red paint on a gold-speckled, white-glazed ceramic vase, the text wrapping around the front side of the bulbous, hourglass-shaped container. The work establishes a distinction between "narcissism," on the one hand, and "self-awareness" on the other, the two being, by the logic of this statement, mutually exclusive. In contrast to the uncritical narcissist, lacking in cognizant self-reflexivity (narcissism as a literal reflection: Narcissus dumbly gazing at his own image in the pool), is the self-aware person. By being conscious of what they are doing, the person who is self-aware is a different animal from the person who is not aware of their self-looking—namely, the narcissist. Wang's work is decisive and youthful, its bubble letters seemingly belying its critical insight. The work might *look* narcissistic, it says, but it isn't: it is taking up the very long history of women's and POC artists' work being written off as narcissistic, and doing so with self-awareness of its method. Such belying of the work's criticality is, of course, the point.

Wang made this work as a protracted response to a 2014 *Los Angeles Times* review of her solo debut at Night Gallery, which art critic David Pagel eviscerated, calling it narcissistic. The review stuck with the artist, who continued to process it through her studio work. Pagel describes Wang's 2014 exhibition as a "heavy-handed confessional," hailing the work into a long history of confessional writings and art while adding "heavy-handed" to distance it from any kind of redeeming nuance. Pagel writes that "narcissism and social responsibility do not collide or even

commingle in 'I Want That Bag.' ... They simply sit, side by side, in the young artist's half-baked paintings and undeveloped sculptures," thus re-inscribing the Freudian narrative of narcissism as a failure to develop. Pagel distinguishes narcissism from self-reflectivity by marking the latter as ethical: with considered self-reflection comes the possibility for personal transformation through that very self-awareness. Instead, "Wang's works are too quick to the punch to be self-reflective or to inspire such self-awareness in others." The critique of narcissism becomes not only an aesthetic critique but an ethical one: the narcissistic artist is a socially irresponsible artist.

Some of Wang's painted collages take the form of aggressive confessionals. Today, publicizing one's shortcomings has become an end in itself—not a step toward self-transformation, as it was 17 centuries ago when St. Augustine got the genre started, but a self-serving defense of the way things are. That's the tone of Wang's works, particularly *Upper Middle Class*, a slapdash double portrait of her dad and herself.[114]

Wang takes what has been projected onto her by the art critic and makes new work with it. During a studio visit over Skype, Wang shared with me sketches of her work in development: line drawings of shapely, undulating vase outlines with words written inside, dated like journal entries. Some read like affirmations, wrestling with this distinction between narcissism and ethical self-awareness: "I AM TOO GOOD TO BE A NARCISSIST." Others are confessionals, twisted and darkly comic in their meta-formalism: "I went to a pottery class instead of my friend's funeral." Wang has gone on to make confessional paintings and sculptures in which her scathing self-disclosures are written in large font over medium and large acrylic-on-canvas paintings and smaller kiln-glazed ceramics. Works like *I married for health insurance*, *I just want to be a white girl*, and, perhaps most contentiously, *I love rape porn* (all from 2017) continue her practice of publicly disclosing loaded "truths"—wrapped up in the personal politics of gender, race, sex, class, and political economy.

Pagel's review entrenches a mutually exclusive opposition between Wang, the millennial feminist artist who is uncritically narcissistic, and figures like Augustine, whose autoreflective work is one of intellectually

productive self-transformation. Pagel assumes Wang's work is not self-aware in that self-realized sense but is self-looking in a juvenile, petty way. The critic's assumption that Wang's work is naïve extends the Freudian view that women are naive narcissists into the twenty-first-century art world. If Wang's work makes an incisive critique through that narcissism, it would be, Freud and Pagel seem to assume, *by accident.*

For my part, I wonder whether the narcissism of Wang's work in the artist's first solo show in Los Angeles extends a self-imaging and mirroring of the self into a mirroring of society. Pagel describes Wang's paintings and sculptures as the "visual equivalent of tweets: thumb-jerk responses that are a lot less clever than—and nowhere nearly as consequential as—their senders think." This was written two years before the Trump presidency, during which Twitter has served as the American president's primary mode of communication with his public—a perhaps seemingly petty but ultimately consequential and populist communication medium that is simultaneously "thumb-jerk," as Pagel put it, and soberingly effective. Ultimately, Pagel sees nothing substantive in Wang's work: in place of real politics, there is a self-defeating posturing: "Wang's idea of aiming higher involves littering her pictures with tidbits of info about global warming." Is the "narcissism" that Pagel perceives in Wang's work not a trivial self-looking so much as a personally situated, socially aware representation of the political climate of America in 2014, with the artist's calling out of hypocrisies in the words and actions of influential pop cultural figures like Leo Dicaprio a useful tactic? Is such a true-to-life representation too cynical for Pagel's tastes? Is this not what good art does—turn a mirror to society, to show it to itself? Is this not the move from the "particular" to the "universal" that so many writers and artists—many of them white men—describe their work as doing?

In place of Pagel's "heavy-handed confessional," I would like to suggest "postconfessional" to describe Wang's work. This is work that comes after the confessionalism of the 1950s, and is changed by the political and aesthetic waves ushered in by postmodernism. Contemporary autotheory by Wang and many others engages strategies such as postconfessional confession and a self-aware, critical narcissism as a way of subverting long-standing histories that posit women's turns toward the "self" as something other than critical or smart. Reviews like Pagel's explain in part the

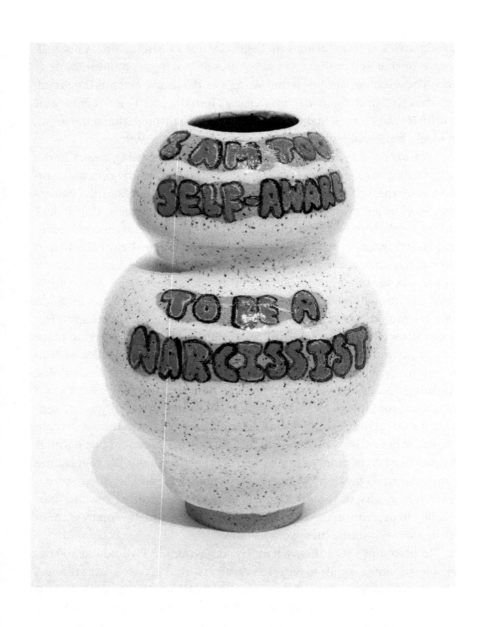

Christine Tien Wang, *Narcissist*, 2019,
ceramic, glazed. Courtesy of the artist.

tendency in the autotheoretical impulse for artists and writers to resist straightforwardly "self-turning" genre descriptors like memoir and autobiography in favor of terms that foreground their work's concomitant criticality—as autotheory does.

CONCLUSION

This book on autotheory as artistic' practice pays keen attention to the vital points of connection between and among contemporary art, film and video, visual culture and theory, feminism and gender studies, and literary studies. As a writer, a researcher, a self-taught curator, and an artist, as well as a working-class, first-generation student from a settler-colonial, white family context in the Canadian prairies of Treaty 4 lands, I write with an investment both in the many objects of study taken up in this book and in the methodology these texts embrace vis-à-vis autotheory as a feminist mode that is still being defined. The works of art and writing that I spend time thinking through and with in these chapters are works that *mean* something to me, personally and intellectually, politically and affectively—and whose resonance with autotheory vibrated somewhere inside my curious, theorizing body and stuck, for a time, in ways that required their own processing, along with the texts they took up.

In my theorizing of autotheory as an artist's practice that bubbles up in earlier eras but takes shape more coherently from the 1960s onward, I am interested in works of art and writing that directly engage the discourses of philosophy and theory in ways that are often nuanced and ambivalent, providing critique and affirming criticism without simply writing something off (and so distinguishable from "cancel culture"—that thing is "OVER") or finding a smug sense of self-satisfaction in the act of a well-executed critique (the smugness that always strikes me as particularly bourgeois). As the poet Danielle LaFrance put it in her potent autotheoretical script, "On Aftermaths": "The point is never to find satisfaction in critique—that's for eating ice-cream."[115]

The work is never done, and no critique is all-encompassing or infallible, even if it were to resemble the most perfectly intersectional, feminist, decolonial way of critiquing things. Every standard is an ideal point, an

abstraction, that we can crawl toward in the sense that Allyson Mitchell and Deirdre Logue have in mind as they write through Monique Wittig and José Esteban Muñoz, shooting a video from the low-to-the-floor perspective of their cats, as I discuss in chapter 4. I hold this point with me as I write this theory of the autotheoretical impulse and as I reference the work of many notable feminist artists, writers, critics, curators, activists, and others who live lives that are committed to the hard work, who might not feel safe to be as vocal as others, or who might be shy to admit that they don't really *get* certain philosophers, perhaps because they are working-class first-generation students and their first exposure to these ideas was in graduate school, or because they understand that *getting* a philosopher—in a sense of mastery—might not even be the point.

In chapter 1, I take up Adrian Piper's 1971 *Food for the Spirit,* a performance in which the artist moves between reading Immanuel Kant's *Critique of Pure Reason* and taking "proto-selfies" with a camera and a mirror as a way of conceptually metabolizing Kantian aesthetic philosophy. By recasting this work in light of the notion of autotheory, this chapter provides insight into the precursors of autotheory in early conceptualism and body art and presents Piper as a pioneer in this area, while exploring the nuanced contributions Piper's work makes to scholarship on Kant and the as yet unresolved issues raised by Kantian aesthetics, including the revelation of autotheoretical murmurings present within Kant's own thought. In chapter 2, I consider autotheory as a practice by which artists can coyly critique problematics of theory, status, economics, and capital. Looking at work by such artists and curators as Sona Safaei, Hazel Meyer, and Sonia Fernández Pan, I consider how they engage autotheory to address the ways theory circulates and accumulates value in culture.

Chapters 3 and 4 focus on practices of citation, or the referencing of other people and texts as sources of information and influence, in autotheoretical work. Chapter 3 opens with a reading of Nelson's *The Argonauts* beside Barthes's *A Lover's Discourse* to establish a context for the performative use of citation as a strategy in queer feminist work. Extending these notions of intertextual intimacy and identification, chapter 4 considers the mimetic drive in contemporary art, whereby artists reproduce books by hand as a mode of citing theory. I turn to installation art by Cauleen Smith, and Allyson Mitchell and Deirdre Logue that use visual means

to place citations beside autobiographical material. The act of making-haptic through auto-inflected processes of transcription is also a making-human, rendering objects of research and study into something palpably human and, perhaps, humane. In chapter 5, I focus on the aesthetics and ethics of disclosure and exposure, considering the nuanced feminist politics around autotheoretical practices and movements such as #MeToo. The book concludes with questions around theory's relationship to alterity, the possibilities of decolonizing theory, and the futures of autotheory in relation to ongoing issues related to knowledge, the self, land, and place.

The autotheoretical impulse comprises the impulse to critically theorize and philosophize from the perspective of someone who is clearly subjective and embodied; to process lived experiences as a theorist or philosopher of sorts; to understand one's self and one's life in relation to theory and philosophy, and to understand one's self as part of one's practice of making work—be it a painting, a piece of writing, a film, and so on. Just as autotheoretical practices are myriad and multiple, the body of theoretical work, or the specific modes and traditions of philosophy that a given artist or writer engages in their work, depends on the context within which they are working as well as their own critical sensibilities. For Piper, as a leading-edge conceptual artist working in America in the late 1960s, it is Immanuel Kant, whose aesthetic philosophy continued to hold an influential place in the mid-twentieth-century American art world; for Kraus it is the 1970s French poststructuralist thought of theorists such as Gilles Deleuze and Félix Guattari, which her then husband, Lotringer, is seen as having brought to America, that she processes as a so-called failed filmmaker; for Nelson, it is the twinned lineages of queer theory represented by Barthes and Sedgwick, which she then processes through her own Prop-8 era, queer California life.

According to Mieke Bal, art-making is thinking.[116] Living, too, involves a practice of thinking; in many autotheoretical practices, both art-making and living become practices that the artist theorizes. Life and art, theory and practice, and their interrelationships become objects for, and sites of, theorizing. Autotheory relies on theorizing and philosophizing from the particular situation one is in, drawing from one's own body, experiences, anecdotes, biases, relationships, and feelings in order to critically reflect on such topics as ontology, epistemology, politics, sexuality, or art.

Autotheory involves a reflexive movement between and among thinking, making art, living, and theorizing. In all its plurality, autotheory can be defined by this self-reflexive movement among art, life, theory, and criticism—a movement encompassed in Bal's description of autotheory as a "spiral-like activity."[117] The commingling of theory and the self brings with it the need for self-reflection. Both *auto* and *theory* are enmeshed in the autotheoretical practice of theorizing and philosophizing, and so both involve work—rigorous and often difficult work. Jennifer Doyle's formative writings have shown how what constitutes "difficult" work or material for one person might not be difficult for another: she makes the case that conversations in contemporary art should move away from discourses of controversy to languages of "difficulty." Doyle's art historical writings are autotheoretical: she begins with a lived anecdote and moves through these different bodies of anecdotal knowledge, critical art writing in one hand and queer feminist affect theory in the other. She describes experience as an artist's material, qualifying her argument with the assertion that "experience here is not an unquestioned zone of personal truth to which one retreats but a site of becoming, of subject formation—it is an ongoing process that produces the conditions of possibility for recognition, understanding, and difference."[118] One's life experience, then, when shared in one's work is open to critique.

Theorizing autotheory as an artist's practice, I keep an eye both on the past—historicizing autotheory in light of its multiple antecedents—and on the future. I suggest that autotheory might be understood as the mode that Nelson calls for in *The Art of Cruelty* when she describes a post-avant-garde aesthetics that seeks to "dismantle" or, at the very least, "poke fun at" the dominant macho histories of avant-gardism that have historically precluded women and the gender-nonconforming.[119] As I write a working, flexible, ever-evolving history of autotheory, I remain attuned to the ways women, Indigenous artists, Black artists, POC artists, LGBTQQ2S+ artists, and poor and working-class artists turn to autotheory as a way to process and transform the discourses and frameworks of theory through their embodied practices and relational lives. At the same time, I resist those more militant frameworks that posit oversimplified oppositions between "male theory" or "canonical theory," on the one hand, and "feminist practice" or some other counter-to-the-status-quo practice on the other, even

though I might reference these provisionally (in my view, the ossification of these divisions can become counterproductive—intellectually, politically, and socially—when relied on too much). Instead, I consider the ways autotheory troubles any easy recourse to the theory versus practice, or art versus life, divide. By contextualizing the recent turn to autotheory in the twenty-first-century worlds of art and literature within a longer dynamic and transnational history of feminist practices across media, this book provides an in-depth overview of contemporary autotheory that is transdisciplinary in scope, and that I hope will encourage other scholars to continue to build on this rich theme and body of work.

1

PERFORMING KANT

Surviving Philosophy through Self-Imaging

Before theory became assimilated, it was embodied.
—Alex Bag, *Untitled Fall '95*

Kant, pronounced "can't."
—Fred Moten, "Black Kant (Pronounced Chant)"

In 1971, the American conceptual artist Adrian Piper performed a private work in her studio apartment in New York City. In the piece, Piper fasted and read Immanuel Kant's *Critique of Pure Reason* (1781), periodically interrupting her reading to take photographic self-portraits. The artist's choice of philosophy text was significant: the *Critique of Pure Reason* is a canonical work of Enlightenment-era philosophy that occupied a central place in art world conversations at the time, largely thanks to the influential American art critic Clement Greenberg's preoccupation with Kantian aesthetics. As such, Kant's philosophy was at the core of Greenbergian formalism and modernist art theory in the mid-century art world within which Piper was working.

As a recent art school graduate, Piper was told by her peers that she should read Kant, because his philosophical writings engaged with similar ontological and epistemological questions to those that Piper was engaging with in her studio work. She decided to start reading Kant, but rather than keeping this act separate from her studio practice, she framed it as

part of a conceptual artwork. The performance, which Piper would title *Food for the Spirit,* consisted of her moving between monastically reading Kant's *Critique of Pure Reason* (or rather, his first *Critique*), scribbling annotations in the margins as she read passages over and over, and capturing her image on a photographic film negative using a Kodak Brownie camera and a mirror. The photographs, which were developed after Piper completed the durational performance, serve as the primary documentation of the work, often displayed in galleries and museums as a stand-in for the original, private performance. More important for my concern in this book, the photographs also signal an autotheoretical drive, in both the history of philosophy and the burgeoning feminist art movement, that prompts me to look more closely at this shuttling between the *philosophical* and the *self-imaging* as an early work of autotheory or autophilosophy.

In her artist statement for *Food,* Piper configures Kantian philosophy as that which "was shaking the foundations of my self-identity." Here she introduces a fundamental philosophical problem facing the artist: the divide between the demands of philosophy, on the one hand, and the demands of the artist's embodied self, or "I," on the other. This statement summarizes the conceptual premise of *Food*; it is preserved in Adrian Piper's personal-institutional archive, the Adrian Piper Research Archive Foundation (APRAF) in Berlin, along with the rest of the documentation of the work, which includes the photographs and the marked-up copy of Kant's *Critique*. The statement, written after the piece was finished, reads:

Private loft performance continuing through summer, while reading and writing a paper on Kant's *Critique of Pure Reason,* fasting, doing yoga, and isolating myself socially. Whenever I felt that I was losing my sense of self due to the profundity of Kant's thought, I went to the mirror to peer at myself to make sure I was still there, and repeat aloud the passage in the *Critique* (underlined on the following pages) that was shaking the foundations of my self-identity, until it was just (psychologically manageable) words. I recorded these attempts to anchor myself, by photographing myself and tape-recording the reiterated passages (the tape has since been destroyed). These attempts did not succeed, so I eventually abandoned them, and just studied the *Critique*. Upon finishing the paper, I found I could not look at or think about the *Critique* for two years afterwards.[1]

The photographs were, as Piper writes, mediumistic attempts to "anchor" herself in space and time, during the often abstracting process of absorbing oneself in reading philosophy over an extended and hyperfocused period of time. The fear of "losing" her self that seems to come with the work of reading Kant in isolation instigates Piper's movement toward the mirror, prompting her to take self-portraits to ensure that she still in fact "exists" as a body with a reflection. The oscillation between rigorous philosophical study and "narcissistic" self-imaging enables Piper to process and "survive" Kantian aesthetic philosophy, while at the same time challenging long-standing gendered and racialized views of the incompatibility of rigorous study and self-representing, "narcissistic" work. More than performance documentation, the photographs embody Piper's literalizing of Kant's transcendental aesthetic through the empirical confirmation of the "I" that self-imaging provides.

While Piper's work has not been previously described as autotheoretical, the structure of *Food*—with its formal movement between artistic self-imaging and an almost devout philosophical practice—bears a generative resemblance to the tendency in contemporary cultural production to integrate autobiography with philosophy and theory. Considering Piper's body art as autotheoretical allows scholars and artists to better understand the rich multidisciplinary and multimedial history of the autotheoretical impulse as it manifests in and through feminist practices over the twentieth century. With Piper's 1971 *Food*, autotheory becomes a performative way for a racialized woman artist to work through problems present in both Enlightenment-era thinking and in the developing Euro-American art world during the shift from high modernism and formalism in the 1950s to contemporary art and conceptualism in the 1960s and 1970s.

This chapter focuses on Piper and her engagement with Kant. My reading of *Food* as autotheoretical also makes a case for the nuanced contributions that Piper's studio art practice makes to scholarship on Kant and the as yet unresolved issues raised in his philosophy, including the slipperiness of his notions of transcendental idealism and the transcendental aesthetic, which continue to be debated within elite scholarly philosophy circles. The autotheoretical movement in *Food* allows Piper to process Kant's philosophy and provide an embodied reading that exceeds both

the terms of Kant's system and contemporaneous readings of Kant by feminist and nonfeminist scholars alike. Indeed, I argue that Piper's *Food* extends existing scholarship on Kantian philosophy and functions as a transformative work of feminist critique that inscribes the artist's *self* within systems that might exclude her as a racialized woman artist and philosopher: both the Kantian system of philosophy and the primarily white male conceptual art world at the time Piper was making work. Through her practice-based approach to processing Kantian philosophy, Piper reveals the autotheoretical murmurings present within Kant's own thought. In so doing, she reveals herself as an ideal reader of Kant, and—in an elegant bending of affirmation and critique provided via autotheoretical self-representation—Kant's true heir.[2]

By recasting Piper's *Food* in light of autotheory, this chapter provides insight into the pivotal precursors of present-day autotheory in early conceptualism, body art, and performance, and shows that Piper can be understood as an early innovator in this field. Revisiting this work in the context of the newly developing framework of the autotheoretical allows me to explore the functioning of autotheory as a feminist mode historically, and also allows me to theorize what the dual orientation toward the "self" and "philosophy" performs in the larger contexts of contemporary art, theory, gender, and race. I consider documentation of the 1971 work—photographic self-images and a heavily marked-up copy of Kant's *Critique*—and paratextual elements such as Piper's art criticism and philosophical writing in my discussion of *Food.*

While Piper's works have drawn responses from performance scholars, art historians, artists, and critics, I find the lack of sustained engagement with *Food* striking. In particular, little attention has been paid to the place of Kant in Piper's work, even though she has gone on to publish substantially on the philosopher. The scant scholarship on *Food*, and the need to acknowledge the contributions of racialized and Black feminist artists to the fields of Kantian philosophy, conceptual art, and theory, underline the importance of this chapter.

As a contemporary artist, Piper has worked extensively across media, creating work in body art and performance, drawing and painting, photography and other photographic-based work, video art and installation, collage, and other media, including language- and text-based work on

objects, including blackboards (in *Everything #21*) and business cards (in *My Calling (Card) #3*). The range of Piper's practice was on view at the Museum of Modern Art in 2018 in the retrospective *Adrian Piper: A Synthesis of Intuitions, 1965–2016*. Writing in response to the landmark exhibition, the critic Holland Cotter described Piper's multidecade oeuvre as a "thinking canvas," bringing to mind recent descriptions of autotheory as a practice of "life-thinking," in contrast to the more well-defined genres such life-writing and memoir. Spanning fifty years of Piper's work, the retrospective emphasized the transdisciplinary, transmedial, politically active, and conceptual nature of Piper's art practice as the work of someone who is "both, and equally, a visual artist and an academic scholar"—and, I would add, a philosopher.[3]

Conceptual art, in its mid-twentieth-century rise, can be understood as one space in which the work of philosophy was being taken up, at a time when philosophy's influence and efficacy in culture were waning. In Fredric Jameson's outline of history and the 1960s (which I largely follow in this book, though with a healthy wariness of Jameson's ultracynical view of postmodernism), as "philosophy" per se wanes, the artist becomes akin to a philosopher.[4] As noted in the introduction to this book, such conceptual artists as Joseph Kosuth and Sol LeWitt understood what they were doing with conceptual art to be similar, in effect, to what philosophers were doing in their writings. Piper presents an interesting case, for she is explicitly both an artist and a philosopher, and her lifelong practice moves equally between these two vital aspects, as she makes and exhibits artwork while writing philosophical essays and books.

Food emerged at a time when consequential changes were taking place in the art world at the level of medium, content, form, and artist-audience demographics. Even as the late 1960s and 1970s started to see the rise of a newly cohering feminist art movement[5] and other explicitly politicized movements, among them the Black Arts Movement and budding LGBTQ+ movements, the art critic Clement Greenberg's formalist take on Kantian philosophy still held considerable sway. Greenberg's theory of aesthetics was shaped by the Kantian notion of disinterest, which Greenberg extended to his project of developing a theory of "apolitical" art formalism. Greenberg valued the high modernist practices of minimalism and abstract expressionism over the rise of the "de-materialization of the art

object."[6] Yet as the 1950s gave way to the 1960s, practices like body art began to supplant such traditional art media as painting and sculpture, and emphasized the ephemeral/conceptual elements in the creation of artwork, including time, space, context, and, almost unavoidably, *politics.*

Greenberg's (and others') accounts of Kant were largely grounded in Kant's third *Critique,* the *Critique of Judgment,* wherein Kant works through the specific question of aesthetic judgment; this should be distinguished from Piper's *Food,* where the focus is on Kant's *Critique of Pure Reason,* in which the specific question of aesthetic judgment is more or less absent. In the first *Critique,* Kant's focus is on the ontology of subjecthood and objecthood, and how one perceives one's self and other "objects" in the world. Kant's notion of "disinterest," so central to Greenberg's high modernism in its privileging of form, is wrapped up with his analysis of the judgment of taste, and several steps removed from the ontological metaphysics of the transcendental aesthetic that characterizes much of his focus in *Critique of Pure Reason.*

Piper describes the early days of conceptual art as "a white macho enclave, a fun-house refraction of the Euroethnic equation of intellect with masculinity," and emphasizes the imperative to bridge conceptual art practices with a feminist framework attuned both to the politics of representation and to the unique history of Black conceptual art practices and Black philosophy and self-imaging.[7] However, while it is important to contextualize Piper's work in light of the work of critical race scholars and the histories and practices of Black conceptual practices, Uri McMillan acknowledges the risks scholars and critics run if they try to understand Piper's practice as being primarily or only about race, "at the expense of what it began as: a bodily and psychological experiment in transcending the boundaries between subjecthood and objecthood to become an art object."[8] It is this aspect of Piper's work—the philosophically thorny tension between "subjecthood and objecthood" as it haunts history—that I focus on in this chapter. I propose that Piper's practice both instantiates and fleshes out problems related to metaphysics and ontology, such as the status of the subject and the tension between subjectivity and objectivity in representation, through her embodied, autotheoretical reading of Kant in *Food.*

Over the course of her practice, Piper has expressed ambivalence about ontologically affirming any particular racial identity. As Holland Cotter writes, echoing many other critics, in his review of Piper's history-making MoMA retrospective, "Her aim is not to assert racial identity but to destabilize the very concept of it."[9] Reading Piper's work in terms of Blackness is complicated by her conceptual move to "retire from being Black." Her 2012 self-portrait *Thwarted Projects, Dashed Hopes, a Moment of Embarrassment*, framed as a gift to the artist on her sixty-fourth birthday, raises the question of what role a given racial or national designation serves in an artist's practice: in a context where "racial designations" are qualified in relation to ancestral data, Piper comes to the conclusion that her English and German ancestry outweigh her "African heritage," and so she will "retire" from being Black. If I were to abide by the rules set out by Piper in the context of her conceptual art practice, I would refer to her not as a Black artist or even as a racialized artist but as "the artist formerly known as African American."[10] And yet a consideration of Piper's self-imaging as a nonwhite woman is integral to understanding the very real race politics of her work—and the legacies of her practice in relation to Blackness (and its performances) in twentieth-century America—as well as the transformations she enacts through her autotheoretical engagement with Kant in *Food*. I refer to Piper with shifting language—half-Black, racialized, and notwhite, for example—both to make space for an acknowledgment of race in her work and to resist the ossification of her self-presentation in relation to any singular category of race.

Piper's interest in Kant began at the tender age of twenty, when, after finishing art school, she was looking to explain the thinking that lay behind her recent work. Encouraged by others in the art community, Piper sought ways to contextualize her art practice in relation to the theoretical discourse of the time, a practice that has become increasingly important to the work of contemporary artists and how they are received by academic and art world institutions.[11] She explains how she first came to Kant's first *Critique* in 1969, after having worked through some Kantian ideas in her studio practice without realizing it as such:

My first inkling that there was something amiss with the Humean conception of the self came before I knew enough Western philosophy to call it that. I am grateful to Allen Ginsberg, Timothy Leary, Edward Sullivan, and Swami Vishnudevananda for urging me to read the *Upanishads, Bhagavad Gita* and *Yoga Sutras* in 1965. I am grateful most of all to Phillip Zohn for his willingness to argue with me at length about the import of these texts, and for introducing me to Kant's *Critique of Pure Reason* in 1969, after reading an art text of mine on space and time ("Hypothesis") that inadvertently echoed its doctrine of transcendental idealism.[12]

Having been introduced to Kant, Piper made *Food* as a means of set-ting aside time and space to catch herself up on the canonical texts that her peers had told her would provide insight into the problems she was working through in her studio practice. With the title *Food for the Spirit*, Piper casts Kantian philosophy as that which will sustain her through a period of fasting, a making-literal of the process of rumination (as deep thinking and as chewing). That she does not look particularly spirited in her self-portraits is ironic, with her thinness—noted in performance art-ist Gabrielle Civil's autotheoretical critique of the work[13]—pointing to a potential lack of nourishment. Conceptually, Piper's title gestures to a problem that philosophy poses for philosophers and feminists alike: the place and status of the body (and different kinds of bodies) in philosophy. Piper invokes autotheory through the conceptual work's framing devices, including the title and the artist's statement: by conflating "spirit," which in the Kantian scheme means a kind of interiority, with "food"—literally, physical matter that feeds the immanent body, and figuratively, nourish-ment for one's spiritual and philosophical life.

Staged in the artist's studio as a private performance, Piper's *Food* is constituted by the continual movement, repeated for a duration in the thick heat of a New York City summer, between reading Kant attentively and hungrily and reinscribing herself on the photographic film.[14] In the resultant proto-selfies, the artist is staring straight into the camera with a sense of *purposive* presence that is not quite stoic, but not quite "af-fective" either. Piper processes key aporias within Kantian philosophy and provides insight into epistemological and ontological questions at the core of Kant's work, primarily the relation between appearances or rep-resentations and the "thing in itself"; the relation between sensibility

(the "transcendental aesthetic") and understanding ("transcendental logic"); and, relatedly, the tension between the "transcendental subject of apperception" and the empirical subject. She frames the act of reading philosophy—itself a form of "consumption"—as metabolization, wherein Kant's philosophy of the transcendental aesthetic is configured as nourishing matter "for the Spirit."

Over the course of the work, the artist ritualistically enacts a conceptual transubstantiation whereby Kantian philosophy is rendered sustenance or "food" that the artist will figuratively (and, in light of her fasting, somewhat literally) subsist on over the course of the performance. The embodied metaphor of philosophical sustenance is in sustained tension with the notion of "spirit" as abstracted from the body (like the tensions sustained within Kant's philosophy). Piper frames the bodily metabolizing of philosophy as a work of conceptual art that self-reflexively draws attention to these philosophizing processes and practices (rumination, metabolization, consumption) as such; she makes art of the embodied process that reading and seeking to understand philosophy require. In *Rationality and the Structure of the Self*, her two-part tome on Kant and Hume, Piper discusses the ways "our personal investments in our favored moral theories" are "deep," and how these moral theories are digested by us, incorporating themselves into our body and transforming us into rational Kantian moral subjects.[15]

Piper makes literal the conceit that Kant's *Critique* will "nourish" her, that this intellectual work will translate into material that the artist can metaphorically consume for intellectual nourishment through the act of fasting. Piper stages this belief in philosophy or high theory—a higher power, perhaps?—within the frame of conceptual and body art, enacting a devotion to the hegemonic discourse surrounding her as a contemporary artist through practices of fasting and rigorous reading. She becomes a kind of self-documenting Kantian monk, repeating passages of Kant as a mantra while capturing a ghostly imaging of her self through the mirror. These themes in *Food* connect to a transhumanist philosophy and the ways in which it turns to technology as a possible means of "transcending" the limits of our embodiment. This is another effect of Piper's iterative self-photographing process over the course of *Food*: art-making and self-imaging as means of immortalizing the self or existing outside the confines

of one's body as an object—a transformation made possible through the technology of photography.

Piper understands the stakes of Kantian philosophy to be high, and she translates these high theoretical stakes into affective and psychological terms. Her description of transmuting Kantian ideas into "(psychologically manageable) words" intimates a sense of philosophy and theory as overwhelming—a kind of psychic onslaught, with the parentheses representing at the level of form the affective management taking place in the content of the work. Yet she does not appear overwhelmed or frazzled in the images she acquires of herself: she performs in front of the mirror in control, self-composed, a good reader of Kant and a burgeoning philosopher in her own right. She is also female, racialized, and in varying degrees of nudity—opening herself up in a way that is keenly vulnerable in a Kantian space. In her later book on Kant, Piper makes repeated reference to what she calls the "conceptual unmanageability" of reality when a subject is confronted with theoretical anomalies and conceptual anomalies in their world.[16] On a Kantian level, the "literal self-preservation" that the selfies provide for Piper preserves the "rational agency" of the Kantian subject[17] and allows her to manage the theoretical and conceptual anomalies that she encounters as she reads. The practice of taking selfies, or imaging herself in a performative way, can thus be seen as self-attuning.

By presenting the practice of reading Kant as a demanding, self-abnegating ritual, Piper signals the ways that philosophy requires self-discipline and self-denial to an extent that the artist has a difficult time coming to terms with. By choosing to fast and practice yoga as part of the conceptual conceit of the work, she extends this self-denial to the embodied state of her working. That this is a work of durational performance—with its connotations of physicality and endurance—further compounds the work as physically and psychologically demanding. Piper describes this process as destabilizing to her "self-identity." It is also, she makes known, ultimately psychologically unmanageable. Ritualistically turning away from Kant's text and toward the mirror establishes the dual practice of theory and philosophy, on the one hand, and the auto or self on the other. She represents philosophical reading and research as grueling, even as something self-immolating for certain readers that requires self-imaging as a counterpractice.

Piper's turn to self-imaging as a way to "anchor" herself in a philo-sophical practice points to larger moves within autotheory as a post-1960s mode of feminist practice. The feminist roots of such a move cannot be overstated. In autotheory, the bodies of theory and philosophy that a given artist might work with depend on the historical, geographic, and institu-tional or para-institutional contexts she's working in: in Piper's case, it is the hegemony of mid-century high modernist formalism that might pre-clude her own conceptual art practice from being recognized as legitimate. It must also be noted that Piper's self-imaging is not simply an anxiety-fueled response to the prospect of Kantian transcendence as understood by feminist philosophers and art historians like Irigaray and Jones, even as this is gestured to in part in the artist's statement and the work's documen-tation. Rather, it is an instantiation of the very problematics and terms that Kant himself is working through, and ought be considered as such when read as the work of sophisticated philosophical reasoning that it is.

SELFIES, SPECULARIZATION, AND THE SUBJECT–OBJECT DIALECTIC

Piper uses the camera in conjunction with the mirror to evoke the dou-bling of the self through narcissism. In Kantian philosophy, there is a doubling effect in the conception of the subject, with both the empiri-cal subject and the transcendental unity of apperception, which refers to the "self-consciousness" that one has of one's existence *as* subject.[18] For Kant, "Pure apperception or the original apperception is the self-consciousness which while producing the representation 'I think' cannot itself be accompanied by any further representation."[19] This pure subject is gestured toward by the artist's camera, visibly reflected in the mirror as Piper holds it near the center of her torso a few inches below her exposed breasts—tying Piper's work to the selfies in both feminist art and on social media platforms today.

The selfie is a photographic practice, or what Jones calls a practice of "self-imaging," that takes the twentieth-century invention of the snapshot (inaugurated by the Kodak Brownie camera—the make that Piper uses in *Food*) and employs either the reflective surface of the mirror (seen in *Food*) or the act of pointing the camera directly toward oneself (a pose enabled

through technological developments such as handheld cameras and cell-phone cameras) to take a self-portrait.[20] The camera is the mediating instrument that transmutes, through the physics of light, an image of the world into a re-presentation. But the mirror also serves a pivotal function in the physical workings of Piper's proto-selfie: Piper does not turn the camera toward herself to capture her image directly but turns the camera toward the mirror to capture her image as it is reflected by the external, and inverting, surface. The mirror transforms the pure eye or "I" of the camera into a part of the artist's physical existence, staging the transcendental and empirical subject together as one and the same, doubly haunting.

The artist's use of a mirror as a means of ensuring that one still "exists" as a physical body is a theme explored by other feminist conceptual artists. The British Palestinian artist Mona Hatoum's *YOU ARE STILL HERE* is a sculptural work consisting of sandblasted mirror glass in which the eponymous text is written across the mirror's surface.[21] The mirror provides textual confirmation that the viewer is "still here"—which is to say, alive and producing a mirror-image reflection. The viewer is the image reflected back in the mirror, introducing a participatory element; when the viewer departs, they make a liar of the text. I came across this work for the first time at the Tate Modern in the spring of 2016: I was walking through Hatoum's landmark retrospective after spending a few hours in the art-historical, multi-artist survey exhibition *Performing for the Camera,* where I viewed photographic documentation of Piper's *Food*. Autotheory was on my mind, and as I gazed into the mirror of Hatoum's work, the engraved text reminding me of my own mortality and existence in space and time, I considered the trajectory of Hatoum's practice on view in the retrospective. In the 1970s, Hatoum created works using her body and autobiographical materials, working in the mediums of body art, video, performance, and installation; her more recent work tended toward a controlled, formalist aesthetic, with impressive, large-scale sculptures in which her own body and autobiography were abstracted.

Across their conceptual art practices, both Hatoum and Piper seem to recognize the ambivalently affirming effects—and affects—of enacting this literally narcissistic (or self-looking) turn to the mirror as evidence of their own existence. Yet the mirror image is not an exact image of ourselves but an inverted reflection, an inversion of our bodies as objects in space

and time. Luce Irigaray uses this point as the driving conceit in *Speculum of the Other Woman*, her formative, even canonical, work in the field of feminist theory and philosophy.[22] Another notable example of a feminist engaging with the philosophy of Kant, and contemporaneous with Piper's 1970s work, Irigaray's *Speculum* configures the distorted view of reality that the mirror provides as a metaphor for the distorting effects that patriarchal views of the world have on our understandings of women and women's bodies. Irigaray argues that, far from being objective, the view of reality that is reflected in the surface of the mirror is subjective, gendered (as male), and, most consequently, distorting: the mirror reflection is an inversion. Kant himself acknowledges the mirror image as an inversion, with the mirror presenting a liminal point for his philosophizing in *Prolegomena*, where he extends his lifelong desire to create an empirical metaphysics—itself a speculative, even impossible, aim.[23]

In "Paradox A Priori," the chapter of *Speculum* devoted specifically to the philosophy of Kant (the book discusses different male philosophers in reverse chronology, beginning with Freud and ending with Plato), Irigaray philosophizes the distorting nature of specularization in the context of Western philosophy, writing that any "window" to the universe that we receive in philosophy is "always already defined in/by the subjectivity of man."[24] Of course, in Irigaray's philosophical writings, her use of "man" is not as a universal subject standing in for all humanity (as it is, say, in the King James Bible) but a deliberate pointing to the gendered nature of philosophy *as* subjective, embodied, male, racialized, and so on. Thus Irigaray's *Speculum* is an incisive example of a feminist work of philosophizing coming out of the particular time and place of post-1968 France that activates an autotheoretical mode to critique Kant and what she calls "the false universals that plague philosophy." She herself writes self-reflexively as a woman to critique Kant and Western philosophy for failing to recognize the subjective nature of their own philosophical perspectives. "It is my gesture in *Speculum*," Irigaray explains, "to reveal how the philosopher expresses their subjectivity in a presumed objective terrain. In *Speculum*, I make appear the philosopher's subjectivity in their presumed objectivity."[25]

Through abstraction, Irigaray explains, male philosophers and theorists present their work as universal and generalizable, even as it might

be grounded in their own lived experience as men. Irigaray takes to task the failure of male-authored philosophical discourse to acknowledge itself as such, inquiring into the mechanisms of language that facilitate the elision of the particular speaking subject in the name of "universal" truths that are without gender or a body. Irigaray's project begins with an analysis of the exclusion of women or the feminine from discourse and subjectivity. When it comes to participating in language, Irigaray recapitulates the options that are open to her: she can either speak as man (or "neuter"—without "sex difference") and be intelligible, or she can utter as a female and be deemed unintelligible (for example, hysterical). For her to "speak intelligently" (and intelligibly) as a woman and to take part in philosophical discourse as a being whose body is gendered and inscribed as female or feminine, she must enter into the discursive mechanisms of subject-formation through a method she terms mimesis. Piper professes her desire for a similar "abstraction" and a transcendence of her body in works like *Food* and in her texts. Ultimately, Irigaray rejects Kant's "transcendental illusion" for its divide of the transcendental from the phenomenal, drawing on feminist psychoanalytic theory to conclude that this issue in Kant's philosophy grows from the philosopher's repression of his relationship to "the mother."

EMPIRICAL EVIDENCING: EMBODYING THE TRANSCENDENTAL AESTHETIC

Similarly, Piper's autotheoretical selfies are, on one level, a feminist critique of those problems. They are also, as I will now demonstrate, an instantiating and embodied processing of the very philosophical questions that Kant was working through when he wrote his *Critique of Pure Reason* in Königsberg at the age of fifty-seven. In it, Kant philosophizes the conditions of subjective experience; Piper also does this in *Food*, by means of her own body and practice. Piper's self-imaging is a material evidencing, after the fact of the live (and private) performance, of her being reflected back to herself while looking in the mirror. It is an empirical evidencing, via narcissism, of her philosophical subjectivity and existence within the terms and reading-processes associated with Kant's first *Critique*. There is ambivalence, yes, but there is also a decided, unyielding presence, one that

instantiates an autotheoretical feminist practice to engage with Kantian philosophy in an affirming and complicated way. Her specularization becomes an integral part of the work of reading Kant, not a supplement to the act of study.

Within Kant's epistemological system there is the "thing in itself" *(Ding an sich),* related to a priori knowledge, and there is the perception of the thing, related to a posteriori knowledge. According to Kant, one can perceive, but not access a priori, the "thing in itself." For Piper as an artist-philosopher and the perceiver of herself (and her self) through perception, the selfie becomes an attempt to access her own being as the "thing in itself" through re-presentation after the live event of looking in the mirror. In this way the selfie stands as a representation of a posteriori knowledge and the attempts at an empirical mode of metaphysical understanding. Piper's autotheoretical selfies embody this process of phenomenological mediation; they are traces of the artist's wrestling with the status of the self (and its knowability) in the *Critique.* In this way, beyond its perhaps more obvious feminist resonances, Piper's act of taking a self-portrait as a means of empirically and experientially securing confirmation that she "exists" as a body can be interpreted as her instantiating the Kantian problematic between a priori and a posteriori knowledge through an autotheoretical practice (Piper takes a photograph of herself as a means of navigating the Kantian terrain of a priori and a posteriori reasoning: once the film develops, Piper will theoretically know, a posteriori, that she exists, or at least existed in the context of making that work). The selfie provides a posteriori knowledge—or knowledge known on the basis of experience (rather than a priori knowledge, or knowledge known independent of experience)—of Piper's existence in the world as a self with a material reflection.

Through self-portraiture, Piper evidences her existence as a rational and embodied subject. The instability of representation that Kant is concerned with in his philosophy continues in Piper's photographs, with the artist's relative visibility and invisibility across the different images pointing to the question of whether, and in what ways, the photograph as an evidencing object of empirical-metaphysical representation can be trusted. In the context of the conceptual artwork, these self-portraits are both "empirical" in their evidencing function and "metaphysical" in their

visual language. Just because Piper appears to us on the surface of the photographic paper does not mean, Kant's philosophy would hold, that we have access to her as the "thing in itself" and that we can know her a priori.

The degree of Piper's visibility varies between photographs, with underexposure times rendering the artist differently visible in different images. Her experimenting with the paradoxes of visibility might, on the one hand, be read as a way of rendering sensory intuition (the transcendental aesthetic) intelligible; on the other hand, it might be understood as her enmeshment in the paradoxes of visibility explored in feminist performance art and body art practices of the time.[26] The visual language of low-contrast, underexposed photographs brings to mind the metaphysical play of performative photographic practices past, including nineteenth-century spirit photography and performative specter-self-portrait experiments, such as Hippolyte Bayard's *Self-Portrait of a Drowned Man* (1847). While the mise-en-scène of the photographs varies between images, in most of them Piper can be viewed from the knees up: above her head is empty space—perhaps a space of metaphysical contemplation, one that opens up space for the kinds of "transcendence" that Piper desires through the process of reading and philosophizing.

The photographs documenting *Food* are dimly lit, with Piper appearing somewhat ghostly, her visibility obscured to different degrees over the series. There is a graininess to the photographs that might connote the historical unintelligibility of Piper as a woman of color facing, quite literally, an Enlightenment-era German idealist philosophy written by white European men in the context of a similarly white male–dominated 1960s and 1970s conceptual art. Certainly, Piper's underexposure might also be understood through the politics of race bias in photographic technologies and lighting, which historically privilege the proper lighting of Caucasians or those with light skin. Piper could be seen as anachronistically reclaiming the aesthetics of nineteenth-century photography—a field developed and dominated by Euro-American men of relative leisure and means—from the loss of contrast due to underexposure to the vignetted corners of the square frame and the distance of the subject (here, Piper) from the focal plane. Positioned slightly off-center, Piper is framed with horizontal symmetry, and there is vast negative space looming over her head. This composition makes it clear that it is more important for Piper

to direct her gaze toward the camera's reflected lens (a conceptual, even defiant stance) rather than toward the viewfinder (an authorial and traditional approach, but one that would give Piper more control), thereby extending her self-exposure to the dizzying effects of studying Kant. Looking relaxed and resolute, Piper faces the camera (and, subsequently, the viewer of the photographs) straight on, claiming her space; standing nude yet invulnerable, Piper documents her performance in an image suggestive of the metaphysical, in her nakedness, Blackness, and femaleness casting herself as both Kantian and in-excess-of-Kant.

Kantian aesthetics pertain to the sensorial, or that which is perceptible by the senses, following the Greek *aisthesis*, which means "sense perception." For Kant, the aesthetic is "that whose determining ground can be no other than subjective."[27] Building on fellow German philosopher Alexander Gottlieb Baumgarten's notion of "aesthetics," Kant's use of the term is "in accordance with the ancient distinction of αἰσθητά and νοητά, to 'the science which treats of the conditions of sensuous perception.'"[28] In his writings on the transcendental aesthetic, Kant discretizes objects into *phenomena* and *noumena*, where *phenomena* are what we perceive (representations, "mere appearances") and *noumena* are the "thing in itself" or the unknowable. Kant famously conceives of objects in space and time as representations, or "merely appearances," and space and time themselves as "appearances": this is the doctrine called "transcendental idealism." To quote Kant:

Everything intuited in space or in time, hence all objects of an experience possible for us, are nothing but appearances, i.e., mere representations, which, as they are represented, as extended beings or series of alterations, have outside our thoughts no existence grounded in itself.[29]

For Kant, reality is dependent on our perception of it as embodied subjects with sensorial capacities. If we remove the subject—here, Piper (as artist-philosopher, subject)—then the objects in space and time—here, also Piper (as art object, as object in space and time that can be perceived by the subject/is constituted through that subject's perception)—"would disappear."[30] Piper demonstrates a belief in the transcendental idealism of Kantian philosophy in a way that involves a degree of abstraction and a suspension of disbelief that contributes to the work's conceptual punch:

the possibility that she, as a subject and an object, might "disappear" (as a unified and coherent self) during her disciplined engagement with Kant is enacted through her performance in *Food*, and the visual decisions the artist makes around gesture and image.

As a human being who exists in space and time, Piper as the artist in *Food* is an "[object] of an experience" and therefore "nothing but [appearance], i.e., mere [representation],"[31] but she is also an object *of* representation, foregrounded as such through the act of photographing herself. Rendered aesthetically, Piper becomes perceptible through the senses—a process that, early in Kant's first *Critique,* is posited in contrast to the "unmediated" and "precognitive" process of "intuition"—when she views herself through the mediation of the mirror, and through the perceiving senses of herself and others when her image is presented in a photograph. This interpretation of Kant that Piper invokes in *Food* is also evinced in her later writings when she describes how, in Kant's transcendental analytic, he "effectively rethinks the independence of intuition and understanding and finally offers an account in which the two are interdependent."[32]

In *Food,* the selfies serve as a trace of the process of physically instantiating the tensions of Kant's "empirical deduction" as it presses up against the "transcendental deduction" through the ghostly image of the artist-philosopher that appears in the photograph. According to Kant, "transcendental deduction" refers to "the way in which concepts can be related to objects *a priori*," or independent of human (sensorial) experience; in contrast, "empirical deduction" refers to "how a concept is acquired through experience and reflection on it."[33] In his section "On the Deduction of the Pure Concepts of the Understanding," Kant outlines a key aporia with regard to the functioning of the understanding in relation to the distinction between subject and object: "namely how subjective conditions of thinking should have objective validity, i.e., yield conditions of the possibility of all cognition of objects; for appearances can certainly be given in intuition without functions of the understanding."[34] Speculatively speaking, Piper's self-imaging is a conciliatory response to this problem: by transmuting her sensorial perception of herself, ephemeral and elusive as this may be, into a concrete object (the photograph), she transforms her perception of the self—a "subjective [condition] of thinking"—into something with "objective validity."

The doubling mechanism of the "narcissistic" selfie becomes a functional attempt to transmute that which is accessible to intuition into that which is accessible to understanding. By infusing this self-imaging with philosophical rigor through the conceptual premise of *Food*—that the artist as such becomes "spirit" through a self-abnegating engagement with Kant's *Critique*—Piper's "appearances" interface with "the understanding," at least in theory.

TEXTUALLY METABOLIZING

In the physical copy of Kant's *Critique* that Piper marks up during her performance, we find a particular preoccupation with the sections that probe the subject/object relation central to Kantian aesthetics. Piper theorizes this metaphysical problematic at the core of Kant's *Critique* and the larger matrix of Western representational structures through self-imaging and marking up the margins of the book. Some of the pages of the book have been torn out to give Piper better access to make these notes, and the violence of tearing pages out of a book gives further weight to the reading of *Food* as a counterpractice to hegemonic notions of philosophy and the ways in which philosophy is consumed.

To understand Kantian philosophy, Piper favors a more physical engagement that entails making a given page more accessible and highlighting passages she perceives to be key to her own art practice and understanding: rather than uphold the purity of the philosophical text by not writing on it or disfiguring the book in any way, she makes it her own, adjusting it to her needs as someone with a body existing in a given space in a given period of time. Presumably hungry, fasting as she reads, there is a ravenousness to her markings on the page, a making-visible of the process of her ruminating on Kant. Writing on her copy of the book, Piper annotates passages through symbols and shorthand. On page 472, for instance, she draws a box around words such as "knows himself," and scribbles an exclamatory "NB!" that distorts as "NG!" in the adjacent margin. These moments of semantic slippage are found throughout Piper's marginalia and remind the reader, formally, of the excesses of study. As she consumes Kant through her own sensorial system, the margins bear

the trace of her digesting. As I read the textual traces of Piper's engagement with Kant on the surface of the page in the form of these personal notations, I bear witness to those moments in Kant's book that I imagine were most resonant for Piper at the time of her reading in her New York City studio during the summer of 1971.

The legibility of Piper's notes, to an external reader, varies across pages. While some notes are difficult to read, there are exceptions, such as when Piper writes what appears to be "logic ally"[35] next to the following passage: "how subjective conditions of thought can have objective validity. … For appearances can certainly be given in intuition independently of functions of the understanding."[36] In this way, whether accidentally or not, Piper hails philosophy—the "master discourse"—as something that exceeds the "logical": an ally or source of discursive support for her art practice. By hailing philosophy as a "logic ally," Piper invokes Kantian reason as discursive foundation for her work.

As she reads, Piper understands the importance of self-consciousness to the Kantian subject, and also understands that, by the logic of the Kantian system, "to be self-conscious we must at least make this general distinction between objective and merely subjective connections of representations."[37] She perceives that such self-consciousness is unavoidably embodied and immanent, and in both *Food* and *Rationality and the Structure of the Self,* Piper clarifies the Kantian conception of the rational self through an embodied, self-referential feminist practice that is invested in these long-standing, ongoing questions related to ontology and reason. "For Kant," Piper writes, "self-consciousness is a necessary precondition for unified moral agency, not a contingent product of it. My account follows Kant's in this regard."[38] *Food* is as much a practice of the artist seeking to know or understand herself as it as a practice of the artist seeking to know or understand philosophy. As she works through the relationship between modern philosophy and her art practice, Piper engenders insight into enduring philosophical questions related to self-knowledge and reflection. Through the self-imaging in *Food*, Piper performs such "self-consciousness."

The final section that Piper underlines is a passage in which Kant describes man as constituting both "phenomena" or sensibility and "a purely intelligible object." This ontological duality in Kantian philosophy has been critiqued by such feminists as Irigaray, who takes issue with the

divide between "transcendent" (spirit)—typically reserved for men—and "phenomena" (body). In the performance, Piper enacts the following passage of Kant's *Critique*: "[She] is thus to [herself], on the one hand phenomenon, and on the other hand … purely intelligible object." She stages Kant's conception of self-consciousness and "pure apperception" through the process of ritualistically taking selfies while reading Kant's *Critique*. Notably, in Kantian terminology, apperception refers to self-consciousness, and the "transcendental unity of apperception" is "Kant's conception of the basic structure of a unified consciousness."[39]

Piper's fasting, and her dedication to parsing the *Critique* over a set period of time, demonstrates her sacrifice of the artist's body to the pursuit of higher knowledge. My reading of Piper's self-imaging in terms of "survival"—a mode of surviving philosophy—is consistent with Piper's diction in her writing. In her philosophizing of Kantian self-consciousness, Piper refers to cognitive "assaults" that one encounters in life and the strategies one turns to for "coping," which brings us to Piper's notion, building on Kant, of "pseudorational defenses."[40] The "assaults" referred to stem not from philosophy so much as from theoretical and conceptual anomalies in the world. For Piper, as for Kant (for whom the proper use of reason is key to the viability of human society), philosophy and "theoretical reason" are posited as a means of survival. If this is the case, what do we make of Piper's recourse to selfie-taking as part of a self-disciplined philosophical ritual, and her description of this activity as a survival mechanism? Piper writes: "So the demands of theoretical reason must be attenuated and bent to the contours of our limitations."[41] This proclamation can be read as an endorsement of the autotheoretical mode, which sees the "limitations" of individual and embodied life as productive of theoretical work.

The self as embodied, immanent, affective, and limited (in our capacities, in our rationalities)—this is what theoretical reason (or at least its "demands") must be "attenuated and bent to." I read this philosophizing statement of Piper's as a call for a kind of flexibility on behalf of both the theory and the subject. This passage sums up Piper's conclusions about theoretical reason based on her engagement with Kant, and resonates with the concerns of contemporary feminist theory, including ableism and accessibility and the place of the self. I understand Piper's statement as metonymically embodying her nuanced subversion of the Kantian system

through an autotheoretical feminist practice: one that upholds many of Kant's terms and at the same time calls for an "attenuation" of "theoretical reason" and its "demands" in light of the "nonideal" circumstances in which we find ourselves in our everyday lives.

When it comes to Kantian philosophy and feminism, the presiding understanding seems to be that Kant's work suppresses the embodiment and subjectivity in philosophy that feminists are committed to theorizing and enacting.[42] This prevailing feminist reading of Kant takes issue with Kant's perceived disregard for the material body and his notion of aesthetic disinterest. Amelia Jones, for example, describes Kantian aesthetic philosophy as attempting "to erase the vicissitudes of bodily interest," and in this way she positions feminist body art practices in direct contrast to Kantian aesthetics.[43] In Jones's view, feminist body art allows an artist to constitute herself as both subject and object, body and mind; she makes this argument in relation to Piper's *Food,* among other works, where "subject" and "object" refer not specifically to the Kantian sense of the terms but to the more general, patriarchal context of art history in which women—as feminist philosophers from Irigaray to de Beauvoir have argued—are precluded from intellectual subjectivity and the possibility of "transcendence" by virtue of their embodiment. Jones's account of Kantian aesthetics, which perceives in Kant's work a fundamental suppression of the body, is found in other feminist art historical writings, and is likely attributable to the hegemonic place that Greenberg's "mystified Kantianism"[44] holds in the mid- to late twentieth-century art world. But what do these readings of Kant leave out?

Piper's self-images function not as a supplement to her rigorous Kantian philosophizing but as a necessary part of an autotheoretical practice of art-making and philosophizing invested in questions of epistemology and ontology. What is interesting here is that feminist body art and conceptual art as autotheoretical practices become not simply legitimate sites of theorizing but necessary sites from which to work through and instantiate long-debated or difficult to resolve philosophical problems. Modern and contemporary theorists alike are troubled by "the apparent consequences of [Kant's] tendency to identify appearances with representations of them"[45]; it is through such an oblique, literally self-reflexively embodied practice of reading Kant that Piper engenders fresh insight

into these long-standing questions. If we take *Food* as an early example of "research creation," then we see that she troubles understandings of Kant that were dominant at that point, including the influential interpretation of Kantian aesthetics espoused by Greenberg. Piper brings philosophy—its language, its structures, its historical baggage, its institutional scaffolding—into complex, bodily interaction with herself and her work. Her engagement with Kant through an artwork is both conceptual and formalist, embodied and abstract, and so complicates the terms of Greenberg's Kantianism, which foster a dubious divide between "content" and "form." Piper herself has written on the ways Greenberg established an opposition between "political content" (tied to concerns of gender, race, sex, and so on) on the one hand, and "form" on the other, with his theory of formalist aesthetics. Greenberg's 1950s art world formalism configured "social content—particularly explicitly political subject matter ... as sullying the 'purity' or impeding the 'transcendence' of a work";[46] Piper's own readings of Kant are more dialectical. A sharp opposition between "content" and "form" seems disingenuous, especially when read in light of Kant's developing notions, such as "subjective universality," which he proposed to resolve the problems presented by questions of aesthetic judgment and form.[47]

Piper's critical take on Kant in *Food* is represented to the audience or the "reader" not through an essay or a peer-reviewed article but through an embodied artwork and an artist's statement. Just as the work is prescient in its apprehension of the selfie in feminist art practices and autotheoretical work, so too is it ahead of its time with regard to art practice as research. The work itself is "enough." Piper would continue to study Kant's work for decades, exceeding the somewhat arbitrary temporal parameters of an MFA program or a studio-based PhD. Piper's decision to begin reading Kant in early adulthood began the process of lifelong learning and study that is the work of so many contemporary artists—especially those working conceptually.

SURVIVING PHILOSOPHY: AUTOTHEORY AS SELF-PRESERVATION

Through the autotheoretical orientation she activates in *Food,* Piper reveals the critical insufficiency of declaring a de facto opposition between

feminist practice and Kantian thought. Piper responds to feminist traditions of critiquing the modernist, Greenbergian characterizations of Kantian thought as one of aesthetic disinterest. Her critique is complicated further by her extended and in-depth engagement with Kantian philosophy over the course of her life, up to the present day. The work is very much a thinking with and through Kant and her own embodiment as an artist and philosopher. She enters the work with a sense of curiosity, and it is this curiosity that drives the work, rather than some predetermined feminist "aim." *Food* seems impelled by a practice of philosophy more than a practice of politics per se (if philosophy and politics can be disentangled from each other, even in theory) and can come to conclusions that a practice, otherwise driven, might not. Indeed, Piper's *Food* takes a more oblique approach to Kant than the works of some other feminists—especially those feminist art historians and scholars for whom Kant's work represents a rather simplistic opposition to "feminist alliances with *the body*"—and engenders a different kind of insight into Kantian questions from the perspective of a racialized, woman artist whose presence in the work, by virtue of its self-imaged immanence-transcendence, renders the philosophical *political* (in spite of itself).

Piper's self-images function not as something separate—or separable—from her practice of philosophizing. Rather, the self-images are a necessary part of that practice. This is consequential to a consideration of the stakes of autotheory as a contemporary artist's practice because it shows the ways that there is something in the chemistry—the formal commingling—of *auto* and *theory* that is philosophically generative and politically refreshing. In doing so, Piper reveals overlooked sites of alliance between Kantian philosophy and what we might understand today as antiracist, intersectional feminist concerns. Enabled by self-imaging, Piper is present as a nonwhite woman artist and a philosopher—a subjectivity precluded by Kant in his writings, which for all their latent potentialities remain Eurocentric and phallocentric in scope. Juxtaposed to the practice of rigorous philosophizing, her status as part of philosophy—a thinking, reading, writing, active *subject* part—is underscored. Piper instantiates a sympathetic confrontation with Kant through her self-representation. Her embodied subjecthood exceeds the categories of philosophical subjectivity that existed at the time Kant was writing and the largely white, German, middle- to

upper-class men for whom he was writing. But was Kant writing *for* them, or were they the only readers of his work at that point in history? This distinction seems important, particularly when it comes to the materialist histories of philosophical study, and it is a distinction that Piper's work—committed to an ongoing study of Kant—seems cognizant of.

In her postperformance reflection, Piper describes the ritual of self-portraiture as having been unsuccessful in grounding her against the disembodying effects of Kantian thought. The problem of the efficacy or "success" of feminist self-imaging in contemporary art practices is one that continues to be up for debate, and those working autotheoretically—as a mode engaged with philosophy and theory alongside such "self"-focused practices—are well positioned to respond to these debates. In the wake of *Food*, Piper wrote her compelling 1974 book, *Talking To Myself: The Ongoing Autobiography of an Art Object,* which extended her practice of philosophizing, in an autotheoretical way, the ontology of the subject in relation to subjectivity and objectivity.[48]

Even though Piper required two years away from Kant's philosophy once her grueling *Food* performance had come to an end, she would go on to work with Kant's philosophy as an artist, scholar, and philosopher up to the present day, publishing two extensive volumes on Kant and Hume and founding unique, multidisciplinary fellowships for Kantian research through her Adrian Piper Research Archive Foundation. Did the artist simply need a little time away? A brief break from Kant, to let the philosophy integrate into her body? To be sure, Piper's ambiguous relationship with Kant seems of a piece with the often ambivalent, affectively charged relationships between artists and the theory their work engages, as found in the growing impulse toward autotheory in feminist and queer cultural production. As an approach that is self-reflexively subjective and rigorous, autotheory allows artists, writers, activists, and scholars to process theory and philosophy in their work in ways that are relevant to living. This work of processing philosophy's discourses through the pronounced particularities of an embodied, extradiscursive life often results in complicated critiques and affirming subversions.

An unprecedented conceptual artwork, *Food* is in good company with other resuscitative readings of Kant's *Critique of Pure Reason*, such as Kojin Karatani's *Transcritique*, where Karatani ascertains the ethical roots of

socialism in Kant's first *Critique* through inventively reading Kant and Marx against each other.[49] In his self-described "theorizing lecture," "Black Kant (Pronounced Chant)," Fred Moten, who, like Piper, moves among the positions of artist, writer, scholar, and philosopher, frames the text he performs aloud as an attempt "to mobilize the poetry of Norman H. Pritchard as a theoretical lens and amplifier through which to see and hear Kant more imaginatively, which is to say accurately."[50] We might also understand Piper's similarly unusual and oblique approach to reading Kant in her body art and conceptualism to be a way of "more accurately" understanding central aporias in Kant's philosophical system.

Within the conceptual framework of *Food,* Piper's Kantian selfies function as an empirical evidencing of her self that is an integral part of her reading and understanding the aporias in Kant's *Critique*. The selfies serve as traces that bear testimony to the ongoing tension between attempts at self-preservation and the fruitful failures of those attempts. Through the conjoining of performance for the camera and philosophical study, Piper processes and, in turn, fleshes out long-standing philosophical problems related to metaphysics and ontology, including the status of the subject and the tension between subjectivity and objectivity in representation. In response to the anxiety prompted by a disciplined reading of Kant, Piper's repeated self-imaging becomes an autotheoretical refrain to the process and practice of ruminating on philosophy as a feminist artist. Reading *Food* as a work of autotheory gives renewed insight into persistent tensions between feminist art practice and Kantian philosophy.

Through her art and writing practices, Piper prompts an aesthetic confrontation between Kantian philosophy and feminist conceptual art and body art practices that challenges the mid-century ideology of aesthetics that privileged "disinterested" art. She centers herself as an artist-philosopher in a way that both resonates with and challenges Kant's philosophical system: a system that can be read as an antecedent to autotheory in its proto-phenomenological assertion of the inextricability of knowledge, perception, the senses, and understanding but that at the same time ignores the role that particular aspects of embodiment—including race, gender, sexuality, and ability—play in structures of subjectivity. In this way, Piper critiques Greenberg's Kantian-inspired modernist formalism as a kind of bad metaphysics and, in the process, reveals herself as a cunning

reader of Kant. *Food* reveals Piper to be one of Kant's best readers: she understands the paradox of Kant's philosophical system—predicated on sensorial perspective, and thus on the body, while at the same time failing to consider the body in its gendered, racialized, and abled aspects. By autotheoretically metabolizing Kantian philosophy, Piper creates a way into even the most difficult to parse philosophy (the overused pun of "I Kant" has been fodder for many a meme) for a whole school of artists and outsider philosophers after her.

2

NO THEORY, NO CRY

Autotheory's Economies and Circulations

You say I'm free now the battle is over and feminism's over and socialism's over yeah say I can consume what I want now, consume what I want now.
—Jenny Hval, "The Battle Is Over," *Apocalypse Girl*

STUDIO VERSUS THEORY

"I haven't painted in months," an artist friend tells me during a studio visit. She is a painter who has just begun her MFA at a reputable Canadian art college-turned-university and has become more and more vocal about the lack of time she has to work in her studio. "All we do is read theory!" She is exasperated and tired, surrounded by half-finished canvases, wondering why she pursued graduate school as an artist if there is no longer time for her to make art. And she is not alone: as philosophy, theory, and criticism become an increasingly large part of the curriculum for studio art MFA and PhD programs and as more art schools become universities,[1] there are artists who push back. Some of these artists respond by working autotheoretically, making art that critically engages with the centrality of theory and discourse in contemporary art, academia, and their varied economies—social, political, financial, or cultural.

The tendency toward autotheory has emerged alongside broader discursive, material, social, and institutional shifts in how we think about the production and mobilization of theory and knowledge in twenty-first-century

institutions, including art colleges-turned-universities and contemporary art galleries. The rise of PhD programs in studio practice is one contextual cue; another is the accompanying turn by research institutions and funding bodies—such as Canada's Social Sciences and Humanities Research Council (SSHRC)—toward recognizing "research-creation" as a legitimate mode of academic output. Over the past few decades, fine arts programs at a handful of universities in the UK and, later, in the United States and in Canada—where all major art colleges have been transformed into universities—began to welcome doctoral students into practice-based studio art programs, on the premise that an artist's art practice constitutes academic research and can be articulated as such through an accompanying textual thesis. Today the integration of theory and practice is encouraged to varying degrees within such academic disciplines as visual studies, critical and creative studies, performance studies, environmental studies, and women's and gender studies. The increasing number of studio art PhD programs has meant the displacement of artists holding an MFA, previously a "terminal degree," which in turn has affected the politics of which practicing artists are "hireable"—particularly to the tenure track—to teach in art colleges-turned-universities. Such programs call into question how far the trend of practice as research and evidence can or should be taken, or at least raise the question of whether this further academicization-as-professionalization is beneficial for practicing artists.

PhD studio art programs are not universally praised, either by artists or by academics, even as they are growing in number. Doctoral candidates in studio art have the task of articulating and defending their art practice in theoretically based academic language, drawing on and refining the discourses they encounter during MFA studies and PhD coursework in their written thesis and graduating exhibition. Anecdotally, I've heard professors in these programs lament PhD studio art candidates' inability to adequately articulate their practice in the required theoretical terms. I've heard from practicing artists who refuse to do a PhD in studio out of their own conviction that their practice is incommensurable with the more empirical research output that academia requires. I've heard from artists in PhD studio programs who claim that their departments have a difficult time securing SSHRC funding for their projects. And finally, I've

heard from artists who have completed a PhD in studio only to discover they are no longer interested in having an active art practice because of burnout, disillusionment, or the different demands or desires resulting from scholarly professionalization. To be sure, many artists do willfully (and even happily) move through PhD programs and emerge from them with still active—and perhaps even stronger, in the eyes of the major art institutions—practices.

Outside these programs, some artists, particularly those working in feminist social justice spaces, see all theory as top-down or gatekeeping. They see a binary opposition between "practice"—getting your hands dirty and doing something—and "theory"—the discursive and the academic. Instead of something potentially liberating, theory to them appears inaccessible and a mark of privilege, both because of its advanced discourse and terminology and because of the resources (time, energy, money for tuition) required to engage with and produce it. Some artists, such as those who organize with the Feminist Art Collective,[2] distance themselves from theory in an effort to find egalitarian, anti-authoritarian modes of organizing in the arts.

Discourses of elitism have long been a feminist issue. But while alternative modes of organizing in contemporary art make space for artwork that might not have made it past the academic gatekeepers of today's contemporary art institutions, an overly defensive reaction to theory can lead to anti-intellectualism within activist spaces. In *Teaching to Transgress,* bell hooks warns of the danger of devaluing the written and spoken word in favor of "concrete action." Instead of positing theory and practice as oppositional, or seeking a practice that purportedly rejects all things "theory," she calls for a socially engaged feminist theory grounded in practice. In her view, all feminist theory (if it can properly call itself feminist) is first and foremost a wrestling with "the concrete," a means of making "sense of everyday life experiences."[3] Theory can become a way of articulating those experiences in ways that are transformative: for example, Black feminist theory transgresses white-supremacist patriarchal institutions through its articulations and practices. Hooks encourages women from diverse backgrounds to create theory from their life, as everyone's lived experience presents multifaceted, and urgent, positions from which to theorize. This insight and urgency are at the root of the autotheoretical impulse.

Eschewing theory and other intellectual modes as "elitist" plays into the hands of right-wing politicians who, by describing liberals as the "elites" ("Champagne socialists," "latte-drinking liberals"), draw attention from the perhaps more true elitism of financial wealth and material power. At the same time, however, theory and its dissemination in culture are wrapped up in their own forms of capital and agency. In this chapter, I explore contemporary autotheoretical practices in which artists address the circulation and valuation of theory as a specialized language in art and feminist spaces. I focus on autotheoretical work by American, Iranian, and Canadian artists, including Hazel Meyer, Sona Safaei, Madelyne Beckles, and Jayson Musson, to unpack theory's relationship with cultural capital, valuation, and circulation. I especially consider the politics of these works and the transformative possibilities of autotheory, while keeping an eye on the context of neocolonial, advanced late capitalism and what is largely, in the case of these works, a Euro-American-centric global art and theory scene. In examining these artists' practices across media, I investigate the discursive and material economy of theory, particularly as it manifests in the larger context of neoliberalism with its drives toward individualism and self-definition.

NO THEORY, NO CRY

The artist Hazel Meyer's work *No Theory No Cry* is one particularly playful and parodic autotheoretical response to the contested place of theory in contemporary art. The work began as a sketch, which was later reproduced by the artist as a six-by-eight-foot banner made of felt, silk, tulle, and thread. The words "no theory no cry" are scribbled in Meyer's childlike handwriting—an expressive font that has become its own kind of character in Meyer's practice—above a figure who, viewers of Meyer's work know, is a hand-scrawled self-portrait: a cartoon-like version of the artist that functions as a queer motif in her works. *No Theory No Cry* came out of Meyer's frustration with what she experienced as a lack of space for the emotional and the embodied within the discursive and the theoretical, particularly when it came to how theory was taught in her MFA program. The text restages the discourse of theory, which becomes another kind of

Hazel Meyer, *No Theory No Cry*, 2009,
banner, felt, silk, tulle, thread. Installation
view at OCAD University Graduate Gallery,
Toronto, 2009. Courtesy of the artist.

character in the work, as affecting. Meyer playfully intervenes in the world of "theory" as it currently exists, while also inscribing the kind of theory she wished did exist—theory that is accurately affective, with big sloppy tears flowing down.

In a text that functions as a kind of artist's statement, as well as a lyric that accompanies the visual work, Meyer articulates her equivocal feelings about theory:

no theory no cry / is rigorous & articulate & assertive & obnoxious & / emotional with a predisposition to tears / theory helps /theory hinders /a tumultuous relation-ship/the artistic process / a prosthetic axis / a simultaneous conquer and defeat/ no theory / no cry / is the possibility to double back / & inform the teeth that bite your ass.[4]

Meyer rewrites Bob Marley's frequently remixed reggae song "No Woman No Cry," itself an anthem of ambivalence; the work represents the ambivalence toward theory that many artists experience in contemporary art spaces, including the institutional spaces of the art college-turned-university, through language, imagery, and humorous citation. *No Theory No Cry* presents an image of autotheory with the capacity "to double back," self-reflexively. That there might be a way of practicing theory that is both "articulate" *and* "obnoxious," "assertive" *and* "emotional," is something Meyer hopes for. This critique aligns with histories of feminist thinking on the politics of intelligibility and legibility.

Many feminists, including Indigenous, Black, and POC feminists, neu-rodivergent feminists, feminists with disabilities, and poor and working-class feminists, have struggled to be recognized as critically intelligible when they speak in ways that the patriarchy hears as abject (words like "shrill" or "obnoxious" come to mind), overly "emotional," or otherwise nonintellectual or incoherent. In *No Theory No Cry*, Meyer attunes to these feminist histories in theory. The artist describes this work as her attempt to "provoke a conversation between theory and art making." By describ-ing theory and artistic practice as existing in "a tumultuous relationship," Meyer animates theory and artistic practice or *process* in more human and humane terms—to comical, anthropomorphizing effect. The accompany-ing brochure for the work reads: "Like, if theory was a little crying bundle,

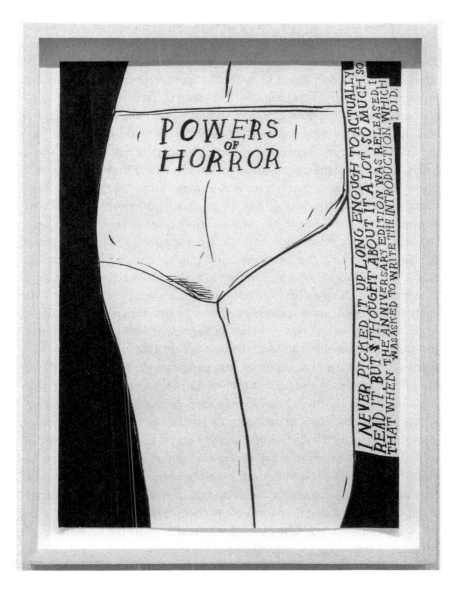

Hazel Meyer, *Power of Horror*, 2015, drawing,
ink and watercolor on paper. Installation
view, Zalucky Contemporary, Toronto,
2017. Photo: Toni Hafkenscheid. Courtesy
of the artist.

wouldn't you take it in your arms and say ... No theory no cry." Using col-
loquial language and personifying "theory," Meyer invokes a tenderness.
Theory is transmuted into a "little crying bundle" that the artist might
comfort and nourish like a baby that is completely dependent on her,
holding it in her arms and swaying from side to side.

Meyer's *No Theory No Cry*, like so many other works that engage an
autotheoretical mode to enact critiques of the art world and artistic prac-
tice in the contemporary moment, is fundamentally ambivalent: "theory
helps," but also, in the next breath, "theory hinders." I first came across *No
Theory No Cry* in 2014 through my involvement with *Theory Boner,* a queer
feminist zine collectively organized by graduate students and artists Mary
Tremonte and Jenna Lee Forde. Much of the power of *Theory Boner* lies in
the humor and immediacy of the title. Appropriating the phallic "boner"
from a queer-femme, trans-centered, and gender-nonconforming view, the
title intimates a kind of figurative hard-on that those contributing to the
zine share for theory. Carefully printed on a Risograph duplicator using
their art college-turned-university's donated printing resources, *Theory
Boner* compiles contemporary theory references, including quotations from
Judith Butler, essays that straddle the personal and the critical, collages and
comics, drawings and manifestos, and performance and video stills that
are often focused on the body. My contribution was stills from my video
Self Love Limits, in which I continually reapply red lipstick and bend and
contort to kiss each part of my body, the remaining blank spaces standing
as evidence for the "limits"—quite literally, here—of self-love, and the need
for collective practices of support and care (an accidental riffing on, and
soft femme response to, Vito Acconci's somewhat self-violent *Trademarks*,
in which the artist, known for ultra-conceptual works that are complicated
around issues of consent, marks his own body by biting it).[5]

Meyer has extended her autotheoretical approach to art-making in
projects that address the world of sports, bringing in her experience as a
queer woman from a poor background to effectively queer the world of
athletics and team sports in mixed-media performance works that involve
group performance, sculptures, banners, and text. During a conversation
with the artist, Meyer cites modernist poet and art collector Gertrude
Stein's claim that "there is no repetition, only insistence"—which Meyer
too affirms in her approach to text. She cites Julia Kristeva, whose *Powers*

of Horror resonates with Meyer's lived experience with Crohn's disease. In her performance *Muscle Panic,* one of the objects involved is a denim jacket with ABC's *Wide World of Sports* logo (1961–1998), but the logo now reads "Wide World of Wholes." Next to the text are two buttholes, one orange and one pink, carefully scribbled in Meyer's iconic hand-drawn style. The artist refuses the psychoanalytic equation of women's holes with "lack" and introduces the motif of a queer feminist politics of women's anal eroticism that moves through her larger practice—where the artist has sought to "reclaim her asshole" from chronic illness through a women-led anal politics of pleasure and integrity. Her reproduction of "holes" as "wholes" serves as a playfully polysemic counter to Lacanian and Freudian psychoanalytic theory, which she extends to a present-day art context of queer feminist performance art, group collaboration, and celebratory forms of conceptual art practice that aim for accessibility for all.

In projects like *Theory Boner*, artists and writers and curators come together to configure critical theory as something that must be processed and transmuted through the body and is very physical and even sexual in its effects on us; like Meyer's *No Theory No Cry,* which cites theory's capacity to bring a "thrill" and a "chill" and to "make the tears flow," *Theory Boner* sets out to make space for a way of relating to theory that is embodied, affective, and more directly relevant to the lives of queer and gendernonconforming feminist artists, activists, and students. As a mode that often directly and self-reflexively integrates lived, embodied experience and theoretical discourse and frameworks, autotheory has the potential to at least attempt to reconcile scholarly or academic ways of working with more activistic, community-based ways of being, feminist or otherwise. Might autotheory assuage the perceived tensions between accessibility and contemporary theory, and between populism and philosophy?

AUTOTHEORY AND ACTIVATION: WHAT CAN THEORY DO?

As part of the Frieze Talks in London in 2009, *Frieze* co-editor Jörg Heiser led a panel discussion titled "Scenes from a Marriage: Have Art and Theory Drifted Apart?" with philosopher Simon Critchley, curator and critic Robert Storr, and artist Barbara Bloom. The provocative panel title suggests

that art and theory have figuratively "divorced" after a long "marriage" or "happy period of co-habitation."[6]

Heiser points to the 1980s as a time when, following the dawn of postmodern theory in the 1960s and the poststructuralist turn in the 1970s, theory crystallized and became central, or at the very least "prevalent," in the art world, both in the processes of making art and in curators' and critics' critical responses and contextualizations. Today (2009), Heiser explains, some artists are distancing themselves from theory, while other artists continue to "attach" themselves to it. Critchley responds, "Yes, a certain model of theory has become tiresome," and says that this model of theory is the "top-down model, or theory as legitimation of the artist." When artists understand theory and how to mobilize it and wield it in their work, they come to possess a certain agency as they move through contemporary art and academic spaces—as discursive as these spaces tend to be.

To illustrate, Critchley describes art schools of the 1990s as dominated by a "terroristic model" of theory, in which artists were "made to feel stupid by their inability to master theory with a capital 'T,' with which is meant a stack of texts usually translated from French, by authors whose names start with a D, sometimes an F or a T." As he speaks, you can hear laughter bubbling up around the room. "Without wanting to insult anybody in particular," Critchley concedes, he points to particular MFA programs such as Goldsmiths in the 1990s as having been especially pernicious in fostering this kind of relationship between theory and contemporary art. (This is also the period that Chris Kraus responds to in her autotheoretical feminist art writing and criticism in *Video Green: Los Angeles Art and the Triumph of Nothingness*, where she criticizes the MO of MFA programs and contemporary art institutions in the context of 1990s LA.[7])

Artists subjected to this "terroristic model" of theory, whom Critchley describes as being "often very good" as artists, were "cowered into submission and driven in some cases to distraction, in some cases nervous breakdowns." Critchley points to the anxieties that this manifestation of theory, specifically "theory with a capital 'T,'" provokes in artists—especially those pursuing graduate degrees in their field. Turning to the present, Critchley asks, "How does one approach the way art thinks in its own terms without drowning the art in theory?"

Many feminist artists are acutely aware of these concerns, and make autotheoretical work to push back against the more oppressive ways that theory circulates in places like art schools. This issue of a "top-down model of theory" that serves as discursive legitimation for an artist's work is often contested through autotheoretical practices. Art is neither purely conceptual nor purely intuitive, as Critchley acknowledges, and autotheoretical works exemplify the capacity for an artist to work between these two poles. In the wake of high modernism, autotheory as a transmedial mode of practice becomes a way to hone the power and affect of theory as it comes to interact body, subjectivity, and the experience of living in the world. These works are not "drowning" in theory in Critchley's sense but are instead finding ways of treading water, swimming through and maybe even enjoying it, finding strength, pleasure, and *jouissance* in the practice of that movement *through.*

Artists, writers, critics, and scholars who gravitate to working in autotheoretical ways seem to be attuned, at least subconsciously, to the truth that theory is subjective, embodied, and material, and that there are limits to what it can do. Theoretical frameworks can be very useful in providing structure for abstract notions, scaffolding developing ideas, and holding fluid concepts. It is when we start to fetishize theory as an intellectual discourse or wield it in ways that are inaccessible and violent that problems arise. In the twenty-first-century, when the autotheoretical turn is gaining traction in scholarly and popular contexts, scholars and artists and critics ought to remain attuned to the ways that theory, like so many other material *things*, can ossify into commodity status and circulate in ways that are colonizing and alienating, oppressive and destructive. Instead, we might remember the ways theory can *hold*—much as a vessel holds an effervescent tonic—ideas that are sparkly and excessive, nourishing and weird.

NAME RECOGNITION: ON BUYING (INTO) THEORY

In the contemporary moment, theory can range from something that self-identified feminist artists and collectives might distance themselves from for its perceived hegemonic and institutional power to something that is ambivalently engaged with as an artist's material, or even adored as

a fetish object with cultural capital and scholarly recognition. On the flip side of the "terroristic model" of theory are fervent, affective relationships to theory that can ossify into uncritical loyalty—a cultlike allegiance to a certain school of thought or a theorist.

Even in milder forms, to call oneself a "Derridean" is to incorporate one's theoretical identifications into oneself. You become a self-identified "Derridean," a "Nietzschean," a "Lacanian," a "Butlerian," maybe even—though perhaps more rarely today, as we begin to take more seriously the lived effects of a philosopher's or theorist's work and actions in the world, in relation to such once abstract notions as *ideology*—a "Heideggarian." This tendency is more common with male theorists, Butler being an exception; I've never heard of someone publicly call themself a "hooksian," a "Lordeian," an "Ahmedian," an "Irigarayan," or even a "Kristevan," even when they might effectively *be* such. Was it a coincidence that the surnames of male theorists, and male-proximate butch theorists like Butler, were more readily namified in this way? Feminist theorizing introduces another way of being with theory that is less assimilative—one *becomes* a certain thing—and more akin to an ally or a friend, something positioned *beside*, in the sense espoused by Eve Kosofsky Sedgwick in her own experimentally autotheoretical treatise, *Touching Feeling*.[8] I take up the politics of queer feminist citation as a mode of intimate relation in chapters 3 and 4, where I approach recent autotheoretical literary and visual artworks through ideas of intertextual intimacies and intertextual identifications.

Conceptual artist Sona Safaei takes up the fetishization of theory in contemporary art spaces in an ongoing body of work that renders the names of selected theorists, conceptual artists, and art critics as corporate logos or brands. The artist renders the names of theorists and contemporary artists in a Louis Vuitton pastiche brandscape, which is then printed across different commercially produced objects and paracommodified materials: as a large-scale press backdrop for people to pose in front of and have their photographs taken in *Bibliography* (2013), as an artist's multiple coffee mug available in an unlimited edition in *V+1* (2014), and as a limited-run, luxury handbag in *Swift Memorial* (2016). Safaei's handbags resemble the Louis Vuitton bags that were emblematic of socioeconomic cachet in the mid-2000s, objects that themselves embody the contradictions of mimetic repetition in advanced late capitalism.[9] Made familiar

JEAN BAUDRILLARD John Guillory

Jacques ◇Lacan BORIS GROYS Roland Barthes

 John Guillory JEAN BAUDRILLARD Nicolas Bourriaud

Roland Barthes 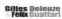 Jacques ◇Lacan BORIS GROYS Michael Asher

 Nicolas Bourriaud John Guillory JEAN BAUDRILLARD

BORIS GROYS Michael Asher Roland Barthes Jacques ◇Lacan

Sona Safaei-Sooreh, *Bibliography*, 2013,
vinyl print. Courtesy of the artist.

and then unfamiliar through the supplanting of Louis Vuitton logos with the names of theorists and artists rendered as logos, Safaei's *Swift Memorial* becomes a site to reflect on contemporary art theory's investment in processes of valuation and discursive exchange.

The work points to the ways that the author function is enmeshed in neoliberal, advanced late capitalist economics of value: the cultural capital to be derived from possessing a Louis Vuitton bag and flaunting it on your arm as you walk around is not unlike the cultural capital to be derived from possessing knowledge of theorists and notable contemporary artists and flaunting that knowledge by waxing lyrical about Deleuzoguattarian rhizomes. Here, the punchline of this work's joke is the name recognition of a theorist or a contemporary artist whose work, in this "postphilosophy" space of theory, or "metaphilosophy," as Jameson calls it, functions effectively as a kind of theory—so there is Deleuze and Guattari, Lacan, Barthes, and Baudrillard, alongside Michael Asher and Andrea Fraser ("institutional critique") and Nicholas Bourriaud ("relational aesthetics"). By selecting the names of those whose work was central to her grad school experience as an immigrant artist studying in late oughts Toronto, Safaei enacts Foucault's "author function" to parodic effect, pointing to the fetishization of theory in art spaces and prompting reflection on the cultural capital—and the varied costs—of learning and citing.

When the viewer considers the global context of the US–Iran relationship and the lived impact of US economic sanctions on Iran, where the artist's father lives, since November 1979, the autotheoretical aspect of Safaei's work comes into clear view. Safaei made the conceptual decision of pricing the bag—an artist's multiple in an edition of three—with a view to these transnational, political economic relations. A first-generation Iranian Canadian artist, she has long been interested in the global economics and politics of the relationship between Iran and the United States, and she creates art objects whose production and pricing are both literally and conceptually influenced by trends in the global political economy and cultural capital. Safaei makes conceptual decisions as to how her work is priced for art collectors, and in so doing stages localized interventions in the global art market. For her coffee mugs, which the artist had commercially produced by a Chinese company, the cost increases with each purchase: as

Sona Safaei-Sooreh, *V+1*, 2014, sculpture
(artist's multiple). Courtesy of the artist.

demand for the work increases, so too does the cost and, in turn, the market value. As an object of exchange, Safaei's handbag in *Swift Memorial* embodies the tensions of the personal and the political in a globalized age of late capitalism and the neoliberal hegemony of the West: quite literally, the US sanctions on Iran have implications on the production of the bags, as the price of the bag changes depending on the buyer's nationality.

Safaei's creation of a reproducible theory brandscape embodies what Chris Kraus, in her *Video Green: Los Angeles Art and the Triumph of Nothingness*, wrote of as the aesthetic of "neocorporate neoconceptualism" that dominated the art being made by MFA-educated students in 1990s Los Angeles.[10] With a conceptually charged self-awareness, Safaei literalizes the neocorporate neoconceptual aesthetic by staging the commodification of intellectual discourse and the process by which theorists, via contemporary art education programs and adjacent art institutions and publications, become *brands*. Of course, Safaei's joke relies on knowing these discourses—having at least some basic working knowledge of contemporary theory, and the stakes and claims of the theorists and artists being referenced, is required to get the joke of this work.

When Kraus makes reference to what she calls the "Bataille Boys" in *I Love Dick* (1997), I take this naming as a provocation to prompt reflection on the ways we consume theory and discourse—and their social and political effects (and affects). Kraus's sense that the swooning young male fanboys surrounding her then husband—the renowned cultural critic and Semiotext(e) founding editor Sylvère Lotringer—at critical theory- and art-related events were both sycophantic and latently misogynistic drove her to coin this moniker. Yet to understand Kraus's winking interpellation, the reader must know what Bataille signifies; they must have some recognition of how theorists have framed themselves and their thinking socially and institutionally. With the name "Bataille Boys," Kraus writes through her own frustrations at the hagiographic cult followings that form around certain schools of thought, and the unchecked sexist (and racist, though the focus of *I Love Dick* is on sexism and anti-Semitic politics) baggage of those primarily male-centered scenes, pointing to Bataille for the macho notions of transgression, erotism, and economies of energy his theory embodies. Like this cheeky hailing of "the "Bataille Boys," Safaei's

transmuting of names into brands coyly comments on the ways theory can become a fetish, uncritically consumed by certain educated populaces.

In her 2008 essay "Stick to the Facts," Kraus discusses how MFA students at American universities are "bullied into legitimizing their work within some form of discourse. This discourse (like life itself) is, 80 percent of the time, disingenuous, and entails attaching oneself to those who at that moment exercise power."[11] In the process of professionalizing their practices they find that, in order to be understood *as* contemporary artists, they must demonstrate some mastery of theory—or what Kraus refers to more generally here as specialized "discourse"—specifically, the theory

Sona Safaei-Sooreh, *V+1*, 2014, sculpture
(artist's multiple). Still from a single-channel
video by the artist. Courtesy of the artist.

that is fashionable and influential during the time of their MFA studies. Safaei's work is like a time capsule of theoretical fashionability and influence in a certain era—not unlike the colored pattern of the Louis Vuitton bag that she gestures to, reminiscent of a Paris Hilton–era 2000s. There are metanods in the artist's particular choices: the trendiness of Bourriaud's relational aesthetics at the time of the artist's MFA, or John Guillory's work on cultural capital and canon formation as it relates to Safaei's comparison of the cultural value that attaches to theorists, to financial capital in a global marketplace tied to imperialist sanctions and literal war.

Sona Safaei-Sooreh, *Swift Memorial*, 2016, sculpture (artist's multiple with accompanying website: www.swiftmemorial .com), Installation view at Zalucky Contemporary, Toronto, 2017. Photo: Toni Hafkenscheid. Courtesy of the artist.

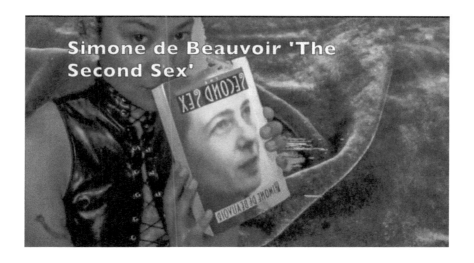

"HARD THEORY": *FUN, FLIRTY, FEMINIST!*

Some artists look specifically to the canons of feminist theory as a site or *cite* for their critique of how theory is consumed. Artist Madelyne Beckles engages an autotheoretical mode to playfully critique the circulation and valuation of feminist theory in the late 2010s, using performative strategies from infomercials and other modes of selling to comment on the ways that theory is consumed in both feminist and nonfeminist contexts. In her video *Womanism Is a Form of Feminism Focused Especially on the Conditions and Concerns of Black Women* (2016), Beckles uses performance for the camera to appropriate the form of a TV infomercial to sell twentieth-century feminist theory—or what she calls "hard theory." Hamming it up for the camera, Beckles positions herself as a "Flirty Feminist," dancing around

Madelyne Beckles, *Womanism Is a Form of Feminism Focused Especially on the Conditions and Concerns of Black Women*, 2016. Single-channel video (still). Courtesy of the artist.

in a bra and panties. She emphatically fondles the pages of books like bell hooks's *Killing Rage: Ending Racism* (1995) and Germaine Greer's *The Whole Woman* (1999) as a voice-over narration (hers) reads the ad copy:

We offer a variety of books to suit your style. You'll have access to the canon of au-thors that some women pay thousands for in university credits. Read the likes of hooks, Lorde, and Greer, for a fraction of the price! With today's brand of feminism, you no longer have to compromise looking cute. ... Call now, and start your journey into womanhood—*woke* womanhood.[12]

The artist's outfits and actions change with each book she presents: when she flips through Simone de Beauvoir she is kinky, wearing black lingerie, and proceeds to bend over and spank herself with *The Second Sex* (1949) while smoking a cigarette. When she reads Rosemarie Tong's *Feminist Thought* (1989), she sits on the floor meditating, stretching, and doing Pilates, the book still open. As the narrator continues to read, it be-comes clear that the product the conceptual advertisement is selling is feminist theory and, concomitantly, "wokeness"—something of value, the ad reader notes, in a world where more and more people are be-coming woke. The ad positions its product as a low-cost alternative to going to university, pointing to the class politics of tuition and raising questions around the accessibility and feasibility of graduate school. It knowingly jabs at the exorbitant costs of studying the liberal arts, while gesturing to the commodification of feminism and theory more broadly. If knowledge is power, and if intersectional feminist theory knowledge is "wokeness," then knowledge of intersectional feminist theory and the particular canons formed therein is in turn a special kind of power in to-day's world. Through performance for the camera, Beckles addresses the ways woke discourse via feminist theory is "bought" and "sold" in a way that straddles the satirical and the sincere.

In another performance for video, *Theory of the Young Girl* (2017), Beckles critiques the French post-Marxist collective Tiqqun's book *Pre-liminary Materials for a Theory of the Young-Girl* (2012). The artist intimates the problems in Tiqqun's text through her physical gestures, intonation, and use of material objects as she reads direct lines from Tiqqun, such as "I'm so happy, I could give a shit about being free." Tiqqun's book was

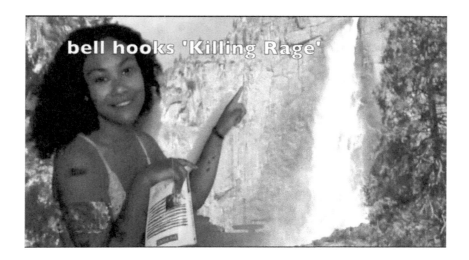

written anonymously, a point that stands in stark contrast to the hyper-visibility of Beckles, a young biracial woman who performs as herself, a known and named woman. The conceit of Tiqqun's book is that the writers theorize capitalism through a discursive appropriation of the figure of "the Young-Girl": it is "the Young-Girl" who, in their view, embodies late capitalism most clearly.[13] As she reads to the camera, Beckles demonstrates how disturbing the Tiqqun's text is, with its misguided appropriations and disparaging fetishizations of girlhood; at the same time, she gestures to the failures of feminism—a common theme in her work. Through her performance for video and her collaborative performances with such artists as Petra Collins, Beckles approaches feminist theory's canons with a reflexive skepticism that exists somewhere between affirmation and critique.

Madelyne Beckles, *Womanism Is a Form of Feminism Focused Especially on the Conditions and Concerns of Black Women,* 2016, single-channel video (still). Courtesy of the artist.

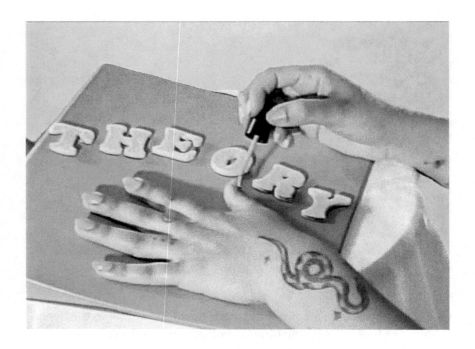

Beckles applies lipstick and stares straight into the lens: "The young-girl knows the standard perversions," she reads, with a stoic look on her face. Her costuming and design choices make even creepier the daddyish infantilization within Tiqqun's theory, even as she resists such an infantilizing grip through her adult woman articulations. At first glance, she might appear to fit into Tiqqun's theory of who or what the Young-Girl signifies, but it soon becomes clear that she is something else altogether: a feminist artist with a not easily assimilable practice. In Tiqqun's theory book, the "Young-Girl" is a disembodied abstraction; in Beckles's video, the Young-Girl is someone subjective and human—an ontological positioning that is embodied through her own speaking body.

Madelyne Beckles, *Theory of the Young Girl*, 2017, single-channel video (still). Courtesy of the artist.

Madelyne Beckles, *Theory of the Young Girl*,
2017, single-channel video (installation
view, exhibition documentation). Courtesy of
the artist.

In an iconic shot, Beckles places her hand on a handmade book that reads "THEORY" in big bubble letters and proceeds to paint her fingernails pink. "The Young-Girl is not expected to understand you," Beckles says to the camera, in the closing lines of the video. Pausing after this loaded utterance—enmeshed in the long-standing feminist politics of intelligibility, in response to which many autotheoretical practices began—Beckles holds eye contact with the camera until the video fades to black. Beckles's videos activate the autotheoretical mode through contemporary forms of practice, such as performance for the camera and web-based interventions, to question the ways that forms of theory and discourse acquire value and cachet in certain communities and social spheres while excluding or even outright oppressing others: autotheory functions as a nuanced way to critique—with ambivalence—the powers of these discourses in our perniciously neoliberal lives.

AUTOTHEORY IN SOCIAL MEDIA: INTERSECTIONAL FEMINIST MEMES

Artists working in postinternet contexts of social media platforms and pervasive selfies extend the autotheoretical mode of embodied-processing-of-theoretical-discourse to forms like the meme, the hashtag, and the social media handle or digital form of discursive-self-identification.

The hashtag #ToplessTheoryReading, started by Barcelona-based curator and writer Sonia Fernández Pan (@sf__pan), has been mobilized as a collective movement via Instagram, with artists, writers, and curators in Spain, Germany, and elsewhere using it to tag portraits of themselves topless as they read books of theory. Fernández Pan notes that, while she initially harbored reluctance to using hashtags, she now sees them as a productive form of decentralized knowledge classification and mobilization that feminists can use.[14] A search of #ToplessTheoryReading turns up people across the gender spectrum sitting topless, holding open books of theory and art criticism in a way that covers their breasts. In doing so, they apprehend the algorithm's censoring of "cis-female" nipples, preemptively covering all genders of nipples while foregrounding the cover, title, and author of a given book of critical theory or contemporary art criticism, often written in German or Spanish (including a Spanish translation of

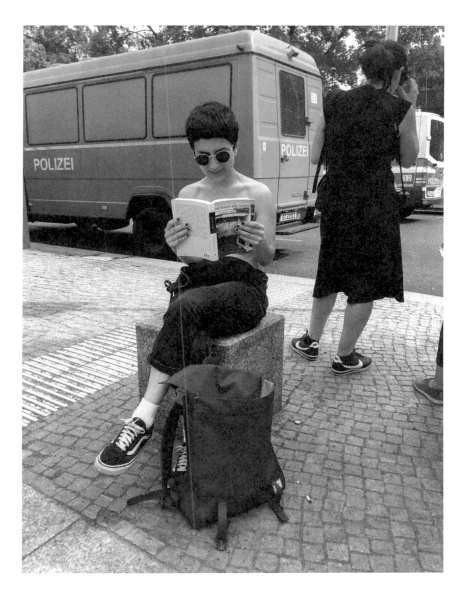

Sonia Fernández Pan, *Topless Theory
Reading* (Sonia Fernández Pan reading *Der
Klang Der Familie*), 2018. Photo by Anaïs
Senli, originally posted to Instagram (May 27,
2018). Courtesy of Sonia Fernández Pan.

I Love Dick, Te Amo Dick). By organizing as a hashtag, they encourage a trans-national movement whereby folks can pose topless with their theory book of choice, freely exposing themselves, in a sense—most often the person posing is reclining in a chair or sitting outside in the sun, looking comfortable and relaxed as they read, and other times with reminders of the perhaps hostile contexts they find themselves in featured in the mise-en-scène, as in the photograph of Fernández Pan with a Polizei van behind her posted to #ToplessTheoryReading. The photograph was taken during a demonstration against Germany's ultra-Right. Fernández Pan's hashtag

Sonia Fernández Pan, *Topless Theory
Reading* (Anu Cze reading Chris Kraus's
I Love Dick), 2019. Photo by Sonia Fernández
Pan. Courtesy of Sonia Fernández Pan and
Anu Cze.

takes the act of reading a book on one's own—something that, when done in public, can become a virtually unnoticed part of the background—as a quiet form of subversion that differs from other nudity-focused protest art, such as that of the radical Ukrainian activist group Femen.

#ToplessTheoryReading is a particularly playful take on the auto-theoretical move of self-imaging, here in states of undress—one that makes the book itself part of the practice of online self-construction and community formation. In a post for New Year's Eve 2019, Pan shared a

Sonia Fernández Pan, *Topless Theory Reading* (Sonia Fernández Pan, Su Yu Hsin, Tzu Ting Wang, Lucia Morales, Anu Cze, Ania Nowak), 2019. Photo by Regina de Miguel, originally posted to Instagram (December 31, 2019). Courtesy of Sonia Fernández Pan.

#ToplessTheoryReading photograph featuring herself and artist and writer friends, among them Lucía Morales and Su Yu Hsin, the group looking confident and joyful in their reading, some peering down at their book, others friskily meeting the camera's eye. The post prompted comments like "Let's read together!" from friends who were absent, underscoring the role the hashtag plays in displaying and mobilizing transnational communities for reading theory.

In addition to autotheoretical hashtags, we find autotheoretical social media handles. Essayist and critic Andrea Long Chu, for example, is located online @TheoryGurl. In Long Chu's piece "On Liking Women" (2018), she autotheoretically reads through Valerie Solanas's *SCUM Manifesto* through her perspective as a self-identified "transsexual." Asserting that "The Society for Cutting Up Men is a rather fabulous name for a transsexual book club," Long Chu caustically writes through the phenomenology of liking (desiring) women as a trans woman through the experience of reading Solanas.[15] Adopting the form of a personal-critical essay, Chu writes her teenage queerness through the post–Judith Butler question of the relationship between desire and identification ("The truth is, I have never been able to differentiate liking women from wanting to be like them," she writes). The text reflects on the charged experience of desiring women and feminism *as* trans and provides a reflection on the gleaming relevance of Solanas—the often abjected, radical specter in twentieth-century feminism's history—for feminisms today.

While writers like Chu extend the now entrenched genre of the personal-critical essay online as a way of engaging autotheoretically with certain fringe ideas and texts, others working on questions related to autotheory, art, and feminisms engage "theory" through alternative modes of long-form writing and meme production. Montreal-based Latinx artist @gothshakira, for example, composes lengthy written posts on Instagram that become part of the image macros she then circulates as memes.[16] The artist describes herself as an intersectional feminist meme administrator who writes "confessional femme memes" and disseminates them on Instagram. She borrows images from popular culture, including present-day Latinx female figures—Jennifer Lopez, Selena Gomez, Shakira—and uses self-portraits of herself posing in different fashionable outfits; she then positions these images beside a large block of text to create a larger

text-image pair within a single image. The texts she composes most often begin with the rhetorical formulation "when u realize," or some version thereof, and as such are comfortably at home in the meme universe in which she writes and circulates her work.

@gothshakira is self-aware of the forms that her long-form, autotheoretical memes take: in one of her memes on Instagram from early 2017, which has since been deleted, the text reads "When the confessional femme meme is longer than a sentence" and is superimposed on an image of Aziz Ansari reading Sylvia Plath's *The Bell Jar,* his face one of focus and slight confusion. Taken from a 2016 scene in Ansari's autobiographical television series *Master of None*, the image acquired additional charge after Ansari's own "#MeToo moment" in January 2018, when the published account of a sexual experience with Ansari by a woman named Grace further complicated the conversations that were taking place in popular culture and the news media around the nature of enthusiastic and ongoing consent and the lines separating sexual harassment, sexual assault, and a "bad date." The original joke of @gothshakira's meme was that if a femme artist's "confessional meme" is longer than a single sentence, readers are likely to approach it as if they were reading a heavy, feminist confessional novel, with its multiple chapters and pages and its presumed tediousness; hence her decision to use a run-on single sentence to cover a paragraph's worth of ideas.

Many feminist meme creators are subject to antifeminist hate mail and trolling, but @gothshakira believes that because her work is both explicitly feminist *and* explicitly intellectual, the level of vitriol she receives from trolls is higher. To be sure, the written aspects of her memes are lengthier and often more cerebral or theoretically informed in their language than most internet memes, incorporating references to such theorists and writers as hooks, Davis, and Lorde. Both confessional and theoretical, her strongest memes bring together her incisive take on feminist theory with an intersectional politics of access to problematize the very intellectual ideas and leftist discourses and modes of articulation (and disarticulation) she is wrapped up in. I first met @gothshakira when she gave the keynote address at an art history conference in Montreal, which, to its credit, shook up hegemonic modes of the field under the theme of "no neutral art, no neutral art historians." In her memes, the primary medium in which she works, @gothshakira addresses the problem of what might be

when u realize that aggressively and abrasively shaming everyone who does not share the same fourth-wave feminist views as u and/or has not been liberally educated and/or has not spent copious amounts of time on tumblr or in other social justice-oriented spaces whether intangible or tangible is classist, counterproductive, and is employing the same strategies of the very systems of oppression that ur trying to circumvent and that, although the emotional and social labor reserves required from u may be great, the answer lies in compassionate understanding and patient/educational dialogue in the interest of coexistence/the forward progression of humanity as a whole

Instagram screen capture, @gothshakira, meme, 2016. The text reads "when u realize that aggressively and abrasively shaming everyone who does not share the same fourth-wave feminist views as u and/or has not been liberally educated and/or has not spent copious amounts of time on tumblr or in other social justice-oriented places whether tangible or intangible is classist, counter-productive, and is employing the same subversive strategies of the very systems of oppression that ur trying to circumvent and that, although the emotional and social labor reserves required from u may be great, the answer lies in compassionate understanding and patient dialogue in the interest of coexistence/the forward progression of humanity as a whole." Courtesy of @gothshakira.

called the "discursive privilege" of wokeness, which, like critical theory, is a learned language of those who went to liberal arts colleges and graduate school, a matter of access tied to such factors as class and race. In one such meme, an image of Shakira looking away from the camera in quarter profile with a soft gaze is placed next to a long text.

Couched in @gothshakira's characteristic language, it begins with a common rhetorical conceit of memes: "when u realize," and concludes with an abbreviated intersectional feminist analysis of the accessibility and class issues around liberally educated, "woke" language. With her Instagram tagline "GRAN SACERDOTISA DE LOS MEMES" providing a frame, @gothshakira exemplifies the ways in which artists have taken to social media platforms to disseminate ideas from theory and engender autotheoretical content through the viral form of a meme.

Leveraging the form of the humorous meme and a wide readership on the internet, @gothshakira also addresses the problematics of intelligence, gender, race, and power in everyday life contexts, including dating, as a woman in her twenties and thirties. One such meme featuring a laughing Selena Gomez in stock photo lighting reads: "when upon realizing ur smarter than him he either sexualizes u for it or tries to mock/put u down for it (or most commonly both) in order to secure his dominance and reaffirm his own feeble sense of masculinity"; here, the artist identifies the particular form that toxic masculinity takes toward young women whose intelligence is seen as threatening. The resonance of @gothshakira's humor comes from it being based in a relatable, identifiable context: late 2010s Montreal (which could be replaced by another city that is purportedly progressive, alternative, bohemian, and "art-sceney"). @gothshakira's use of the hyperinformal rhetorical structures of meme administrators as her discursive mode of autotheoretical subversion is paradoxically both self-effacing in its rejection of "proper English" grammar and self-assured in its astute critiques of the world around her.

AGAINST MASTERY: ON READING THEORY OTHERWISE

The American artist Jayson Musson's *ART THOUGHTZ,* an extended work created during the 2000s, comprises a series of videos (or performances for

the camera) hosted on *YouTube* in which Musson, performing the role of his "hyper-Black" alter ego Hennessy Youngman, provides viewers with introductions to key contemporary art concepts and figures.[17] The videos, each an autotheoretical vignette, function as works of conceptual art and institutional critique that address head-on such issues as white supremacy and the excesses of global capitalism in the contemporary art world. In the videos, "Youngman" uses self-defined Black dialect "to take control of art world discourse" through a parodic performance that makes accessible—or reveals the terms and faulty logics of—contemporary art keywords and codes through an "excessive" Black hip-hop persona.

The videos open with loud rap music, such as the iconic late 1990s sound of Jay-Z's "Big Pimpin'," followed by Youngman giving an introduction to that day's topics. By demythologizing contemporary art world terms and icons while at the same time explaining those terms to an internet audience viewing these videos, Youngman diminishes their power and also provides access to that very power, through education, to those who might be excluded. In addition to being parodic (of both contemporary art and hip-hop culture), the videos are didactic, quite literally explaining ideas in humorous ways. These internet-based performances function as explanations of and alternatives to hegemonic art discourse and education, performed through the embodied Youngman, a young Black man living in America. By brilliantly (and comedically) breaking down the elusive terms of contemporary art world discourse and poststructuralist theory,[18] as well as the predominantly Western canon of notable figures[19] and practices[20] of the American art world, Musson shows to what extent access is central in considering structural racism in relation to art institutions. It is when the work's parody veers uncomfortably into "reality" that it is the most incisive: when opening the video *How to Be a Successful Artist,* for example, the number one way Youngman names is to "be white."

Adrian Piper's work, discussed in the previous chapter, can be seen as a precedent. In *Mythic Being*, an early 1970s drag performance, Piper "donned an Afro wig, moustache, and aviator sunglasses to assume a belligerent but philosophically hip male persona, a persona who claims to 'embody everything you most hate and fear,' but who also could be found at the typewriter working out Kantian quandaries in cartoon thought bubbles."[21] Diana Stoll describes this work as Piper's satirical take on the

authority and style of the "philosophically hip male" of the 1970s.[22] The humor of Piper's reference to Kant lies in what Kant represents on the level of cultural capital: Kant stands for what those in the know, the "philosophically hip males," are reading. As with Musson, the humorous send-up of the ways theory becomes power serves at the same time as a serious reframing and redirecting of theory and the structures undergirding, and ungirded by, it—such as graduate school.[23]

Works like these remind us that form and context play key roles in how conceptual work is received, and the context includes the location and mode of access to a work. Musson's *ART THOUGHTZ* is an internet-specific site, and Musson works with online culture to disseminate his work. Because of its location on YouTube, it is conceivable that non-art and nonacademic audiences might stumble upon the videos. The word "ART" is in there, which flags it as something potentially conceptual, related to contemporary art—and yet other contextual cues are distinctly blurred. Autotheoretical practices often draw attention to the particular role of critical thought in an artist's practice. In works like Musson's *ART THOUGHTZ* and Meyer's *No Theory No Cry*, performative self-imaging become a comedic means of navigating the fraught politics of theory and its contested place in art institutions, from museums and galleries to artist-run centers and art colleges-turned-universities. In Meyer's hand-drawn persona and Musson's performance for video, the artists process and subvert dominant discourses and frameworks of theory in contemporary art practices through the autotheoretical shuttling between "self" and "theory," "body" and "text."

Autotheoretical practices present ways of reading theory apart from "mastery." Some artists might read theory as a form of activism, others as a form of pleasure. In an interview for *Bookslut,* Nelson describes her physical experience of reading theory as akin to "swimming in waters that are way, way over your head." Here, reading theory is a practice that, like the psychoanalytic experience of *jouissance,* is a kind of painful pleasure that comes with "enjoying the unfathomable deeps."[24] In light of the issues of intimidation posed by theory as a "master discourse," the process of engaging with theory might be better approached as something you let wash over you (the deep waters) rather than something you seek to master or control for a given textual end. The same could be said for the

process of experiencing certain artworks—especially works of contemporary art—that, like theory, can seem profoundly elusive without long study or possessing the code to the singular meaning behind a given work. But what if we step back from this understanding of art and theory as something insular and impalpable and instead see it as something excitingly complex—a challenge like "swimming in waters that are way, way over your head"—that has, in place of a singular and specialized meaning, a whole spectrum of possible meanings, understandings, applications, and ways of responding?

In an interview with Helen Stuhr-Rommereim, Kraus describes the practice of reading theory as an "exhilarating" experience, one that is "very close to the experience of looking at art ... a great, expansive high."[25] This attention to the visceral effects and affects of reading theory by someone who moves through the world in a body shifts the focus away from mastery and toward other things, such as pleasure, experimentation, play, and different forms of understanding that might evade or even exceed the "mastery of knowledge" that one commonly finds in an academic classroom. The counterargument might be that only those with the "leisure time" for reading—let alone reading theory—are allowed that pleasure, though the tendency to uncritically associate theory and reading with an unreachable pursuit (after all, mass media seem to have no trouble finding leisure time to capitalize) in part perpetuates this politically harmful divide of "the elite who study and read" and the so-called "Every(hu)man" who might pride themselves on being "uneducated," while, say, voting directly against their own best interest as a result of lacking media literacy. The flexibility with which the artists discussed in this chapter engage theory—as form, material, frame, content, name, and object of critique—across a range of backgrounds and life experiences shows the potential of autotheory to resist, bypass, and refashion the durable structures that have historically dictated who has access to discourse and knowledge—and to shed light on the variable forms of power and agency made possible through such knowledge.

3

CITATION AS RELATION

Intertextual Intimacies and Identifications

Reading allowed me to inhabit my life more completely.
—Genevieve Hudson, *A Little in Love with Everyone*

Not everything inside of you is yours.
—Anne Boyer, keynote address at *AUTO-* (2019)

POSTMEMOIR, MARGINALIA, AND THE MISE-EN-PAGE

"Everyone, it seems, has a memoir to write," critic Jessica Weisberg observes in the *New Yorker*, and "one wonders if there are any readers left or if they're all too busy blogging." Her May 2012 article, "Can Self-Exposure Be Private?," was prepared in response to Canadian American artist Moyra Davey's *Les Goddesses* (2011), a film featured in the 2012 Whitney Biennial. Weisberg focuses on Davey's alternating between references to philosophy and literature and the poetic representations of herself and her life in the space of her Manhattan apartment: "It always comes back to her." In one of the most memorable scenes from *Les Goddesses*, Moyra takes a book off her bookshelf and, cracking open a window of her apartment, leans over the edge to blow dust off the book's spine. Weisberg points out Davey's noncontemporary yet "remarkably current" references to the history of philosophy, constituted in a form that falls "somewhere between a critical study and a personal essay."[1] While not offering a term to describe this

Moyra Davey, *Les Goddesses*, 2011,
film (stills). Courtesy of the artist.

reflective and readerly way that Davey works, writing books and making films, Weisberg seems to be dancing around using the term "autotheory."

As autotheory takes shape in different ways across different media and practices, including the essayistic films of artists like Davey, one of its most obvious manifestations in the contemporary is the visible integration of references to theory and philosophy in the context of a written autobiography or memoir. Here, conventionally "academic" practices such as footnoting and margin-marking are incorporated into works that, on first glance, might seem to ally with genres of autobiography and memoir. What prompts artists and writers to make these references visible as a key part of their production, working with citations as artist's material? How are readers and audiences to understand the often performative integration of such scholarly modes in creative work? And what is to be made of the emergent form of the postmemoir—which seems to be growing at a similar pace as the larger autotheoretical turn—wherein memoiristic practice and criticism or other critical practice are brought together as part of a single, often generically nebulous, text?

Questions of citation are the focus of this chapter and the next. I consider citation—the referencing of other people and texts as sources of influence and information—as a mode of intertextual intimacy and identification. With that in mind, I reflect on the possibilities and problematics of citation as a practice of community formation and communion in feminist contexts. In this chapter I focus mainly on literary works, with Maggie Nelson's *The Argonauts* (2015) as my main case study, while in the following chapter I turn to the visual arts.[2] But there is much crossover in both cases; as I've emphasized, the autotheoretical impulse manifests most clearly in those expanded contemporary practices where the arts, literature, and criticism meet. I open with a reading of *The Argonauts*, among the earliest texts to be described as autotheory in contemporary literary circles, along with Roland Barthes's *A Lover's Discourse* and Eve Kosofsky Sedgwick's affect theory. In doing so, I introduce a queer literary history of performative citation practices, revealing the ways that citation in these autotheoretical works brings together different modes of critical practice to commingle and transform. This establishes a context for reading the performative, even theatrical, use of citation in postmemoir and autobiography as a strategy in feminist and queer work. I ground my reading

Moyra Davey, *Les Goddesses*, 2011,
film (stills). Courtesy of the artist.

of *The Argonauts* in notions of citation, broadly understood, to consider questions related to reading and textual pleasure from an intersectional feminist perspective.

I consider the use of citation in *The Argonauts* in relation to significant precursors, such as Gloria E. Anzaldúa's *Borderlands/La Frontera: The New Mestiza* (1987) and Nicole Brossard's *fiction théorique* in books such *Picture Theory* (1982), whose writers engage citation as part of a larger critical, autobiographically driven, and collectively motivated (for the "collective" of lesbian Mestiza/Chicana/Chicanx communities and lesbian Francophone/ Québécois communities, in these respective examples) project of theorization and articulation.[3] Contextualizing Nelson's formal innovation in relation to Barthes, I also look to succeeding iterations of this mode, as found in such works as Joanna Walsh's *Break.up* (2018), to consider the future of these ways of citing theory in the margins of life-writing.[4] This leads to a reflection on the possibility (or impossibility) of queer feminist communities in *theory*, and what a reference to theory actuates when incorporated into an otherwise personal or memoiristic work. Nelson's incorporation of her lover and life partner, the American transgender visual artist Harry Dodge, into the citational structure of her text provides an opportunity to reflect on intersubjectivity, authorship, and the ethical relationships between the writing "self" and an "other."

MARGINAL CONCERNS: MARKING THE MARGINS, QUEERLY

Maggie Nelson's *The Argonauts* is a work of autotheory that brings feminism into conversation with queer theory, generating a text that is responsive to philosophical and theoretical questions relating to queerness and normativity, relationships and family structures, feminism and motherhood, and the philosophical and material capacities of language. Like other works of autotheory, *The Argonauts* exceeds given categories of genre and form. As someone whose work has largely shaped the trend called "autotheory" in literary circles, it is no coincidence that Nelson writes adeptly across genres: she has worked as a poet, essayist, biographer, novelist, art critic, and art historian, and much of her work reveals alliances between poetry and visual art. Nelson was previously the chair of creative writing

at the studio-based CalArts, and recently moved to USC as a professor of English; she is part of a growing trend for the autotheoretically oriented to thrive in both art and literary worlds, a trend also exemplified by Claudia Rankine, Chris Kraus, Hilton Als, and Jennifer Doyle.

The practice of marking up the margins of a book while reading often shows a deeper level of engagement with a text, as we saw in chapter 1 with Piper's markings on her copy of *Critique of Pure Reason,* the spine of the book' broken and the pages splayed open for ease of use. The marked-up-margins show an artist's or writer's physical engagement with the book: maybe there's a passage that rings particularly significant to ideas they are working through, so they draw an arrow next to it, or they add a note. Adding marginalia becomes a means for writers to elaborate their responses to reading or a way to identify notable passages they'd like to return to in the future.

Autotheory has an interesting relationship with margins, and writers and artists who work autotheoretically often extend the conceit of writing, annotating, and scribbling in the margins in conceptual ways. We see this reproduced in published literary work, for instance in the mise-en-page of *The Argonauts,* where Nelson places the name of the theorist, writer, or artist cited in the margin of the page directly beside where she quotes or summarizes their ideas. While a formally innovative practice, this beside-the-text and in-the-margins use of citation is not Nelson's invention: she is, in fact, reiterating the form that Barthes innovated in his *A Lover's Discourse.*

In his book, Barthes places the surnames of different philosophers—from Goethe, Nietzsche, and Sartre to the Flemish mystic Ruysbroeck and the psychoanalyst Donald Winnicott—in the margins of a loosely autobiographical book that is constituted as different "fragments" or poetic vignettes of lovers interpellated by the discourse of love. Nelson uses this structure as a container of sorts, within which she seeks to unpack and understand experiences as a queer-identified woman interpellated by discourses of love in her relationship with Harry Dodge. Nelson shares Barthes's desire to philosophize questions related to language and love, and she extends the critical-personal curiosities that drive Barthes's text to questions of particular relevance to her life, from whether a cisgender woman can be queerly pregnant to what queer family-making and feminist stepparenting might look like today.

At first glance, *The Argonauts* comes across as a memoir populated by references in the margins of the page to named philosophers, theorists, and writers, from Luce Irigaray and Ralph Waldo Emerson to Paul B. Preciado and Anne Carson. Nelson contextualizes the autobiographical narrative of her relationship with Dodge within an intertextual terrain of citations sourced from literature, theory, philosophy, and art. The choice of citations comes out of Nelson's practice of theorizing her lived material through these different referential texts and, in doing so, reveals the personal to be theoretical—and also ethical, aesthetic, and political. By placing names in the margins, Nelson draws attention to the citations as one reads: in English, and in Euro-American publications generally, one reads from left to right, top to bottom, and so the eye is drawn to the citation in the margin as part of the experience of reading. This is in contrast to endnotes and even footnotes, which a reader may choose whether or not to read—something that only the most attentive and studious readers might do.[5]

In *Break.up* (2018), British novelist Joanna Walsh sets single-sentence quotations in the margins, citing author and text, as might be found in an epigraph, physically beside the anchoring narrative of the narrator's (ostensibly Walsh's) transnational travels following a break-up. So many words become integrated into the margins that the quotations push into the body of the text, changing the shape of the text on the mise-en-page to become almost serpentine. This intervenes in the reader's experience of reading Walsh's "personal" narrative—a postmemoir memoir of sorts that follows the protagonist's experience traveling and writing emails in the wake of a terminated romantic affair. In many ways, Walsh's *Break.up* brings full circle the ouroboric orientations of autotheory—reflexive and reflective, citing others as part of an autotheoretical community. It is probably no coincidence that most of the writers she cites are themselves ones who have worked autotheoretically, from Barthes to Kraus.

To be sure, the theme of writing-in-the-margins even crops up on an intranarrative, thematic level in Kraus's *I Love Dick,* when Kraus playfully collides the conceit of female-coded practices of diary writing with German high theory in her metafictional references to the character Chris Kraus writing marginalia. Describing Chris Kraus's process, Kraus explains:

She read Harlequin Romances, wrote her diary and scribbled margin notes about her love for Dick in Sylvère's treasured copy of Heidegger's *La question de la technique*. The book was evidence of the intellectual roots of German fascism. She called it *La technique de Dick*.[6]

For the metacharacter "Chris Kraus," marking the margins as a reader becomes the female character's way of instantiating a critical-creative intervention into a male-authored text and finding voice as a writer through doing so. In contrast to overwriting or disregarding a text, the woman's act of marking in the margins becomes a way of writing with it and beside it, possibly subverting it along the way. While Kraus incorporates her dense array of references into the body of the text—leaving the margins of the page "clear," as it were—there is a nod to the importance of marginalia in an attentive and rigorous reading practice. The physical act of scribbling in the margins comes to stand for the simultaneity of rigor and reflection.

AUTOTHEORY AS A LOVER'S DISCOURSE

As revealed in both the margins and the body of the page, Maggie Nelson's *The Argonauts* is a meeting space for different lineages and practices of what has come to be called "queer theory"—lineages that Nelson positions beside her own decidedly queer life. The first is represented by Barthes, a gay male French theorist who serves as a hinge between structuralist semiotics and poststructuralism and whose queerness, while significant to his role in contemporary theory, remains latent in his texts. The second, interrelated lineage comes from Sedgwick, a queer feminist affect theorist who identifies as a fat woman and a gay man.[7] Nelson performatively weaves these lineages together within the traditions of the New York School poets and Wittgensteinian language games to write a work of autotheory, using citations to build a feminist canon that spans the literary and the philosophical.

By bringing these lineages together and processing them through the context of her life, Nelson opens up space for larger theoretical transformations in queer theory. She revisits Barthes and Sedgwick through the perspective of her autobiographical experiences and theoretical investigations as a writer, lover, and scholar, approaching their works as an

intertextual ally. One of the questions she is most consumed by in the book is the status of the normative/transgressive binary in queer theory and queer life, and she comes to form related questions, such as what a maternal erotics that evades Freud might mean. Barthes's and Sedgwick's frameworks serve as textual conditions of possibility and as catalysts for Nelson's inquiry into these questions, with Nelson's life experience factoring in as anecdotal evidence.

The Argonauts opens with an intimate scene of sharing theory: Nelson and Dodge debate Wittgenstein's idea that language can contain the inexpressible. While Nelson the writer begins by seeing language as sufficient, Dodge the visual artist believes "that words are *not* good enough," and with this a conflict is established that will continue to the end of the text.[8] Through intimate contact, Nelson's theoretical stance shifts, and *The Argonauts* becomes a site for her to work through her now troubled understanding of language and the inexpressible. On the most obvious level, language is limited in its use of gender pronouns: "Dodge is neither male nor female,"[9] and is therefore always already limited in/by language. Embodying the practice of autotheory, fragments or pieces of text become the means by which Nelson expresses (and, by the logic of performativity, constitutes) her love for Dodge, as well as the means by which she generates new theory in her work.

The second passage that Nelson shares with Dodge is from *Roland Barthes by Roland Barthes*. Barthes's oeuvre is a key point of reference for Nelson. The book's title draws from his story of the mythical vessel *The Argo,* a "fabled craft whose repeated rebuildings result in a ship that shares no scrap of timber with its prior iteration, yet somehow remains itself,"[10] framing Nelson's text in relation to themes of transformation and becoming. The book's opening pages connect the symbol of the *Argo* to motifs of love, repetition, language, and time: "The subject who utters the phrase 'I love you' is like 'the Argonaut renewing his ship during its voyage without changing its name.'"[11] In this same mode, Nelson appropriates the structure and form of Barthes's *A Lover's Discourse*, iterating it to new feminist effect. By placing text in the margins of the page, she experiments with the limits of the mise-en-page in what might seem, at first, to be a more conventional memoir or life-writing text. Through her own autobiographical discourse and choice of citations, she enacts a Barthesian "rebuilding."

In the opening to *A Lover's Discourse,* Barthes includes a section titled "How This Book Is Constructed";[12] in this way, it resembles a work of conceptual art, which is often presented with an artist's statement to provide the reader or viewer with a point of entry. *A Lover's Discourse* is structured as a series of what Barthes calls "Figures"—"fragments of discourse," anecdotes from the lover's life framed within small provocations, with the title at the top of the page serving as the "argument" and a dictionary definition of a word (most often a verb, but sometimes a noun) serving as a kind of epigraph. Barthes includes his "References"—names, titles, and initials—in the margins of the page, a practice Nelson repeats in *The Argonauts.* Part of the legacy of poststructuralism, to which Barthes's writings were formative, is the understanding of any literary or cultural text as a "tissue of citations, resulting from the thousand sources of culture."[13] Barthes's argument in "The Death of the Author" challenges the long-held view that the literary text originates with the author alone as the singular source of its meaning—a holdover from the Romantic era, with its view of authorial genius and genesis in the (most often male) scribe. As a text, *The Argonauts* is reflexive about its constitution as a "multi-dimensional space in which a variety of writings, none of them original, blend and clash,"[14] and in this way extends the poststructuralist play Barthes described as characterizing literature of the future.

Barthes explains that *A Lover's Discourse* is a "simulation" of a lover's discourse rather than something recorded from life, positioning his practice as a movement away from the psychoanalytic and toward the performative by using theoretical and performance metaphors, and approaching the fragments of discourse as akin to physical, embodied "figures." "The word," Barthes writes, "is to be understood, not in its rhetorical sense, but rather in its gymnastic or choreographic acceptation."[15] Barthes frames the work as performative, making clear how he "stage[s] an utterance, not an analysis," and composes a "structural" portrait rather than a psychological one through the text. As a "simulation" of discourse written by the theorist who proclaimed that "a text is made of multiple writings, drawn from many cultures and entering into mutual relations of dialogue, parody, contestation,"[16] *A Lover's Discourse* puts Barthes's theory into practice, bringing together a range of voices and texts to create a paradoxically monologic "dialogue" on the language of love—its linguistic structures, its strange logic.

With the form and structure of *A Lover's Discourse,* Barthes demonstrates a palpable move toward the autotheoretical. He brings together the names and titles of different authors and texts—many of them philosophical and theoretical—with interlocutors from his own life to reflect on philosophical and discursive questions relating to the nature of romantic love; he refers to the different reading practices that give rise to these different types of citations as "ordinary reading ... insistent reading ... occasional reading ... conversations with friends."[17] This concern with reading practices (and the different discursive and epistemological modes they engender) is shared by both Sedgwick and Nelson.

Even as he seeks to shift the emphasis away from the author as the single origin of a text's meaning and toward the reader as the new "destination" for a multiplicity of meanings,[18] Barthes remains the one who assembles the different texts and, like a documentarian, retains a large amount of control in constructing the narrative (open-ended as it may be) that the reader encounters. Though he places the words "put together" in quotes that rhetorically mimic air quotes, Barthes nevertheless does put together different references next to his own words and reflections, drawing from diverse literary and theoretical sources in a classically postmodern way. Instead of two lovers speaking to or with each other, in Barthes's *A Lover's Discourse* one man "speak[s] within himself, amorously, confronting the other (the loved object), who does not speak."[19] The "other" here is objectified ("the loved object") and silent ("does not speak"), while the lover-speaker—a vaguely autobiographical Barthes—speaks "within himself" about the passion and pains of being in love, based on his own experience of that physiological and affective state. The speaker positions himself as a madman for love: by including fragments such as "I am crazy," the conceit of the speaker as a split self "speaking within himself" is at home with contemporaneous French theoretical writings of the 1970s, including Deleuze and Guattari's work on the "schizoid," and other experimental approaches to poststructuralism and schizophrenia (many of them published in translation for an English-speaking American readership in Semiotext(e)'s "Schizo/Culture").

One of Barthes's aims in writing *A Lover's Discourse* was to elevate the discourse of lovers—an everyday discourse, as well as a private one—to the realm of critical theory. At the time of his writing, this discourse was,

he wrote, "completely forsaken by the surrounding language: ignored, disparaged, or derided by them, severed not only from authority but also from the mechanisms of authority (sciences, techniques, arts)."[20] Barthes brings together the "low" of lovers' speech with the "high" of philosophy. Composing the text with a view to a mass public, he hoped these "figures"— anecdote-like fragments of phenomenological states of being in love— would be recognizable to readers from their own lives; he emphasized that the work's success would lie in this kind of reception: "A figure is established if at least someone can say: 'That's so true! I recognize that scene of language.'"[21] The meanings of this cross-genre work are grounded in lived experience—both from the perspective of the author and from that of the reader. Of course, the "author" here is at once Barthes and the writers whose words make up the "tissue of citations" he points to in the margins. Furthermore, the reader, according to Barthes's logic, is also part author in being a coproducer of the text's meaning, recognizing themself in the work and contributing to its meaning through the active process of readerly digestion.

The citations in the margins are Barthes's gesture at acknowledging the source of an idea, and in this way he maintains, however ambivalently, the status of an author (or of a text, as when he references the *Symposium* instead of Plato or *Werther* instead of Goethe) as originary. His references are intended less as "authoritative" and academic than as "amical" and friendly. His approach to referencing is more playful than scholarly references typically are, affectively charged and formally experimental. Barthes writes that the names and titles he cites in the margins mark, for him, his recollection of an idea that "has seduced, convinced, or ... momentarily given the delight of understanding (of being understood?)."[22] The moment that a text resonates with the understanding—that faculty of reason we saw Kant (and Piper) seeking to conceptualize through performance in chapter 1—is also a moment of "being understood." Citation, placed next to memory, becomes a way of making one's life intelligible.

A Lover's Discourse maintains that one becomes interpellated by the discourse of love when one is in love or loved by someone who is in love. Through autotheoretical vignettes organized by a given word ("image/ image," or "magie/magic") and a phrase ("'I am crazy'" for "fou/mad," or "'I am odious'" for "monstreux/monstrous"), Barthes reflects on the

discourse of love as someone who is performatively interpellated by this discourse and, accordingly, is vulnerable and emotional. Ultimately, Barthes presents the lover's discourse as a paradox: on the one hand, the language of lovers can be rendered theoretically; on the other hand, this language is an extradiscursive affective experience that exceeds the terms and parameters of discourse as linguistic and semiotic.

By framing the language of love as a practice of theory, on par with other discourses investigated by theoretical heavyweights, Barthes lends the language of love and affection the weight of the academy. His references include names of philosophers and writers (or others with active writing practices). Most of the names Barthes cites are of European men, many of them French or German, including Nietzsche, Freud, Goethe, Proust, Winnicott, Lacan, Rousseau, Balzac, and de Sade. With Freud and Nietzsche present, Barthes's citations gather the progenitors of what is called contemporary "theory," or the critical tradition that Paul Ricoeur calls "the hermeneutics of suspicion."[23] In so doing, Barthes positions this discourse of love within a certain intellectual lineage or canon of theory as upheld in the West, writing as a structuralist-turned-poststructuralist who flirts with the autotheoretical, in different ways, throughout his life.

Nelson extends the Barthesian paradox of a lover's discourse in *The Argonauts,* where she attempts to inscribe the affects and philosophical problems of her own experience of being in love with a trans man in Proposition 8–era California. Within the citational and poetic field of *The Argonauts*, Nelson renders her love interest, Harry Dodge, as both the subject and object of her (lover's) discourse. Extending the form and themes that Barthes introduced in *A Lover's Discourse* in 1977, Nelson interpellates Dodge in the early twenty-first century within her text; she also includes Dodge as a citation among other citations (names of theorists, writers) in the discursive framework that undergirds *The Argonauts* as autotheoretical. Nelson borrows from Barthes's text both in form and content, citing some of the same names that he does—Lacan makes an appearance, as does Winnicott. But just as Barthes draws references from the context he is writing in (the 1970s literary theory scene in France, during the shift from structuralism to poststructuralism), Nelson draws references from her context of writing—poetry and literature, as well as post-third-wave feminist and queer theory in California.

As Nelson's citational practice moves along through the text of *The Argonauts*, we can see how contemporary theory has diversified and taken shape in different subsets of theoretical practices over the past few decades. There is representation from some key poststructuralisttheorists (Deleuze, Foucault, Butler), psychoanalysts and psychologists (Donald Winnicott, William James), French feminists (Luce Irigaray, Julia Kristeva, Monique Wittig), and other feminist theorists, many who write on art, photography, and film (Susan Fraiman, Susan Sontag). Barthes references the Tao and other Eastern practices and traditions, such as haiku; Nelson references American Tibetan Buddhist Pema Chödrön, as well as other American figures who have written on Buddhism in a Western context, including Allen Ginsberg and Dodie Bellamy. Nelson cites the names of canonical queer theorists both past and present—Foucault, Butler, Bersani, Preciado—along with queer affect theorists and phenomenologists Sedgwick, Sara Ahmed, and Eula Biss. She cites poets such as Eileen Myles, Denise Riley, Lucille Clifton, and Anne Carson, and the dance artist Deborah Hay. Ginsberg and Deleuze haunt the text, coming to the fore in relation to the women with whom they were in writerly relationships. In the case of Ginsberg, Nelson shifts attention to the poet's mother, with the citation "Naomi Ginsberg, to Allen" giving a gestural voice to Naomi (for whom Ginsberg wrote his famous poem "*Kaddish*" as part of his mourning process).[24] For Deleuze, it is Claire Parnet, with whom he cowrote *Dialogues* in 1977: they return as a coupled citation throughout *The Argonauts* as Nelson explicates her anxieties around collaboration and authorial merging in the context of her writing practice.

Even as she writes from her own "I," Nelson positions her book as existing fundamentally *for* Dodge. Paul B. Preciado makes a similar move in *Testo Yonqui (Testo Junkie)* (2008)—the book from which Nelson takes the term "autotheory"—positioning their book as existing for one specific, and absent, reader. "You're the only one who could read this book," Preciado writes in an apostrophe to Guillaume Dustan, a gay French writer who died of an unintentional drug overdose in 2005.[25] Nelson's performative use of citations in *The Argonauts* fosters intimacy at the level of form; extending this to the themes of her text, Nelson frames the practice of sharing theory (as well as other texts, such as literature and poems) as an intimate, meaningful act between two queer lovers. On both levels,

queer intertextuality engenders space for intersubjective and reparative relations between people.

Yet the loved or beloved other occupies an ambivalent space in *The Argonauts*, just as in *A Lover's Discourse.* In both texts, the dialogic is invoked: as writers and theorists, both Barthes and Nelson are concerned with issues pertaining to relationships; both approach these issues autotheoretically, through topics of language, philosophy, and (to different extents and effects) queerness; both invoke a space of polyvocality through citation. And yet both take on the position of singular author rather than, say, writing the text as a collaboration (as in the case of Allyson Mitchell and Deirdre Logue, discussed in the next chapter) or as a sustained conversation between two "equals" (as in Kathy Acker's and McKenzie Wark's transcribed email exchanges in *I'm Very into You: Correspondences 1995–1996*[26]). Nelson is self-aware about her anxieties around sharing authorship; the situation is especially charged when it comes to her writing about her lover as a trans person—since, at least until quite recently, with the increased visibility and public support of trans writers, trans subjectivities were often precluded from writing themselves in philosophy. Dodge will later write his own autotheoretical book, *My Meteorite*, published in 2020, that is a similarly genre-defying, postmemoir work in which Dodge writes through the death of his father, the multiplicity of kinds of love (riffing, as Nelson does, on Barthes), and finding meaning amidst randomness in a world of entropic chaos.[27]

COMPARATIVE LIFE-READING: INTERTEXTUAL INTIMACY AND IDENTIFICATION

While the term "autotheory" foregrounds the "auto" (or *autos*, self), many works approach this self in relationship to others, theorizing relationships through autotheoretical modes. In 2018, during a three-part panel titled "The Rise of Autotheory Inside and Outside the Academy" on which I participated at the ACLA convention in Los Angeles, my colleague and friend Alex Brostoff thoughtfully described the sociality of autotheory in her paper "Toward an Autotheory of Intertextual Kinship." In this paper, which focuses on *The Argonauts* and *Testo Junkie*, Brostoff makes the apt point that "autotheory" is, in fact, "a misnomer."[28] The autobiographical relation to

theory that Nelson develops in *The Argonauts* is highly mediated through and dependent on the intersubjective, marked by the insistence of communication and intimacy, both with the figures in her life and with her theoretical forebears. The act of citing theory becomes a way to better understand one's experience in the world and, at the same time, to provide insights gained from that experience into sexuality, politics, art, family, community, and other topics.

Through formal play, Nelson underscores the ways that her writing self—the narrator and the character "Maggie Nelson"—operates and writes in undeniable proximity to others. It doesn't matter whether these are others with whom she is intimately involved as a lover or whom she "knows" through texts as a reader. Such transtextual relationships take place within, across, and beside other human beings, stories, and texts, and the writer cites each in turn.

We find this approach in earlier autotheoretical writings, such as Anzaldúa's *Borderlands/La Frontera: The New Mestiza.* In it, Anzaldúa writes "towards a new consciousness"—*"la conciencia de la mestiza"*—and cites Mexican philosopher José Vasconcelos Calderón's theory of *"la raza cosmica"* alongside her experience as a self-identified "mestiza" to elucidate this consciousness.[29] Anzaldúa incorporates endnotes—typically used in academic work—into her creative-critical work to engender a space for queer, feminist, mestiza-becoming that engages citations as a reading list and a diverse intertextual undergirding for her personal-poetic-theoretical narrations. She finds philosophical and political allies in Calderón and others, such as Irena Klepfisz and Isabel Parra, next to whom she can write her autotheoretical invocation of "the Borderlands"—as land, as ontology, as consciousness, as epistemology, as relationship with an other, as multilingual translation and communication, as Indigenous becoming. While Nelson cites her lover, Dodge, in the margins of *The Argonauts*, Anzaldúa cites herself, framing chapter 4 of *Borderlands*, *"Cihuatlyotl,* Woman Alone," with one of her short poems as an epigraph; the name "Gloria Anzaldúa" is credited as the speaker, in an act of self-citation that becomes, effectively, an act of self-determination and self-respect. Anzaldúa takes space in her book to recognize her work as work and her poetry as poetry—a move that brings to mind "self-care," in Lorde's sense, according to which it is "an act of political warfare" for the marginalized—willful survival and

self-assertion in spaces that have been hostile to them.[30] In conceptualizing self-care, which might easily be co-opted by neoliberalism and capitalism, as a collective and liberatory form of care for the self, Lorde provides intersectional feminists with a framework for self-care that is truly empowering.

Much of the power *The Argonauts* lies in Nelson's processing theoretical ideas and modes of thinking and writing through her own particular experience in the world as queer, as a stepmother and a biological mother, as a lover of Dodge, and as a now-sober woman in recovery from alcoholism. Nelson's choice of citations is specific to her life circumstances and the questions she takes up. In autotheory, writers and artists join lived experiences to intertextual references—to the history of art, literature, philosophy, film, and pop culture—as part of the development of a theory. I term this epistemological shuttling "intertextual identification" and "intertextual intimacy." It denotes a tendency for those working autotheoretically to draw parallels between their own experiences and the experiences of others, using the similarity between their lives and others' lives as the basis for choosing the examples they cite. Often, though not always, this intertextual identification—that moment of seeing oneself in an other, or recognizing one's experiences in a new way—coexists with the para-academic uses of citations and references as a way of acknowledging the source of knowledge or influence in one's work.

Intertextual intimacy and intertextual identification describe a way of reading, a way of writing and making work, and a way of referencing or placing *alongside.* The autotheorist reads and chooses citations they identify with, or that resonate with their experience; they then propose a hypothesis or *theory* based on the evidence provided by their life—the "auto"—and others'. Both the "auto" and the "theoretical" allow them to process particular questions and ideas, whether personal or philosophical—or, most often, *both at once.* The artist's life becomes a kind of "life-text" to be cited alongside other citations as a way of developing and advancing a theory; self and life become material through which to explore questions, form theories, and "test" them against different forms of evidencing, whether anecdotal, political, social, art historical, literary, pop cultural, or some other form. In autotheoretical works by writers like Kraus, Rankine, Als, and Masha Tupitsyn and artists and filmmakers such as Moyra Davey and Cauleen Smith, intertextual identification names less

a specific practice than a general tendency to read texts—and the lives and mythologies associated with them—as a way to better understand their own lives. In Davey's *Les Goddesses*, the artist places an autofictionalized story about herself and her siblings next to the story of Mary Wollstone-craft and Percy Bysshe Shelley, citing around them a cross-historical cote-rie of other thinkers, such as Goethe and Susan Sontag (in reference to Marguerite Duras, Davey utters aloud: "She had stamina, as Sontag would say, and she was not afraid of the wet"[31]).

Nelson theorizes jealousy through the perspective of her own lived ex-periences of feeling jealous in her relationship with Dodge. She lends her-self gravity by positioning her own anecdotes beside ones from queer and feminist literary figureheads she respects, such as Gertrude Stein and Alice B. Toklas. Committed to the project of releasing herself from jealousy's grip, Nelson processes a problem that is both philosophical (what is the nature of jealousy?) and personal (Nelson is troubled by her experiences of jealousy in her relationship with Dodge) while turning to texts (lives and works) from history to gain perspective on and insight into the topic. Insofar as *The Argonauts* is focused on couples, it is not surprising that Nelson looks to literary and artistic couples and duos from history: Stein and Toklas, George and Mary Oppen, Deleuze and Parnet. Nelson finds strange solace in stories of jealousy existing between Toklas and Stein; with the comfort of body-minds she respects, Nelson can rest assured that she is not alone in feeling queer jealousy. In this way, intertextual intimacy and identification is as much a gut-propelled, self-protective drive as it is a drive to critically process and reflect. Citation becomes an evidencing of the philosophical movement from the individual to something closer to the universal—other people whose work I respect have gone through this or have felt what I have felt. This might be jealousy in a queer romantic relationship (Nelson) or self-starvation as a mode of rejecting patriarchy's cynicism (Kraus, seeing herself in Simone Weil).[32]

AUTOTHEORIZING TRANS-FORMATION

One of the most memorable and frequently quoted lines from *The Argonauts* is Nelson's description of the "many-gendered mothers of my heart," in

reference to theorists like Sedgwick and Barthes and the others whom she cites.[33] Nelson borrows this line from American poet Dana Ward to describe the people who influence her writing and her life—practices that are, for the autotheorist, inextricably interwoven. The description of "mothers"— maternal figures with offspring—as "many-gendered" continues Nelson's queering of motherhood, decoupling the mother as a parental figure from its etymological/ontological associations with cis women. By foregrounding these figures as being "of my heart," Nelson makes affective the citational practice that structures her reading and writing.

Other arguments that Nelson advances around philosophy and motherhood, such as the incisive statement that "in its rage at maternal finitude, the child turns to an all-powerful patriarch—God—who, by definition, cannot let anyone down,"[34] are not so much her own invention as her rearticulation of arguments previously made by others. (In this instance, the argument is one Kaja Silverman makes in *Flesh of My Flesh*, and Nelson references accordingly). A decentered and multiply citational mode of writing supplants the singular (male) author as genius or inventor, in which patriarchy has historically been so invested. This decentered view of the writer or artist is by no means a solely feminist one—it was Barthes who popularized this view with "The Death of the Author," one of the theoretical-essay-cum-manifestos recognized as inaugurating the shift from structuralism to poststructuralism in twentieth-century theory scenes. And yet works like *The Argonauts* are conflicted when it comes to decentering the "self," and ideas of solo authorship and ownership over a narrative or a text.

In some ways, *The Argonauts* is a trans narrative written from the perspective of someone who loves a trans person (instead of someone who *is* a trans person)—a cisgender woman in a partnered relationship with a trans man. Nelson positions the book as a devotional testament of love for Dodge. Through her choice of citations, the book becomes a space where queer feminist voices convene around questions related to sexuality, family-making, and relationships. And yet, as critics have noted, for all of *The Argonauts*' attention on Dodge, Dodge himself remains strangely silent in the text—arguably, in ways, even exploited. Nelson takes her writerly approach from Barthes, who describes his method in the *A Lover's Discourse* as creating a space where the narrator is "speaking within himself, *amorously,*

confronting the other (the loved object), who does not speak."[35] Writing in a late postmodern literary context, Nelson is self-aware of the problems that come with writing about another known and named person; her decision to choose Barthesian solipsism to write about her queer love is curious, and underlines the pull of "autotheory" as an orientation that allows the writer a degree of comfort and agency in the respective freedom of their own *self*-knowledge (in the sense of "this was my experience, and all I can do is write from the relative confines of my experience").

But Nelson also finds herself within the trans narrative. Much of the focus of *The Argonauts* is a philosophical project of queering the pregnant body. Nelson does this by placing her narrative of pregnancy alongside the narrative of Dodge's female-to-male gender transformation, using citation to engender similarities. Nelson presents a queer narrative of two bodies transforming in close proximity to each other: turning to autotheoretical strategies of intertextual intimacy and identification, the quintessentially "queer" narrative of Harry's transformation on testosterone is juxtaposed with the supposedly "normative" narrative of Maggie's pregnant body: as Nelson writes, "Our bodies grew stranger, to ourselves, to each other."[36] Theorizing the ontology of pregnancy in a postphenomenological mode, Nelson asks: "How can an experience so profoundly strange and wild and transformative also symbolize or enact the ultimate conformity? Or is this just another disqualification of anything tied too closely to the female animal from the privileged term (in this case, nonconformity, or radicality)?"[37] By placing her own experience of being pregnant beside her partner Dodge's experience of gender transitioning, Nelson attempts to queer the boundary between the normative and the radical, the so-called homonormative and the more transgressively "queer." She takes assumptions within twenty-first-century queer discourse and deconstructs them through her autotheoretical reasoning—for example, the assumption that the transgender body represents a "queerer" ontological state while the cisgender pregnant female body represents "normativity" (extending Butler's notion of compulsory heterosexuality to heteronormative reproductive futurity in the Edelmanian sense).

Along with this queering of the pregnant body comes a queering of the antisocial turn as it exists in queer theory via Leo Bersani and Lee Edelman. Nelson's writing brings a feminist approach to the language

and frameworks of a gay-male-authored canon of queer theory and its politics of refusal that emerges from both the new precarity politics of the left (*The Argonauts*) and masculine avant-garde traditions of extremism and violence in performance (*The Art of Cruelty*). We can read Nelson's writings as deconstructing dominant discourses in purportedly experimental and progressive spaces through a queer feminist perspective. Yet the view that there is something quintessentially more queer haunts the text, even as Nelson, following Sedgwick's lead, seeks to get beyond binary thinking. Indeed, on some level this text reads as a defense of Nelson's own queerness, first in spite of and later—through an autotheoretical reasoning that draws on feminist theorist Jane Gallop's anecdotal theory and gender studies scholar Fraiman's notion of "sodomitical maternity"[38]—because of her status as a cisgender queer pregnant woman who rejects both homophobic heteronormativity and antisocial calls for queer negativity.

One of the most complicated, unresolved passages in *The Argonauts* is when Nelson relates her and Dodge's exchange after she shares a draft of the book with him to read. Nelson acknowledges the issue of consent, but then quickly dismisses it in favor of a philosophy of writing practice that emphasizes the "free expression" of the speaking "I" above the feelings of the other.[39] Following Sedgwick, Nelson places honesty (whatever honesty may mean in a philosophical sense, rooted as it is in the speaking self who believes herself to be honest) above other drives, advocating acknowledging the complications of discomfort and other difficult feelings while nevertheless proceeding with one's project as planned. In this passage Nelson alternates between an acknowledgment of the "politically on point," or perhaps "best feminist practices," way of going about things in the twenty-first-century context of feminism—whose framework of intersectionality can at its most cynical become a kind of hierarchy that gives voice only to those who can present themselves as most oppressed—and a concession to her own desires.

When Harry tells Maggie that "he feels unbeheld—unheld even," Nelson does not change her course; instead, she is honest about how she bristles against Dodge's words, and how she realizes that she *should* be receptive, even if she isn't going to be. "I try to listen, try to focus on his generosity in letting me write about him at all," Nelson writes, yet she concedes that this "generosity" is not generous enough for her: "How can

a book be both a free expression and a negotiation?" She recalls when they used to speak about writing a book together: "It was to be titled *Proximity*. Its ethos would derive from *Dialogues II,* co-authored by Gilles Deleuze and Claire Parnet."[40] For Nelson, these social and ethical issues are inextricable from philosophical issues related to writing. She admits that as a writer, she has not figured out what it would look like to write in a way that adequately holds both the self and the other; the self-consciously citational structure of the text, which formalizes the autotheoretical move quite literally and visually on the mise-en-page, might be her attempt to do so.

Like many others involved in the autotheoretical turn, Nelson employs lateral citation. To cite laterally means to cite one's peers, friends, cohort, or colleagues instead of citing only upward—established philosophers, scholars with tenure, and so on. In the denouement of *The Argonauts*, Nelson cites the name "Harry" three times in the margins;[41] here, the name of Nelson's partner takes up textual space as a "legitimate" citation alongside the names of heavy-hitter theorists. At the same time, there is a rhetorical difference between when Nelson cites Harry and when Nelson cites someone else. She refers to Harry by first name only, distinguishing Harry, the beloved, from theorists like "Beatriz Preciado" or "Michel Foucault," who are referred to by first name and surname.

Part of a feminist and queer feminist citation practice involves destabilizing hierarchies of influence as a movement toward a relational politics. By concluding her practice of citing texts with citations of "Harry," Nelson brings the text, as an homage to Harry (or to her feelings of love for Harry, two different but related matters), to a kind of closure. In an interview after the book's publication, Nelson pointed to writers she respects who engage in a similar practice of citation; she noted that Eula Biss, for example, "quotes her sister with as much gravity as she quotes a philosopher."[42] The lifelong collaboration between Anishinaabe artist Rebecca Belmore and her sister Florene Belmore comes to mind here, too, with Florene writing on her sister's art after years of working in close partnership with Rebecca as friend and family as well as an installation support person who travels with her to international biennales and provides feedback on her work; in terms of intimacy, Florene's art writing and criticism brings to mind the spirit of Randolph's fictocriticism in 1980s Toronto, with Florene's work being tied to an Indigenous kinship

network that challenges Western, colonial conceptions of critical distance and professional boundaries. The two dramatized this through the conceit of staging a private conversation in public, reflecting on their longterm collaboration in relation to ideas of experimenting with criticism from an Anishinaabekwe viewpoint.[43]

But for all the utopic feminist potentiality of collaboration in theory, Nelson admits that the very thought of such authorial "merging" causes her "too much anxiety" to move forward with the idea. And so she continues to write as the singular author, citing others as part of her story. She is honest about the resistance she feels to "los[ing] sight of my own me," and returns instead to autotheory as a practice grounded as much in her own experience as in the experiences of the theorists, poets, and lovers she cites.[44] While not unique in these feelings, Nelson might be in the specificities of her candor. In speaking about a recent project that involves conversations with family members in Jordan, the writer and artist Mira Mattar put it this way: "I wanted inter-subjectivity without enmeshment."[45] In many autotheoretical works there is a desire to theorize one's life, intersubjective as it is, but also a desire to maintain the boundaries of the "self" as separate from others. Not unlike Adrian Piper's ritualistic turn to the mirror when faced with the anxieties of losing oneself brought on by reading Kant in isolation (see chapter 1), Nelson's anxieties stem in part from the gap between good feminist practice and her need for something messier and more honestly intersubjective in its relations and stakes. "I'm not saying this is good pedagogy," Nelson states after joyfully acknowledging that "I can talk as much as I want to" in her role as a professor. "I'm saying that its pleasures are deep."[46] Is feminist autotheory a space where the pleasures of theorizing meet the pleasures of candor? With Nelson's admission, autotheory is that place where the pleasures of practicing theory meet the pleasures of telling one's story, or of relaying—with an attempt at *honesty*—how one really views one's lived actions and behaviors in the world, regardless of what another person thinks. So how does the disclosing of truths, and the pursuit of "truth," relate to the autotheoretical practice of theorizing, especially when it comes to feminist and queer feminist modes of being in relation with others in consensual, ethical, critical, and life-affirming ways?

While *The Argonauts* announces its proximity to the work of Barthes in its title and its form, Nelson's greatest theoretical affinity is with the work of Sedgwick. In its embryonic stage, *The Argonauts* began as three inter-related texts: a talk that Nelson gave on Sedgwick, a review she wrote of Sedgwick's posthumously published *The Weather in Proust* (2011), and an exhibition essay that she wrote on the American trans-medial artist A. L. Steiner's 2012 exhibition, *Puppies and Babies*.[47] Adding another intertextual layer, I first read *The Argonauts* in 2015, the year it was published, which was also the same year that Nelson's partner Harry Dodge had his solo exhibition at Wallspace in New York, an exhibition that took its name, *The Cybernetic Fold,* from Sedgwick's 1995 essay "Shame in the Cybernetic Fold: Reading Silvan Tomkins." With two decades separating the essay and Dodge's art show, it is clear that the ideas Sedgwick was engaging in her mode of practicing theory—a mode often referred to as queer femi-nist affect theory, and that is often autotheoretical in its personal-critical orientation—are still abuzz.

What does theory know? Sedgwick's essay, written with her collabora-tor and former student Adam Frank, opens with "Here are a few things theory knows today":

Or, to phrase it more fairly, here are a few broad assumptions that shape the heu-ristic habits and positing procedures of theory today (theory not in the primary theoretical texts, but in the routinizing critical projects of "applied theory"; theory as a broad project that now spans the humanities and extends into history and anthropology; theory after Foucault and Greenblatt, after Freud and Lacan, after Levi-Strauss, after Derrida, after feminism) when it offers any account of human beings or cultures.[48]

What follows is a coy summation of the characteristics of contempo-rary theory in its manifestation as a form of "applied theory" that has, as Sedgwick and Frank suggest, become quite prescriptive. To practice good theory, for example, one knows that in order to understand represen-tation, language and discourse should be elevated above all else, and that one must be fiercely anti-essentialist by sufficiently distancing oneself from

any recourse to biology. Sedgwick and Frank then describe their theoretical alignments in the article, turning to the 1960s American psychologist and theorist Silvan Tomkins, whose work on affect guides their theorizing of shame. Aware of the taboos of their alignments—a perceived lack of loyalty to the poststructuralist prescriptions aligned above—Sedgwick and Frank position themselves as outsiders or "queer" *theorists*—theorists who are, in fact, actively *queering* theory through their unfashionable critical positionings: "You don't have to be long out of theory kindergarten to make mincemeat of, let's say, a psychology that depends on the separate existence of eight ... distinct affects hardwired into the human biological system."[49] The writers position themselves as outsiders to what is properly "theoretical," even while their article is published in *Critical Inquiry*, a reputable, peer-reviewed journal of theory and criticism.

In Sedgwick's 1999 biographical study, *A Dialogue on Love*, written a few years after "Shame," she wrote through her experience of depression after undergoing chemotherapy for breast cancer. The text is constructed around her psychotherapy sessions with her male therapist; her intersubjective mode of relating to, and conversing with, her therapist forms the premise of this "dialogue." As Katy Hawkins puts it, *A Dialogue on Love* engages an "experimentation with form" as a way to "[facilitate] new ways of understanding bodily crisis": "Sedgwick's approach to metastatic breast cancer develops the theoretical concepts from across her oeuvre."[50] At the heart of Sedgwick's contribution to the expanding field of contemporary theory and queer theory is her open and honest practice of writing in ways that transgress convention, even as her own privileged positioning as a literary scholar trained within the halls of the Ivy League might complicate her claims to outsider status.

As we consider questions of access and legitimacy around autotheory as a feminist approach to scholarship, it is noteworthy that Sedgwick had first to prove herself academically through more conventional literary scholarship on nineteenth-century writers like Henry James before she was able to theorize issues related to gay lives[51] and, later, to theorize queerness in fresh modes of writing that bridge the self-reflexively autobiographical, the lyrical, the theoretical, the psychoanalytic, and the performative. Just as Sedgwick challenges acceptable ways of doing theory, so too she challenges acceptable ways of identifying—even within the most "queer"

and "radical" LGBTQQIA2S+ spaces. Identifying as a fat woman and a gay man and immersing herself in a lived practice of theorizing and feeling queerness while being in a long-term and ostensibly monogamous marriage with a cisgender man, Sedgwick destabilizes understandings of the relationships between queerness, desire, sex, and identification.

Quite famously, Sedgwick proposed a new definition of "queer" that would continue to resound in queer communities decades after she coined it: queer as "the open mesh of possibilities, gaps, overlaps, dissonances and resonances, lapses and excesses of meaning when the constituent elements of anyone's gender, of anyone's sexuality aren't made (or can't be made) to signify monolithically."[52] Sedgwick's overtly (or overly?) capacious definition—one that creates some distance between queerness and sexual orientation—has come to shape definitions of queerness in queer theory and popular culture in a way that is, to this day, contended. Is everything queer? Can (or should) everything be (capable of being) queer—or queered? Sedgwick's conscious traversing identifications—a fat woman, a gay man—could just as easily be taken as an extension of calls to destabilize gender and to claim ways of being in the world that are more fluid and nonconforming, rather than as politically unintelligible in the current discourse of queer feminisms. Sedgwick theorized queerness from an ambiguous gender identity at a time when trans writers and theorists, while very much a part of gay life and actively making work, did not have the same visibility in popular culture or academia as they do now.[53] Less binarized gender identifications and sexual orientations, including nonbinary, pansexual, and genderqueer, were not a part of the conversation in 1980s and 1990s queer theory in the way that they are in the 2010s and 2020s, and one wonders how Sedgwick's language might change if she were alive and writing and feeling and flirting today.

When it comes to subjectivity and becoming, is there such thing as identificatory limits? How do we parse the distinction between identifying as and identifying with, specifically in regard to queer feminist politics? Nelson's identification of cis pregnancy as queer, a move she makes through the use of "trans" as a citational conceit, is perhaps less contentious than the fluidity of identifications and desires advanced by Sedgwick's autotheoretical work. Nelson's conceptualization follows from

Butler's Derridean decoupling of desire and identification in favor of a more binary-blurring and performative conception of gender. As a mode of writing through the self as relational, autotheory seems particularly well equipped to flesh out the nuances of such complicated identifications, even as it also presents problems related to identification and relationality. Writers and theorists can suspend existing conceptions of appropriate identifications—even within more progressive and/or transgressive spaces, such as queer politics—as autotheorists writing from a first-person positioning and disclosing identifications (and identifications-desires) that obfuscate what is appropriate for or to them.

Sedgwick's self-identifications have not been warmly welcomed by either her own or the current queer context, a matter Nelson ruminates on within the intertextual and autotheoretical fabric of *The Argonauts*.[54] Nelson sees this scenario as close to her own, given her experience of pregnancy. The issue, returned to throughout Nelson's book, is whether pregnancy for a cisgender woman can be understood as properly queer, whatever that might mean, even as she is a queer woman in a relationship with a trans man. Nelson turns to Sedgwick's work and its receptions to engage the problematics of what "queer" means in the contemporary moment. She contextualizes her inquiry from within her queer marriage to Dodge and their family-making in Proposition 8–era California, and moves smoothly between references—Ahmed, Sontag, Bersani, Chödrön—arriving finally at Sedgwick. It is Sedgwick's definition of "queer" as "wanting it both ways" that most resonates with Nelson, enabling her to keep queerness grounded in sexual orientation while also distancing the two. "There is much to be learned from wanting something both ways," Nelson writes in one of the text's many moments of relishing in ambivalence. Throughout the text, Nelson reminds us that the work of theory is to flesh out liminal spaces, to resist generalizations, and to sit with ambivalence. Paradoxically, there is also a palpable desire to get at the "truth" as part of her epistemological-ethical project of autotheoretical queer theorizing. Nelson cites Sedgwick's statement that "what it takes—all it takes—to make the description 'queer' a true one is the impulsion *to* use it in the first person," following this with a description of Sedgwick's first-person identifications in her own "real life":

Sedgwick, who was long married to a man with whom she had, by her own description, mostly postshower, vanilla sex, knew about the possibilities of this first-person use of the term perhaps better than anyone else. She took heat for it, just as she took heat for identifying with gay men (not to mention *as* a gay man), and for giving lesbians not much more than an occasional nod.[55]

Nelson uses the practice of autotheory to seek insight into the age-old question of truth: what is truth, how do we access truth, what makes something truthful, and so on. The discourses of honesty and, perhaps even more fraught, sincerity present complications to philosophical and epistemological questions of truth. Nelson follows these observations on Sedgwick's "queer" identifications with the conclusion that "such were Sedgwick's identifications and interests; she was nothing if not honest." She invokes pathos for Sedgwick and a soft allegiance with what she was doing, intimating that Sedgwick's way of living was more sincerely queer "than the poles of masculinity and femininity could ever allow."[56] Writing alongside Sedgwick and other ghosts of queer theory's past, Nelson extends her project of troubling binary oppositions around gender, sexuality, and identity while also upholding her insistence on honesty and sincerity. Nelson, too, desires a space for "honesty" and "truth," even as these terms are themselves impossible, looming as a horizon a theorist-writer might move toward but never touch.

AUTOTHEORY'S OTHERS: WHAT STORY IS MINE TO TELL?

The rise of autotheory is wrapped up in ethical questions around writing and art: Whose story is yours to tell? What are the parameters of your "I," and are you speaking within those bounds? If your truth is your truth and my truth is my truth, then whose truth is *truth*? Nelson makes an effort to bring a lived ethics to the space of theory (and vice versa), using the forms of a queer, feminist, autotheoretical practice to do so; one of the ways she does this is through disclosing her weaknesses and her desire to grow and become more emotionally mature in her relationship.

But what stories is an "I" able, or permitted, to tell? Can Nelson write about trans subjectivities and politics if she is not trans? Similar questions have emerged in recent years: Can a nontrans actor can be cast in the role

of a trans character (thereby taking that role from a potential trans actor, some would argue)? Can a non-Indigenous writer write a story about indigeneity? If we push this further, we reach certain questions that are familiar in the mainstream, such as whether a male author can—or ought to—write a female protagonist, and so on.

The ethical questions around autotheory and authorship that Nelson gestures to in *The Argonauts* are taken up directly in Alison Bechdel's *Are You My Mother? A Comic Drama* (2012), the graphic artist's second graphic novel, which can best be described as autotheoretical.[57] In it, Bechdel homes in on her relationship with her mother in light of questions around queerness, writing, influence, psychoanalysis and psychotherapy, canonicity, and time. A key problem Bechdel returns to throughout is the problem of writing *truthfully*, from life, about a loved one. What does it mean to write these stories and publish them in forms that can be widely read? *Are You My Mother?* is often described as a graphic memoir, a genre description that has been used to describe Bechdel's 2007 work *Fun Home: A Family Tragicomic*, a queer coming-of-age story that centers on her relationship with her father, a closeted gay man who ran a funeral home.[58]

Before writing book-length graphic memoirs, Bechdel was known for her autobiographically-inspired comic strip *Dykes to Watch Out For* (1983–).[59] Bechdel structures the book through intertextual identification and an ensuing parallel narrative structure of layered citations, positioning the narrative of her relationship with her mother alongside narratives from throughout history that she finds generative points of connection with: these include the life stories of Winnicott, Virginia Woolf, and Adrienne Rich. Some of the stories press up against Bechdel's own life (her rejection letter from Rich, for example, becomes a motivating event in the story).

Identifying with Woolf's proclaimed "obsession" with her parents, for example, Bechdel places Woolf's process of writing *To The Lighthouse* beside her own process of writing the book *Are You My Mother?*[60] Bechdel extracts similarities and theorizes them as she considers broader philosophical questions around autobiography and feminist writing practice. Just as Nelson and Dodge are divided on issues of language and writing, Bechdel and her mother are divided on the proper place of the autobiographical "self" in writing. Bechdel's mother, like literary critic Helen Vendler (whom Bechdel cites), is of the view that "some things are private"

and "the self has no place in good writing."[61] Bechdel, on the other hand, says that sometimes you have to be personal and specific in order to be universal. She delves into these "private" matters in her graphic novels—first the story of her father's queerness and suicide in *Fun Home,* and now the story of her strained relationship with her mother. Like Anzaldúa in *Borderlands/La Frontera* and Nelson in *The Argonauts*, Bechdel enlivens citations as a way of better understanding philosophical questions and fostering intersubjective relationships between different lives, texts, histories, and contexts—ones related in life, and ones related through reading.

Not only does Bechdel acknowledge that she is going against her mother's wishes by writing about her, she also includes in the book the protracted process of her unpacking these issues during private sessions with her psychotherapist. In this effort at taking moral responsibility, Bechdel makes transparent her process of wrestling with these questions. Like Nelson, she brings a candor to her work by including her loved ones' responses to a text in the text itself. Through parallelism of narratives, characters, concepts, and artworks, their autotheoretical texts place "personal" experience within a greater discursive, social, and political context, grappling with these questions in similarly personal-critical ways.

Honesty and truth are slippery terms. Like sincerity, honesty is difficult to talk about when it comes to performative, post-conceptual-art practices. One way to do so is to consider honesty as its own rhetoric, one the writer or artist performs to different effects. Speaking of "personal criticism"—a marginal practice that feminist academics dabbled in alongside more legitimized modes of doing scholarship in the 1980s and early 1990s—Nancy K. Miller states:

By the risks of its writing, personal criticism embodies a pact, like the "autobiographical pact" binding writer to reader in the fabrication of self-truth, that what is at stake matters also to others: somewhere in the self-fiction of the personal voice is a belief that the writing is worth the risk. In this sense, by turning its authorial voice into spectacle, personal writing theorizes the stakes of its own performance: a personal materialism.[62]

Resembling autotheory in its impulses and effects, Miller's personal criticism is predicated on the formation of a relationship between writer

and reader. Like a good postmodernist, Miller understands that any kind of subjective writing practice is performative: the writing "I" constitutes itself through the act of writing. Yet there is a generative tension between "the fabrication of self-truth," on the one hand, and "the self-fiction of the personal voice" on the other, a tension we find both in personal criticism and in more recent autotheoretical texts. Something that autotheory might be better positioned to do than such genres as memoir is the reflexive act of "turning its authorial voice into spectacle" and, in turn, "[theorizing] the stakes of its own performance." Considered in this light, Nelson's disclosures of her faulty thoughts and limitations might not be meant to rouse pathos or preemptively protect herself from criticism so much as to establish the performative "personal materialism" that Miller speaks of. Nelson theorizes the stakes of her own disclosures (considered within the larger contexts in which she writes) through the act of disclosing.

The use of transparency—or, to put it another way, disclosure—in feminist autotheoretical work varies greatly between writers. Although nearly two decades separate Kraus's *I Love Dick* from Nelson's *The Argonauts,* both books have received a great deal of attention from a twenty-first-century millennial readership. In chapter 5, I theorize the feminist politics of disclosure and exposure in *I Love Dick*, and the ways in which Kraus's disclosing of the bad behavior of men is an echo of feminist "whisper networks" and a prophetic anticipation of the ultra-public #MeToo movement of today. In both texts, a female narrator addresses a beloved, and the beloved or "object of desire" to whom the text is addressed is a named and known public figure.

While Nelson's narrative is grounded in her "actual" experience of being in a romantic, committed, and consensual relationship with Dodge, Kraus engages in a performative obsession, interpellating Dick as the driving conceit of her written text without his consent. Kraus's heterosexual encounter with Dick could be read as a queering of heterosexuality through its hyperbolic, even campy parody, while Nelson explores a self-reflexively queer relationship with a partner who is "neither male nor female." In both texts, the theoretical context of performativity (as developed by Butler) shapes an approach to hetero desire that is critical, with both writers approaching heterosexuality as a performative construct. And yet as readers we understand that the beloved other that Nelson invokes

exists in a "reality" outside the text, whereas the "Dick" that Kraus invokes is grounded less in "reality" and more in a hyperbolic performance of the real—a "real" that touches on delusion (or is it metaphor?) and the perverse power dynamics of heterosexuality as they persist in the latter half of the 1990s. In this way, the ethical valences of the two books are different, and the writers take distinct tonal approaches in representing these relationships to readers.

Nelson distances herself from social media, going so far as to state, "Instantaneous, non-calibrated, digital self-revelation is one of my greatest nightmares." She explains how her decision to disengage from social media as a mode of autotheoretical expression—where the internet continues to serve as a space for the long-standing feminist "personal made public"—comes from her anxieties around the "temptations and pressures" involved in having oneself "[hoisted] ... onto the stage of Facebook."[63] Instead, Nelson writes herself and theorizes in the pages of a book, where there is a different kind of temporality—a slowness, perhaps—that gives room for more thoughtfulness and consideration.

But what is the rhetoric of honesty that Nelson engages in her writing? To what uses is this rhetoric being put in *The Argonauts*? Although both *The Argonauts* and *I Love Dick* engage in what could be called a feminist politics of disclosure, disclosure for Nelson is less about outing the bad behavior of others and more about disclosing her own limitations, problematics, complicities, and imperfections as a human being, as a partner, and as a writer. By positioning her work as driven by a Sedgwickian honesty, Nelson's disclosures are more about revealing the slippages and gaps in contemporary practices of living, working, loving, writing, fucking, and theorizing as feminist and queer. Refusing to perform a perfectly correct feminism, Nelson makes space for the kinds of philosophical capaciousness and nonbinary (in the most literal sense) thinking that Sedgwick strove for. As it did for Sedgwick, this move has opened Nelson up to criticism—some, perhaps, deserved.

Over the course of *The Argonauts*, Nelson works autotheoretically to build an argument for her own queerness and legitimacy as a queer theorist (by autotheoretically engaging larger theoretical questions related to the ontology of queerness, family-making, and romance). In this way, Nelson's practice could be described as straddling the reparative and

the paranoid. Reparative reading is Sedgwick's response to the limits of paranoid reading as a hegemonic mode in the academy: "The monopolistic program of paranoid knowing systematically disallows any explicit recourse to reparative motives, no sooner to be articulated than subject to methodical uprooting."[64] Because of its antihierarchical impetus and ameliorative nature, reparative reading, much like other critical feminist innovations, is vulnerable to dismissal as frivolous or unserious—especially in light of its drive toward unknowing.

Paranoid readings of *The Argonauts* are not difficult: I can just as quickly critique the problematics of Nelson's trans appropriations as I can the problematics of her appropriation (and preemptive defenses) in giving her white baby an Indigenous name at the book's close. I think much of the point of Nelson's text is the attempt to make space for the reparative as an indeterminate way of reading, writing, conversing, thinking, and theorizing in present-day queer communities, and yet I'm cognizant of how her rhetoric of honesty is a way of performing herself as someone who is relatable and self-aware as she constitutes her own politicized discourse of love for Dodge. Nelson's rhetorical performance of honesty becomes a preemptive shield, discreetly defending the writer from more predictable feminist criticisms. Nelson does this through establishing a trustworthy narrator who is upfront about her own limitations, a version of the "nobody is perfect" defense that circulates in political and pop cultural debates. As a reader, I am left with the resultant tension between the slipperiness of her evasion and the novel's keen contributions to an autotheoretical approach to writing.

Along with the problematics of honesty and disclosure is the tension between autobiography and fictionalization. As discussed, other queer feminists, such as Lorde and Anzaldúa, wrote their lives in similarly citational ways in the 1980s. Nicole Brossard's *Picture Theory* (1982), for example, is framed by a citation from Wittgenstein—in reference to his theory of language games—used as the book's title. Brossard plays with genre and form to write through lesbian relationships in autobiographical ways, though much of her work is put through the prism of fictionalization. The distinction between transmuting the *autobiographical* through the "fictional" is a difference between Brossard's writing of the 1970s–1980s and Nelson's of the 2010s, with 1990s works like Kraus's *I Love Dick* seeming a curious hinge between the two.

In chapter 5, I discuss the ways Kraus critiques fictionalization as largely disingenuous in certain literary scenes throughout history: since many writers are writing about real-life events, fictionalizing them merely gives a false distance from the "personal" material it is based on, rendering the work more critically appreciated and protecting it from charges of narcissism. Kraus claims that most of the so-called fictional work written by men is actually based on real-life material, and that, for that reason, the tendency for canonized male authors to present such work as fiction is disingenuous at best. The feminist politics of the autobiographical, in tension with the theoretical and the fictional, is a key problem that pervades the autotheoretical—with the very notion of "autotheory" presenting an aporia.

AUTOTHEORY AND ETHICS: BECOMING A (MORAL) SUBJECT

In the body of *The Argonauts*, the theoretical or literary citation is also invoked as a form of aspiration, like a memeable inspirational quote for the theoretically inclined. One of the texts that Nelson shares with Dodge in the text's opening pages is "a fragment of a poem by Michael Ondaatje"; the poem, though unnamed in this book, is his "The Cinnamon Peeler." On her choice of passage, which begins "Kissing the stomach / kissing your scarred / skin boat. History / is what you've travelled on / and take with you," Nelson explains, "I didn't send the fragment because I had in any way achieved its serenity. I sent it with the aspiration that one day I might—that one day my jealousy might recede, and I would be able to behold the names and images of others inked onto your skin without disjunct or distaste."[65]

Nelson introduces the tension between who she is and who she hopes to be, positioning the practice of citation as aspiration as much as a description of past or present circumstances. Striving to be better, autotheoretical works like *The Argonauts* and Sheila Heti's 2010 *How Should a Person Be?* engage ethical questions through the transcription of real-life anecdotes and conversations that the writer witnessed, overheard, participated in, or read, and then reappropriated in the context of their own work. Heti's book, though better described as autofictional than autotheoretical, asks the question, "How should a person be?" to reflect on ways of being in the

world in a manner that sounds childlike, though written for adults.[66] In this way, these works return us to philosophy's roots—where philosophy is the practice of reflecting on how to live well (though the means by which one figures that out can paradoxically brush up against the aims).

Does being honest about one's own limitations and theoretical short-comings in a text preemptively defend these shortcomings from criticism? Within the context of contemporary feminist theory and practice, is this kind of self-effacing honesty rhetorically or philosophically effective or subversive, or does it reinforce what is stereotypically expected of women? Ethical and political questions related to feminist disclosures and the act of writing with, to, for, or about an other are thorny, whether the author's or artist's approach is one of performative antagonism (Kraus vs. Dick) or of sincerity (which is also performative). Similar to the distinction Nelson draws between who she is and whom she hopes to become through the practice of thinking and writing autotheoretically, ideals of relationality, intersubjectivity, and intimacy exist in the text as the kinds of ideals she strives toward. Nelson admits her own deep-seated resistance to sharing authorship, even as she populates her text with the voices of others. But what about those practices where the loved one does speak? Or those practices where authorship is shared between collaborators? Related to questions of autotheory and incorporating others into one's work—the citational act as a move toward communion and intimacy, or disclosing as a means of holding folks responsible for their bad behavior through calling in or calling out—is the question of whether feminist autotheory constitutes a moral or ethical imperative.

The question of whether theorizing is an *ethical* practice is one I've been thinking through as I've considered the autotheoretical impulse as it manifests in contemporary cultural production—especially, it seems, in feminist, queer, and BIPOC practices ("from the margins," as it were). On November 17, 2017, I attended a talk by Maggie Nelson at the Art Gallery of Ontario, sponsored by the Canadian Art Foundation. Nelson was in conversation with Sheila Heti. The focus of the talk was *The Argonauts,* although Heti admitted near the beginning of the talk that prior to that week she hadn't actually read Nelson's work before. She had heard through the grapevine that Nelson was writing a book on motherhood, which made Heti nervous because she too was working on a book on motherhood. When

she had this occasion to read Nelson's book—required of her, of course, for this paid talk—she read, I imagine, with an eye to her own book, conceding her relief to see that she and Nelson were approaching the question of motherhood differently enough and so, it followed, Heti was safe to continue her own project for a commercial market predicated, even in feminist spaces, on certain forms of competitiveness and "who got there first" (Heti's *Motherhood* would be published the following year).[67]

Copies of Nelson's book were available for purchase at the back of the room, although my sense from a glance around the space was that all three hundred or so of us had read the book at least once, and likely had it nestled on our bookshelves next to other feminist and queer theory books. The talk began, and Heti asked Nelson some open-ended questions. As I listened to Nelson speaking, I thought to myself: *This is what a philosopher sounds like. This is the work that a philosopher does.* She spoke with a deep intelligence and what I can only describe as a level-headedness toward subjects of politics, ethics, and aesthetics that I actually (again, in spite of myself) found surprising in such a feminist lecture. Rhetorically, Nelson was focused on philosophical modes of thinking, approaching her answers to questions and prompts as a philosopher would—from an intelligent place of not knowing. She wasn't reciting predictable intersectional feminist talking points, even though she was engaging with feminist problems in a manner that, in my view, could be more effective for bringing social change (by changing how people, including those from diverse backgrounds, view social issues). I wouldn't encounter that experience again until American poet and essayist Anne Boyer's keynote at the *AUTO-* conference at the Royal College of Art in London, in the spring of 2019, when Boyer interwove thoughts on Goethe and the demonic, repetition as insistence, and how trauma is a question of class. Boyer's words had all of us postgraduate feminist writers and artists effervescent, excited to keep on doing the work of theorizing, the work of auto-engaged critical thought, and intersectional living—and the creation, it seemed around me, of yet another theorist fan subculture, one with, admittedly, my kind of taste: the "Boyer Babes" (*I love her,* the various women and nonbinary friends I met in London exclaimed, after the talk. *She is brilliant!*)

After about an hour of conversation between Nelson and Heti, they opened up the room to questions. A docent walked around the space,

passing a microphone to those who wanted to speak. First my friend Margeaux Feldman, a local feminist writer and activist, asked a question about who has access to writing autotheoretically; she drew from her own position as a PhD candidate to contextualize her question. Another woman opened up about her experience having recently given birth, asking Nelson—or perhaps just sharing, in the hope of reciprocal sharing—how she reconciled the affects involved in watching a child who was once inside you grow up into a human being who exists apart from you. After a few more questions that were well attuned to the vibe of the room, a young woman stood up, her voice shaking, and began to quote a passage from Nelson's *The Art of Cruelty.* It was a particularly difficult scene, in which Nelson describes the experience of a man (presumably a pedophile, though not labeled as such) who was caught by NBC's reality television show *To Catch a Predator* in the process of meeting up with a minor. "When they showed up to the man's house," the woman went on to say, "he shot himself in the head." The room got a bit colder, and my heart started to beat a little bit faster. She continued to speak with a faltering determination, even as she looked about to cry.

"So, I guess what I'm asking is: have recent feminist movements gone too far?" the woman asked (maybe she said, "Have we gone too far?"; I can't remember). She was alluding to #MeToo and the outing of—and subsequent 'disposal' of—men who rape and assault, clearly working to parse questions that were uncomfortable and thorny. The women around me began to turn to each other and whisper, softly scoffing. I could see their faces contorting, ridiculing the woman who was standing there, clearly disapproving of her. I felt as though I was transported back to highschool, surrounded by mean girls. The woman who asked the question had clearly gone against the consensus of the room (does the room have a consensus?), against the ideological presuppositions in the hearts of young female and nonbinary graduate students like me, who voraciously consume books like *The Argonauts,* nodding emphatically as we read. In a quiet way, I felt refreshed that the woman was plucky enough to ask a question like that: she was going against the obvious points of feminist talks like these, not as a troll but as someone who was, I believe, seriously invested in the same feminist politics of social justice, but from a different viewpoint—one that might be more aligned with non-white, anti-colonial conceptions of justice, such as radical frameworks of restorative justice.

She was, it seemed to me, asking a question at a theory talk that was radically empathic in the truest sense of the word, tied to a very thorny problematic, and most of the people in the room found that off-putting— something exceeding what was permissible in a space of feminist thought and its presumed working-through of complex ideas.

I watched as Nelson responded. Like the woman who posed the question, Nelson did not mention specifics, moving instead into a broader philosophical conversation about how, in her work, she is not particularly interested in *making generalizations.* (This felt like a radical statement, but everyone in the room stayed with her, because they're with Nelson, like fangirls: the "Nelson Girls"; like a future version of Kraus's "Bataille Boys" in *I Love Dick*.) Nelson went to explain how she uses strategies like equivocation in her writing, and that she writes in a way that involves looking at a question from multiple perspectives, shuttling between stances as she theorizes. She is wary of generalizations, adding that she is also very wary, as a queer person, of discourses of perversion. (When Nelson says this, I hear it as an almost radical, whistling statement: this was around the time Louis CK was having his "#MeToo moment," which brought the discourse of perversion into the mainstream, and to defend against the use of such language from a woke, queer feminist perspective complicates the politics of Louis CK and his actions, at least if we separate out the obviously key factor of consent. Whether this occurred to others in the room, I do not know.) I wondered how Nelson would be able to create a space for a different kind of feminist conversation around violence and sex, one both philosophical (in its unknowing, liminality, grayness) and political, even galvanizing. For Nelson the autotheorist, thinking through feminist problematics is something best done philosophically—expanding out beyond universalizing statements and binary oppositions to a less predetermined, and possibly reparative, way of thinking and being. The woman who asked the question thanked Nelson before sitting down again.

The day after the talk, a friend of mine, who is in some of the same feminist art communities and social spheres as I, wrote a post on Facebook. It began:

A big hearty 'Fuck you!' to the lady at the Maggie Nelson talk who seriously asked 'what about the rapists?', I'm paraphrasing but you get the idea. My most sincere

condolences to anyone who has to spend time in the company of someone with so much internalized misogyny.

On the one hand, I could see where my friend was coming from. Perhaps they were a survivor, like me, and writing from a place of anger that precludes the kind of sheer empathy or desire-for-understanding-the-other that catalyzed the woman at the talk to ask her unpopular question. On the other hand, I was reminded of how effective social media platforms are at decontextualizing material that really requires context for proper, productive understanding. It would be difficult, if not impossible, to comment on the post with a counterperspective without being discursively and socially obliterated and hailed as a rape apologist or the like (even though I am a woman and queer survivor of rape, with a long history of working in frontline feminist activism to support other rape and sexual violence survivors; none of that would matter, in the decontextualizing space of the Facebook post's comment section, where I could be seen as but a "dissenting" voice, maybe even a troll). But I was at the talk too, and that's not how I remember the events relayed in the post at all. The woman asking the question referenced Nelson's *The Art of Cruelty*, a feminist art historiography that carefully deconstructs the twentieth-century avant-garde's often uncritical devotion to transgression, violence, cruelty, and extremism—as found in self-violent, ultra-self-serious performance art, for example—taking issue with the premise that this kind of work has the cathartic or redemptive power "to restore us, or deliver us anew, to an unalienated, unmediated flow of existence characterized by a more authentic relation to the so-called real."[68] This was important context for the woman's question, which was not "What about the rapists?" so much as "What are the limitations of empathy and reparation in feminist spaces, particularly when it comes to rape and other forms of sexual violence that are beyond the pale?" And, "what do we do, as a society, with rapists?"

"Critics have limits," as Jennifer Doyle writes in *Hold It Against Me: Difficulty and Emotion in Contemporary Art* (2013), and it seemed as though rape was, in fact, the limit point for many at the talk.[69] It occurred to me, as I reflected on my friend's post, that a topic like this was so charged as to be virtually unintelligible. When it comes to questions of rape, maybe we hadn't yet gotten to a place where we *could* approach it "philosophically," if

philosophically means "with a critical distance"—although, as this book shows, this is not its only possible (or even usual) meaning. Maybe, for many of the survivors in that room, the only thing permissible to say is "fuck rapists" and "believe women," echoing the predetermined memes and hashtags that we circulate as an act of politics—the meme as unquestioned and woke coping mechanism rather than something discursive or theoretical and therefore up for debate. But what if another survivor's healing practice, and I include myself here, means moving beyond the pain to ask the more difficult questions? Yes, obviously, rapists are bad, and they need to face consequences for their actions. This should go without question, and I know that the fact that it does *not* go without question is what is driving my friend and others to experience the level of anger and dismay they do when the topic comes up. And yet rapists, like sociopaths and pedophiles, are also flesh-and-blood people, and anyone seriously invested in questions of ethics will ask what we do with these limit-point cases of violence. What do "we," societally or as communities, do about this? What do "we," as feminists, do about this? These are questions that theorists like Nelson, as evidenced in *The Art of Cruelty*, are invested in asking—and who better to take up this question than feminist philosophers and theorists, in communion with their communities?

As I write this anecdote, I feel conflicted, a twisted feeling in my gut. I don't want to "call out" my friend for their post. I feel for them, and I understand their anger. I have felt it too. I still feel it. The Nelson talk was the same week of the Brett Kavanaugh hearings, which only contributed to the sense of urgency and awareness that rape was horrific, and that more often than not, rapists go without adequate, if any, punishment or accountability. What I want to do is to consider the ways that postinternet culture complicates practices of philosophizing *as historically understood*—maybe, for some of the feminists in that room, a practice of theory and criticism is not about radical empathy or diving headfirst into the epistemological and ontological unknown. Maybe theory is not about the limit-points of ethics. I do not have all the answers. But I continue to return to this anecdote, in the context of a consideration of autotheory as a feminist mode, because it raises the question of what feminist spaces for criticism—like a feminist theorist's talk and the post-talk Q&A, in a room of sympathetic audience members with presumably similar political allegiances

(*like, we're all on the same side*)—are for, and what kinds of questions and conversations are permissible or welcomed there. There is a difference between the woman who raises the question of how to deal with rapists and the rapists themselves—and this is a point that is worthwhile taking seriously, as feminist theorists and artists and critics taking part in public conversations around difficult and charged topics.

Two years later I was in London, presenting at the Royal College of Art as part of their *AUTO-* conference, a two-day gathering of writers, artists, curators, and critics engaged in practices that exist in proximity to two increasingly popular, nebulous terms: autotheory and autofiction. Anne Boyer was the keynote, and over lunch she talked about the distinction between GenX'rs—"anti-ethical" in terms of what was considered cool and countercultural—and millennials—seemingly obsessed with being ethical, a performance underscored by terms like "virtue signaling." I shared the anecdote about the Nelson talk and my friend's response to it with Boyer and the other conference presenters. Some were discussing how millennials are too scared to ask questions in class because of cancel culture: "They're terrified to say the wrong thing, because if they say the wrong thing then maybe they'll be destroyed for that." They discussed among themselves for a bit, and then Boyer pushed back. "We are not born ethical beings. We become ethical, through learning and asking questions. If we're not asking these questions in the classroom, then where are we thinking about these things?" Along with the classroom, I would add other spaces dedicated to philosophy and theory, to thinking-together.

If we cannot take up these questions in a philosophical space like a Maggie Nelson talk at the AGO, in a room of presumably like-minded people (or at the very least similarly oriented with regard to key political question), then where can we take up these questions? And if we cannot consider these questions anywhere or at any time, then what happens to these questions-needing-answers? Do they fester? (I'm certain that everyone in that room at the AGO held intersectional feminist ideals, at least in theory [*this refrain: at least in theory, at least in theory*]). Surely this was a safe space for discussions—or at least a "safer space." The very women who ridiculed the interlocutor for asking the question were probably the same ones who would describe that space as a safe space, and who would demand that their own needs be met in it. But, as is so often the case, in

my experience of feminist-described spaces, one person's boundary can be another person's trigger. One person's need can be another person's limit-point. Where does that leave us, as a feminist community? Maybe some survivors do not have enough distance to begin to theorize questions about the ontology of violence or whether disclosure can "go too far," and maybe this is OK. But these are questions worth asking.

As a survivor of sexual violence and sexual assault myself, and as someone diagnosed with related mental health issues, including C-PTSD, I do not pose these questions naïvely or out of some kind of internalized misogyny. While I sometimes lapse into glibness—perhaps my own defense mechanism—I ask these questions from a desire to continually seek knowledge and understanding in those places that are the most thorny and liminal and urgent *and personal*, and to think about autotheoretical practices as ways of transforming how we think and speak about ethical issues, in addition to aesthetic and political ones. This, it seems to me, is what autotheory as a contemporary mode of practice is well positioned to do. Maybe then the social structures and institutions that we move through—that we think in, and cry in, and laugh in, and feel frustrated in, and feel excited in, and feel misunderstood in—might be transformed. Why were we attending Nelson's talk, if not to take up complex questions together? Were people attending solely to have their own presuppositions and viewpoints affirmed? Was theory just another vacuum? Was contemporary art and feminist discourse just another vacuum too?

Theory, and especially autotheory, I think, has the capacity and, in fact, the *responsibility* to do something else—to approach things differently—and autotheory makes space for the exchange between lived, personal, subjective experience and contextualized consideration, critical reflection. Might a feminist practice of autotheory after Sedgwick's "reparative reading" be radically reparative and empathetic to "the other"—even the furthest, most alienating "others" to present-day, intersectional feminism? And if so, are there limits to that empathy? I continue to engage this issue in chapter 5, when I discuss the feminist politics of disclosure and exposure at more length. First, though, in the chapter that follows, I consider citational practices in autotheory across different forms—visual art, installation, mixed media, and video—and the kinds of intertextual and intersubjective intimacies and communities engendered through these works.

4

PERFORMING CITATIONS AND VISUALIZING REFERENCES

Drawn Bibliographies, Sculpted Theory, and Other Mimetic Moves

All reading, every reading, is a desire for image, an intention to re/present, which gives us hope.
—Nicole Brossard, *The Aerial Letter*

CITATION AS ARTISTIC MATERIAL: SCULPTURE, VIDEO, MIXED MEDIA

In the previous chapter I discussed the ways writers and artists engage the autotheoretical impulse in their work by placing citations—a standard academic practice of referencing the ideas of others in order to back up one's own hypotheses or theories—in highly visible places in a work. Instead of the reference becoming obscured in a footnote or an endnote, the eye is directed toward it: it forms a considered part of the mise-en-page or the mise-en-scène. In these works, the artist or writer draws attention to the citation as a constitutive component of the work, with the citation becoming a core part of the process of reading a story, watching a video, or listening to a track. In this chapter I turn to work by Cauleen Smith, Allyson Mitchell, and Deirdre Logue, where similar practices of citing theory in the context of autobiographical works are at play—but now in different media and at different scales. I consider the tendency for visual artists to render references as physical materials in autobiographical art, a practice related to the performative citations within memoiristic or postmemoiristic writings studied in the previous chapter.

In recent contemporary art, many artists have chosen to reproduce books of theory and critical literature by hand, whether as 2D drawings or 3D replications. From American artist Cauleen Smith's *Human_3.0 Reading List* for Black survival in Black Lives Matter–era America, where the artist haptically reproduces books by such writers as Frantz Fanon, Sylvia Wynter, and W. E. B. Du Bois to comprise a hand-drawn reading list that serves as "armor" for Black folks, to queer settler Canadian artists Mitchell and Logue's human-sized replications of queer theory books using gluten-free papier-mâché as part of a larger installation on queer futurity, these works fit within the broader autotheoretical turn in contemporary art. How do artists' practices transform these texts' meanings, and what kinds of relationships are fostered between the artist's life, the cited text, the audience, identification, and community?

In the hands of artists like Mitchell and Logue, who work from explicitly autobiographically informed and embodied studio practices, a book of theory, a bibliography, or a reading list is extended beyond its purely indexical function to connote something affective and communal, desirous and difficult, in the context of an art installation or a performance for video. Mitchell and Logue are both collaborators and lovers/partners who cofounded the multisited space FAG (the Feminist Art Gallery) out of their home in 2010, riffing on the model of short-term queer feminist collectives demonstrated by the New York–based LTTR collective.[1] I consider their practice of autotheoretically processing queer theory, and its histories and futurities, through their collaborative practices as artists and curators, looking to their recent collaborative exhibitions to consider the mimetic impulse of reproducing theory citations in the context of artwork. The question of identity—its fixity, its malleability—and its relationship to autotheory comes in near the close of the chapter. The relationships I discuss can become named identities whose discursive rise and fall threatens the integrity of the self—with the example of "lesbian" coming to the fore with Mitchell and Logue's recent work in autotheorizing questions of lesbian death, discursively speaking, in relation to queer belonging.

In queer feminist practices, the politics of community is often an important part of the work—at least in theory. One way of assuaging the ethical issues involved in autotheoretical work is through collaboration. Lauren

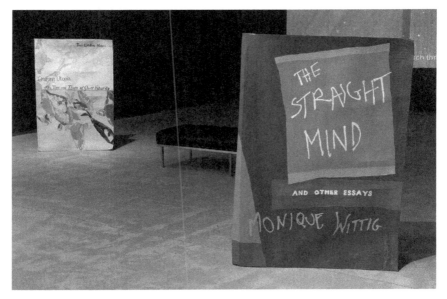

Allyson Mitchell and Deirdre Logue, *I'm Not
Myself At All*, 2015. Multimedia art exhibition
at the Agnes Etherington Art Centre,
Kingston, ON (installation view). Photos:
Agnes Etherington Art Centre. Courtesy of
the artists.

Berlant and Kathleen Stewart's *The Hundreds* (2019) engages collaborative writing as a political and theoretically self-reflexive practice in which the shared act of writing autotheoretically is organized by the constraint of writing hundred-word pieces. Berlant's and Stewart's writing has roots in a specific theoretical genealogy of queer feminist affect theory and in adjacent literary practices such as poetry, with examples including Hiromi Goto and David Bateman's co-authored text on alcoholism, *Wait Until Late Afternoon* (2009).[2] By working collaboratively with a beloved other, or another kind of collaborative partner and friend, the voice and agency of that other is incorporated more agentially: the work is created, in part, by them, typically in active and ongoing conversation and negotiation. Similar to practices of lateral citation, collaboration encourages cross-pollinating and more equal playing fields or footings. While Nelson expresses her anxiety around shared authorship in *The Argonauts*, as we saw in chapter 3, Mitchell and Logue embrace collaboration—even with its potential difficulties, charged as collaboration may be for those working together in addition to living and sleeping together (all these forms of intimacy that cohere in autotheoretical work).

Mitchell and Logue maintain active individual and collaborative artist practices in addition to living together as lovers/spouses and organizing as feminist art collectors, curators, educators, and community organizers with FAG. They work in media like performance for the camera, self-imaging practices like soft sculpture self-portraits, and text and manifestos. Mitchell works as a professor of women's and gender studies, teaching courses in queer theory and affect, alongside her long practice of making self-reflective, fat-femme art. It is not surprising that ideas of research factor into her work, often explicitly—though the ways she incorporates theory into art is often very "lowbrow," rendering elevated theory something accessible in a way that might be described as queer-femme maximalist kitsch. It is in their collaborative work as artists, though, that the autotheoretical thrust of their work comes to the fore. To take this up, I consider two exhibitions of their work as artist-collaborators, exploring them in relation to queer possibility and futurity: the 2014 exhibition *We Can't Compete* at the University of Lethbridge Art Gallery, and the 2015 exhibition *I'm Not Myself At All* at the Agnes Etherington Art Centre.

Allyson Mitchell and Deirdre Logue, *I'm Not
Myself At All*, 2015. Multimedia art exhibition
at the Agnes Etherington Art Centre,
Kingston, ON (installation view). Photo:
Agnes Etherington Art Centre. Courtesy of
the artists.

We Can't Compete features works across media, including video and sculptural works, sound, found object sculptures, and two crocheted text banners, one reading "We Can't Compete," the other "We Won't Compete," a message of solidarity that seeks to queer neoliberal, capitalistic tendencies toward individualism and competitiveness in art and academia.[3] In one corner of the gallery stands a mixed-media sculptural work that serves as a primary focal point for audiences when they enter the space. In it, two large audio speakers support stacks of multicolored binders and books of theory and art, including feminist theory, queer theory, and theoretical work on issues in contemporary art. The artists sourced the binders and books from around campus, collecting academic texts and catalogues on feminist and queer art from the university's library holdings. A looping soundtrack of songs by the indie band Abstract Random plays through the speakers. Emerging from the base of the sculpture are floor-length strips of red tape that draw the viewer's attention to the sculpture as a kind of source of energy for the installation. Beaming out from these theory-art-binder-speakers, the red tape lines are like vibrational sun rays—the speculative "heat source" of the work. The artists underscore the importance of feminist and queer theory and art, and the role of library research, by configuring this work as the heart of the installation—a metaphor tied as much to affect as it is to circulation.

The artists' work strives to show the inextricability of queer theory from queer practice, both at the level of the artwork and at the level of their lives as partners, collaborators, and cat parents. As Sarah E. K. Smith, who curated their exhibition in at the Agnes Etherington Art Centre, writes, "These self-referential works, intimately connected to the artists' lives, forge a connection between domestic queer realities and feminist and queer discourse (both historic and contemporary)—ultimately bringing queer theory into queer practice." Smith's description of Mitchell's and Logue's works as "reflect(ing) critically on the artists' lived experience" brings to mind an autotheoretical approach to art-making; in addition to the artists critically taking up the politics, aesthetics, and theoretics of their own lives, they engage with and cite works of theory as core materials.[4] By working autotheoretically, artists like Mitchell and Logue foreground queer and feminist theory not only as a source of knowledge and

consciousness-raising but also as sustenance for queer feminist living and becoming. They stage the theory text as a site where their interwoven roles in the world—artist and curator, educator and professor, community activist and organizer, lesbian and lover, cat mom and neighbor—can come together and find nourishment through critical thinking and insight, engaged conversation and the intermingling of ideas and theories, and the forging of new understandings across differences.

While the exhibition *We Can't Compete* can be read as an integrating of queer theory and queer practice, it can also be understood as a wrestling with the very limitations and (im)possibilities of queer futurity through its forms, materials, and themes. In their video *Hers Is Still a Dank Cave,* the artists juxtapose theoretically informed reflections as text on the screen with their own performing bodies.[5] The video is an anchoring work in the larger exhibition, and it is autotheoretical in the perhaps most obvious definition of the term (the artists themselves are performing in it, beside books of theory). The artists activate performance for the camera and the medium of video art to represent the practice of reading theory as fundamentally physical, collaborative, and entangled with different kinds of intimacies.

This work evolved out of their residency at the Art Gallery of Ontario in 2015, where the two artists made *Hers Is Still a Dank Cave* in front of a green screen. In the video, Mitchell and Logue appear clad in light beige full-body-suits—a shade approximating the "flesh tone" of their own white settler bodies—standing in front of a green screen with the floor lined with chroma key green material. They've created an immersive space, in which they proceed to playfully perform for the camera with different objects they created out of gluten-free papier-mâché. Dressed in the body suits, the artists interact with the text on the screen, working together and approaching that work with a sense of playful resolve. Texts from feminist and queer theory appear on the screen, blown up in Mitchell's characteristically maximalist style. Recognizable quotations from feminist theory are newly iterated to humorous effect on the screen: Simone de Beauvoir's famous saying "One is not born, but rather one becomes a woman" from her 1959 *The Second Sex* is translated on the screen as "One is not born, but rather one becomes a tabby," a fitting cat-lady reference for a video in which the artists' cats

To mold a new reality closer to the heart.

feature as incidental actors and the artists use a low-to-the-ground camera view as a nonanthropocentric, "pussy"-centred site of vision.[6]

Mitchell and Logue lovingly draw a portrait of queer theorist José Esteban Muñoz as an elegy to him, with the dates of his birth and death marking a project of mourning; smiling, in one scene in the video, this hand-drawn Muñoz holds up a placard that reads "NOBODY KNOWS I'M A LESBIAN," a winking disclosure that aligns this ostensibly cis-homosexual man with the lesbian artists making this work. Whether this is a comment on allyship, a posthumous granting to Muñoz of honorary lesbian status, or the revelation of a hidden "truth" about the writer remains gaily ambiguous. The homage to Muñoz riffs, perhaps unintentionally, on the play of other more bemusing gender identifications, like Sedgwick's (discussed in the last chapter), where no one knows that she is a gay man. Lines from Muñoz's best-known book *Cruising Utopia* feature alongside images from the artists'

Allyson Mitchell and Deirdre Logue, *Hers Is Still a Dank Cave: Crawling Towards a Queer Horizon*, 2016, single-channel video (still). Courtesy of the artists.

domestic lives and their art practices, joined as they are through their collaborative institution "FAG"—another rhetorical commingling and gender play, the lesbian-identified artists also going by this name: an acronym that nevertheless reads as "fag," shorthand for "faggot"—and related, though in a coincidental way, to other downtown/West End Toronto-based media arts project spaces like "Video Fag," cofounded by two gay male artist-partners a few years after Logue and Mitchell cofounded theirs.

The queer politics of this autotheoretical video continue to cohere around practices of reading theory and the relationship between these theory texts and the artist's own queer, domestic lives. At one point in the video Logue holds a gigantic pink "highlighter": standing 152" inches high and made of gluten-free papier-mâché, it is humorously large, pink, and phallic (when I say this aloud during a presentation, the artists laugh and tell me: "Your words, not ours!"), something she must wield to achieve a purpose. Mitchell lies near Logue, reclining on her side on a giant piece of letter-sized paper, one hand holding her head up and the other hand pointing to the line that should be highlighted. Logue positions the highlighter to touch the place on the "page" to which Mitchell points, carefully balancing the unwieldy object with her body; as she moves the highlighter, the magnified "page" is highlighted in yellow, the magic of video editing rendering the act of highlighting "real" by illuminating the passage on the screen. With a sense of humor about contemporary feminist discourse and its discontents, Mitchell dons a white tee-shirt that reads "I'm With Problematic," with the screen-printed sign of a pointing hand mimicking Mitchell's own pointing hand below. Through this shared performance the artists embody the scene of reading theory as something laborious that requires support. They transform the often solo act of reading and discerning meaning from a theory book—as one might do when studying for their comprehensive exams as a graduate student, or working on the next big academic tome—into an act that is best done, lovingly, by two.

INTERGENERATIONAL QUEER FEMINIST COMMUNION

One of the ways the artists autotheoretically process queer theory's histories and futures is by reimagining relationships across different generations

of queer theorizing. The artists create strategic alliances between 1970s lesbian feminism and post-2000s queer theory, enacting these alliances in performative ways. They stage intergenerational conversations in theory, bringing Monique Wittig's *The Straight Mind* (1992), a formative work of twentieth-century lesbian theory, into conversation with Muñoz's *Cruising Utopia: The Then and There of Queer Futurity* (2009).[7] Continuing the autotheoretical orientation of their work, the artists construct mimetic reproductions of theory texts as sculptural objects and two-dimensional drawings in the context of *I'm Not Myself At All*. In the space of the exhibition, the video is bookended by two large, mimetic reproductions of Wittig's *The Straight Mind* and Muñoz's *Cruising Utopia*, constructed from the same gluten-free papier-mâché as the highlighter.

Transforming these books into sculptural objects, Logue and Mitchell extend the practice of intertextual intimacies, identifications, and performative modes of citation that we find in written works like *The Argonauts* to a cheeky endpoint. Within Mitchell's maximalist sculpture and immersive installation work, theoretical and literary texts—cited in Mitchell's and Logue's work as key, formative references for their own lived practices as artists, feminists, and scholars—become literal, material components of the artwork that exceed their indexical function. Working with sculpture and installation, the artists gesture at honoring the contributions of second-wave, French lesbian feminism while being aware of the limitations of such epistemological modes—for example, issues of racial diversity and trans-inclusion. In doing so, they strive to understand where lesbian feminisms might fit in today's queer contexts.

The books become structuring motifs, indexical reference points, and symbolic-material art objects within the playfully intertextual fabric of the exhibition. In contemporary art, it is not uncommon to incorporate found objects into a piece, or to frame a found object as a work of art. But rather than placing the books themselves into the gallery space, Logue and Mitchell hand-make mimetic versions of the books that are joyfully enlarged, standing with a vulnerable strength as papier-mâché objects. Traces of the artist's hand are visible through their haptic reproduction of theory books—whose influence on their work the artists foreground *as* artwork. The artists layer citations as an indexical gesture atop the art-historical traditions of conceptualism—where conceptual art itself can be described as

"the aestheticization of indexes."[8] Through mimetic, handmade processes, the artists elevate feminist and queer theory books to the status of idol. The maximalist theory books function both as part of the larger installation and as their own sculptural works to be pondered.

The two large books quite literally bookend or "frame" the projected video—theory is, after all, a framework, and here it serves as a physical frame—so that the viewer's experience of the work is somehow informed by a recognition of the role these two works played in its making. The question of the fetishization of theory reemerges here. I suggest that what we find in this work is not a straightforward fetishizing of theory—although there is that too, in a knowing way (blown up in size, the texts assert their dominance with the lightness of hand-brushed paint and GF, sick-woman-aligned,[9] material)—but a foregrounding of the importance of theory to the practice of living and working queerly and feministly as queer feminist artists, for whom the labors of continually bridging theory and practice are key. It is an act of recognition, extended to comical effects through the massive scale and the winking choice of materials.

In Madelyne Beckles's and Petra Collins's 2017 performance at the MoMA, the artists read an oversized mimetic reproduction of Angela Davis's book *Women, Race, and Class* as they sit on the couch next to a similarly oversized bag of Cheetos, the book and the Cheetos serving as two different forms of collective and aestheticized consumption, maybe an oblique form of comfort "eating."[10] This is one of many threads connecting Beckles's work to Mitchell's and Logue's (another thread being that Mitchell is Beckles's aunt). In 2019, Beckles and Mitchell collaborated on a two-person show, *What Motivates Her?*; the exhibition itself became a form of juxtaposing intergenerational feminisms in contemporary art to reflect on questions related to feminisms, sexuality, race, and the body.[11] Now, instead of two books of theory—Wittig and Muñoz—we have two women, related by blood, representing two generations of feminist theorizing. The artists' hanging installation of disco balls, each held in a multicolored macrame "pouch" handmade by Mitchell, stands as a poignant metaphor for the two artists, differently racialized and with different relationships to institutions and power by virtue of their ages and experiences, yet joined through family and a shared studio practice, holding each other in collaboration.

The creation of such strategic alliances through unexpected juxtapositions is a move found in earlier feminist autotheoretical works as well. Nancy K. Miller's *Getting Personal: Feminist Occasions and Other Autobiographical Acts* was published in 1991, the same year that feminist scholar Jane Gallop introduced the practice that she would come to call "anecdotal theory" in her controversial and autotheoretical work *Feminist Accused of Sexual Harassment* (1997).[12] Gallop defines anecdotal theory as a "practice" and a "project" that draws from the literary theory methods of psychoanalysis, deconstruction, and feminism.[13] Her first use of this practice was her 1991 "A Tale of Two Jacques," an autotheoretical inquiry into the relationship between psychoanalysis, here exemplified by Jacques Lacan, and deconstruction, the project of Jacques Derrida. Gallop describes this text as both "a mid-seventies encounter" of dominant trends in theory at the time and as an elucidation of "a drama I lived through," underscoring both the performative and autotheoretical aspects of her theoretical enactments.[14] This essay was followed by "Dating Derrida in the Nineties" in 1992, in which Gallop thought through the relation between feminism and deconstruction as an autotheoretical engagement with Derrida's 1972 reading of the representation of women in Nietzsche. Gallop seeks coalitions between the "personal" of second-wave feminism and poststructuralist theory that is seen as rejecting the personal, such as Derrida's deconstruction—which was seen as fundamentally at odds with 1970s feminism by many of her contemporaries. Observing a shift in perspective on the place of the personal in theory that took place in the time between the second wave and the third, Gallop writes:

Although deconstruction was often held to be in opposition to the sort of personal discourse favoured by seventies feminism, by the nineties it became possible to recognize a deconstructionist personal and speak a personalized deconstruction. My project of anecdotalizing theory is located very much at this intersection of the deconstructionist with the personal.[15]

Anecdotal theory is a means of reinserting the "truly literary" into theoretical writing practices, in addition to integrating the "auto" and "theory." Gallop cites Joel Fineman on the anecdote as a literary form that is simultaneously "literary and real," or metaphorical and literal in the sense

of the lived as "the moment ... the here and now."[16] Her reference to the "occasional" in her description of anecdotal theory recalls Miller's use of the "occasional" to describe personal criticism or "narrative criticism" in 1991, which underscores how such a personal-critical mode of writing remains marginalized—at least temporally.

An anecdotal approach can create unexpected juxtapositions between the personal and the theoretical. For Shannon Bell, juxtaposition serves as an autotheoretical, and often performative, strategy to develop feminist thought. Describing her approach in writing *Fast Feminism,* Bell explains: "The underlying contention is that feminism needs to be infused from non-obvious philosophical locations. ... The most non-obvious site is the work of Paul Virilio, the hypermasculinist philosopher and technologist of speed."[17] Positioning her own femme, sexually fluid, performing body—which engages in sexual activity with queer partners, joyfully ejaculating for the camera—next to Virilio's hyper-masc speed theory, Bell introduces a new practice she terms "fast feminism."

In Bell's view, the unexpected juxtaposition she performs in *Fast Feminism* is something that her feminist mode of theory and practice will critically, conceptually, aesthetically, and politically benefit from—something that feminist theory and experimentation in a sense require. In *I Love Dick,* Kraus infuses feminism from similarly "non-obvious philosophical locations" (see chapter 2) of male-authored philosophy, just as Piper infuses feminism from a the "non-obvious philosophical locations" of Kant's first *Critique* (see chapter 1). On the one hand, these are the contextually relevant bodies of theory that, as good contemporary artists and theorists, they are accordingly responsive to: meaning is context-bound, after all. On the other hand, what might at first seem like strange coalitions are, on reflection, understood to be meaningful allegiances and deliberate conversations that the autotheorist stages.

When in *I'm Not Myself At All* Mitchell and Logue juxtapose Muñoz and Wittig—two different thinkers from two different lineages of queer theory—as a strategy for engendering new theories and new knowledges that are attuned to a present-day queer feminist context, citation becomes a mode of experimentation where the artists take risks through juxtaposition. Their meta-queer-feminist-theory world is less elusive or "highbrow" than it is playfully kitsch and winsomely humorous and sincere—a

common tone in the artists' work. The humor of the work, for all of its theoretical in-referencing, is accessible through its moments of absurdity. Books of queer theory become birds, flying out of a bowl of hummus that the artists stir with celery sticks, like witches stirring a cauldron. Near the end of the video they lie in a cozy heap among other nylon bodies, those of the constructed "womyn" that the artists have created from textiles and other haptic materials, held in a kind of womb by the creations of Mitchell's lesbian monsters/lesbian sasquatches. They listen to a folk rendition of Rush's "Closer to the Heart" as a sea of hands holding up lighters in an act of solidarity sway from side to side. It's another weird juxtaposition, with the self-aware, sonic commingling of 1980s dude metal and 1990s acoustic lez.

On the other side of the exhibition, we find the site-specific drawing *Recommended Reading* (2010), a mimetic reproduction of the artists' personal library featuring meticulous drawings of book spines that have been photocopied into wallpaper. The work functions as queer feminist canon formation, with titles of representative texts from second-wave, third-wave, and lesbian feminisms, as well as some representation of trans and bisexual feminisms, lining the walls. The title *Recommended Reading* uses the rhetoric of a course syllabus to invite viewers to take note of the titles and read the books at their leisure: there is not a necessary rule, as "required reading" would suggest, but informal suggestions that the artists believe their audiences will benefit from having read. Mimetically handmade, the work cites theory texts—with indexical references to the title, author, and often iconic cover art—but the texts themselves are not available for reading in the gallery. Instead, the books become indexical references, affectively charged signifiers related to what will be a subsequent practice of readerly study after leaving the gallery. Viewers are visually invited to look at the source texts that have been so formative for these artists, whose works, as autotheoretical, are grounded in their lives, and to perhaps reference them as a reading list for later perusal.

Similar citational and transcriptional gestures are found in other recent art exhibitions, such as Marie-Andrée Godin's *(Im)possible Labour* at Diagonale in Montréal (2019), part of the artist's series *WWW³ (WORLD WIDE WEB / WILD WO.MEN WITCHES / WORLD WITHOUT WORK)— Magic, Future and Postcapitalism.*[18] The installation comprises a textile work, a hand-tufted carpet that viewers are invited to sit and lie down

on, and a series of texts displayed on another wall and spanning an autotheoretical narrative. Near the back of the gallery, where viewers both enter and exit, is a small, framed bibliography of recommended reading: while the texts themselves are not available, the list encourages visitors to continue their engagement with the politics and aesthetics behind Godin's exhibition through later reading and reflection.

The motif of the reading list in recent feminist art exhibitions lives in strange tension with the tendency in larger popular culture toward hashtags like #TL;DR ("Too Long; Didn't Read"). In contrast to deeming a passage of text too long to invest time in reading, especially in an accelerated, twenty-first-century mode of living that privileges synoptic communications (such as Tweets) and skimming, contemporary feminist works

Laura Hudspith, *TL;DR*, 2017, neon sign
(installation view), Project Gallery, Toronto.
Courtesy of the artist.

that foreground the reading list or theory book can signal the importance of a slower, more committed practice of reading. It can also signal the artist's valorization of long, difficult books: this, perhaps, as part of an ethics, aesthetics, and politics of living *as* feminist, in a manner gestured to in recent books, such as Sara Ahmed's *Living a Feminist Life*.[19] As I discussed in chapter 2, depending on the context and the artist's practice, indexical references to books of theory can be a valorization of the attentive practice of reading, but they can also be something else—more akin to virtue signaling and woke signaling, but here intelligence signaling. I think here of the Portlandia sketch in which a group of hipsters out for brunch try to outdo each other by naming the articles they've recently read in an accumulating list of publications, like the *New Yorker,* stretching the premise to extremes in the hyperbolic style of the show's satire.[20]

What do such mimetic practices of drawing out theory perform in the context of a twenty-first-century contemporary art scene? What does it mean—politically, aesthetically, symbolically, and socioculturally—to render a book of theory into a sculptural object read in relation to other objects? What drives these artists to reproduce the very texts they are reading *by hand?* And what is the significance of *theory books* in art, especially contemporary art by feminist artists and queer artists? How do artists' autotheoretical practices transform these texts and their meanings? The act of making-haptic through autobiographically inflected processes of transcription is also a making-human, rendering these objects of research and the texts we read into something palpably human and, perhaps, humane. The act of *drawing out* becomes a way of processing, of affectively relating to, enacting, embodying, purging (in a kind of catharsis), these formative discourses, texts, and quotations in ways that are resonant with feminist, queer, and BIPOC politics. Responding to *I'm Not Myself At All*, Love raises questions about Logue and Mitchell's body of work that could be asked of autotheory as contemporary feminist practice more generally, pointing ultimately to the inextricability of "what you love and what you know":

One of the key questions that *Hers Is Still a Dank Cave* asks is how we can tell the difference between what you love and what you know. If practice presents an alternative to "traditional quantitative and qualitative scholarly research methods," it always raises the question of what kind of knowledge intimacy can yield.

How do we know when we are engaged in practice-based research and when we are just living? Is extracting meaning from everyday life the richest relation we can have to it?[21]

The texts in the artwork are ones that mean something to these artists—that mean something theoretically but also affectively, socially, politically, and ethically. These are texts that the artists recommend others read, watch, and engage with, based on how influential they were for the artists themselves; the practice of reading and citing these texts is, Mitchell and Logue emphasize, as much "practice-based research" as it is "just living."[22]

NAMING NAMES: CITATION, COMMUNITY, COMMUNION

As we have seen, citation forms an integral part of a queer feminist practice of world-making: referencing theory—for instance, reproducing a bookshelf, with the book spines visible, as a drawing in an art installation—becomes a way of building communities through discourses and ideas that are intersectional, liberatory, challenging, and affirming. These references create discursive bridges—for example, between second-wave lesbian thought and post-third-wave queer theory—through considered juxtaposition.

Others take a more cynical view of the use of citation in artistic and literary works and see the incorporation of citations into autobiographical work as a way to make the work seem more cerebral than otherwise. Writing on Moyra Davey's film *Les Goddesses* (2011) for the *New Yorker*, Jessica Weisberg writes, "By narrating her story through her favorite authors, Davey avoids the narcissistic pitfalls of autobiography."[23] This take on Davey's work from Weisberg—a critic who is perhaps less sympathetic to the autotheoretical mode than others—reminds us of the ways the charge of "narcissism" continues to be wielded against women artists who reference themselves in their work—and that the charge of "narcissistic" is, most often, mutually exclusive of being intellectual or conceptual. It is Davey's citing of others, Weisberg says, that "saves" her work from the pitfalls of narcissism and establishes it as intellectually legitimate and aesthetically

interesting. By referencing others alongside herself, her work is saved from the intellectually abject realm of narcissism.

In "Feminist Approaches to Citation," media arts curator Maiko Tanaka differentiates what Mitchell and Logue, in their collaboration as FAG, do with citations from what the more typical, patriarchal, Western models of citation *do*. Tanaka cites gender studies scholar Katie King's theory of critical feminist bibliography, writing that "a critical feminist bibliographic practice asks what and for whom are we invested in when we cite, what do we consider having value, and what kinds of research can be produced?" A feminist approach to citation might extend the citation as an institutional and legalistic device (one that we use to avoid plagiarism, for example) and as a means of recognition (of the author or the theorist, whose work is valued by the given system). The citation becomes a means of tracing both theoretical and conceptual lineages—the source of an idea—and relational/kinship and affective lineages. In Tanaka's view, FAG's practice exemplifies this kind of citation practice, wherein citation is a means of "making visible the lineages and legacies of inspiration and support that make up a feminist art community."[24] This is not unlike what Nelson does with her citational practice of naming names in the margins of the page in *The Argonauts,* where she mimetically reiterates the structure and conceit of Barthes's *A Lover's Discourse* using references to both feminist and queer theory and more standard canonical theorists, writers, and philosophers such as Wittgenstein.

Feminist theory and practice are well accustomed to the idea that a person citing an idea or text has a "personal" relationship to that text. Jeanne Randolph coined the term "fictocriticism" to describe her autofictional approach to art writing and criticism at the end of the twentieth century. Working as an artist and writer-critic in the tight-knit community of Toronto's Queen West scene in the 1980s–1990s, Randolph was looking for creative and critical ways to engender "critical distance" in her approach to writing about art. Fictocriticism emerged as her way of making-transparent her ties to the artists whose work she was responding to—friends, acquaintances, lovers, friends of lovers, neighbors. It was also a way for her to process these relationships as an integral part of the work, fictionalizing them in performative ways. By performing art writing and criticism as a "subjectivized" mode, Randolph reveals how "*all* art

critical texts inherently act out a subjectivized rhetorical form"—which is to say that no art criticism can purport to be objective or disinterested (in the Kantian sense, as understood by Greenberg).[25] Rooted in parafiction, Randolph's fictocriticism is aligned with the efforts of other post-1960s feminist artists and writers who experimented with incorporating their relational lives into conceptual work in ways that are critically and artistically generative.

Citing names of friends and fellow artists and thinkers is also a way of inscribing a community and, relatedly, recording and canonizing a movement (from within it). This tendency can be found across twentieth- and twenty-first-century avant-garde and experimental scenes, from Frank O'Hara and the first-generation New York School to John Cage and Merce Cunningham and the Fluxus scene, to Eileen Myles and the third-and-fourth-generation New York School poets. In such works as O'Hara's *Lunch Poems* (1964) or Cage's *Where Are We Eating? and What Are We Eating?* (1975), the poets or artists mention names of people they were associating with at the time—some of whom would become well-known figures in the history of twentieth-century art, poetry, dance, and performance.[26] What might seem like name-dropping to today's readers is, perhaps more accurately, the poet or artist naming shared influences in the community or scene in which they are embedded and invested. This does not mean that the names being cited do not still possess a certain kind of discursive value or social currency in a given scene—whether an experimental, avant-garde scene or an academic scene. As discussed in chapter 2, the issue of the fetishization of theory, and the formation of organizations, groups, cliques, and cult followings around certain theoretical frameworks or modes of thought—often summarized with the theorist's name (Kraus's parodic "Bataille Boys," or real-life groups such as the punning "Lacan Salon" out of Simon Fraser University in Vancouver)—remains present. The line between theory as an affirming and critical form of community building and communion and theory as uncritical fellowship or "followership" is a question that hovers over this book—and many artists who work autotheoretically fall somewhere between the two.

These practices of writing about people in one's life as part of a larger critical and theoretical practice are tied to the impulse of lateral citation as much as they are to the autotheoretical impulse of understanding one's

life in relationship to others—other people, other texts. Joanna Walsh's *Break.up* (2018) brings the self-reflexivity of autotheory full circle.[27] She extends the autotheoretical form of citing-in-the-margins that we find in Nelson's *The Argonauts*, and also incorporates quotations from other contemporary autotheoretical work; Kraus's *I Love Dick* (1997) and *Aliens and Anorexia* (2000), for example, feature heavily. She integrates quotations by other philosophers, artists, and theorists from the early through late twentieth century, among them Freud, Baudelaire, Kierkegaard, Barthes, Breton, Sontag, Scarry, and Carson. Referencing many of the works of autotheory I discuss in this book, Walsh demonstrates an awareness of the autotheoretical history on which she's riffing, as well as the experimental scene she is a part of—a scene in which presses like Semiotext(e), the book's publisher, play a central role, in another metalayer of self-reflexivity. Like O'Hara, Cage, and others before her, Walsh references the names of others working in the experimental (here, autotheoretical) ways that she is working, forging an aesthetic community of practice and form.

The flip side of citation as progressive community building and nourishment is the question of whether naming and references simply make a given movement or work more insular and inaccessible. I noted in chapter 2 that in order to get the joke of more parodic texts of autotheory texts— Musson's *ART THOUGHTZ* tutorials, or Safaei-Sooreh's theory logos—one needs a working knowledge of theory and art: one needs to know the reference to get the joke. It requires some working knowledge of theory and contemporary art to know what Kraus means (and why it's funny) when she refers to a group of young men gathering around her then husband as the "Bataille Boys," or what it means for there to be a Deleuze and Guattari logo on a Louis Vuitton–style bag. This excludes a substantial part of the population who might not have attended college or university, or who perhaps went to college but managed to avoid those "liberal arts" classes, or who are educated folks but simply don't like art or theory and don't find it interesting to visit art galleries or read philosophy.

That said, it is debatable whether theory is therefore inaccessible in a way that is problematic. Like other fields and professions, theory and art involve specialized discourses with particular languages, frameworks, and points of reference that allow a given community to communicate. Some defenses of theory turn to examples in other fields, such as medicine, to

describe the drive behind specialized language—the purpose, that argument goes, is not to alienate others but to devise a way of talking about something for which existing language is not enough. It is an argument I have used when describing the usefulness of theory for practicing artists when I teach my large first-year lecture class to studio art students at a Toronto university.

Reviewing *Autotheory*, a video art screening program I curated at the Vtape artist-run center in the spring of 2018, writer Chelsea Rozansky responded to the auto-orientation linking the works: "It isn't narcissism, but a kind of badass move, to assert your presence in a discourse that marginalizes you: that talks about you, but only to itself."[28] The artists' videos, though self-referential and often directly self-looking (many of the works engage practices of performing for the camera), might be described less as *narcissistic* and more as a process of bringing out their selves by referencing frameworks and discourses that have historically marginalized them (as Black, as queer, as two-spirit). In other words, they are autotheoretical. The works I assembled in the screening, which included Mitchell and Logue's *Hers Is Still a Dank Cave*, brought humor and levity to what can sometimes become a morose self-seriousness in theory and art discourse.

The "narcissism" of video art as a contemporary art medium describes the literal self-regarding that video art technologies made possible in the 1960s–1970s. The narcissism of video art was described in 1976 by art historian and critic Rosalind Krauss, who, following the theoretical footsteps laid out by her mentor and teacher Clement Greenberg, approached theorizing this emergent medium in terms of Greenberg's notion of "medium specificity." Krauss asked: What is the essence of the medium of video art? What is specific to this medium that makes it different from other media? What new practices does video art, as utilized by artists, make possible? The response she proffered was that the medium of video is not something aesthetic per se but is rather the psychic mechanism of narcissism itself. Video art can be defined, she emphasized, by its allowing artists to look at themselves, creating a loop of self-reflectivity that many artists, performing for the camera, have extended in conscious ways.[29]

As I assembled the screening during my research residency in Vtape's extensive archives, my interest was to consider the history of video art and narcissism through the idea of autotheory, used as a provocation through

which to approach Indigenous and Canadian video art. The earliest work I included in the *Autotheory* screening was Martha Wilson's *Art Sucks* (1972), in which Wilson uses performance for the camera to literalize the consumptive rituals of conceptual art and citation practices in the late 1960s and early 1970s.[30] While the title *Art Sucks* first reads as a deprecatory, presumably winking (this is, after all, a work of *art*) statement about art, it soon becomes clear that Wilson is referring to the way conceptual art can be said to *suck* in the sense of sucking things up, sucking things into itself, like a vacuum. As a young woman artist working in a 1970s art scene, Wilson sees the fundamental self-reflexivity of conceptual art traditions and calls it as she sees it: it *sucks*—it sucks everything back into itself, with an assimilative effect of literal incorporation (though with digestion comes the possibility for transformation).

Wilson often reads the artist's statement about a given work before moving into the "work" proper, a performance-for-video format that obfuscates the line between what constitutes the work and what constitutes the frame. The video presents the artist's statement—a framing device used in conceptual art—as part of the body of the work rather than as a frame that exists partially outside or in supplement to it (to take the Derridean sense of the *parergon*).[31] Seated at a table with a small stack of paper in front of her, Wilson addresses the camera:

Art-making is a process which sucks identity from individuals who are close to it, but not participating themselves. The only way to recover identity is to make art yourself. In early June, 1972, I captured the soul of Richards Jarden in a color photograph. As soon as I ingest the photograph I will recover the identity that was drained from me in the past, and we will be of equal power.

She goes on to show a photograph of the American conceptual artist Richards Jarden, one of her contemporaries. After presenting it to the camera, she tears it in four pieces and takes it in her mouth, chewing and swallowing each piece. The ingesting becomes a communion-like act in which the feminist artist incorporates a formative male conceptual artist into her body as a means of recovering her own agency as a conceptualist who works in proximity to him "in the scene."

Wilson's work comments on the idea that an artist must cite another, preexisting artist in order for their own work to be valid *as* art—a practice that academics are profoundly familiar with and that defines citation in its most base sense. Indeed, it would be difficult—impossible, really—for me to get this book past the gatekeepers of peer review if I weren't grounding my own theories of autotheory in what scholars before me have said.

The artist's rendering of citation as an act of incorporation—even cannibalization (she's eating another artist, or at least a representation of an artist)—brings to mind a point literary scholar Kaye Mitchell makes when she discusses empathy and intersubjectivity in recent feminist writings. Reading Kate Zambreno's autotheoretical book *Heroines,* Mitchell describes how the socially alienated–feeling Zambreno writes the lives of other women from history (other "madwomen" and "mad wives") around her own experience, with citation functioning, in the writer's mind, as the invocation of a community based on shared experience. But what might begin as a well-intended project of building community can become, Mitchell noted, cannibalistic when incorporated into writing and art.[32] When discussing Chris Kraus's identification with Simone Weil in *Aliens & Anorexia*—"Re-reading *Gravity and Grace* by Simone Weil, I identified with the dead philosopher completely," Kraus writes[33]—Mitchell asks: "Is this intense identification empathy, or is it appropriation?" I'm not sure I see it as either, though in works like Kraus's *I Love Dick* and Nelson's *The Argonauts* I would say there is less empathy and more appropriation, in the sense of taking the intertext into oneself, using the experiences of others as a form of self-help and self-understanding (which is then, as it turns out, shared with others through publication). In the context of an autotheoretical text, such a practice of self-help and self-understanding becomes part of a larger philosophical project, one that takes up questions about the nature of queer and cis-het relationships, or what it means to write about one's life, or to philosophize, or to write art criticism, or to be recognized as an artist, or "who gets to speak and why."

The tension between citation as a form of community-building that sustains oneself and others and citation as a way of incorporating others into oneself—a figurative cannibalization—for primarily one's own benefit (artistic practice, scholarly research, reputation, self-knowledge, the

health of a relationship with a partner) haunts autotheoretical works. As the Berlin-based artist Alanna Lynch put it in a virtual studio visit with me during my ongoing curatorial experiment *Fermenting Feminism* (she was speaking about physical processes of microbial transformation and interspecies symbiosis, in relation to kombucha SCOBYs, but I think her words are relevant here): "Symbiosis is not always mutually beneficial."[34] Sometimes, someone benefits more than someone else, even if you're feeding off each other symbiotically, in relationship through shared food sources or shared intertexts—where texts are their own kind of sustenance, for research and study. Community can become cannibalism; of her literary community of "modern madwives," whom Zambreno invokes around herself to feel less lonely in her experience as an academic's wife in a new town, she writes, "I began cannibalizing these women, literally incorporating them."[35] There is a desire for collectivity and solidarity and belonging; there is also the desire to return to how "I feel" and how "I experience this situation," which can be at odds with how *you* feel and experience the situation—something I continue to witness in even the most well-intending feminist- and social justice–oriented spaces. If my boundary is your trigger (and vice versa), then how do we organize together? Can autotheory, and the impulse toward collectivizing citation practices, provide some insight here—particularly when it comes to listening to and hearing each other both within and through our interrelated practices?

Other scholars are more optimistic about what lateral citation and other citation practices that involve this intense form of identification— what I refer to as intertextual identification—can do, politically speaking. Tanaka maintains that feminist citation practices do, in fact, have the capacity to provide "nourishment" for those who experience marginalization or displacement by the dominating systems of thought, like women of color or Indigenous people.[36] To illustrate, Tanaka provides an anecdote of her experience writing letters to her friend, a fellow woman of color, that were rife with citations of feminist literary and theory heavy-hitters like Claudia Rankine; these letters, Tanaka argues, make space for her and her friends' own experiences, anecdotes, and responses to reading to be legitimate sources to be referenced and shared. Tanaka extends Barthes's argument from "The Death of the Author," which names the reader as a coproducer of a text's meaning, to make a case that the reader's or

audience's lived experience is significant to the ongoing, multidirectional process of citation practices that come to constitute meaning in culture.[37] By formatting this argument through letter-writing with a friend, Tanaka underscores feminist citation as something to be shared. Tanaka and her friend, alongside Rankine, become "legitimate references" and sources of knowledge.

The question of whose voice constitutes a legitimate "source" to be cited bears consideration from an intersectional feminist perspective. As discussed in the previous chapter, this question emerges in *The Argonauts* when Nelson cites her lover, the visual artist Dodge, alongside other queer and queer feminist thinkers. It also undergirds Zoe Todd's discussion of the place of Indigenous scholarship within Canadian intellectual institutions, where she cites her own reflections as an emerging Métis scholar next to Sara Ahmed's writings on feminist citation:

Hiba Ali, *Postcolonial Language* (featuring Shreya Sethi, Diamond Stingily, Alé Alvarez, and Hiba Ali), 2013, single-channel video (still). Courtesy of the artist and Vtape.

We, both Indigenous and non-Indigenous scholars and artists alike, tend to cite non-Indigenous thinkers before Indigenous ones because the currency of words within the academy demands it. … Thinking *with* Ahmed's work, I argue that in dealing with Indigenous ontologies, citation is also a *resuscitation* of specific ways of framing legal orders and cosmologies themselves. As an Indigenous feminist, I seek through my work to revive and enliven the thinkers and worlds that honour and acknowledge the lives, laws and language of Indigenous peoples as distinct and concrete intellectual traditions in Canada.

Todd highlights the issue of valuation, referring to "the currency" of citations within academic institutions. Like Sedgwick's spatial positioning of "beside," or more recent discussions of lateral citations, Todd places herself as "thinking *with* Ahmed's work." She herself becomes an important lateral citation, referencing Ahmed's work while emphasizing her own long-standing commitment as an Indigenous feminist to enlivening sources and texts—"lives, laws, and language"—that the colonizing culture has sought to kill.[38] For Indigenous feminism, then, a feminist approach to citation is one grounded as much in "resuscitation" as in kinship, sustenance, and support for individuals and communities who have been, and continue to be, marginalized and oppressed by the dominant cultures.

REFERENTIAL ACTIVISM

While citation is an important part of autotheoretical practices, the creation of one's own theories from the substance and contexts of one's life is often just as important—this is part of what constitutes the shuttling of "autotheory" as a mode. Writing in their contribution to the introduction to the third edition of *Borderlands/La Frontera,* composed in "ten voices," T. Jackie Cuevas writes: "Anzaldúa's sense of activist-scholarship reminds the queer-minded, left-of-center that we must remember to hope—and to act—as we theorize. And that we must continue to make our own theories, not just believe the insidious lies that we are taught about ourselves and each other." Incorporating their own investments in Anzaldúa's work, Cuevas concludes: "I'm grateful to la Gloria as I navigate living Chicana,

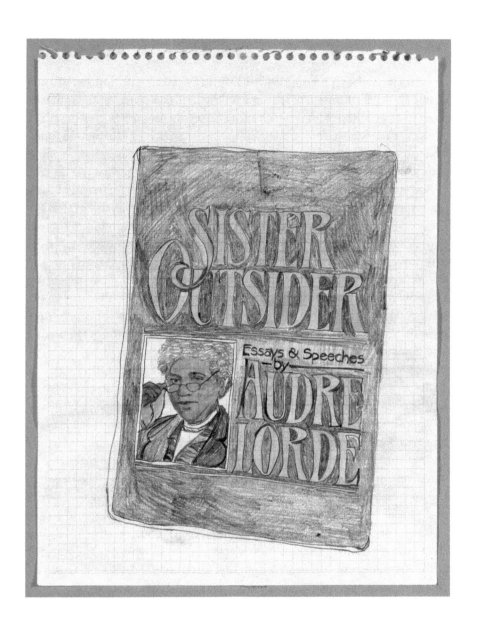

Cauleen Smith, *Human_3.0 Reading List
(Audre Lorde)*, 2015, drawing. Courtesy of
the artist.

living queer, living poet, living storyteller, living teacher, living activist-scholar, living borderlands every day."[39]

On December 30, 2015, Bhanu Kapil tweeted "'Citation is feminist memory.'—Sara Ahmed."[40] Citing a fellow feminist writer and woman of color in a tweet about feminist citation, Kapil demonstrates how practices of citing theory have extended to online social media platforms as a mode of feminist networking and disseminating ideas. By stating that "citation is feminist memory," Ahmed (and, iteratively, Kapil) suggests that there is a shared archive, a kind of textual collective unconscious for feminists that takes shape as citation. Ahmed configures the citation as integral to the preservation of feminist history (or "herstory")—a diaphanous history dependent on these decentralized, collective, ongoing processes of citing utterances, ideas, and texts. Reviewing Jill Soloway's on-screen Amazon Video adaptation of *I Love Dick*, McKenzie Wark writes, "The no-future sensibility of punk is now the general condition, which is also one of no-past."[41] The works of Nelson and Mitchell and Logue resist both tendencies: turning to the past through citation becomes a means of theorizing and envisioning a future for queer feminists.

Especially within BIPOC, feminist, and queer scenes, there can be a more explicitly politicized project of community building, cohesion, and recognition involved in the making-visible of citations in artwork, as an antidote to histories of oppression. An impulse toward ideas of art and writing as "world-making" projects is found in such spaces, where "world-making" means, most simply, imagining new, more progressive, intersectional, and just worlds. World-making projects shuttle between the speculative and the literal, which we find in works like FAG—Logue's and Mitchell's collaborations in curating and programming, and in art-making—and other recent feminist-focused contemporary art projects, like the Black Wimmin Artist committee and The Feast, whose 2019 gathering at the Art Gallery of Ontario brought one hundred Black women artists together to share a meal in the central space of the art museum.

In a project I am involved with for 2021, envisioned and directed by curator Jaclyn Quaresma at the Durham Art Gallery, I and three other artist-curators—Whitney French, Rebeka Tabobondung, and Myung-Sun Kim—were invited to "speculate the potential outcomes of feminist science-fiction author Octavia E. Butler's unfinished *Parable* series" in the

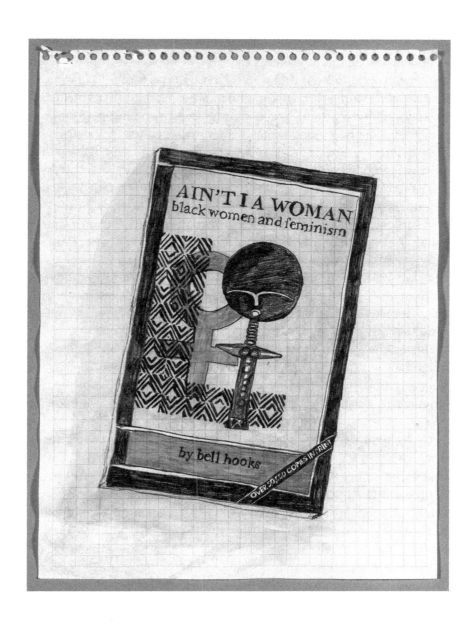

Cauleen Smith, *Human_3.0 Reading List (bell hooks)*, 2015, drawing. Courtesy of the artist.

context of the regional gallery space, as part of a larger project of collaboration and imaginings around Butler's *Parable* books. Quaresma invited us to organize exhibitions that would extend the possibilities of Octavia Butler's *Parable* series through experimental exhibition formats including site-specific interventions, like a community garden, and performative gatherings, cohering around four themes: trickster, teacher, chaos, and clay. Curators and artists, reading and discussing Butler's books together over the period of two years, will hone Butler's deep and generative, yet unfinished work in a contemporary context, processing through practice the possible lessons that Butler rendered allegorically through the science fiction genre. As I research Butler, prompted by my conversations with Quaresma, I'm moved to find her handwritten notes in her drafts—statements like "More Hispanics" marked in the margins, as notes to guide the writer as she represents the religion of Earthseed and the context from which it emerges. The margins are emphatically punctuated with exclamations. Even in her drafts, the importance of intersectional feminist world-making to her sci-fi is visible in Butler's work.

Black feminist artist and filmmaker Cauleen Smith foregrounds citationality as a collective practice of community building. In *Human_3.0 Reading List* (2015), Smith draws out the covers of theory books using dark graphite and acrylic on graph paper. The graph paper ties the work to contexts of school and learning, in contrast to a more "elevated," high-art space. In her artist's statement on the work, Smith explains that Black people living in Black Lives Matter–era America are "engaged in combat without the proper armor"; her work provides one response to this structurally constituted "lack" (insofar as, through generations of structural racism, Black people in America have been denied access to accumulating the kinds of generational capital—inherited wealth in the form of money, and other forms of value and protection—that many white Americans, especially those with class privilege and old money, have, which is one of many convincing arguments for reparations). Smith advocates for study—"deep and active study"—and critical conversation as activistic armor in place of weapons and alongside defense gear:

And so I declare once more: Black people are engaged in combat without the proper armor. In addition to gas masks and kevlar jackets, and smart phone video, we

require inoculations that repel the seductions of corporate servitude. I offer this as an action:

STUDY. Deep and active study.

Supplemented with CONVERSATION engaged in with the intention of producing RESISTANCE.[42]

Available in digital versions online, Smith's drawings are framed by her "Human_3.0 Reading List—The Manifesto," which articulates the impulse behind the project. She emphasizes the importance of reading books of theory and literature as consciousness-raising and mobilization for Black folks in America, in the era of the Black Lives Matter movement: "The rhetoric of this movement exists within a lineage of activism which has been informed by the lucid contributions of artists like James Baldwin and Nina Simone, to name just a couple." Smith emphasizes that this list is not intended to "make activists" but to "cultivate black consciousness which then inevitably defines and shapes and guides the actions and decisions we make as we shape and build our world": this distinction underlines how autotheoretical practice is grounded in the politics of everyday life.[43] Smith's reading list emerges from her life—she includes those books that have provided her with strength—and the collective "auto" of Black Americans that might find similar strength in these readings.

In most of the works, Smith draws the full covers of the books, complete with the cover art, the book's title, the author, and other paratextual information. Smith's illustrated reading list features books by writers like Toni Morrison, Darko Suvin, Sylvia Wynter, Cedric J. Robinson, Moraga and Anzaldúa, Lorde, Gerda Lerner, Haraway, hooks, Fanon, Paula Giddings, Elizabeth Alexander, Lawrence W. Levine, Hafiz, Du Bois, Samuel R. Delaney, Angela Y. Davis, Baldwin, Moten, Butler, and Muñoz—the last linking her work to Mitchell's and Logue's, as the artists grapple with shared ideas around queer feminist world-making in the twenty-first century.

Smith says her "abridged list" is a starting point—what she calls "an offering of study"—for later contributions and sharing. She encourages those who come across her work, whether online or as postcards distributed at cafés or book co-ops in Chicago, to read the books and draw the covers of other books they want to add to the rolling collection. The reading list did not originate with Smith: it was built from lists shared with

Cauleen Smith, *Human_3.0 Reading List
(Frantz Fanon)*, 2015, drawing. Courtesy of
the artist.

Cauleen Smith, *Human_3.0 Reading List
(Angela Y Davis)*, 2015, drawing. Courtesy of
the artist.

the artist during her years of study with scholars and activists like Angela Y. Davis; now, she shares the list with others to provide access to theory outside universities. "Our Universities cannot exist without enslaving students through debt," Smith writes, citing Moten and Harney's *The Undercommons*. To quote Smith:

These 14 books[44] are just the start, all that I had time to draw. These are some of the books that literally changed my life, saved my life and sustain my life, but also, (fair warning) make it difficult for me to go along, get along, look the other way, and gets mines. These behaviors neatly summarize the Neoliberal Code of Conduct, to which I say: Screw you. I share these books in the hopes that through study and conversation exchange occurs and the inoculation sticks. Resistance is not futile. RESISTANCE IS ALL WE HAVE.[45]

Smith not only draws out the books by hand; in some of the images, she brings the hand directly into the image, drawing a hand—often a Black hand—holding the book of note. In each case, the trace of the artist's hand is there through the haptic materiality of graphite on paper. As a form of haptic reproduction, copying something by drawing it by hand has a different kind of affective charge than, say, reproducing it with an iPhone photograph. Smith's drawing of the covers of theory books—like Logue's and Mitchell's—is performative and iterative: rather than the uncanny effect produced by close resemblance to the original, these drawings are clear about their differences from the "actual" text. Drawing these book covers takes time, and Smith mentions the logistical parameters of life under neoliberalism when she explains that the books on the list are only those that she had the "time" to draw. Tactile and ritualistic, appearing friendly like a comic or a children's book, the practice of mimetically drawing out theory books makes them—academic as they might be—more approachable for more people.

The act of metaphorically arming oneself with books of theory also emerges in the work of Black artist Carolyn Lazard, there in relation to the phenomenology of chronic illness and hospitalization. In Lazard's *In Sickness and Study* (2015–2016), the artist arms herself with books of theory and literature each time she receives blood transfusions for an autoimmune disorder. Lazard repeats the performance series over the course of two years, documenting it with a selfie for each book that she takes

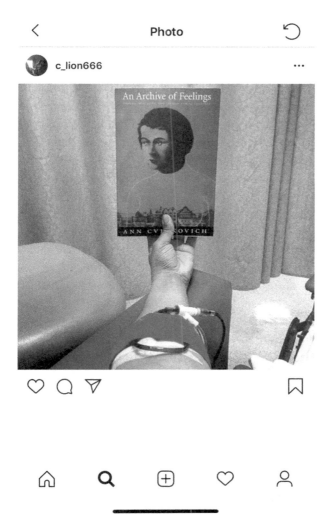

c_lion666 ...

Carolyn Lazard, *In Sickness and Study (An Archive of Feelings)*, 2015–present, digital photograph posted to Instagram. Courtesy of the artist and Essex Street Gallery.

with her iPhone camera. The composition of each digital photograph is similar, focusing on Lazard's arm, bandaged and connected to an IV drip. Her arm is extended and holding a single book out with the cover facing the camera: such books as Audre Lorde's *Sister Outsider,* Ann Cvetkovich's *An Archive of Feelings,* McKenzie Wark's *Molecular Red*, Fred Moten and Stefano Harney's *The Undercommons*, Alison Kafer's *Feminist, Queer, Crip,* and Octavia E. Butler's *Dawn.* The act of posing with books of feminist and queer theory is an autotheoretical gesture found on social media platforms such as Instagram, which is where Lazard first shared this work as a web-based performance of sorts. Here, the self-imaging of Adrian Piper's *Food for the Spirit* (1971), discussed in chapter 1, returns in a different way.

The given canon—if we are to use this concept, fraught as it is—from which an artist, writer, or critic draws when sourcing citations and points of reference in their autotheoretical work will shift according to context, be it cultural, geographic, historic, or social. This becomes clear, for example, when looking to autotheoretical works by Indigenous and Black writers and artists. The books Lazard chooses to bring with her to her hospital visits are often feminist or feminist-adjacent theory, as well as books that engage issues around biopolitics and the medicalization of bodies. These autotheoretical practices are themselves often practices of canon making, based on which texts they select and represent through photography, drawing, and performance. In Lazard's case, not all the books are "theory" in the strict sense; there is also literature, including fiction, that operates in proximity to theory—Octavia E. Butler's science fiction work *Dawn,* for example, which is wrapped up in critical projects of social justice, political imagining, and new world-making.

Lazard's ongoing project of performance for the camera brings into practice ideas that she has explored in her other writings, like "How To Be A Person In the Age of Autoimmunity," which recounts the story of her diagnosis with Crohn's disease.[46] This autotheoretical text, written as a first-person narrative grounded in the lived experience of chronic illness, is framed with an epigraph from an 1827 letter written by Goethe to Hegel: "I'm afraid that then dialectics in its total abstrusity is only good for totally sick, ill, and mad people." Lazard's text, written in 2013, would go on to be cited in subsequent autotheoretical writings on illness and pain, including artist, writer, and self-described psychonaut Johanna Hedva's *Sick Woman Theory.*[47]

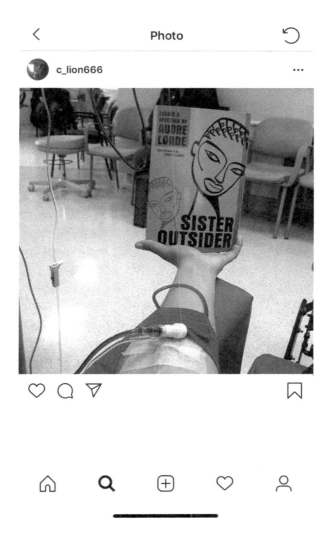

c_lion666

Carolyn Lazard, *In Sickness and Study (Sister Outsider)*, 2015–present, digital photograph posted to Instagram. Courtesy of the artist and Essex Street Gallery.

In autotheoretical practices, citations can take the form of a kind of speculative, even spiritual, communion with theorists and philosophers. In Larry Achiampong and David Blandy's *Finding Fanon Trilogy* (2015–2017), the artists create a three-part cinematic series that autotheoretically takes up the philosophy of Frantz Fanon in a twenty-first-century, globalized context, through the premise of the artists collectively seeking out Fanon's lost plays. The men became close friends during their studies at the Slade School of Fine Art; in their collaborations, they think through their respective positionalities in the wake of Thatcher-era England and the ideas of so-called postcolonialism that were circulating at that time.[48] They co-authored the script of *Finding Fanon*, a shared narrative where it is not clear who wrote what, blurring the racial divide at the level of authorship. The script takes the form of an overlaid audio narration, giving an autotheoretical framework to the actions performed on-screen. The film's conceit of a "quest for Fanon" drives the narrative forward while reenergizing Fanonian philosophy from at least two interdialogic, contemporary points of view.

Their script integrates Fanonian thought, found texts, and personal statements, the two men contemplating Fanon's work decades after its writing. Their writings take up key ideas in Fanonian philosophy—the psychopathology of colonialization, ideas of radical anticolonial humanism, and the impacts of decolonization—from their perspectives as artists with different racial backgrounds and experiences in Britain. In the third film of the trilogy, Achiampong and Blandy are performative stand-ins for Fanon and Jean-Paul Sartre, and the film is inspired by Fanon and Sartre's textual conversations and collaborations (Sartre wrote the preface to Fanon's 1961 work *Les Damnés de la Terre,* which can be read as a gesture of allyship to Fanon's psychoanalytic critique of colonialism at the height of decolonizing movements in Africa[49]):

It was only in their search for the lost plays of Frantz Fanon, a man who predicted much of what we will show you ... that everything became clear. It's an unfinished conversation. It's never-ending. It has to be.[50]

In the films, Achiampong's Blackness and Blandy's whiteness visually play off each other; many of the actions show the men "sharing space," underscoring the omnipresent theme of solidarity across difference. There is a quiet sense of calm compassion, as the men move through an unnamed, undated future that is ambiguously utopian or dystopian—but certainly postapocalyptic. By focusing in on the material, resource-driven aspects of colonialism and its impacts on the land in *Finding Fanon Part One*, the artists gesture to the fact that the colonialist drive is still very much present—in the mining of minerals for iPhones, for example. Yet over the course of the three films there is a hopeful mood that vibrates between sentimental and stoic, heightened by a soaring cinematic score. In *Finding Fanon Part Three,* themes of collective world-making and futurity come to a head as the artists bring their children in as "nonactor" actors alongside them: Achiampong's two Black children, and Blandy's two white children, walking with the artists together through an undetermined land. As they seek him out, the philosopher Fanon (present through the legacy of his written words) becomes their guide.

In works like Smith's *Human_3.0 Reading List* and Achiampong and Blandy's *Finding Fanon Trilogy*, the artists show their beliefs in the possibility of a better future by visually representing and allegorizing books and theorists that energize and nourish their cause. Refusing the academic and art world trends of Afro-pessimism or Afro-futurism, Smith employs autotheory to affirm the value of reading theory as something with the capacity to change communities for the better. She grounds these affirmations in her own lived experience: "This reading list is for the Doers-Who-Think; not the academics who think there's no point. This shit is for the afro-nihilist. Because the only reason to destroy a world is if we share the fundamental belief that a better world is possible."[51] Works by Lazard, Smith, Mitchell and Logue, and Achiampong and Blandy embody the possibility of social and political change and personal empowerment and care through consciousness-raising and envisioning of more inclusive and livable futures for more people, invoking BIPOC, queer, and feminist theorists as allies.

The autotheoretical project, alongside the citational practices discussed throughout this book, involves reflecting on history, ancestry, land

and place, embodied existence in a given place at a given time, the philoso-
phers and theorists before us who have passed, whose texts and ideas and
words live on in and through us: how might we commune, as it were, with
these ancestors? In *Finding Fanon Part Two,* the artists ask, "Do you really
think Fanon is here? Is there some remnant of his plays embedded on the
top of that mountain? Above that rendered sky?"[52] As they move through
the landscapes in their video, bringing their children in with them, the
answer seems to be—somewhere in their hearts and minds—that yes, in
some sense he is here.

Larry Achiampong and David Blandy, *Finding
Fanon Part Three,* 2017, film (still), image by
Claire Barrett. Courtesy of the artists.

YOUR AUTO IS OVER (IF YOU WANT IT): AUTOTHEORY
AND IDENTITY DEATH

What can I do about all the years I defined myself as a feminist? I have no other alternative but to revise my classics, to subject those theories to the shock that was provoked in me by the practice of taking testosterone. To accept the fact that the change happening in me is the metamorphosis of an era.
—Paul B. Preciado, *Testo Junkie*

One of the flip side of feminist world-making projects is the revelation that, with true change comes certain forms of loss. In the thick heat of the Toronto summer in 2014, I and my two friends and collaborators, Amber Christensen and Daniella Sanader, biked over to Logue and Mitchell's house to interview them. The topic was the artists' vision for a Feminist Art Fair International (FAFI), which would require the creation of an intersectional feminist economy not predicated on capitalistic, patriarchal, neoliberal modes of circulation and value.

FAFI was a speculative idea, or ideal, that would require a complete reimagining of what an art economy could mean. During our conversation, Mitchell and Logue conceded their exhaustion: their collaborative work, using their own money to organize and pay artists, uses all kinds of energy, and they were committed to the work of paying artists—with no exceptions—and making art as lesbian feminists. And yet they are not unaware of their privileged positions—as white, settler feminists, as a professor (in Mitchell's case), and as home-owners. "We use our privilege," they said, as they reflected on the choices they have made throughout their life to put the intersectional feminist theory they held in such high regard into *practice*.[53] In the time since, though, the artists have had to grapple with some difficult truths in relation to their own subject positions in their larger, present-day queer communities: the "lesbian," it seems, is over.

What would it mean for these lesbian artists to no longer have their identity of "lesbian" to hold on to—if their core identification, as they have known it throughout their lives, is at risk of extinction? One of the crisis points in Mitchell and Logue's work with "lesbian" came in the wake of the first iteration of their *Killjoy's Kastle,* staged in Toronto in the fall of 2013. The work was vehemently critiqued by some as trans-exclusionary, with

many of the work's "jokes" (related to castration, for example) received as violent and triggering. The artists took these critiques seriously, and while they might not have themselves agreed—one of the hand-painted signs in the entrance way warns, in the characteristically winking, kitsch-witch discourse: "No satanic transphobic humans allowed!," and trans-identified folks were an integral part of the project—they reworked the work and continued to engage in difficult conversations with the different communities they brought the work to, including queer communities in Los Angeles and Philadelphia, where the project was positively received.[54] But the initial opposition to their piece signaled something larger, which remained with the artists and which they took seriously: a turn by a growing number of queers against classic forms of queer identification.

Although lesbianism might not be over, the identity of "lesbian" seems, for some, to belong to another era. Unlike other reclaimed words, such as the Dan Savage–championed "fag/faggot" and terms like "trans," "non-binary," and "genderqueer," the word "lesbian" is seen in some queer communities as overinvested in a passé view of womanhood and gender difference. It is a problem that the term "bisexual" (which I remain invested in, in terms of my own identification) has come up against too—with its etymological ties to the gender "bi-nary." Terms that are seemingly more open when it comes to the spectrums of identities and sexualities, such as "pansexual" and "queer," have emerged as a counter to the ostensibly 1970s-feeling "lesbian" and the 1990s-feeling "bisexual," both of which have been critiqued for their ostensible exclusion and exclusivity—although such critiques are, in my view, both ahistorical and overly simplistic, often ignoring the actual perspectives of those who identify with those terms for a superficial understanding of what those terms signify.

Mitchell and Logue, as middle-aged lesbian artists, are not unaware of this, and it seems they have been processing it in subtle and conceptual ways through their work over the past decade. Much of their work of processing queer theory's histories and futures includes their practice of theorizing—from their lived, embodied experiences—the ontology of lesbianism and the figure of the lesbian. Even the artists' preservation of historical feminist texts, such as the lesbian writer and theorist Monique Wittig's *The Straight Mind,* in their video art and installation works is not without its ambivalence; Heather Love writes of how Logue and Mitchell

stage the second wave as a kind of "historical hangover," even as the artists include many second-wave works in *Recommended Reading*.[55] Logue and Mitchell are self-aware about the ways certain theories and modes of theory—such as "second-wave lesbian theory"—are differentially coded and valued. Their strategy, to juxtapose such theory with more recent—and perhaps more relevant (the equivalence between more recent and more relevant is a question here, as is the question of the historicity of identities and terms)—theory, seems to have produced the revelation that they must mourn their own lesbian identities.

Mitchell and Logue's work has long been invested in ideas of lesbianism and lesbian-identified communities, from Mitchell's now canonical (in queer feminist scenes) "Deep Lez" to their collaborative *Killjoy's Kastle: A Lesbian Feminist Haunted House*. Their autotheoretical work continues to mobilize lesbian-feminist critique in incisive and playful ways in contemporary art. Their recent work on lesbian death, in the sense of the proverbial death of "the lesbian" (not to be confused with the pop cultural trope/joke of "lesbian bed death") extends their autotheory in a melancholic direction as they investigate the question of whether the discursive identity and term of "lesbian" is now *passé* in the contemporary queer communities in which they live and love. Logue's artwork has long taken up death, and their recent project with Mitchell and artist-scholar friends and peers Eliza Chandler, Kim Collins, and Esther Ignagni on *Deathnastics: Feminist Crip World Making,* dives into questions of disability, accessibility, and dying with dignity through a transinstitutional, crip-led, academic-artistic collaboration.

The "death" of one's identity—an identity one has long defined oneself as, and has reperformed day after day, in the Butlerian sense of an identity "instituted through a stylized repetition of acts"[56]—raises interesting questions around autotheoretical practice and the instability of the "auto." It must be said that, very often, the drive behind such identity-death (or identity killing) is venerable: an identity might be exclusionary, for example, or in other cases outright hateful and violent. Many of us would like to see the final death of "white supremacist" or "Nazi," for example, as a self-defined identity, though with the rise of neo-Nazism and the surging of white supremacy around the world this seems unlikely. The case of the "lesbian," though, is more nuanced. Trans-exclusionary

lesbians, rare though they might be today, have seriously tainted the lesbian brand, and those identifying specifically as "lesbian" are sometimes seen as exclusionary, even as there is a large, transnational community of young, intersectional, trans-inclusive, lesbian-identified folks emerging as part of a younger queer generation.

The problems of ahistoricity and preservations of still valuable aspects of queer history factor in here, as does the question of how self-defining identity circulates, takes on value and cachet, and depreciates in value over time. Some terms—especially those associated with masc-ness (that is, terms used to describe male homosexuality)—seem more resilient, and this is surely a feminist problem. Might the words that those in the millennial generation are readily claiming, for example nonbinary, pan, and gender fluid, be "dead" or problematic in a few decades (perhaps for non-binary's invocation of "the binary" through a negation of it that nonetheless points to and relies on binaryness)? And what will they/we use then? I ask this even as I identify somewhere along the gender spectrum—queer/bisexual nonbinary femme (she/her and they/them pronouns)—and nevertheless am somber in my respect for my lesbian-identified friends. While this is more a thought experiment than anything else, I raise it here to get at the problem of discursively killing off identity categories, and the ways autotheory can take up these problems through lived experience, considered deliberation, and care. It is a consequential question for histories and theories of feminisms and LGBTQQIA2S+ communities.

Still, the question remains: is there is a time-based nature to certain identities, of which "lesbian" is but one example? The politics and aesthetics of autotheory in contemporary art are further complicated when a self-identified identity (in the sense of a chosen term by which one identifies and finds oneself in community) might not be permissible or permanent and, in fact, might be subject to changing fads and discursive death. What does it mean for a given identity to *die?* What happens to the person whose identity has "died"? Where does that leave the one for whom that identity was integral to their sense of self, and their sense of belonging?

Mitchell and Logue's work over the past five years is both a kind of experimental self-documenting of their practices *as* lesbian artists up to this point—and their communities, their networks, their performances, their potlucks (that supposed staple of lesbian culture, referenced by the queer

feminist art journal *nomorepotlucks*)—and a heartfelt questioning as to what comes next. In their recent presentation "Lesbian Death," offered as part of Lisa Steele's *Female Voices* program at MOCA (2019), Mitchell and Logue played a documentation video from *Killjoy's Kastle*.[57] The installation and the many diverse, queer humans who made it happen seemed so different from the trans-exclusionary narrative I had heard about the work, and as I watched the video to the end, the weight of the work—its politics and reception, its difficulties and small successes, its pleasure and its pain—sank into my body.

The question of lesbian history, futurity, and death is thoughtfully taken up in more detail in both recent works, such as Cait McKinney and Mitchell's *Inside Killjoy's Kastle: Dykey Ghosts, Feminist Monsters, and Other Lesbian Hauntings* (2019), and past works, such as *The Aerial Letter* by Nicole Brossard (1985).[58] Muñoz's declaration that "queerness is not yet here" is a refrain throughout Mitchell and Logue's *Hers Is Still a Dank Cave*, and while death does not emerge explicitly in the work, there is an unavoidable sense that something meaningful is about to end. Like Preciado reflecting, in the epigraph above, on his shift from self-defining as "feminist" for many years to self-defining as something yet-to-be-determined, Logue and Mitchell ask: What comes next? In *I'm Not Myself At All,* they concede that "we may never touch queerness," echoing Muñoz's sentiment cited earlier in the video.[59] That queerness—specifically, queer feminism—is a horizon these artists will continue to crawl toward, next to their multispecies companions, without the expectation that it can be attained in their lifetime, is implied through these works.

What lesbian death reminds me of, in the context of a reflection on the autotheoretical impulse in contemporary practices, is the fragility of the *autos* as the ground for our sense of knowledge and understanding, our sense of *self.* As feminist philosophers and activists before us have made the case, identity is important: our practices of making-knowledge and of speculating and coming-up-with-theories and enacting politics is grounded, fervently, in a subjective self. But what happens when that self no longer exists—or at least not as one has been accustomed to name it? What happens when the integrity of that *self*—particularly or, *especially*, as constituted in discourse (here, the "lesbian" as a particular discursive category, temporally marked and different from "queer woman")—is

challenged? What if, as Mitchell and Logue seem fatalistically aware, the challenging of that sense of *self*—that very category of one's *autos,* or of one's *autotheory*—is a necessary part of the politics of intersectional feminisms to which they are committed? What happens then? Is there an endpoint to autotheory? A half-life?

There will come a day when all of our *autos*, no matter how discursively-materially resilient, will come to an end. The question of both literal death and discursive death, both material in their own ways, is a question of particular importance to ideas of autotheory and the autotheoretical turn in contemporary cultural production. Are there possibilities for discursive change alongside social change, particularly when it comes to artistic and critical practices oriented toward the politics of queerness and sexual diversity? With its attunement to the nuances of identity and identification, belonging and becoming, autotheory can make space for practices that work through the fluidity of identity in all its beginnings and endings and middles, and make space for the mourning of those identities that cease to discursively and maybe even materially exist, carried off by political and aesthetic and social and biological changes, doing so with due diligence and respect. Autotheoretical practices of citation become both drivers of that change and a documenting of it, preserving an image of selves in flux.

5

J'ACCUSE

Autotheory and the Feminist Politics of Disclosure and Exposure

It's okay for Vito Acconci to do his sex thing under the floorboards—that's called conceptual art. But when I wanted to do a conceptual piece—a massage parlour with me being massaged by men—my dealer just smiled and said, "Hannah, why don't you just come up to my hotel instead?"
—Hannah Wilke, "A Very Female Thing"

To speak about excess and sacrifice, it must become excessive and sacrificial. It must become simulation if it speaks about simulation, and deploy the same strategy as its object.
—Jean Baudrillard, "Why Theory?"

In this chapter, I focus on the politics of disclosure in relation to autotheory as a contemporary mode of practice across the arts. To do so, I focus primarily on the American art writer and filmmaker Chris Kraus's first major published work, *I Love Dick* (1997), a formative autotheoretical text that has already appeared several times in this book, along with its 2016 adaptation for the screen.[1] Looking to the charged gender-based politics of transgression in relation to contemporary theory, I consider the mechanisms of autotheory by which Kraus subverts the structures and terms of male-authored theory, primarily the lineage of French poststructuralism as it has come to be produced and consumed in artistic and academic spaces in the West. On the one hand, the mode of feminist empowerment

that Kraus performs in *I Love Dick* is "very 1990s" and very American; yet her disclosures of the bad behavior of known, named men in the worlds of contemporary theory, art, and academia are perceptively prescient of what would come to be known as the #MeToo movement, a term coined by Black American civil rights activist Tarana Burke in 2006 and, just over a decade later, a hashtag that went viral. Given how practices of public disclosure continue to be a primary recourse for women and those who are gender nonconforming who have experienced sexual impropriety and violence—after years of being failed by the systems in place to protect them—Kraus's complicated text continues to ring relevant for many.

OUTING BAD BEHAVIOR IN THEORY

Chris Kraus's 1997 *I Love Dick* is a cult novel in which the character "Chris Kraus" develops an obsession with "Dick," an "English cultural critic" and acquaintance of Chris Kraus's husband, "Sylvère Lotringer." In the auto-theoretical world constructed by Kraus, the author features as the third-person protagonist Chris Kraus alongside Lotringer—Kraus's real-life ex-husband and founder of Semiotext(e)—and Dick. Dick goes without a surname in the book but, following a series of events following the book's publication, he was revealed to be Dick Hebdige, the author of the 1979 *Subculture: The Meaning of Style*.[2]

Subcultures and postmodern theory are often seen as sites of *resistance* to a dominant culture, but they can also be sites of their own pernicious power imbalances and oppressions—a point Kraus engages directly in *I Love Dick*. If Hebdige theorizes subcultures, and Lotringer, Deleuze, and Guattari theorize "schizo-culture," then Kraus theorizes the men who theorize subculture and schizo-culture. In *I Love Dick,* Kraus takes to task the lived actions of some of these notable men in relation to the politics of their work, writing autotheoretically and autofictionally to integrate her lived experience in relation to their lives and work. Through the genre of autotheory—and her comedic, even *baffling,* take on it—Kraus exposes the hypocrisies of a nominally left-wing, Euro-American intellectual community, and raises questions around the possibilities of a feminist

counterculture and the effectiveness of experimental writing at the end of the twentieth century.

"So it was that many who became feminists began by questioning the radical questioners," writers Rachel Blau DuPlessis and Ann Snitow relay in their *The Feminist Memoir Project.*[3] Kraus's own journey of finding her "I" in *I Love Dick* begins with her questioning the radical questioners around her. From critiquing the sexism of Deleuze and Guattari's dinner parties to blaming performance studies founder Richard Schechner for "ruining her life," *I Love Dick* is riveting for a niche base of feminist readers—including women and gender-nonconforming graduate students, artists,

Chris Kraus, *Gravity and Grace,* 1995, film
still (16mm film transferred to video).
Courtesy of the artist.

and writers—for whom Kraus's mode of critiquing theory *through* theory, parody, and diaristic writing is refreshingly brash. *I Love Dick* has received a surge of interest in recent years due in part to its prophetic moves around public shame and blame, which finds re-energized relevance in present-day feminist movements. The book shares with fourthwave, postinternet feminists the strategy of disclosure or "outing" of the bad behavior of known, named people as a means of resisting sexual harassment, assault, rape culture, and other abuses of power. Exceeding generic categories and disciplinary delineations, Kraus's often perplexing book has been described in terms like "theoretical fiction" and "sad girl phenomenology."[4]

The popularity that *I Love Dick* has received in its subsequent editions (2006 in America, 2015 in the UK) has been attributed in part to the shifts in culture brought on by blogging, social media platforms, and the "confessional culture" of "oversharing" that these new technologies facilitate. Reflecting on the contrast between the demonization of *I Love Dick* in 1997 and its celebration in 2016, Kraus points to the "more porous ... boundaries of privacy" that we are accustomed to today.[5] Kraus's radical blurring of "art" and "life" in *I Love Dick* is one of the reasons why her work reverberates with millennial feminists: in a postinternet age of widespread disclosure made possible by social media—seen most recently with the #MeToo movement, which, emerging from a history of grassroots feminist efforts, has had mainstream effects in popular culture—Kraus's disclosures translate to an urgent and contemporary feminist politic. To be sure, a large part of Kraus's practice as a writer and self-identified "failed filmmaker" is taking issue with specific theorists and their lived actions, drawing attention to contradictions and hypocrisies between rhetoric and practice. Whether it is poststructuralist men like Guattari excluding women from their anthologies of theory or the revered professor Schechner, founder of the discipline now known as performance studies, behaving in culturally appropriative and sexually inappropriate ways with students, Kraus does not hesitate to call out specific people.[6]

In 2016, *I Love Dick* was adapted as an Amazon Video series by American writer and director Jill Soloway and Sarah Gubbins, with Kathryn Hahn cast in the role of Kraus and Kevin Bacon cast as the titular Dick. The series was canceled in January 2018 after one season, but it contributed to bringing Kraus's book to the attention of a new generation of readers. The

challenge of adapting a book like Kraus's for a more mainstream audience is not lost on Soloway, who acknowledges, in her own critically reflective memoiristic book, *She Wants It,* in which she thoughtfully takes account of her own decision-making processes as a showrunner, that: "When we made the first season of *Dick* and it went out into the world, I realized that Chris had written a show about feeling invisible, and that maybe this created an alchemy where the show was destined to not be watched."[7] Soloway's concession, which comes from a place of staying curious about Kraus's work, taps in to the politics of legibility and understanding that *I Love Dick* is, in fact, about. Despite the book being over twenty years old, and despite the speed with which "feminism" as a movement can move past its earlier waves, something about *I Love Dick* continues to resonate with feminist readers today. Kraus's experimentation pushes up against the limits of what is proper both to the patriarchy and to feminism as a movement, and it stands as an example of the power of comedy, literature, and art as spaces to test the limits of what is possible or effective in cultural production—to think outside what is permissible in other spaces—even as this can also open up the work to misunderstanding.

In *I Love Dick*, Kraus writes from the position of a failed artist married to a man who holds great editorial power in shaping the discourse of contemporary theory in America—which in turn shapes the dominant understandings of politics and aesthetics (of art, language, and so on). She draws influence from the philosophies and strategies offered by feminist theory to subvert those systems that suppress her—including male-led poststructuralism. With a late postmodern self-awareness, an incisive and reflexive relaying of anecdotes, and informed disclosure of real-life details, Kraus is unfaithful in her assumption of the role of philosopher's wife, a role described as such in Irigaray's French feminist critique of the history of philosophy.[8] Through this unfaithfulness, she engages in a strategic performance around "Dick" as part of her "transformation toward self-definition" apart from her husband and, it follows, the patriarchy as it stands in 1990s American critical theory.[9] Kraus's exposing of imbalanced power dynamics in art and academia from the self-immolating position of a "failed" artist who has a simultaneous privileged insider/outsider view of things is a complicated contribution to theory and feminism that warrants more study by scholars of contemporary literature and theory—not only those engaged with feminism and gender studies.

Within the contexts of *I Love Dick* and of Kraus's own life at the time of writing (1993–1994), metonymically, Lotringer and Dick stand in for what Irigaray calls the "master discourse" of theory in its late twentieth century manifestation: namely, 1970s male-authored French post-structuralism in America. As discussed in the Introduction, Semiotext(e) did not publish much work by women until Lotringer began his relationship with Kraus in the 1980s—and even then, the writing by women was framed as fiction. Regardless of whether Lotringer is justified in denouncing feminist theory for its perceived psychoanalytic leanings,[10] he is embroiled in the re-entrenching of contemporary theory as "master discourse" through limiting definitions of theory that exclude women. While contemporary theorizations of gender complicate, or even make untenable, such overly determined binary oppositions as "male" and "female," I use these as unstable points of reference throughout my discussion of Kraus's work in a way that mirrors the cheeky mimicry of Kraus's own invocations of a generalized male/female opposition—a binary that functions ultra-performatively in *I Love Dick*.

Kraus's text opens with "Scenes From a Marriage," a kind of film script synopsis in which Kraus introduces herself, Lotringer, and Dick as characters who fulfill particular predetermined roles in the story. While the men in this scene occupy the realm of the mind, engaging in intellectual discourse with ease, Kraus occupies the realm of the body, subject to the male gaze that feminist film theorists have, by the time of Kraus's writing, theorized to the point of exhaustion. In this scene, set at a dinner party, the men are to criticality what the woman is to carnality. Kraus riffs on this binary, while at the same time evading the predictable feminist script:

Over dinner the two men discuss recent trends in postmodern critical theory and Chris, who is no intellectual, notices Dick making continual eye contact with her. Dick's attention makes her feel powerful, and when the check comes she takes out her Diners Club card. "Please," she says. "Let me pay."[11]

Kraus combines feminist attributes—paying for the bill—with stereotypically feminine ones—her power, in this scene, comes not from her active participation in the literal and discursive economies between men

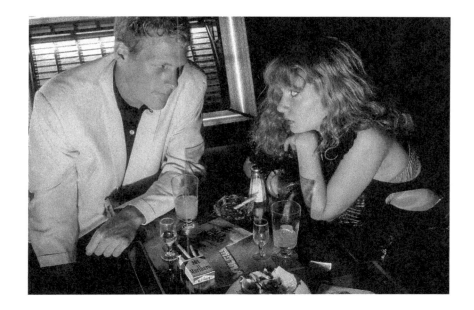

but from her receiving "Dick's attention" through the form of "continual eye contact." This sets the tone for the kinds of ironic, mimetic jokes that ensue. When we understand the book as a series of strategically mimetic acts, the power of the joke—at least for a feminist readership—is underlined. Though excluded from the Symbolic Order of theoretical language and suppressed as a speaking subject as a result of her gender, Kraus nevertheless feels "powerful" because she receives Dick's attention; within the conceit of this joke, the power Kraus experiences from being objectified overrides the power of her desire to be an intellectual. From the outset, she "assumes the feminine style and posture assigned to her within this discourse," and in this way sets the stage for her performance of reproductive mimesis, whereby this feminine performance is but a strategic first

Chris Kraus, *The Golden Bowl or Repression (2),*
2018, digital print on 100 lb uncoated paper,
edition of 5. Courtesy of the artist.

step in the gender inversion she stages in the book.[12] As a self-identified "failed filmmaker" writing an anecdote from her own life in the form of a cinematic pastiche, Kraus satirizes the state of the free and equal woman in a "post–women's lib" society of the late 1990s by foregrounding her agency as both an object of desire and a willing consumer with the economic agency and capitalistic power to pay for dinner—one who leaps past the gender-equitable "going Dutch" to paying for the whole table.

Transmuting the material of her life into cinematic anecdotes, Kraus frames the scene as a darkly comic melodrama where the men represent the elevated discourse of "theory" and women represent something "other"—that which is "unarticulated" and unarticulable, at least within the structures and discourses that Kraus has access to. "Because she does not express herself in theoretical language," Kraus writes, "no one expects too much from her and she is used to tripping out on layers of complexity in total silence."[13] In this faintly fictionalized world, it is not that women are incapable of abstract theoretical thought—as she states here, the character is "tripping out on layers of complexity" in private—but that they have not yet found a language through which to publicly articulate themselves in a way that will be understood by the men who could listen. Here we return to the dilemma Irigaray perceived in the 1970s, when she suggested the strategy of mimesis, while other French feminists, like Cixous, sought a feminine form and language for writing oneself that existed outside the bounds of phallocentric discourse.[14]

Over the course of I Love Dick's plot, Kraus mimetically moves from the phallocentric order of male theorists and cultural critics and her corresponding role as an "Academic Wife," established in part 1, to the role of autotheorist who references the work of other feminist artists, writers, performers, and activists in part 2. Making strategic use of her literary, academic, and art world connections, fostered through her personal and professional relationship with Lotringer, Kraus straddles the line between complicity and critique as she engenders a post-avant-garde aesthetics and politics of autotheoretical feminist practice.

Kraus approaches her lived experience as a prism through which to theorize and stimulate insights into the politics of her personal and professional life. In contrast to Lotringer's cultural and aesthetic role as a gatekeeper, Kraus sees herself as something disparaged and disregarded,

and perpetually so, she believes, because of her gender (and, to some extent, her Jewishness). The book becomes a citation-laden trace of these events—phenomenological and performative. Kraus interjects the primary narrative with essays—essays that could be read as works of art writing and criticism and that theorize such topics as the feminist politics of first-person narration and the influence of an artist's life on the production and reception of their work—looking to such figures as performance artist Hannah Wilke and Jewish painter R. B. Kitaj. Kraus's books in general consist of a constellating of essays that move adeptly, though often abruptly, between theory and art writing, between narrative anecdotes from life and knowing reflections on visual art, film, and literature, with the essayistic structure punctuating the larger autobiographical narrative. This is the case in the move from part 1 to part 2 of *I Love Dick,* for example. The chapters often read as self-contained essays that come to constitute the larger, autotheoretical narrative—a metadiscursive umbrella that holds the story together.

After their initial meeting, Kraus begins to pen letters to Dick that become an integral part of the text's intertextual form; further complicating the metatheoretical layers of the text, Kraus interpellates Dick as her unwitting "ideal reader," implicating him in this strange and sexualized epistolary game.[15] While Lotringer joins in on the letter writing as a kinky, unsettling (due to Dick's lack of informed consent) conceptual game, Kraus's fixation on Dick ultimately culminates in the end of her and Lotringer's marriage. With the first half of the book (part 1) coming to an end as their marriage dissolves, part 2 opens with a fresh citational landscape of references to a wide range of women and feminist writers, artists, theorists, and activists, with Kraus now writing in the first-person "I," surrounded and supported by these women and queers from both past and recent history whose words and lived experiences find resonance with hers.

PERFORMING DISCLOSURE: ON SCHECHNER

With the performative turn in academia and art, the late twentieth century saw the concomitant establishment of performance studies as a discipline in universities (first at NYU, where Richard Schechner, the program's founder, is still employed, and now around the world). Kraus writes

I Love Dick with an awareness of the discursive, material, social, aesthetic, and political contexts of this performative turn, bringing her post-punk/ post–Kathy Acker, American feminist perspective to trouble contemporary theory in parodic ways. Because of its fashionability at the time of her writing, performance becomes one of the key points of entry for Kraus to roast the primarily male figureheads of twentieth-century theory and academic institutions. References to and practices of performance art emerge alongside Kraus's personal reflections on the politics and aesthetics of performance studies at the end of the twentieth century. Linked to performance as a student in the 1970s, a practitioner in the 1980s, and a witness to its evolutions throughout the 1970s–1990s, Kraus brings sharp, anecdotal knowledge to the topics at hand.

The move to bridge art and life is integral to the performative turn in theory, but autotheorists like Kraus observe the gendered hypocrisies, as well as the literal limits, of the blurring of this divide in practice. Obfuscating the line between the two, Kraus generates a work of autotheory that satirizes the terms of theory from a third-wave (and, presciently, fourth-wave) feminist point of view. Just as Kraus points out the contradictions in the field of contemporary theory—contradictions that, at their heart, are often based in gender—so too she points out the limits of the twentieth-century avant-garde's proclaimed desire to blur art and life..

With the high social, cultural, and political stakes of feminist disclosure today, embodied most succinctly in the #MeToo movement and related hashtags, such as #TimesUp, as well as the explicitly gendered tags of #BelieveWomen, and #ImWithHer, the question of the truthfulness and facticity of a woman's public disclosure is urgent—both philosophically and politically. This is one of the more charged problematics of autotheoretical practices and their investments in histories of feminist theory and activism, when one considers how literal to take the claims of the speaking, writing, or performing "I". The question of the truthfulness of an autotheorist's claims is worth further reflection in light of present-day politics around rape culture, sexual harassment, and assault, as the outing of bad behavior, and the naming of names, brings with it certain problems: Is the material transmuted within the autotheoretical text distanced from "reality," through, say, allegory, or is it legally "true"? Can it be neither? Can it be both? Does performance, conceptualism, and the tendency toward

fictionalization bring with them some distance from legal consequence, in contrast to someone writing an ostensible memoir or journalistic piece? These are all questions to consider in relation to autotheoretical writing.

Autotheoretical practices often extend the "meta" moves of postmodernism to something even more properly self-reflective (not just *reflexive* in that cold conceptualism, postmodernism-at-its-most-postmodern way). Kraus performs a dual function in her role as author, actively theorizing her own work as part of her writing the book and, in doing so, at times even preempting critiques. The chapter "The Exegesis" opens with a conversation between Kraus and Dick. They have just had sex, bringing some sense of closure to the building sexual tensions that Kraus has hyped up, while

Chris Kraus, *In order to Pass (1)*—
"Disconnectedness," 2018, digital print
on 100 lb uncoated paper, edition of 5.
Courtesy of the artist.

at the same time, and rather disturbingly, seemingly not changing Dick's antipathy toward her. They discuss David Rattray—"our favorite ghost"—a writer Kraus upholds as an influence throughout the text.[16] With pillow-talk candor, Kraus begins to open up about how she, in her role as Native Agents editor, "made allowances for David's bad behavior" in his life. David's literary success, Kraus explains, affected his wife in toxic ways: "He got bigger while his wife who'd been on the scene with him shrank until she nearly disappeared." This becomes Kraus's moment of revelation, as she sees her own complicity in the structures she is critiquing.

The two get into it, referring to this scene of people—"mostly men"[17]—who came of age in an "early 80s art world":

"He was part of the generation that ruined women's lives," I told you. "It's not just that generation," you replied. "Men still do ruin women's lives."[18]

By framing canonical figures in the contemporary art and theory spheres as "the generation that ruined women's lives," Kraus makes explicit her intervention into the "alternative" canon of theory and art, and grounds her intervention in lived experience—whether her own or that of other people involved in those scenes, or a citational cipher with whom she identifies and can re-perform from history in a more parafictional, performative sense.

This strategy of "identified disclosure,"[19] which involves naming male artists and holding them accountable for their lived actions toward women artists as grassroots feminist activism, has taken off in feminist-influenced movements that recently have gained attention in mainstream media and popular culture. It also surges in the art world: the ongoing protest movements by feminist artists and activists in the name of performance artist Ana Mendieta, during which protestors call attention to the suppressed place of Mendieta's work in major institutions and to the concurrent injustice of strong institutional support for the minimalist sculptures of Carl Andre—Mendieta's husband at the time of her death and her accused, now acquitted, killer[20]—are an example that reverberates particularly loudly with Kraus's text.

Kraus moves from naming names and telling stories—stories that *really happened*, even as they are reconstructed in this postmemoiristic

text—to hyperbolically blaming these men as part of the text's larger allegorical thrust. It is here where the book enters its most performative register. Making reference to the French novelist and playwright Émile Zola, whose famous 1898 letter to the President of the French Republic began with the utterance "J'accuse!" ("I accuse"). Kraus writes:

"J'ACCUSE," (I started typing) "Richard Schechner." Richard Schechner is a Professor of Performance Studies at New York University, author of *Environmental Theater* and several other books on anthropology and theater and editor of *The Drama Review.* He was once my acting teacher. And at 3 a.m. last Wednesday night it occurred to me that Richard Schechner had ruined my life. And so I'd write this broadside rant and wheatpaste it all around Richard's neighborhood and NYU. I'd dedicate it to the artist Hannah Wilke. ... "J'ACCUSE RICHARD SCHECHNER who through sleep deprivation amateur GESTALT THERAPY and SEXUAL MANIPULATION attempted to exert MIND CONTROL over a group of 10 students in Washington, D.C."[21]

With this rhetorical structure, Kraus invokes a famous case in the history of writers and libel. Like Zola, who was aware of the danger his public writing incurred—"I am making myself liable to articles 30 & 31 of the law of 29 July 1881 regarding the press, which make libel a punishable offense," he wrote[22]—Kraus is aware of the risks involved in writing out Richard Schechner's name, his official institutional position, and what she is accusing him of.

She speaks hyperbolically, blaming Schechner for having "ruined" her life, for provoking her move into sex work, and for her failing to be an intellectual or an artist who is acknowledged as such by her contemporaries. Writing from the more mature perspective of a woman nearing forty who is reflecting on her experiences when she was in her twenties, Kraus takes this time to process her experience in Schechner's workshop and draw conclusions from that experience. Through anecdotal evidence and citations, Kraus makes the quite convincing case that spaces of art and theory—even, or especially, those spaces that frame themselves as experimental or avant-garde—are rife with sexism, racism, and pernicious power imbalances, which often go unchecked. *I Love Dick* underlines the charged divide between those who can write theory and those who, under the weight

of power dynamics, find themselves on their knees giving blow jobs to the people theorizing.

Kraus uses her experience in Schechner's inappropriately named "Aboriginal Dream Time" workshop to show that theory is gendered and sexualized, and that the questions of who accesses and authors the work that is understood as "theory" is an intersectional feminist issue. She writes through how her own gender—or gender failure[23]—precluded her from being taken seriously in intellectual conversations when she was an art student in the 1970s. Again, Kraus demarcates the difference between the influential men of art and academia who occupy the realm of the mind, and the women who always already occupy the realm of the body. Emphasizing this context as a fundamentally sexualized terrain, Kraus observes how her female peers used their sexual appeal and physical attractiveness to access these spaces, whether it was "Liza Martin" wearing platform shoes during yoga class or "Maria Calloway" giving Schechner a blow job.[24] Maria Calloway is the most tragic figure here, having done these sexual favors for Schechner without ever being allowed to register for the workshop. What seemed to students at the time to be a transgressive, experimental, exploratory, and intimate space for learning about ideas becomes, in actuality, a space of violated boundaries, cultural appropriation, and exploitation. This is the basis of Kraus's "accusation."

Following her experience as a student at Schechner's workshop, Kraus explains, she decided to start working at a topless bar in order to pay rent. The economic realities of being a student living in NYC heighten the already fraught sexual politics of her life as a young woman: this is an example of Kraus instantiating the schizophrenic impulse of linking two non sequiturs in terms of causation.[25] In a visceral scene in which she describes dancing for lawyers and other powerful men at the bar, Kraus communicates the contradictions facing women—de facto gendered and sexualized—who seek to engage intellectually with men, and be listened to or heard: "I was investigating the rift between thought and sex or so I thought, letting lawyers smell my pussy while I talked."[26] By configuring the "pussy" as that which *gets in the way* of Kraus accessing critical thought—the scent wafting between her and the men—Kraus emphasizes "the rift between thought and sex"; she reveals how the binaries of

CHAPTER 5

mind/body, men/women, and intellectual/sexual persisted deep into the twentieth century.

Kraus's decision to place primary, even sole, responsibility on Schechner for her venture into sex work can be read more figuratively than literally. As part of the larger allegorical structure at work in *I Love Dick,* Kraus calls attention to the ways that men like Schechner—men in positions of power and discursive influence in the academic world and in the arts, including, most importantly, the more "marginal" spaces of experimentation represented by the experimental theater scene in which Schechner would come to hold enormous influence—continue to thrive in ways that not only preclude but can actively hinder, through coercion, sexualization, and other forms of manipulation and control, women and other marginalized people from similar kinds of institutional success. While the men were out there "getting famous," Kraus writes, the women who sought upward mobility in the same kinds of disciplines were "paying for our rent and shows and exploring 'issues of our sexuality' by shaking to them all night long in topless bars."[27] By placing "'issues of our sexuality'" in scare quotes, Kraus gets at the irony of the continued separation of theory and material life, gesturing to the fact that actually living or embodying different elements of marginalized sexual practices is not seen as truly theoretical—a state of affairs that autotheory as a feminist practice turns on its head. Kraus confronts this problem of the underlying incompatibility of women being both theorist and sex worker, both titillating and speaking as an intellectual, throughout *I Love Dick*, setting up these problems only to then address them, through autotheory, over the course of her book.

This tension between theorizing and doing sex work was part of the *Zeitgeist* at the time Kraus was writing, with Kraus and other writers having backgrounds in sex work. In 1999, Singaporean porn star Annabel Chong wrote, "I did this interview where I just mentioned that I read Foucault. Who doesn't in university, right! I was in this strip club giving this guy a lap dance and all he wanted to do was to discuss Foucault with me. Well I can stand naked and do my little dance, or I can discuss Foucault, but not at the same time."[28] Both Kraus, the filmmaker and writer, and Chong, the porn star who came to fame when she starred in the 1996 film

The World's Biggest Gang Bang, understand theory and sex work to be in a tensive relationship, though in different ways: while Kraus brings them together here for symbolic effect in the context of her larger autotheoretical critique about critical theory's sexist biases, Chong seeks to separate the two forms of labor—speaking about Foucault and dancing nude.

As she writes through the Schechner anecdote, Kraus comes to articulate how, as a young woman, the power she had access to was sexual instead of cerebral. She hungered to be part of conversations about art and theory, but the "greater truth" of her "cunt" precluded her from being an equal participant, and so she pursued ways of using this sexual power instead:

Richard seemed to like our morning conversations about Brecht and Althusser and Andre Gorz, but later on he turned the group against me for being too cerebral and acting like a boy. And weren't all these passionate interests and convictions just evasions of a greater truth, my cunt?[29]

By juxtaposing her "cunt" with the oral act of her uttering references to theory, literature, and other vaguely intellectual topics, this scene becomes a metaphor for the larger problem of women's de facto exclusion from the realm of the intellectual if they continue to align themselves in any way with their carnal, sexual, hungry bodies. When she embodies both sexual pleasure *and* intellectual validity, the woman becomes unintelligible to men—she is, as Kraus writes, seen by the audience of "Dicks" as "Some Strange Scene," something resembling hysteria.[30] The account serves as an allegory for why autotheoretical work emerges in feminist histories—to counter phallocentric views of the incompatibility of female embodiment with theoretical rigor, and to make space for a more wide-ranging view of women's sexualities.

In this way, Kraus's book recalls earlier performances by feminist artists of the 1980s to early 1990s, most notably performance artist, sex worker, and sexologist Annie Sprinkle's *Public Cervix Announcement*, a work in which Sprinkle inserts a speculum into her vagina for audience members to come up close and observe. While they gaze through her vaginal canal to the focal point of her cervix, Sprinkle, her cleavage on glorious display, sits self-assured and with a dignified sense of humor and composure, speaking into a microphone to directly address the viewer gazing through

her legs. Her utterances move between cogent sex education and silly comedy; her jokes ease the tension of this intensely intimate performance scene, bringing catharsis into the shared, participatory experience between the performing woman and the various audience members, mainly men, who come to gaze through her vaginal canal.

As noted in the Introduction, feminist performance artists working in the 1980s–2000s, such as Andrea Fraser, Penny Arcade, Karen Finley, and Vaginal Davis, enacted these kinds of juxtapositions in their embodied, conceptual artwork as a way of deconstructing the tendency for patriarchal systems to view the body and the mind, the carnal and the cerebral, as mutually exclusive. Sprinkle can be a "prostitute performance artist" and

Annie Sprinkle, *A Public Cervix Announcement from Annie Sprinkle Post-Porn Modernist*, performed from 1989 to 2004, performance art (photographic documentation). Courtesy of the artist.

have a doctorate, making work that is rigorous and recuperative as a sex worker, artist, educator, and intellectual: her work challenges the male gaze as theorized by Laura Mulvey in the 1980s while inviting men and others into the process of gazing in ways that are pleasurable, entertaining, multidirectional, and consensual. In *Official Welcome* (2001), Andrea Fraser performs the "official welcome" speech for a formal event at an international art museum that "mimic(s) the language and gestures of archetypal figures associated with the art world, including patrons, museum directors, curators, critics and artists."[31] Over the course of her speech, the artist begins to remove her clothes, gradually stripping down until she is in her underwear and then, finally, stands nude, exposed as a naked woman as she continues to speak, establishing a similarly subversive mimetic movement that Kraus, referencing Irigaray, enacts in her book.

In Kraus's *Video Green: Los Angeles Art and the Triumph of Nothingness*, conceptual artist Chris Burden features as a metonymy of male art world power, influence, and complicity in what Kraus views as a gendered double standard when it comes to what artwork is valued or recognized as aesthetically and conceptually important by American art schools and museums. Kraus positions Burden, in his capacity as a professor in a CalArts MFA program and arbiter of institutional and aesthetic valuation, as one of the canonized founders of mid-twentieth-century conceptualism, in opposition to his young female students, like twenty-seven-year-old Jennifer Schlosberg:

"But why," conceptual artist Chris Burden asked his 27 year-old graduate student Jennifer Schlosberg, with faux-paternalistic concern, "do you make yourself so scary?" Burden, as I'm sure you will recall, burst onto the international contemporary art scene when he convinced a friend to shoot him in the arm ... while Burden was himself an MFA student.[32]

Kraus explains how Burden called his student's work "unethical" because of its use of disclosure as a strategy in her work that was "based on social interactions" at the art school. Kraus defends Schlosberg's work as "a brilliant chronicle of the very qualities that define contemporary LA art: ambition, exclusion, and anxiety," and believes that it was the artist's impersonal and "maddeningly opaque" performance of the

(female-authored) personal that frustrated the (male) critics more than anything else.[33] Kraus connects the politics and aesthetics of disclosure in work by female artists to the abjection of these artists from the cultural sphere; there is something about disclosure that is imperative to feminist work, and when this disclosure is precluded by men in the name of ethics and exposure, work by conceptual female artists is stifled and suppressed.

Dramatizing this divide in art and theory, Kraus portrays the female conceptualists, tired and angry at this systemic suppression, moving to "to live around New Mexico in teepees, or become massage therapists and cranial-sacral healers"[34]—a somewhat cynical, ironic gesture to women's inevitable return to embodiment and care, as well as the problematical tendency for some white feminists to appropriate Indigenous traditions that are not theirs to claim or make use of. As Wilke notes in the epigraph to this chapter, male conceptual artists like Vito Acconci can literally masturbate in an art gallery—or Burden can be shot in the arm by a friend— and be recognized as making history-changing conceptual art for doing so, but women's art featuring their own bodies is disregarded as narcissistic and nonconceptual. And so they return once more to the body—as if it could be, in truth, separated from the mind.

What does it mean for Kraus to place the blame for the suppression of women artists and intellectuals on particular known and named men, specifically here Schechner and Burden? It might be a reversal of the mechanisms of structural sexism and victim blaming to hyperbolic effect, or a way of pointing to particular men as metonymic of larger patriarchal problems. In these scenes, Kraus confronts the sexist issues in contemporary art's canon—particularly when it comes to the question of what work is considered properly "theoretical," "rigorous," or "conceptual." To do so, she takes a performative approach, pointing to specific artists and scholars who represent certain scenes and experimental movements as gatekeepers to place the larger, structural blame on their individual, often hyperbranded shoulders. Kraus makes a convincing case that Burden's and Acconci's ways of working with the self lack the kind of self-reflexivity and reflection that feminist autotheoretical practices advocate for. Her disclosures perform the functions of both art criticism and grassroots feminist organizing, where disclosures are a means of holding named men publicly accountable for their actions in a context where they might not otherwise be.

The ethics of Kraus's strategies, taken at face value, can seem suspect: implicating someone in a nonconsensual sexualized game, making that "game" public, and/or willingly debasing herself. But when *I Love Dick* is read as a larger allegory for gender, conceptual art, and critical theory in America in the twentieth century, one sees that Kraus's text adeptly engages the more insidious power dynamics at work in experimental and theory-focused spaces (with their often presumed progressiveness, as if the "counterculture" is always progressive, which is certainly not the case), doing so through incisive callouts and symbolic inversions. She does this in a way that is theoretically insightful, politically engaged, and generatively ambivalent—indeed, the text requires the kind of attentive, nuanced reading that works of theory and conceptualism require.

To be sure, if we contextualize *I Love Dick* in relation to the kinds of feminist writing practices that the Native Agents series represents, we can better understand Kraus's mode of transgression as it oscillates between the ironic and the sincere. Consider, for example, third-wave feminist performance and the fomenting tones of brassy female rebellion in performance and literary work of the 1980s through the 1990s, from the work of Karen Finley and Penny Arcade to Eileen Myles and Liz Kotz's anthology of new lesbian writing *The New Fuck You*.[35] Kraus's disclosures of Schechner's questionable behavior finds good company among the works of other Native Agents writers, who narrate their experiences with known and named men from 1960s–1980s lefty scenes, from the autobiographical perspective of a woman who more often than not is quite young. In *If You're a Girl* (1990)—a text that itself has taken on a performance-based life of its own—writer Ann Rower discusses in close detail her involvement in Timothy Leary's LSD experiments as the babysitter for Leary's children.[36]

In her interactions with Dick, Kraus performatively takes on the role of villain, staging, through autotheoretical implication, feminist revenge within the conceptual space of theory. For two pages, the letters that Chris and Sylvère write to Dick veer into ominous territory, with "abstract" talk of murder, dismemberment, and the disposing of bodies implicating Dick.[37] She cites cases of men murdering women while she reflects, insinuatingly, on the best way of disposing of a body in Manhattan. We can read this section as Chris figuratively enacting the transgressions fetishized in theory by the "Bataille Boys," and by implicating Dick in the topic as a

potential victim and thereby making him uncomfortable, a point is made about the larger structure of violence against women and how violence in the "abstract" is never entirely abstract. Put another way, it extends the concepts that these men might value *in theory*—such as intense Bataillean transgression—to their own selves and lives, asking how they would feel to experience such obliterating violence. This kind of figuratively making literal the terms of the theory upheld in these spaces and of placing the woman in the role of transgressor (instead of the body that is transgressed) contributes to making Kraus's work both challenging and off-putting.

Metaphorical violence against men is found in other Native Agents work, such as Rower's short story "Lovers Slash Friends," in which she references contemporaneous poets and writers in a Bataillean scene of "the threesome of my dreams" and the disturbing, presumably symbolic image of conceptual artist Vito [Acconci's?]'s "slashed body."[38] This is a scene that can be read as male conceptualism being offered on display—the self-violent masculinist avant-garde artist as martyr, re-appropriated into a feminist schema. There are resonances here with French filmmmaker and writer Virginie Despentes's book-turned-film *Baise-Moi*, a "punk fantasy" feminist revenge thriller in which two female survivors of sexual violence and rape seek out and kill rapists. Despentes's first novel, it is one of the most controversial books to be published in France at the end of the twentieth century.[39] *I Love Dick* continues this kind of not-exactly-realist, even somewhat fantastical way of writing about theory and sex. But instead of seeking out and killing rapists, as Despentes's protagonists do, Kraus's violences are more intellectual. Rower's hallucinatory description of Acconci's sacrificial body might be seen as symbolic reparation for the ways Acconci's female contemporaries were precluded from being seen as *conceptual artists* in their own right, just as Kraus's playing with being a kind of "monster" in the pages of *I Love Dick* realizes in theory what she, as the "abject woman," has been rendered, at different times and in different ways, by the patriarchal scenes that exclude her.

In the eyes of the male theory that her text confronts, Kraus threatens the men she implicates in her book more metaphorically than literally, even as the literalism of this book—grounded in real life, with momentary flashes of Ackerian surrealism—haunts this book and the other two books that Kraus wrote in a kind of triptych (*Aliens and Anorexia* in 2000, and

Torpor in 2004).[40] "You were witnessing me become this crazy and cerebral girl, the kind of girl that you and your generational vilified," Kraus writes to Dick.[41] She positions herself as a villain in an intellectual sense, something beyond the pale for a woman in her social context; Kraus's description of herself as "crazy and cerebral" is a continuation of the symbolic power dynamics between the male theorists with discursive value and institutional power, seated at the table exchanging valid ideas with each other in coherent ways, and the vaguely hysterical woman who fails to secure the kinds of discursive agency or intellectual power she desires and needs to be able to live, in good faith, amid the worlds of theory and language and art.

Riffing on the hyperbolically oppositional dynamic between men and women in contemporary theory, Kraus underscores the men's responsibility as perpetrators of violence—those on whom she places her blame ("J'ACCUSE!")—while representing herself, as a woman, in a self-immolating way as a hysteric. She describes her disclosures about Schechner as a "broadside rant": by naming her own utterances "rants," Kraus returns to her mimetic strategy of couching her feminist critiques in self-deprecatory statements (typically ones that extend negative stereotypes about women) as a way of seeming less threatening and reminding the reader of her respective lack of power.[42] The cogency of her aggression is always already muddied in these scenes through her disparaged positioning as "woman." Instead of moving ahead with her threat to out Schechner by "wheatpasting" these disclosures around his place of employment, she tells her story of what happened within the parameters of an autotheoretical text—allowing a different kind of rhetorical and formal control over the story and, to some extent, how the story is read.

Sara Ahmed describes the feminist killjoy as the one who is willing to get in the way.[43] When the feminist killjoy discloses, as they so often do (the feminist killjoy is a key figure when it comes to public acts of disclosure, amplified today via blogging and social media platforms) they function simultaneously as providing "testimony" and as unreliable and suspicious (in the eyes of a defensive, and skeptical, patriarchal status quo). Kraus describes those who disclose as being called "bitches, libellers, and whores," and she riffs on this disparaged, abject woman positioning as she performatively enacts disclosures in her book. As she writes, Kraus makes known

her allegiances with those feminist artists before her who were misunderstood, especially Wilke, stating that the self-implicating disclosures that she is able to make in 1997 are less "embarrassing" than they were in the 1970s when Wilke was making work.[44] Now, in the *Sex and the City* era of neoliberal feminist empowerment and iconic female antiheroes (*I Love Dick* predates by one year Darren Star's *Sex and the City*) and with the growing technologies of the World Wide Web (it also predates, by one year, Nora Ephron's epistolary-email cinematic popular-cum-cult-classic *You've Got Mail*), Kraus feels ready and able to publicly (and intelligently) articulate these things that have happened in her past in ways that Wilke, working in the 1970s, and other women, like Mendieta, were unable to.

BAD ALTHUSSER! BAD RONELL!

It is not necessary to believe that theory is the property of "theorists." Their theory (that of scientists, philosophers) is only the most abstract, purest, most elaborated form of a capacity that is the property of every human being.
—Louis Althusser, "What Is Practice?"

The question of where the line ought to be drawn between theory and practice, art and life, is at the heart of much autotheoretical work. Should a philosopher's, or theorist's or artist's, lived actions in the world be considered something separate from their work? How consequential are their lived decisions to how we understand their work, and the relevance of their work to our own lives? When I began writing on autotheory, asking why we do not seem to consider the real-life actions of a philosopher, theorist, artist, or cultural critic in our reception or understanding of their written work seemed to be a new, even slightly strange (or at the very least niche) question. Only five years into the research, a dramatic shift took place in which the real-life actions of an artist or a scholar or another public figure began to *really matter*. Many men and some women in the public eye began to face repercussions for their actions—actions now understood as fundamentally consequential to how we understand and consume their work.

With decades of feminist activism, writing, and advocacy leading up to this moment, we have moved from a culture of widely accepting and

enabling bad behavior (sexual harassment, assault, rape, other forms of sexual misconduct) to typically having, at least when made public, zero tolerance. For some, this presents a slippery slope: once we begin to consider the *lives* of those artists and theorists whom we adore—artists and theorists who are human and therefore imperfect—things can get really murky, and really *personal*. Do we listen to Michael Jackson's music? Do we watch Woody Allen's or Roman Polanski's films? Do we watch episodes of *The Cosby Show*? Do we watch episodes of *House of Cards*? Do we listen to Louis CK's stand-up? Do we read William S. Burroughs's literature or Louis Althusser's theory? Some advocate for maintaining a degree of separation between the life and the work, and others advocate for flat-out boycotting the work of those who've committed crimes or other wrongdoings.

When considered through the historical perspective of feminisms, the attempt to divide theory from practice is tenuous at best. bell hooks goes so far as to say that theory cannot call itself "feminist" unless it is firmly rooted in a conjoined and consistent practice of *living*. For hooks, feminist theory is by its very definition theory inextricable from practice—theory for life, and theory that emerges from lived experience. A feminist comes to the practice of theorizing from a lived sense of urgency: theory is a way of better understanding the realities of one's lived experience as a woman or, for that matter, as a man.[45] Theory must be grounded in a material practice of living in order to be efficacious, and this point of emphasis directs attention to one of the ways that autotheory is invested in a long-standing tradition of feminisms.

In "Becoming the Third Wave," written in the early 1990s as the third wave of feminism was taking shape, Rebecca Walker writes, "To be a feminist is to integrate an ideology of equality and female empowerment into the very fiber of my life. It is to search for personal clarity in the midst of systemic destruction." Her involvement in feminism, Walker emphasizes, must "reach beyond … reading feminist theory. My anger and awareness must translate into tangible action."[46] By focusing on emotionality, Walker emphasizes the need for feminists to transmute their own particular, fervent emotions—like rage in response to structural injustices—into concrete, collective action. Theory is a part of this, but it is more a means to an end than an end in itself, Walker holds.

Althusser presents a complicated anticipation of autotheory. His elucidation of the relationship between theory and practice in the context of 1960s liberatory movements provides an alternative both to "the primacy of theory over practice" in idealist philosophy and "the primacy of practice over theory" in Marxist materialist philosophy; his proposition that "all human beings are theorists" intersects with the legitimization of underrecognized subject positions in autotheory as a practice that includes other practices, such as "aesthetic practice" and activism.[47] And yet, when the specificities of Althusser's life are included in a consideration of the politics of his work, things get very complicated very quickly. In 1980, Althusser murdered his wife by strangulation, a point that was surprisingly absent from any professors' discussion of his work during my undergraduate and graduate courses on contemporary theory. This presents an ethical dilemma when it comes to how one is to understand Althusser's contributions to "bridging theory and practice," or the political efficacy of his work.

Further complicating the politics and ethics of autotheory, Althusser would later write about his experience of killing his wife in his posthumous autobiography *L'Avenir dure longtemps (The Future Lasts a Long Time)* in a manner that chillingly resembles the objectifying, existential prose of Jean-Paul Sartre's *La Nausée (Nausea)* or Albert Camus's *L'Étranger (The Stranger)*.[48] Ought one's reception of Althusser's work be affected by Althusser's lived decisions? A feminist theorist might respond to this question differently than a nonfeminist, and the rising trend toward autotheory in the arts coincides with a mainstream shift that sees more people in positions of cultural, artistic, and discursive influence (politicians, actors, musicians, professors, museum directors) being held accountable for their lived actions—whether it be their "private" behavior or actions that, increasingly, bleed out from the private into the public (a leaked dick pic, for example). To what extent should Althusser's action of murdering his wife shape how we receive his theory on ideology and praxis? If autotheory is an ethical imperative, how does this shift our thinking about the relation between a theorist's life and their lived practice as a human being living among other human and non-human beings?

Nietzsche is another figure whose reputation suffered from his rumored associations with Nazism and fascism, an association that resulted

from his posthumously published *The Will to Power* (1902), disseminated by his sister, Elizabeth Förster-Nietzsche. And in the collected volume *Lust for Life,* one of the many examples of feminist writers/philosophers/artists writing posthumously, even mythologically, about Kathy Acker's life and work, Avital Ronell writes an anecdote about her frustration with Acker's refusal to engage with Heideggerian philosophy because of Heidegger's presumed association with Nazism. Ronell explains that she identifies as both a feminist and a Heideggerian who understands the politics of theory differently than more militantly myopic feminist thinkers like Acker; she concludes by describing the rift between her and Acker as their irreconcilable "differend."[49]

Of course, as one might imagine, feminists are humans too—and their lived actions in the world are not immune to being toxic, problematic, or oppressive. As the #MeToo movement has grown, there have been women who have come under charge for their own bad behavior.

In the months leading up to my PhD defense, I was working with my supervisory committee to decide on which external scholar would be best suited to serve as my external examiner. Two options offered were Avital Ronell and Nina Power, both contemporary philosophers who have taken up feminist theory and politics to different extents and with whom my committee had some ties. I had not engaged with the work of either in my research, so they both seemed like good choices in terms of their having expertise in the field and an arm's distance from my dissertation. For some reason, my gut was saying to go with Nina Power—so my committee approached her instead of Ronell. I prepared for my defense, brushing up on present-day issues related to feminism and autotheory that might come into the conversation—and the recent movements around #MeToo seemed to be a particularly pressing context that might factor into the conversation. I reread Power's *One-Dimensional Woman*, thinking about Marxist feminism and the different valences that theoretical writing takes when coming from Britain (my supervisor would observe, after my defense, that class was startlingly absent in my dissertation: an irony not lost on me since I was fixated on issues of labor and class in my life apart from the dissertation, and which I have since sought to remedy through an autotheoretical postdoctoral fellowship focused primarily on settler-colonialisms and poor and working-class cultures in Saskatchewan).[50]

In the week before my defense, in the fall of 2018, Avital Ronell would become embroiled in her "#MeToo moment." This was the first major woman on the academic or pop cultural scene to be accused of the kinds of charges that were, it seemed, up until then reserved for men. Ronell's former doctoral student Nimrod Reitman had come forward and accused Ronell of sexual misconduct and ongoing harassment; particularly incriminating quotes, taken from email exchanges between Reitman and Ronell, were now circulating online. As I looked at the images of Ronell circulating online amid all the articles and op-eds and tweets, as I looked at her posed with her giant sunglasses and her stoic and self-assured, bad-ass "cool professor" stance, I felt unsettled and maybe a wee bit relieved. I was looking at an image of a woman who attained this "man-like" status—the power and the phallic status that Kraus herself reaches for, and embodies in allegorically violent ways, in *I Love Dick*, to make a point about gender, language, intelligibility, access, and institutional justice. As I prepared to defend my dissertation that week, I couldn't help but think to myself: boy, did I dodge a bullet!

With the trend toward the public disclosures of #MeToo comes a rather predictable pattern in the wake of those disclosures. As think pieces circulated about Ronell's wrongdoings and Reitman's victimhood, a backlash began to form. Judith Butler wrote a letter in support of Ronell, which was signed by a group of tenured academics and sent to NYU's president and provost. The letter read, "We testify to the grace, the keen wit, and the intellectual commitment of Professor Ronell and ask that she be accorded the dignity rightly deserved by someone of her international standing and reputation." Written before any legal proceedings, the letter invoked the rhetoric of justice: "If she were to be terminated or relieved of her duties" as a professor at NYU, they wrote, it would be an "injustice" that is "widely recognized and opposed." These points were made even as Butler conceded that she and the other signatories "have no access to the confidential dossier" and that the claims being made in the letter were based on their having "worked for many years in close proximity to Professor Ronell and accumulated collectively years of experience to support our view of her."[51] Their evidence was, by this description, solely anecdotal, raising some interesting questions around autotheory as a feminist form. Signing the letter were the names of theory and philosophy heavy-hitters such as

Cathy Caruth, Slavoj Žižek, Jean-Luc Nancy, Jonathan Culler, and Gayatri Chakravorty Spivak.

While some young scholars in America were shocked at what was happening, I and other young scholars and graduate students in Canada knew the situation well. Indeed, a very similar situation had taken place the year prior, when UBC creative writing professor Steven Galloway was accused of sexual harassment and assault by students, and Canada's perhaps best-known feminist writer came very publicly to his defense. Margaret Atwood, along with a number of other signatories and defenders who had the kinds of cultural capital and institutional protections that Butler and company were invoking for Ronell, rallied behind Galloway and publicly shamed the young women who had come out against him with harassment and assault charges. Atwood, who had been writing feminist novels like *The Edible Woman* and *The Handmaid's Tale* since the mid-1960s, went so far as to call the accusations being launched against Galloway as a "witch hunt," with seemingly no irony in her poorly chosen choice of words.[52] At the same time that she was creating the hit American television series *The Handmaid's Tale,* working with a team in Hollywood to represent an antifeminist nightmare state in which women are physically oppressed by men, many thought Atwood had turned against the real, living young feminists in her country, who were studying to be writers like her, and whose studies were punctuated by their professor assaulting and harassing them, being gross and inappropriate, wasting their energy and their time. ("I haven't written since this happened; I haven't written a single word. The core of your identity as a writer is writing. I feel like the core of my identity has been altered in a permanent way," one of Galloway's accusers, Sierra Skye Gemma, told the media[53]). At the same time, Atwood, in her piece "Am I A Bad Feminist?," makes the case that she wants due process in place, for the rights and protection of women as well as men: resisting the name, though perhaps not the spirit, of #BelieveWomen, Atwood writes that "women are human beings, with the full range of saintly and demonic behaviours this entails, including criminal ones"; invoking the term "bad feminist" to describe herself, posed as a question to her long-standing readership (likely of older adults who've known Atwood since her second-wave feminist novels like *The Edible Woman*), she is aware of the discursive politics at play.[54]

When it comes to questions around the #MeToo movement, there seems to be a stark generational divide among feminists. Some older women seem to see younger women as spoiled, attention-seeking, and weak in that they are unable (or unwilling) to deal with the kinds of shit that they themselves had lived through for decades—having their asses grabbed, being spoken to in ways now widely understood to be unacceptable in any context, let alone a place of work. I have seen firsthand the ways that women of a certain generation see my generation and those younger than I am as weak for "complaining" and calling out these men and ruining their lives (so often, with the #MeToo movement, the "life" in question is actually just a "reputation"—no attention is paid to the ways these women's lives are ruined by the assault, harassment, and backlash to their seeking-of-justice and, so often, their failure to find that justice). Claims around the need for due process tend to conveniently obscure the structural sexism and racism within the legal system, something that Atwood acknowledges, to her credit, in her op-ed.[55]

As the week went on, many of the writers my dissertation on autotheory was most invested in—writers and theorists like Jack Halberstam, Chris Kraus, and Jennifer Doyle—would rise to the occasion, voicing their respective defenses of Ronell. Young scholars and graduate students, tuning in online, voiced their horror. Not only had a formative, female philosopher (not necessarily a *feminist* philosopher, but a female one) now fallen from glory—Ronell, the author of theory tomes like *The Telephone Book* (1989) and *Crack Wars* (1992)[56]—but their other admired feminist and queer theorists like Halberstam, whom they read in classes and cited in their gender studies work, were now rallying behind Ronell.

In writing and signing the letter, Butler and signatories like Kraus sought to defend Ronell's character based on their long-standing relationship with Ronell: they were establishing a context for understanding, based on their lived experience in relation with Ronell, which could be seen as an autotheoretical move. If the context of Ronell's character is that she breaks boundaries, perhaps this ought to be considered when it comes to evaluating Ronell's lived actions: the boundary-breaking does not just necessarily stop with the good, above-board stuff. This point is a problem within contemporary theory and spaces that value so-called countercultural subversion, and autotheory finds itself in a thorny, perhaps illuminating,

place here. Autotheory considers the relationship between life, theory, and art—intermeshed practices of living, studying, loving, learning. So, if Ronell is pushing boundaries in her theory, it is conceivable that she might push boundaries in her life, too. This philosophical self-contradiction is perhaps an irresolvable aporia within autotheory as feminist practice itself. Perhaps the question for feminist autotheory to ask, next, is whether it is boundary-breaking that we are interested in or another mode tied less to macho, avant-gardist histories that veer towards cruelty.[57]

The convoluted, contemporary feminist politics of Ronell's "#MeToo moment" in the fall of 2018, and the seemingly sudden flipping of everything that American feminist and queer theory of the twenty-first century held sacred, reached a climax when queer theorist Lisa Duggan published a post on her blog. In the post, she conducted a close reading of Nimrod's and Ronell's exchanges: a cringeworthy moment that revealed the importance of context when it comes to the subversive possibilities of autotheory, and the function of close reading. Duggan went so far as to provide a textual analysis of Nimrod's and Ronell's exchanges, mobilizing queer feminist affect theory to "read" the power dynamics and conclude that Ronell was not in the wrong.[58] Drawing textual evidence from those emails, and reading the situation in light of Ronell's and Nimrod's larger personal lives and sexual identifications, Duggan maintained that Nimrod's status as a gay man and Ronell's status as a lifelong lesbian refuted any case Nimrod could make about Ronell's attempts at a sexual relationship with him.

Other writers and scholars, many from BIPOC contexts, took up the labor of responding to Duggan's claims. Kenyan American writer and comp lit professor Keguro Macharia wrote "kburd: Caliban Responds," citing a past quote by Duggan as an epigraph ("Stories of identity are never static, monolithic, or politically innocent").[59] Macharia drew from the logics of Duggan's own body of theory to trouble Duggan's reading of the Ronell-Reitman exchange: he looked specifically to her writings on the instability of identity, for example, which become a counterpoint to her claim that Ronell's lesbian identity precluded her from desiring a gay man. His piece honored the past contributions and work of the theorists coming to Ronell's defense while directly questioning their actions around Ronell and wanting better from them:

I know Jack Halberstam as one of the savviest thinkers on queer subcultures and minor forms. Halberstam has an amazing ability to theorize how quotidian encounters and forms express how power and marginalization work. *Female Masculinity* (Duke 1998), *In a Queer Time and Place* (NYU 2005), and *The Queer Art of Failure* (Duke 2011) paid attention to small spaces and ephemeral forms, tracking power as it circulated around minoritized people and forms. I find myself baffled that a prominent theorist of subcultural figures and forms so readily dismisses Twitter.[60]

Here, Macharia points to the limits of these theorists' own criticality. For some of these older feminist and queer feminist professors, being able to take seriously the disclosures circulated on social media platforms, and the claims being made in those public disclosures, was seemingly beyond what they could do. The limitations of close reading as a tried and true literary methodology are also gestured to here, with a sole focus on the text—an inheritance from the New Criticism of the early twentieth century literati—along with a selective focus on contextual cues (the two "characters'" respective sexual identifications) coming at the expense of real lives and attention to complicated relationship dynamics and power imbalances as they persist in academic and para-academic spaces.

Ronell is not the first feminist woman or the first feminist woman philosopher and scholar to be accused of sexual harassment or assault. In 1997, the same year Kraus wrote *I Love Dick,* feminist professor Jane Gallop would write her own autotheoretical book, *Feminist Accused of Sexual Harassment.*[61] The book is Gallop's autotheoretical response to the accusations, launched against her by her students, of sexual harassment, and it continues to be pointed to as a contentious work of feminist theorizing. Gallop describes the autotheoretical approach she took in writing this book as "anecdotal theory," by which she means her approach to writing draws from other fields of influence in literary theory methods, such as psychoanalysis, deconstruction, and feminism, alongside autobiographical anecdotes that the writer relays through "truly literary" modes of narrative. Gallop cites American author Joel Fineman's characterization of the anecdote as a proper literary form, maintaining that the anecdote is both "literary and real," metaphorical and material, in the sense of relaying "the moment ... the here and now,"[62] which gives it its social-semantic power.

Gallop writes self-reflexively, with the rhetorical force that honesty brings to a third-wave feminist project. Now in her privileged role as a professor of English literature and gender studies working in the United States, she turns to feminist theories of the personal alongside her experiences as a student coming of age in 1971 to provide justification for her having sexual relationships with her students. Gallop explains, "Feminists who write about teaching have stressed the importance of the personal, both as content and as technique," going on to argue for the blurring of boundaries between sexual/intellectual and professional/personal as something that is liberatory rather than predatory or problematic (or unlawful).[63] She makes use of the rhetoric of honesty as a way of explaining her context and reasoning behind her decisions: whether it succeeds in helping her case (discursively, legally, or socially, in terms of reputation) is another question—and a very charged, uncomfortable one at that.

BAD FEMINISTS AND THE CANCEL CULTURE: CALLING IN, CALLING OUT

To complicate things further, Kraus's *I Love Dick* itself proves problematic when read through feminist lenses. Kraus's unrelenting and nonconsensual implication of the character Dick (and, by association, the real-world Dick), for example, while richly allegorical, remains unsettling. What's more, the limits of Kraus's own feminism come into view when considered in relation to her neoliberal and gentrifying powers in real estate, or her disparaging comments about feminist film. Indeed, Kraus is far from a "perfect victim," a term that has circulated in feminist spheres to protest the idea that victims of harassment or assault must themselves have behaved in a perfect, upstanding way to be believed or to receive sympathy or the possibility of justice. Within the body of her book, Kraus fails to be a perfect victim. That *I Love Dick* is not straightforwardly feminist—and that the protagonist or "heroine" is not a perfect victim—might contribute to its profound resonance with fourth-wave feminist audiences.

For Kraus's strategy of self-deprecation extends to feminism: while her work is effectively feminist, the character Kraus brashly evades the "feminist" label. Further complicating things, Kraus admits "Sylvère-the-pragmatist kept telling me I'd have better luck if I'd just call myself a

'feminist,'" which would give her work a context within which it could be understood.[64] The character Chris tells Dick that, while she loves postmodern theory, she rejects "experimental film world feminism," which I take to mean feminist film theory of the 1980s, with its emphasis on Lacanian psychoanalytic theory and "the gaze":

What put me off experimental film world feminism, besides all its boring study groups on Jacques Lacan, was its sincere investigation into the dilemma of the Pretty Girl. As an Ugly Girl it didn't matter much to me. And didn't Donna Haraway finally solve this by saying all female lived experience is a bunch of riffs, completely fake, so we should recognize ourselves as Cyborgs?[65]

Despite her history as a filmmaker, Kraus does not identify with this branch of feminist theory: that Kraus willingly accepts Dick's gaze in the opening scene underscores this point. Self-identifying as an "Ugly Girl" warrants her an outsider positioning in relation both to heterosexual men and to feminist film theory. Kraus's rejection of certain movements in feminism resembles the critiques of feminism advanced by artists like Wilke—with her "Beware of Fascist Feminism" statement on a 1977 poster[66]—or critics like Camille Paglia. As a writer of both autotheoretical narrative novels and art writing and criticism (the two so often intertwined, as in books like *I Love Dick*), Kraus often dives into the contradictions that folks who are essentially part of the global elite but identify as anti-oppressive live in their day-to-day lives—in their sexual relationships, in their classrooms, at their dinner parties. *I Love Dick* is a very effective insider/outsider critique of the US leftist intellectual establishment, with Kraus writing this critique from the perspective of her background as an artist and her marriage to an influential gatekeeper in US leftist thought. Just as Irigaray's mimesis is an example of approaching the master discourse in an oblique way in order to deconstruct it, Kraus's distancing of herself from the "feminist" label is an oblique way of practicing feminist work in a way that, paradoxically, might make her work more effective in its feminist aims by preemptively avoiding a reader's or broader public's response of defensiveness.

In the spring of 2019, I flew to London to present my work on autotheory and video art in the *AUTO-* conference at the Royal College of Art. I'd recently met the local curator and writer Letitia Calin, and we spent

hours waxing lyrical about the possibilities of curating visual art exhibitions around New Narrative writing, the recent Kathy Acker exhibition at the ICA London, and the place of the late Hervé Guibert's work in the development of present-day autofiction. Over dinner in the East End, just blocks from Whitechapel Gallery, where she worked part-time in the bookstore, Calin filled me in on the recent events surrounding Nina Power and the London scene. Over the previous few months, Power had been virtually shunned by the philosophy/academic and art scene in London. She was now associated with the alt-right, Calin explained, though she couldn't recall how that was or what Power had done or said, exactly. It was something she said when she was drunk, Calin thought. Details were hazy. And even though Power wrote an open letter in her defense, the consensus among "the scene," as it were, was that Power was now blacklisted. She lost money on rescinded speaking engagements and other work she had booked. We speculated that Power's mental health struggles and traumas would likely worsen in this period of backlash and isolation. Among the traumas, I learned, was that the man she was dating had been beaten by police the previous year, an event that triggered a perceived radicalization of Power's own ideological leanings.

"What happens to all of her previous work—her deep, thoughtful commitment to Marxist thinking and Marxist feminisms?" Calin asked me. Do we just throw it all away? We sat there, reflecting. Of course, the question wasn't only about Nina Power. It was about everyone who's ever made a song or a film or an artwork or a book of theory and who had done something shitty, something objectionable, maybe even something criminal, maybe even something horrific. There was a spectrum of shitty actions, and even the beloved feminists had begun to find themselves on that spectrum, revealed to be imperfect, like the men they'd long critiqued. Now it was up to us, it seemed—the younger, emerging feminists who were as yet unblemished—to figure out what was to be done with them and their critical-creative contributions in the world.

When I got home to my sleeping quarters that night—the guest rooms in the social housing complex Golden Lane Estates, just down the street from another social housing and arts complex, the Barbican—I searched "Nina Power" on my phone. There was no Wi-Fi in the room, so I used up data, reading on the small phone screen. The main sources I could find on the issue were Power's open letter, posted on her website, and

Twitter responses, such as the one by artist Liv Wynter: "Fuck Nina Power. Said it since day [one]. And don't be surprised that you find fascists in your institutions or fascists in your feminism. Be more vigilant. Don't let stuff go unquestioned. F U C K Nina power."[67] Wynter had been Tate Modern's artist in residence before stepping down from her position in protest of the Tate's failing women through its failure to address systemic sexual harassment.[68] I wanted to understand what Power had done, and its tie to fascism. I agreed with Wynter, that we need to keep questioning things, and I admitted to myself that I had always found Power's writings a bit elusive, as though it was feminist philosophy of a sort and it was really smart but it wasn't meant for me, really—or perhaps I wasn't British or European enough to understand the relevance of Marxist theory to understanding labor today (it was almost too smart for me, I thought, in those moments when I returned to the familiarity of my imposter syndrome as a working-class kid, a first-generation college or university student).

Others come to Power's defense, such as the Berlin-based media and criticism collective *New Models,* which writes in a composed, somewhat passive aggressive manner: "Whether or not the recent Nina Power debate is of interest to you (her anon accusers call her a fascist & a TERF, among other things), her response offers a cogent reflection on the contemporary terms of power, celebrity, identification, and belonging."[69] As I put more pieces of the puzzle together, reading tweets, it seemed that Power misgendered a trans woman and was associating with dudes on the alt-right and apologizing for a women's group known for its transphobia. *Ugh, why!* I thought to myself. *That's shitty.* I set down my phone. And as I tried to fall asleep, preparing for the next morning when I would head back to the *AUTO-* conference at the Royal College of Art, put on by the program where Power coincidentally used to work (she left the RCA prior to these controversies), I felt adrenaline coursing through my body, my head experiencing that familiar, chronic fog that obscures the clarity of my thought.

The latter part of the 2010s saw a wave in intersectional feminist and queer discourse that advocated for recognizing the nuances and problematics of what has been described as "call-out culture" and "cancel culture," tied as it was to the tendency to work in ways that disclosed and exposed named people—a tendency often located in social justice and queer, feminist communities. Online personal-critical essays like Kai

Cheng Thom's "4 Ways That Call-Out Culture Harms Trans Women (And, Therefore, All of Us)" and jaye simpson's "A Conversation I Can't Have Yet: Why I Will Not Name My Indigenous Abusers" (2019) make the case for the need to consider intersectionally the act of calling out.[70] These articles unpack, for example, the ways that call-out culture is not straightforwardly empowering for women and queers: that call-out culture is a problem that needs to be addressed with a view to its ableist, "elitist," and self-righteous tendencies and the ultra-charged histories of white women calling out men of color. The case of #MeToo in Hollywood stands as an example of call-out culture "working," and why it continues to be seen as a viable and desirable way to enact politics. At its worst, call-out culture itself becomes violent, a point Cheng Thom addresses when she defines it as "a culture of toxic confrontation and shaming people for oppressive behavior that is more about the performance of righteousness than the actual pursuit of justice."[71]

Nina Power was a generous and insightful external reader of my dissertation, out of which this book I am writing emerged, and I would be remiss if I didn't acknowledge that. I can disagree with the actions she took after the fact of my defense, while also refusing to discard the person who, at a certain moment in time, provided me with feedback and support through a deep, considered engagement with my 450-page dissertation.

AUTOTHEORY AND THE QUESTION OF FICTIONALIZATION

Kraus's performative and rhetorical moves in *I Love Dick* perform differently from the present-day "call-out "and "cancel" culture, even as their effects are related and their tone quite similar. Kraus writes performatively, allegorically, stating what happened without qualifying it with her own conclusions. Here's a story. Here's the guy who did it. His name is Richard Schechner: maybe you've heard of him? The NYU professor, pioneering director/creator of experimental theater, the founder of the interdisciplinary field now known as performance studies. She names *real-life* names— Richard Schechner is Richard Schechner, Chris Kraus is Chris Kraus, and while this autofictional conceit provides a very thin veil of fictioning, the book is very much rooted in real life, and that is much of the point—this

actually happened and *resultantly, this is consequential* (politically, aesthetically, socially, intellectually).

As an orientation, autotheory takes the actually lived life as important critically, and as worthy of reflection and nuanced consideration in relation to critical and creative practices (which include fictionalization), without turning to fiction as a stylistic-legalistic crutch. Kraus is wary of fictionalizing real-life stories, something she calls out many a male author for doing in disingenuous ways. Instead, Kraus's own diaphanous approach reveals the put-on, performed nature of those very writers who draw from life without acknowledging it as such and who change minor details in a strained effort at fictionalization. This is one way that Kraus transmutes the contradictions and issues she perceives in contemporary theory and literature in conceptual ways.

The practice of disclosing autobiographical "truths" through writing and text has a long and varied history in literature and art, from the diaristic and epistolary forms of eighteenth-century novels through to the *roman à clef* and autofiction, and the degree of fictionalization and veracity-to-life varies across texts and contexts. The *roman à clef,* or "novel with a key," is particularly significant when it comes to autotheory, since the premise of the genre is that there is a nonfiction or real-life tie to the loosely fictionalized characters and events, the revelation of which becomes the figurative "key." Kraus's *I Love Dick* might be read as a meta-*roman à clef,* with her deliberately disingenuous fictionalization pointing, in performative ways, to the real-life people and events on which it was based. (With this in mind, I might understand differently Joan Hawkins's use of the term "theoretical fiction" to describe Kraus's work: Kraus's *I Love Dick* is *theoretically* fiction, but not *actually.*) Autotheory's roots in feminist and queer activism and literary practices also plays a role in this shift of artists and writers toward working in ways that make explicit the relationship between one's life and work. The politics and aesthetics of disclosure as part of an autotheoretical practice began earlier than Kraus's 1997 work, even as Kraus's mode of writing marked a new way of going about feminist critique; with some indebtedness to literary movements such as the New Narrative, Kraus's writing marked a shift to another way of writing narratively and personally.[72]

Writing on postminimalist sculptor Eva Hesse's *Diaries,* written by Hesse between the years 1936 and 1970 and published posthumously in 2016, art critic Mitch Speed explains how Hesse discloses details of mistreatment at the hands of her husband. Speed writes: "On at least one occasion, he [husband Tom Doyle] gives her crabs. Years earlier, reading Camus's *Exile and the Kingdom,* Hesse had sympathized with the book's women who are 'weary of their masks, bored by their relationships. ... In retrospect, this reflection reads like a self-directed warning."[73]

The disclosure of truths about known and named men in Hesse's life links Hesse's work to contemporary writings by figures like Kraus. And yet the distinction must be made between Hesse's writings—written as private diary entries, and conceivably not intended for publication—and works like *I Love Dick* that employ the diaristic mode as a postmodern conceit. Since Hesse's diary entries are presumably not intended to have been read by an audience other than herself, the issue of her *not* fictionalizing the work or changing the names is much different from Kraus's decisions in a work intended for public reception.

Hesse's *Diaries* might not be autotheoretical publications in the way that *I Love Dick* is, but they demonstrate an impulse to life-writing and personal disclosures or confessions that is taken up in explicit, performatively public ways by later writers and artists through to the twenty-first century. There are roots in earlier autofiction; Hervé Guibert, a French writer, critic, and artist and one of the originators of autofiction, famously outed Michel Foucault as homosexual in his 1990 *À l'ami qui ne m'a pas sauvé la vie*, his intimate narrative that takes the form of diaristic entries. The book is framed as fiction but widely understood to be about Guibert's real-life friendship with Foucault and Guibert's experience with AIDS and suicide.[74] The real-life consequences of Kraus's barely fictionalized book came through with Dick Hebdige's lawsuit against Kraus on the initial American publication of *I Love Dick* in 1997.

If the fictionalization is a façade, then why bother? Why not write in ways that directly disclose, instead of writing it as if it were fiction? Let's name the real names and hold those people accountable for their lived actions in the world, so the autotheoretical thinking goes. With the postconfessional technologies of social media that facilitate a culture

of widespread "oversharing," the emergent generations (I'm a millennial myself and still I feel old as I type the word "iGen") have a much different relationship with personal writing and self-imaging than, say, the boomers or even Gen-X. While the stakes of exposing and disclosing directly remain high—one of the reasons, perhaps, why writers in the *roman à clef* tradition and other para-autofictional modes have sought refuge in the realm of "fiction" (another being the critically disparaged place of the memoir, feminized as it is)—there is a palpable generational shift when it comes to the ease of working in those ways. Autotheory's roots in feminist activism come through in relation to the politics of such acts of disclosure, exemplified in movements like #MeToo and #TimesUp, which bring to light abuses of power in institutions of popular culture and academia, such as the Hollywood and the Ivy League industrial complexes.

CODA

"This incident congealed into a philosophy: Art supersedes what's personal," Kraus writes to Dick: "It's a philosophy that serves patriarchy well and I followed it more or less for 20 years. That is: until I met you."[75] She credits her meeting Dick with prompting her into the autotheoretical mode, explaining what other feminists have acknowledged before her: that the view that "art supersedes what's personal," that art renders superfluous or irrelevant the lived and embodied, is one that facilitates patriarchal interests and is directly confronted by autotheory as feminist practice. Kraus's disclosures are one way she subverts the structures and terms of masculinist theory, specifically French poststructuralism in America.

As a mode that enlivens the integration of the practice of living and the practice of theorizing or philosophizing, autotheory is well positioned to be responsive to a real-world politics and ethics that expands out beyond the limits of the written or artistic text. By the logic of Kraus's *I Love Dick*—where her feminist disclosures serve as a prophetic analog mirroring of the #MeToo movement twenty years later—the lived behaviors of theorists, cultural critics, and scholars matter: our reception of

Schechner's performance studies scholarship might be affected, for example, by knowledge of his exploitative behavior towards students. In *I Love Dick,* we find the early bubbling up of the #MeToo impulse within textual, feminist experimentations: Kraus uses a practice of autotheory to disclose her lived experiences in the world of contemporary theory, shedding light on structural forces behind a given theorist's or professor's behavior—behavior that the reader sees reflected back, IRL.

CONCLUSION

AUTOTHEORY IN (DE)COLONIAL TIMES

Ethics is the aesthetics of the few-ture.
—Laurie Anderson

oh there, I guess; like we could critique ourselves free.
—Anne Boyer, *The Undying*

"This paper is rooted in a very specific embodiment." David Chariandy was speaking with a certain softness into the lapel mic on his button-down shirt. A Black man of the Caribbean diaspora, living in the colonized lands of Turtle Island, Chariandy has become most recognized for his fiction writing, some of which is inspired by his life. His work is more directly auto-biographical in recent books, such as the nonfiction *I've Been Meaning to Tell You: A Letter to My Daughter* (2018).[1] That afternoon he was presenting a brand-new work as the plenary talk at the ACCUTE (Association of Canadian College and University Teachers of English) 2019 congress. The title of his presentation was "Theory: A Footnote."

The embodiment to which he was referring was his own, an embodiment that he transmutes through the utterances of this barely fictionalized story. It is the story of a young man with David Chariandy's name: "It's autofiction, but—you know," Chariandy conceded, after the audience burst into sympathetic, knowing laughter when he referred to "Y University," an institution he described as the more radical Toronto university

David Garneau, *Indigenous. Academic.
Solidarity,* 2019, acrylic on canvas. 92 × 76.5
cm. Courtesy of the artist.

located in the suburbs, on the margins of the city. Chariandy related how he was able to attend "Y University" as a first-generation student from a working-class, Black family in Scarborough, and how "Y University" (or York University, to which he was so clearly referring, however disingenuously fictionalized) was the more accessible university when it came to race and class. It was also, as Chariandy noted, a school known for its interest and innovation in this thing called "theory" ("Y has a reputation for being strong in something called *theory,*" he wrote).[2]

Both were reasons why I myself had chosen "Y University" to pursue my PhD research, coming to my studies as a first-generation student from a working-class, white settler family with mixed heritage who, from the first undergraduate course that I took in literary theory, would continue to gravitate to this weird thing called *theory.* "Y" University stood in contrast to the University of Toronto, which represented a more evidently colonial, white, "old-money" institution, located on prime downtown real estate. Of course, all of these universities are colonial, white, moneyed institutions, to varying degrees. Within those spaces, Chariandy's character "David" is not able to articulate the conditions of that embodiment. Chariandy doesn't use those words—"white" or "colonial"—not really; his presentation was more classically literary in its nuance, with his convincing practice of *showing and not telling* through narrative and character and diction.

The impetus behind Chariandy's new work was Dionne Brand's novel *Theory* (2018), a book that engages ideas of the autotheoretical in a novelistic, fictional narrative about the relationship between love and intellectual life.[3] Chariandy had written his dissertation on Brand and other writers, in what would become recognized as the first work on a nascent field called Black Canadian literature. Mirroring Brand's *Theory,* which follows a character struggling to finish writing their PhD dissertation, Chariandy's "Theory: A Footnote" is an autotheoretical response to Brand's work—to which I am in a sense providing my own autotheoretical response here. Chariandy's talk, a very long footnote, was its own cohesive work of literature: a piece of writing that I would suggest is best described as "autotheory," even though Chariandy used the more common term "autofiction" to describe his way of working. I prefer "autotheory" in relation to Chariandy's recent performance because it gets at the fact that Chariandy, by working in ways that are autobiographical and self-reflective (Heike

Geissler's word "nonfiction novel" might be an apt descriptor, too), addresses problems related to theory, theoretical discourse and frameworks, and the politics and aesthetics of that theory as it is practiced and circulated in academic spaces, and as it effects and affects extra-academic life.

When Chariandy concluded his presentation, reading his new text for a nearly precise sixty minutes, the room uproared into a standing ovation. People around me were moved, tears welling up in their eyes. I too was nearly moved to tears, holding back a well of sadness I'd felt since I landed back on the West Coast—this strange city of Vancouver, with its reverberant isolation, its depth of sadness like a tide that ebbs in and out on the costly shores of the "Spanish Banks." Here we were, sitting on the unceded, colonized, ancestral lands of the Musqueam peoples, at the University of British Columbia, a school I dreamed of attending when I graduated from high school at the top of my class, winner of numerous awards, but from which I was socioeconomically barred. Even with scholarships, I could not afford to go to university outside of my hometown (the college fund: a socioeconomic privilege that surely should be acknowledged as such), let alone UBC Vancouver, with its sublime natural and manufactured beauty—its rose gardens and mountains and beaches and boutique architecture. Later, I had the opportunity to move out this way to do my master's degree, not at UBC but in a funded program at Simon Fraser University, the more "experimental" university (with the same concrete brutalism of York U), at least at that time, and where I worked with Chariandy as a teaching assistant in his first-year undergraduate course on postcolonialism and fiction.

I have a memory of David taking all of us teaching assistants out for a delicious dinner at a restaurant in a picturesque area of the lower Burnaby Mountain. It was the end of the course, all our grades were in, and David was treating us to dinner. The memory stuck with me, as I had never felt that kind of respect or self-integrity in the TA role. And he *paid*! For *all of us*! I felt the sense that I *should* feel shame for being so crass about money. I knew that I probably thought about money more than many of my fellow grad students, and that my working-class roots showed when I named the cost of things, or named my income, without the WASPy middle-class reservations of some of my friends and former lovers. Earlier that semester, an English professor had made an offhand comment about how "you

don't want to end up bagging groceries your whole life," to which the small audience of our graduate seminar laughed in knowing acknowledgment: yes, it would *really suck* to bag *groceries* for the rest of your life. I thought of my kind and hardworking dad, who has been bagging groceries and stocking shelves for over thirty years, a frontline job he got when he was sixteen and which he worked at, diligently, until retirement. He always held firm and taught me that no job is superior to another job, just as no person is superior to another person. It was an ethics my parents fervently upheld and practiced, "uneducated" as they might be.

The narrative of "Theory: A Footnote" follows the protagonist David Chariandy as he navigates the intensity of the life-sucking demands of moving up the academic ladder, with a rigorous schedule that becomes self-violent, along with his non-university-educated parents and brother. The character of the brother invokes the most profound pathos. Despite his sharp, sparkling intellect and keen capacity for reading philosophy and critical theory—the most comic, but also ultimately the most gutting, scene involves the brother, on break from his job as a security guard in the city's financial district, giving an almost bafflingly cogent and insightful take on Kant. In that moment, privileges come to light: who is given access to reading and study, and who is given access to reading and study *as a job*—even a precarious one, in the case of a decently funded (the question of "decent" funding being a relative one) graduate student? The question is raised whether the brother is a philosophy scholar, in a sense, or a philosopher in his own right, even if he has never been affiliated with a university or formal philosophy education. David's character experiences a nauseating anger and frustration, which leads him, in the climactic moment, to run to the bathroom of the café and vomit. As if the scene could not get more humiliating, it concludes with the two men being escorted out of the café by the police. The reason? They were sitting at the table without having ordered anything—distracted by the deep conversation they were in—and told they can never return. They are both, we know, young Black men. And they are both, we understand as Chariandy reads, thoughtful philosophers, struggling with the material, political, economic, and structural realities at the end of the twentieth century.

In his paper, Chariandy quotes Christina Sharpe, who warns that "for Black academics to produce legible work in the academy often means

adhering to research methods that are 'drafted into the service of a larger destructive force' (Saunders 2008a, 67), thereby doing violence to our own capacities to read, think, and imagine otherwise."[4] Chariandy's character also considers the lure or powers of discourse, understood as the means through which we are hailed into an institution, invoking an Althusserian notion of interpellation without reference to the French philosopher who murdered his wife by strangulation. There is a violence to discourse, yes, and it's a violence many of us are aware of. It's a violence that can exclude—as in the case of Chariandy's brother, the other central character in "Theory: A Footnote"—and it's a violence that can suppress and suffocate those who are seemingly included—as in the case of David Chariandy's character. David successfully navigates graduate school until he reaches the dissertation proposal stage and has his first very clear moment of reckoning academic discourse and institutional guidelines with his research and lived experience as a Black Canadian man, and his interest in Black Canadian literature and life. Chariandy has explored themes of institutional and class mobility, and the racial politics of those issues, before, in fictional work such as *Brother* (2017),[5] and with the new piece he performed at the congress conference, he addressed head-on the institutional politics of access in the Canadian university through the lens of "theory" broadly understood.

How do writers and artists situate experiences of difference, in real and sincere ways, in spaces that are so hostile to those experiences? Chariandy took this question up with the audience after his presentation. The work he presented was compelling, and while it was clear that many people wanted to voice their ideas and pose questions to Chariandy, I also couldn't help but feel that what we needed most was some space for silence, for taking in all of the subtleties and the very pressing political and intellectual issues that Chariandy had intimated. "I struggle with the ethics of this performance that I did here today," Chariandy concedes. And as more and more white folks in the room voiced their "questions"—most of which were not questions so much as their own responses, mildly patronizing in their encouragement—I wanted to stand up and say, "Weren't any of you *listening* to what David just shared with us?" Instead, I sat down and closed my eyes, cringing a bit, as a professor a few rows in front of me said that

he wants to "mirror what you've just said back to you," as if David had inadvertently found himself in a psychotherapist's room, his self-reflectively Black words being "mirrored" back to him through a white body. Everyone in the room was an admirer of Chariandy and his work—the person *and* the writing—and was there to support him. But despite their best interests, some of those asking questions seemed to not have gotten the larger point of Chariandy's performance.

I sat there, still reverberating from the performance. I could still feel the words "first-generation student" vibrating in me, knowingly; it was common for people to assume that "first-generation students" were also "recent immigrants," an assumption that frustrated me and made me wonder why my parents, and my grandparents, and everyone before me whom I knew so little about—where had they come from, and why had they come here?—hadn't attended college or university themselves. My mother had always wanted to be a lawyer, but her father, a wandering salesman of Romanian, Bohemian, Turkish, and Hungarian descent, told her women didn't go to university. She became a legal secretary instead. Even though I lacked the privileges of a college fund, I had the privileges of my whiteness, my settler background, and the possibilities for class mobility that came with that whiteness, my apparently able body, and my learned "Protestant work ethic" that had become compulsive, even self-harmful, over the course of my life. I then listened as Chariandy described, through cutting diction, the protagonist's—an autofictionalized *him*—self-harm. The character, a young Black man and a perceptive student of literature and theory, exercises until he pukes, studies until it's time to sleep, every day, the rigor of his self-scheduling to attain the "success" of climbing academia's ladder—all so that he can get through graduate school and write the kind of work he wants to write. Theory, here, is enmeshed in pain.

Following his discussion of representations of Black masculinity in academia, and the self-immolation required to be sufficiently "rigorous," Chariandy proffers a definition of theory as typically understood. This definition is written as if to his younger self, explaining the racial dimensions of this so-called elevated discourse and addressing, with a honed incisiveness similar to @gothshakira's latinx-femme memes, the unsettling politics of opacity:

Theory—real theory—would appear to be white; although, increasingly, it can be liberally applied to the non-white, thus affording the raw cultural cash crops of darkness precious opportunities of explication and refinement. Of course, of late, there have been nods, among real theorists, to certain so-named "postcolonialists," especially those whose writings are agreeably opaque—itself a high indication of theoretical sophistication, like being an asshole or having a penis.[6]

With these words, Chariandy addresses one of the problems at the heart of the autotheoretical turn. What constitutes "real theory"? Why has "theory" historically been the purview of white people, and what does this mean for the possibility of decolonizing theory? Why is the realness of "theory" predicated on its opacity? Why could the way of practicing "real theory" be summed up in the word "asshole," and why was this joke so resonant with the academic audience listening and laughing? Weren't we the ones teaching and reinscribing this theory, and couldn't we change it if we really wanted?

Although colonial, white-dominated institutions like universities have foregrounded theory as white, there is a rich history of nonwhite theoretical and philosophical writings contributing to the autotheoretical impulse in culture today. The Negritude movement inaugurated by Aimé Césaire's writings of the 1930s through the 1950s had antecedents in the work by writers like W. E. B. Du Bois and the Harlem Renaissance poets, and subsequent manifestations in the influential work of Frantz Fanon and others following him during the Cold War era. Césaire's 1939 poem *Cahier d'un retour au pays natal* (*Notebook of a Return to My Native Land*) and his 1955 *Discourse on Colonialism* show an autotheoretical impulse, articulating theories of Black becoming in the early days of the decolonial movements of the twentieth century through personal-critical essays or the long poem form.[7] Modes like Césaire's and Fanon's reassert a nonwhite practice of theory that moves between different genres and registers.

After the applause—he received a standing ovation—David was flooded with people coming up to him at the front of the room, shaking his hand and praising his words. Admiring scholars basked in his intelligence and self-respect, his humility. Later that week, I would receive an email sent from ACCUTE and, shortly thereafter, Women's and Gender Studies et Recherches Féministes, expressing their "outrage" at an incident of racial

profiling by UBC security guards and the Royal Canadian Mounted Police against a young Black male scholar at the congress; a series of similar statements would be released denouncing the anti-Black racism and seeking to make amends for their unwitting complicity. The scholar who had been racially profiled was Shelby McPhee, who had traveled from Nova Scotia to present his research as part of the Canadian Black Studies Association. He was wrongly accused of stealing a laptop, and then stalked and harassed by campus security.

If anyone had the misconception that structural racism was no longer an issue, even in a context where people were gathering to speak about these very issues, they were mistaken. Maybe Hegel was wrong: history isn't teleological, and progress isn't teleological either. I thought of other recent political murmurings, like the desire to ban abortion or the possibility that gay marriage rights be rescinded. When progressive changes are made, it doesn't mean that those incremental changes are here to stay. For those who, like Black scholars in academia, have been marginalized and oppressed, that kind of progressive change is something that must continue to be fought for. "And this is happening in 2019," I overheard one white scholar say to another, shaking their heads, as I rode the bus downtown after the conference. "And in *Vancouver*!" "Well, there really aren't a lot of black people here," another scholar said, with a pained expression. "In Vancouver," they added, to clarify.

As I have historicized and contextualized it in this book, the tendency toward working autotheoretically emerges out of and crystallizes through women (and others, including nonbinary and gender-nonconforming) and women's bodies as living and thinking in a world that, given patriarchal and colonial structures, might be hostile to them. But the work that autotheory does in breaking down hierarchies and systemic oppression (even within ourselves) makes it, by those very characteristics, an apt model for all of us—as Chariandy intuits—no matter one's class, race, gender, or background. This is arguably the radicality of autotheory as a mode that has the potential to be egalitarian and accessible: through the exchange between the autobiographical and the critical, it allows those who are living their lives reflexively and with criticality and awareness to theorize from their lived positionings and to engender knowledge and insight from the specificities of their body-minds, thriving in relation to others with whom they might have affinities as well as points of difference, even

dissension. While this might seem a utopic promise, one that might at first appear overly optimistic, I think the range of works emerging over the past half-century that engage autotheory in subversive and liberatory ways points to the possibly radical, and ethical, capacities for autotheory as an inclusive mode with deep feminist roots.

LOOKING AHEAD: AUTOTHEORY, LAND, AND PLACE

Throughout this book I have charted the role of autotheory as a way of processing tensions in the understandings of theory and autobiography, knowledge and the body, community and the self, rhetoric and practice. I have taken up autotheory as a contemporary mode—or, perhaps better, modes—of transforming "theory" from embodied and experiential ways of working. Autotheoretical works fuse the discourses, frameworks, and terms of the so-called "master discourses"[8] of theory and philosophy with self-reflection and self-representation, navigating critical study through embodied and autobiographical practices. Autotheory emerges as a term to describe the ways artists and writers process and transform these discourses and frameworks through their practices of living, making art, writing, and formulating critiques. I have provided a glimpse of some of the ways the intertextual, intersectional politics of autotheoretical practices drive to integrate the *autos* and *theory* in its varied forms—a move indebted to long-standing histories of feminism.

Autotheory can serve as a way of critiquing and transforming existing colonial discourses of philosophy and theory through such practices as autotheoretical citation, through what my friend and collaborator Alex Brostoff refers to as intertextual kinship,[9] and through forms of community-building and radically empathetic, cross-experiential collaborations that considerately and curiously engage the personal alongside the critical. Autotheory can also be, just as importantly, a means of engendering new ways of theorizing or philosophizing that are responsive to and embedded in the lives of those doing the thinking and speaking, including those who have historically been precluded from positions of intellectual authority and authorship and who have been violently suppressed by colonial forces.

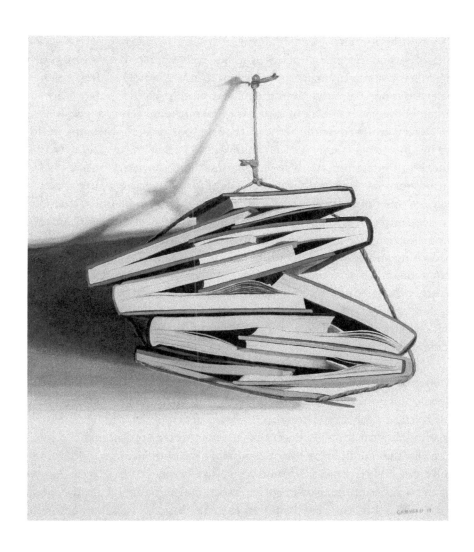

David Garneau, *Inter-text I*, 2019, acrylic on
canvas, 92 × 76.5 cm. Courtesy of the artist.

Autotheory can be seen not just as a descriptor of particular artworks but also as an impulse, practice, and generative force that reconfigures fields, genres, and canons, proposing new relations between selves and theories far more expansive than the master discourses that have governed much of theory's movement through academic and literary spaces.

Kyla Wazana Tompkins writes, "Theory is both descriptive of the world we live in and speculative as well, in that it seeks new worlds and new language to understand what seems 'natural' and 'normal.'"[10] At its best, autotheory offers oblique and ambivalent forms of critique; unexpected ways of practicing theory; new ways of being that can be understood as critical, and efficacious, intellectually and politically; satire and subversion that is more affirming than it is myopically destructive; forms of becoming and being with identity that are in excess of certain delimiting categories and distinctions; and a way of understanding oneself in relation to others, where introspection tied to study and citation becomes a way of understanding both yourself and the world around you, and how your experience in the world ties to history, politics, philosophy, ethics, aesthetics, identity, and becoming.

There is a double-sidedness to autotheory: it energizes and affirms new modes of critique—ones attuned to the politics of intersectionality and decolonial politics that feel particularly fruitful in the present day. With the term "autotheory," though, comes the risk of a potentially excessive methodological individualism that places primacy on the *autos* or self in a way that could bring the questionable logics of late postmodernism full circle ("My truth is *truth*, and your truth is *your* truth"), or the logics of those most militant forms of intersectional thinking ("I am the most marginalized by the center-margin logic of this given context and so I will be the *only one* to speak"). As I have attempted to reveal in this book, autotheoretical works most often exist somewhere in the place where the "self" comes into relation with others—be it other people, through physical and citational communities and kinship networks, or objects of study, such as works of contemporary art and literature—and these moments of brushing up range from antagonistic to loving, pleasurable, and frictive. At its worst, autotheory can become that unproductive form of narcissism—my truth is the only important truth worth listening to, which is fascistic—or solipsism cut off from the world.

Can theory be decolonized? The answer, I think, comes down to practice. In the introduction, I referenced Mieke Bal's description of autotheory as it relates to her practice as a scholar, writer, and documentary filmmaker: for her, autotheory describes "a form of thinking that integrates my own practice of art making as a form of thinking."[11] This definition of autotheory allows Bal to configure varied creative practices as critical, investigative, and self-reflective, and reminds readers of the ways their own art-making can be a form of thinking, too (and vice versa, since their thinking can come through different practices, including making a film, composing music, writing a text, walking on the land with curiosity and attention to its deep histories and presents/presence).

There are many recent autotheoretical practices that find their energy in decentering this thing called "theory," some of which I have looked at in this book, and it is in the centering of Indigenous and Black artists working autotheoretically that, in my view, some of the most interesting work is being done. Continuing to broaden the archive of works and practices that scholars and others study as autotheoretical will make it possible to extend the broader actions toward decolonization—of language, culture, knowledge, institutions like universities and art galleries—to the decolonizing of what is called theory and philosophy in the twenty-first century.

The politics and aesthetics of land and place have reemerged with new urgency in recent years, with the reality that many of us are living as settlers on colonized, Indigenous lands, benefiting in different ways from very violent histories of colonialization and cultural genocide, finally hitting academia, contemporary art, and the mainstream in a more amplified way. As I look ahead to the next steps in my research on autotheory, I am compelled to go more deeply into questions around land and place, tied as they are to autotheoretical feminist histories of situated thinking. Arguably, the politics of land is really the most pressing question right now, tied as it is to both Indigenous justice and to ecological justice (both linked to the survival and futurity of life on Earth).

My next steps in this research extend feminist autotheory more specifically to the politics and aesthetics of settler colonialisms, land, and the poor and working class in the context of the colonized lands of North America. This research takes the form of my returning more deeply to my own studio practice, which spans performance for the camera, video art,

small-gauge film, bookworks, and mixed-media experiments in a range of personal archives. This is a space of intergenerational traumas, and it is work that I believe, intuitively, is necessary work for me to do—personally, politically, critically. As I look to my personal history and experience along-side other personal histories (is not all history personal?) and texts, I consider the politics and aesthetics of class, working-class cultures, the spectra of whiteness, and so-called uneducated knowledges. I find energy in first-gen student clubs shaking up the Ivy League elite. I consider, with an ongoing curiosity, the tensions between globalized postinternet life—in all its nearly disembodying hyperdiscursiveness—and land-based

David Garneau, *Empathetic Conformation*,
acrylic on masonite, 40 cm × 50 cm, 2019.
Courtesy of the artist.

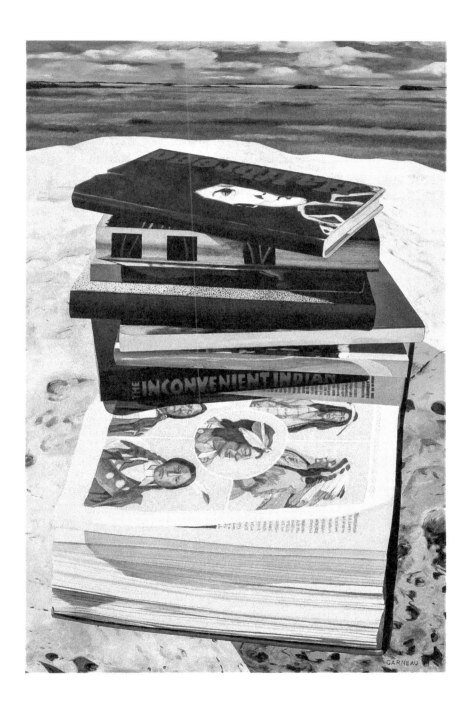

David Garneau, *Displacement. Indigenous on Indigenous Scholarship,* 2019, Acrylic on canvas. 122 × 79 cm. Courtesy of the artist.

modes of being in the world that include worldviews held by Indigenous groups like the Plains Cree and the Métis Nation, who are Indigenous to the lands I know as "home," as a settler raised in an assimilated, white culture in Treaty 4 territories.[12] As I continue working through the aporias of autotheory, I find myself reflecting on reparative futures and, just as important, reparative presents—ways of being that are attuned and empathic, and that share one's perspectives, stories, and cultural practices autotheoretically, while, just as important, listening to the perspectives, stories, and cultural practices of others. While autotheory is predicated on the self, it is by no means solipsistic. The singular can be a gateway to the multiple. And in theorizing together we may, after all, hear ourselves.

NOTES

INTRODUCTION

1. Luce Irigaray, *This Sex Which Is Not One*, trans. Catherine Porter and Carolyn Burke (Ithaca, NY: Cornell University Press, 1985 [1977]), 151.

2. Sohrab Mohebbi and Ruth Estévez, eds., *Hotel Theory Reader* (Vancouver: Fillip/REDCAT, 2016); Jody Berland, Will Straw, and David Tomas, eds., *Theory Rules: Art as Theory / Theory as Art* (Toronto: University of Toronto Press, 1996).

3. Irigaray, *This Sex Which Is Not One*, 149.

4. Nelson notes in an interview with the *Los Angeles Review of Books*: "I flat out stole this term [autotheory] from Paul Preciado's amazing *Testo Junkie* ... it seemed an apt description even if its [*The Argonauts*'s] form, or its particular investment in theory, is quite distinct from Preciado's experiment." Micah McCrary and Maggie Nelson, "Riding the Blinds: Micah McCrary Interviews Maggie Nelson," *Los Angeles Review of Books*, April 26, 2015, www.lareviewofbooks.org/article/riding-the-blinds.

5. See Sofia Samatar (@SofiaSamatar), "what @Keguro_ does here: gukira.wordpress.com is a kind of life-thinking. reminds me of what @Thisbhanu does here: jack-kerouacispunjabi.blogspot.com," Twitter, October 1, 2015, 8:58 a.m. See also Joan Hawkins, "Afterword: Theoretical Fictions," in Chris Kraus, *I Love Dick* (New York: Semiotext(e), 1997), 263–276; Barbara Godard, "Life (in) Writing: Or a Writing-Machine for Producing the Subject," in *Nicole Brossard: Essays on Her Works*, ed. Louise H. Forsyth (Montreal: Guernica, 2005), 191–208.

6. Paul B. Preciado, *Testo Junkie: Sex, Drugs, and Biopolitics in the Pharmacopornographic Era*, trans. Bruce Benderson (New York: Feminist Press, 2013 [2008]); Claudia Rankine, *Citizen: An American Lyric* (Minneapolis: Graywolf Press, 2014); Moyra Davey, *Les Goddesses* (2011), film, 61 min.; Maggie Nelson, *The Argonauts* (Minneapolis: Graywolf Press, 2015); Clarice Lispector, *Água Viva*, trans. Stefan Tobler, ed. Benjamin Moser (New York: New Directions, 1973); Gloria E. Anzaldúa, *Borderlands/La Frontera: The New Mestiza*, 4th ed. (San Francisco: Aunt Lute Books, 2012); Chris Kraus, *I Love Dick* (New York: Semiotext(e), 1997).

7. Barbara Browning, *The Gift* (Minneapolis: Coffee House Press, 2017); Tisa Bryant, *Unexplained Presence* (Providence, RI: Leon Works, 2007); Gillian Rose, *Love's Work* (New York: New York Review Books, 1995); Julietta Singh, *No Archive Will Restore You* (Goleta, CA: Punctum Books, 2018); McKenzie Wark, *Reverse Cowgirl* (Cambridge, MA: MIT Press, 2020).

8. Mary Wollstonecraft, *A Vindication of the Rights of Woman* (Eugene: University of Oregon Press, 2000 [1792]); Shulamith Firestone, *The Dialectic of Sex* (New York: William Morrow, 1970); Sojourner Truth, *Ain't I A Woman?*, speech, May 29, 1851, Women's Convention, Akron, Ohio.

9. Nancy K. Miller, *Getting Personal: Feminist Occasions and Other Autobiographical Acts* (New York: Routledge, 1991), 14.

10. Audre Lorde, *A Burst of Light* (Ithaca, NY: Firebrand Books, 1988); bell hooks, *Killing Rage: Ending Racism* (New York: Henry Holt, 1995).

11. bell hooks, *Feminism Is for Everybody: Passionate Politics* (Boston: South End Press, 2000), 12.

12. Mary Kelly, *Post-Partum Document* (installation), 1973–1977; Martha Rosler, *Semiotics of the Kitchen* (1975), video, 6:09 min.; Helen Molesworth, "House Work and Art Work," *October* 92 (Spring 2000): 71–97; Joanna Walsh, *#TheoryPlusHousework-Theory* (London: If a Leaf Falls Press, 2019).

13. Miller, *Getting Personal*, 21.

14. Miller, *Getting Personal*, 14.

15. Sidonie Smith and Julia Watson, eds., *Women, Autobiography, Theory: A Reader* (Madison: University of Wisconsin Press, 1998), 193, 63, 167. See also Sidonie Smith and Julia Watson, *Reading Autobiography: A Guide for Interpreting Life Narratives*, 2nd ed. (Minneapolis: University of Minnesota Press, 2010).

16. Virginie Despentes, *King Kong Theory*, trans. Stephanie Benson (New York: Feminist Press, 2010).

17. Preciado, *Testo Junkie*, 347.

18. Chloë Brushwood Rose and Maggie Nelson, "'An Endless Becoming': An Interview with Maggie Nelson on *The Argonauts*," *Nomorepotlucks* 44 (2016), www.nomorepotlucks.org/site/an-endless-becoming-an-interview-with-maggie-nelson-on-the-argonauts-chloe-brushwood-rose.

19. Quoted in Jason McBride, "On the Set of the *Transparent* Creator's Next Show, *I Love Dick*," *Vulture*, July 25, 2016, www.vulture.com/2016/07/jill-soloway-i-love-dick-c-v-r.html.

20. "Chris Kraus: '*I Love Dick* Happened in Real Life, but It's Not a Memoir,'" *Guardian,* May 17, 2016, https://www.theguardian.com/books/2016/may/17/chris-kraus-i-love-dick-happened-in-real-life-but-its-not-a-memoir.

21. Cited in Miller, *Getting Personal*, 15.

22. Bhanu Kapil (@hisbhanu), "This is the year I heard the words 'autotheory', ..." Twitter, October 1, 2015, 9:09 a.m.

23. Sofia Samatar (@SofiaSamatar), Twitter, October 1, 2015.

24. Nelson, *The Argonauts*; Audre Lorde, *The Cancer Journals* (San Francisco: Aunt Lute Books, 1980); Kate Zambreno, *Heroines* (New York: Semiotext(e), 2012); Ann Cvetkovich, *Depression: A Public Feeling* (Durham, NC: Duke University Press, 2012).

25. See Marlene Kadar, ed., *Essays on Life Writing: From Genre to Critical Practice* (Toronto: University of Toronto Press, 1992).

26. Anna Poletti, "Periperformative Life Narrative: Queer Collages," *GLQ* 22, no. 3 (2016): 359–379.

27. Sarah Nicole Prickett, "Bookforum Talks with Maggie Nelson," *Bookforum,* May 29, 2015, bookforum.com/interview/14663.

28. McCrary and Nelson, "Riding the Blinds."

29. Nelson, *The Argonauts*, 114.

30. Mieke Bal, "Documenting What? Autotheory and Migratory Aesthetics," in *A Companion to Contemporary Documentary Film,* ed. Alexandra Juhasz and Alisa Lebow (New York: Wiley & Sons, 2015), 124.

31. Bal, "Documenting What?," 133–134.

32. Shannon Bell, "Shooting Theory—An Accident of Fast Feminism: Video and Transcript of Talk by Shannon Bell," *Scholar and Feminist Online* 13, no. 3 (2016), www.sfonline.barnard.edu/traversing-technologies/shannon-bell-shooting-theory.

33. Shannon Bell, *Reading, Writing, and Rewriting the Prostitute Body* (Bloomington: Indiana University Press, 1994), 25–26.

34. Becky Bivens, "The V-Girls: Feminism and the Authentic Subject after Poststructuralism," *View: Theories and Practices of Visual Culture* 15 (2016): 1–2, http://widok.hmfactory.com/index.php/one/article/view/371/865.

35. Jeanne Randolph, "Is Ficto-criticism an Invasive Species?," in *Yesterday Was Once Tomorrow (or, A Brick Is a Tool): Magazines by Artists in Canada during the 1990s*, ed. Kegan McFadden (Winnipeg: Plug-In ICA, 2018).

36. Benjamin Moser, "Introduction: 'Breathing Together," in Clarice Lispector, *Água Viva*, trans. Stefan Tobler, ed. Benjamin Moser (New York: New Directions, 2012), xiii.

37. Hélène Cixous, *Reading with Clarice Lispector* (Minneapolis: University of Minnesota Press, 1990); *Roni Horn: Rings of Lispector (Água Viva)* (catalogue essay) (Göttingen: Steidl, 2006).

38. Stacey Young, *Changing the Wor(l)d: Discourse, Politics, and the Feminist Movement* (New York: Routledge, 1997), 69.

39. Carolyn Ellis, Tony E. Adams, and Arthur P. Bochner, "Autoethnography: An Overview," *Forum: Qualitative Social Research* 12, no. 1 (2011): 1.

40. Young, *Changing the Word(l)d*, 61.

41. Minnie Bruce Pratt, *Rebellion: Essays 1980–1991* (Ann Arbor, MI: Firebrand Books, 1991); Rosario Morales and Aurora Morales, *Getting Home Alive* (Ann Arbor, MI: Firebrand Books, 1986); Gloria Anazldúa and Cherríe Moraga, eds., *This Bridge Called My Back: Writings by Radical Women of Color* (London: Persephone Press, 1981).

42. bell hooks, *Ain't I a Woman? Black Women and Feminism* (Boston: South End Press, 1981); Lee Maracle, *I Am Woman: A Native Perspective on Sociology and Feminism* (Vancouver: Press Gang, 1988); Maria Campbell, *Halfbreed* (Toronto: McClelland & Stewart, 1973).

43. Valeria Radchenko, "Autotheory," FLUX: Valeria Radchenko, April 22, 2017, https://vvval.wordpress.com/2017/04/22/autotheory.

44. kcintranstition, "the academy, autotheory, and the argonauts," *aminotfemme* (blog), April 22, 2016, https://aminotfemme.wordpress.com/tag/autotheory.

45. Jessica Yee, *Feminism for Real: Deconstructing the Academic Industrial Complex of Feminism* (Ottawa: Canadian Centre for Policy Alternatives, 2011).

46. Trisha Brown, *Accumulation with Talking plus Water Motor,* performance (first performed on February 24, 1979, Oberlin College), recorded September 2, 1986, 541 Broadway, New York, https://www.youtube.com/watch?v=4ru_7sxvpY8.

47. Thirza Cuthand is often credited as coining this specific term, in relation to their identification and practice.

48. "Within many of our communities [Indigenous to Turtle Island], Two Spirit people were regarded as third or fourth genders, with some some Nations recognizing up to six genders. ... Third and fourth gender are terms that were historically used to describe Two Spirit people, acknowledging within our traditions that there are more than only the two genders of man and woman. They were considered to have the power of both male and female spirits, and were therefore seen as having a close relationship with the Creator. Two Spirit people were often healers, visionaries, and medicine people within our nations. They were regarded as fundamental components of our communities, cultures, and societies." "Who Are Two Spirit People," The Canadian Centre for Gender and Sexual Diversity, 2017, https://ccgsd-ccdgs.org/1-who-are-two-spirit-people.

49. Audrey Wollen (@tragicqueen), "Tell Me about Sad Girl Theory," Instagram photo, June 22, 2014, http://www.instagram.com/p/pcUbM7szQ5/?taken-by=audreywollen&hl=en; Johanna Hedva, "Sick Woman Theory," *Mask Magazine,* January 2016, http://maskmagazine.com/not-again/struggle/sick-woman-theory; Despentes, *King Kong Theory*. A decade earlier, Kraus, in *I Love Dick*, described the genre she's instantiating as "lonely girl phenomenology."

50. Fredric Jameson, "Periodizing the 60s," *Social Text* 9/10 (1984): 194.

51. Louky Bersianik, Nicole Brossard, France Théoret, et al., *Theory, A Sunday* (Brooklyn, NY: Belladonna*, 2013 [1988]). *Theory, A Sunday* is collectively coauthored by Louky Bersianik, Nicole Brossard, France Théoret, Gail Scott, Louise Cotnoir, Louise Dupré, Lisa Robertson, and Rachel Levitsky; the women worked collaboratively over a set period of time in conversation with each other to develop the texts that would form this experimental anthology.

52. Barbara Godard, "Life (in) Writing: Or a Writing-Machine for Producing the Subject," in *Nicole Brossard: Essays on Her Works,* ed. Louise H. Forsyth (Montreal: Guernica, 2005), 198.

53. Godard, "Life (in) Writing," 191–208.

54. Michael Silverblatt, "Dodie Bellamy: When the Sick Rule the World," *KCRW Bookworm,* (audio blog), September 17, 2015, http://www.kcrw.com/news-culture/shows/bookworm/dodie-bellamy-when-the-sick-rule-the-world.

55. The New Narrative movement began in San Francisco in 1977 and included such writers as Kathy Acker, Lynne Tillman, Carla Harryman, Gabrielle Daniels, Gail Scott, Camille Roy, Laurie Weeks, Gary Indiana, and Bob Flanagan. See Dodie Bellamy and Kevin Killian, eds., *Writers Who Love Too Much: New Narrative 1977–1997* (New York: Nightboat Books, 2017).

56. Robert Glück, "Long Note on New Narrative," in *Biting the Error: Writers Explore Narrative*, ed. Mary Burger, Robert Glück, Camille Roy, and Gail Scott (Toronto: Coach House Books, 2004).

57. Claudia Rankine, *Citizen: An American Lyric* (Minneapolis: Graywolf Press, 2014); *Don't Let Me Be Lonely: An American Lyric* (Minneapolis: Graywolf Press, 2004).

58. Christian Lorentzen, "Is Radical Queerness Possible Anymore? Poet Maggie Nelson's New Memoir," *Vulture*, May 4, 2015, http://www.vulture.com/2015/05/poet -maggie-nelsons-queer-new-memoir.htm.

59. Norma E. Cantú and Aída Hurtado, "Introduction," in Anzaldúa, *Borderlands/La Frontera*, 5.

60. Anzaldúa, *Borderlands/La Frontera*, 19.

61. Zora Neale Hurston, "How It Feels to Be Colored Me," *World Tomorrow* 11 (May 1928): 215–216.

62. Michel de Montaigne, *The Complete Essays,* ed. and trans. M. A. Screech (New York: Penguin, 1991), 1218.

63. Quoted in Anthony Gottlieb, "Montaigne's Moment," *New York Times*, March 10, 2011, https://www.nytimes.com/2011/03/13/books/review/montaignes-moment.html.

64. Silverblatt, "Dodie Bellamy."

65. Gottlieb, "Montaigne's Moment."

66. Henry Chadwick, "Introduction," in Augustine, *Confessions*, trans. Henry Chadwick (Oxford: Oxford University Press, 1991), ix.

67. Jacques Derrida, *The Ear of the Other: Otobiography, Transference, Translation*, ed. Christie McDonald, trans. Peggy Kamuf (New York: Schocken Press, 1985 [1982]), 43.

68. Derrida, *The Ear of the Other*, 61.

69. Derrida, *The Ear of the Other*, 6–7.

70. Derrida, *The Ear of the Other*, 16.

71. Derrida, *The Ear of the Other*, 10.

72. Audre Lorde, *Zami: A New Spelling of My Name* (New York: Crossing Press, 1982).

73. Elizabeth Alexander, "'Coming Out Blackened and Whole': Fragmentation and Reintegration in Audre Lorde's *Zami* and *The Cancer Journals*," *American Literary History* 6, no. 4 (1994): 696.

74. For example, see Jacques Derrida, *La Carte Postale* (Paris: Flammarion, 1980); Jacques Derrida, *Circonfession* (Paris: Éditions du Seuil, 1990).

75. Luce Irigaray, remarks at Luce Irigaray International Seminar, University of Bristol, June 15, 2016.

76. Irigaray, remarks at Luce Irigaray International Seminar.

77. Irigaray, *This Sex*, 67.

78. Carolee Schneemann, *Imaging Her Erotics: Essays, Interviews, Projects* (Cambridge, MA: MIT Press, 2002), 21.

79. Carolee Schneemann, *Interior Scroll* (1975), performance with script, East Hampton, New York.

80. Sigmund Freud, *The Standard Edition of the Complete Psychological Works of Sigmund Freud*, vol. 14, trans. James Strachey (London: Hogarth, 1974), 69.

81. Luce Irigaray, *Speculum of the Other Woman,* trans. Gillian C. Gill (Ithaca, NY: Cornell University Press, 1985 [1974]), 68.

82. Simone de Beauvoir, *The Second Sex*, trans. Constance Borde and Sheila Malovany-Chevallier (New York: Random House Vintage 2011 [1949]), 757–759.

83. Irigaray, *This Sex*, 151.

84. Luce Irigaray, *An Ethics of Sexual Difference*, trans. Carolyn Burke and Gillian C. Gill (Ithaca, NY: Cornell University Press, 1993 [1984]), 119.

85. Audre Lorde, *Sister Outsider* (Berkeley: Ten Speed Press, 1984); hooks, *Ain't I a Woman?*; Hélène Cixous, "The Laugh of the Medusa," trans. Keith Cohen and Paula Cohen, *Signs* 1, no. 4 (1976): 875–893; Adrienne Rich, "Notes toward a Politics of Location," in *Blood, Bread, and Poetry* (New York: Norton, 1989), 210–231; Dona Haraway, *Simians, Cyborgs and Women: The Reinvention of Nature* (New York: Routledge, 1991), 3; Peggy Phelan, *Unmarked: The Politics of Performance* (New York: Routledge, 1993).

86. Irigaray, *This Sex*, 150; bell hooks, *Teaching to Transgress: Education as the Practice of Freedom* (New York: Routledge, 1994); 70; Zoe Todd, "An Indigenous Feminist's Take on the Ontological Turn: 'Ontology' Is Just Another Word for Colonialism," *Journal of Historical Sociology* 29, no. 1 (2016): 4–22.

87. Todd, "An Indigenous Feminist's Take," 4.

88. Hiba Ali, *Postcolonial Language* (2016), video, 25:00 min., Vtape 8834, http://www.vtape.org/video?vi=8834.

89. See Judith Butler, *Precarious Life: The Powers of Mourning and Violence* (New York: Verso Books, 2004); Judith Butler, *Frames of War: When Is Life Grievable?* (New York: Verso Books, 2009).

90. Lindsay Nixon, *nîtisânak* (Montreal: Metonymy Press, 2018).

91. David Macey, *The Penguin Dictionary of Critical Theory* (New York: Penguin, 2000), 379.

92. Jameson, "Periodizing the 60s."

93. Jameson, "Periodizing the 60s," 193–194.

94. Jameson, "Periodizing the 60s," 187–188.

95. Arkady Plotnitsky "The Medusa's Ears," in *Nietzsche and the Feminine*, ed. Peter Burgard (Charlottesville: University of Virginia Press, 1994), 250.

96. Jameson, "Periodizing the 60s," 207.

97. Philippe Lejeune, "A New Genre in the Making?" *a/b* 32, no. 2 (2017): 159.

98. Jeffrey R. Di Leo, "Deleuze in the Age of Posttheory," *symplokē* 6, no. 1 (1998): 175.

99. David Chariandy, "Theory: A Footnote," plenary talk at ACCUTE (Association of Canadian College and University Teachers of English) congress, Vancouver, June 2, 2019.

100. In "Conceptual Art and Feminism," Jayne Wark notes how feminist conceptualists resisted male conceptualism's precluding of "subject-centred inquiry." "Conceptual Art and Feminism: Martha Rosler, Adrian Piper, Eleanor Antin, and Martha Wilson," *Woman's Art Journal* 22, no. 1 (2001): 42.

101. Bellamy and Killian, *Writers Who Love Too Much*, 505.

102. Henry Schwarz and Anne Balsamo, "Under the Sign of *Semiotext(e)*: The Story According to Sylvère Lotringer and Chris Kraus," *Critique: Studies in Contemporary Fiction* 37, no. 3 (1996): 206–209.

103. One of these early Native Agents texts, Ann Rower's *If You're a Girl* (1990), is described by Rower as "transfiction," a mode of writing that combines real life and fictional "intervention."

104. Schwarz and Balsamo, "Under the Sign of *Semiotext(e)*," 214.

105. Joseph Kosuth, "Art after Philosophy." *Studio International*, October 1969, 2.

106. Wark, "Conceptual Art and Feminism," 46.

107. Wark, "Conceptual Art and Feminism," 44.

108. Rosalind Krauss, "Video: The Aesthetics of Narcissism," *October* 1 (Spring 1976): 50–64.

109. Joan Jonas, "Joan Jonas Interview: Layers of Time," *Louisiana Channel*, April 7, 2016, https://www.youtube.com/watch?v=WISlYE4dOKw.

110. Amelia Jones, *Self/Image: Technology, Representation, and the Contemporary Subject* (New York: Routledge, 2006), 180; see also 134.

111. Kraus, *I Love Dick*, 172.

112. Jones, *Self/Image*, 157.

113. Schneemann, *Imaging Her Erotics*, 32.

114. David Pagel, "Christine Wang's 'I Want That Bag' a Heavy-Handed Confessional," *Los Angeles Times*, June 17, 2014, https://www.latimes.com/entertainment/arts/la-et-cm-art-review-christine-wang-i-want-that-bag-at-night-gallery-20140610-story.html.

115. Danielle LaFrance, "On Aftermaths," paper presented at ACCUTE (Association of Canadian College and University Teachers of English) congress, Vancouver, June 2, 2019.

116. Bal, "Documenting What?," 134.

117. Bal, "Documenting What?," 124.

118. Jennifer Doyle, *Hold It against Me: Difficulty and Emotion in Contemporary Art* (Durham, NC: Duke University Press, 2013), 146.

119. Maggie Nelson, *The Art of Cruelty: A Reckoning* (New York: W. W. Norton, 2011), 265.

CHAPTER 1

1. Adrian Piper, *Food for the Spirit* (Berlin: Adrian Piper Research Archive Foundation, 1971), performance, artist's statement.

2. I thank an anonymous reviewer for this suggested choice of phrasing, which is beautifully apt.

3. Holland Cotter, "Adrian Piper: The Thinking Canvas," *New York Times*, April 19, 2018, www.nytimes.com/2018/04/19/arts/design/adrian-piper-review-moma.html.

4. Fredric Jameson, "Periodizing the 60s," *Social Text* 9/10 (1984): 178–209.

5. Jayne Wark points to the 1970s as a time that saw "the advent of the feminist movement in the arts" ("Conceptual Art and Feminism: Martha Rosler, Adrian Piper, Eleanor Antin, and Martha Wilson," *Woman's Art Journal* 22, no. 1 [2001]: 47). Feminist performance art and conceptualism advances in the 1970s as well, with the advancement of the feminist art movement that continues through to subsequent decades.

6. Lucy Lippard, *Six Years: The Dematerialization of the Art Object from 1966 to 1972* (London: Studio Vista, 1973).

7. Adrian Piper, *Out of Order, Out of Sight: Selected Writings in Meta-Art 1968–1992, Vol. 1* (Cambridge, MA: MIT Press, 1996), xxxv.

8. Uri McMillan, *Embodied Avatars: Genealogies of Black Feminist Art and Performance* (New York: New York University Press, 2015), 101.

9. Piper's 2018 retrospective at MoMA marks the very first time that the museum has "given over all of its sixth floor special exhibition space to a single living artist." Cotter, "Adrian Piper."

10. Adrian Piper, "News (September 2012)," adrianpiper.com/news_sep_2012.shtml.

11. Vanessa E. Jones, "The Fallen Academic Star of Adrian Piper," *The Journal of Blacks in Higher Education* 36 (2002): 121.

12. Adrian Piper, *Rationality and the Structure of the Self, Vol. 2: A Kantian Conception* (Berlin: Adrian Piper Research Archive Foundation, 2013), xx.

13. Gabrielle Civil, *Swallow the Fish: A Memoir in Performance Art* (Fairfax, VA: Civil Coping Mechanisms, 2017).

14. The precise duration of the piece is not known. The most detailed description of the work's duration is as follows: "This piece was performed in my loft in NYC continually throughout the summer of 1971." Piper, *Out of Order, Vol. 1*, 55.

15. Piper, *Rationality, Vol. 2*, 288.

16. Piper, *Rationality, Vol. 2*, 292.

17. Piper, *Rationality, Vol. 2*, 289.

18. On the doubling of the subject in Kant, see Siyaves Azeri, "Transcendental Subject vs. Empirical Self: On Kant's Account of Subjectivity," *Filozofia* 65, no. 3 (2010): 269–283.

19. Immanuel Kant, *Critique of Pure Reason*, trans. and ed. Paul Guyer and Allen W. Wood (Cambridge: Cambridge University Press, 1998 [1781]), 132ff.

20. Amelia Jones, *Self/Image: Technology, Representation, and the Contemporary Subject* (New York: Routledge, 2006), 134.

21. Mona Hatoum, *You Are Still Here* (London, Tate Modern, 1994), sandblasted mirrored glass and wood.

22. Luce Irigaray, *Speculum of the Other Woman,* trans. Gillian C. Gill (Ithaca, NY: Cornell University Press, 1985 [1974]).

23. Immanuel Kant, *Prolegomena to Any Future Metaphysics That Will Be Able to Present Itself as a Science*, trans. and ed. Gary Hatfield (Cambridge: Cambridge University Press, 2004 [1783]), 37.

24. Irigaray, *Speculum*, 205.

25. Luce Irigaray, remarks at Luce Irigaray International Seminar, University of Bristol, June 15, 2016.

26. See Peggy Phelan, *Unmarked: The Politics of Performance* (New York: Routledge, 1993), 31.

27. Immanuel Kant, *Critique of Judgment,* trans. James Creed Meredith, ed. Nicholas Walker (Oxford: Oxford University Press, 2007 [1790]), 294

28. "Aesthetic, n. and adj.," *OED Online* (Oxford University Press, 2018), oed.com/view /Entry/3237.

29. Kant, *Critique of Pure Reason*, 426–427.

30. Kant, *Critique of Pure Reason*, 168.

31. Kant, *Critique of Pure Reason*, 426–427.

32. Adrian Piper, "Intuition and Concrete Particularity in Kant's Transcendental Aesthetic," in *Rediscovering Aesthetics: Transdisciplinary Voices from Art History, Philosophy, and Art Practice,* ed. Francis Halsall (Redwood City, CA: Stanford University Press, 2006), 8.

33. Kant, *Critique of Pure Reason*, 220.

34. Kant, *Critique of Pure Reason*, 222.

35. It is possible I am misreading "logically" with an extra space: even if it was an unconsciously inserted space by Piper, it bears the trace of what I read into it here.

36. Kant, *Critique of Pure Reason*, 124.

37. Nicholas F. Stang, "Kant's Transcendental Idealism," *Stanford Encyclopedia of Philosophy*, ed. Edward Zalta, http://www.plato.stanford.edu/entries/kant-transcendental -idealism.

38. Piper, *Rationality, Vol. 2*, 52.

39. Kant, *Critique of Pure Reason*, 472; Piper, "Intuition and Concrete Particularity," 14.

40. Piper, *Rationality, Vol. 2*, 289.

41. Piper, *Rationality, Vol. 2*, 299.

42. The publisher's summary for Robin Schoot, ed., *Feminist Interpretations of Immanuel Kant* (University Park, PA: Penn State University Press, 1997), reads: "Because of his misogyny and disdain for the body, Kant has been a target of much feminist criticism. Moreover, as the epitome of eighteenth-century Enlightenment

philosophy, his thought has been a focal point for feminist debate over the Enlightenment legacy—whether its conceptions of reason and progress offer tools for women's emancipation and empowerment or, rather, have contributed to the historical subordination of women in Western society."

43. Jones, *Self/Image*, 14.

44. Amelia Jones and Adrian Heathfield, eds., *Perform, Repeat, Record: Live Art in History* (Bristol, UK: Intellect, 2012), 74.

45. Stang, "Kant's Transcendental Idealism."

46. Adrian Piper, "The Logic of Modernism," *Callaloo: A Journal of African Diaspora Arts and Letters* 16, no. 3 (1993): 576.

47. See Kant, *Critique of Judgment*, 301.

48. Adrian Piper, *Talking to Myself: The Ongoing Autobiography of an Art Object* (Hamburg: Hossman, 1974).

49. Kojin Karatani, *Transcritique: On Kant and Marx*, trans. Sabu Kohso (Cambridge, MA: MIT Press, 2003).

50. Fred Moten, "Black Kant (Pronounced Chant)," *TextSound: An Online Audio Publication* 21 (February 2007), http://writing.upenn.edu/pennsound/x/Moten.php.

CHAPTER 2

1. In Canada alone, all the major art colleges have become universities over the past two decades: the Ontario College of Art and Design (now OCADU) in 2002, the Emily Carr Institute of Art and Design (now ECUAD) and the Nova Scotia College of Art and Design (now NSCADU) both in 2003, and the Alberta College of Art (now Alberta University of the Arts) in 2018. Alongside these institutional changes, doctorate in studio art programs now exist at two Canadian universities, York University and Western University. In the UK, comparable PhD programs have existed since the 1970s.

2. The Feminist Art Collective, or FAC, was known as the Feminist Art Conference from 2013 to 2018. During my time on its programming committee (2013–2016), the organizers tended to describe theory as "hierarchical," rejecting it for other modes of describing what they do.

3. bell hooks, *Teaching to Transgress: Education as the Practice of Freedom* (New York: Routledge, 1994), 70.

4. Hazel Meyer, *No Theory No Cry* (Toronto: OCAD University, 2008), artwork, anthem, and brochure.

5. Vito Acconci, *Trademarks* (1970), gelatin silver print.

6. Heiser, Jörg, with the participation of Simon Critchley, Robert Storr, and Barbara Bloom, "Scenes from a Marriage: Have Art and Theory Drifted Apart?," Frieze Talks (London, October 16, 2009), podcast, https://frieze.com/fair-programme/listen -scenes-marriage. Subsequent quotations in this section are from this podcast.

7. Chris Kraus, *Video Green: Los Angeles Art and the Triumph of Nothingness* (New York: Semiotext(e), 2004).

8. Eve Kokofsky Sedgwick, *Touching Feeling: Affect, Pedagogy, Performativity* (Durham, NC: Duke University Press, 2003).

9. See Marcus Boon's discussion of the Louis Vuitton bag and counterfeits of the Louis Vuitton bag in relation to "The Platonic World of Intellectual Property" in *In Praise of Copying* (Cambridge, MA: Harvard University Press, 2010).

10. Kraus, *Video Green*.

11. Chris Kraus, "Stick to the Facts," *Texte zur Kunstv* 18, no. 70 (2008): 132.

12 Madelyne Beckles, *Womanism Is a Form of Feminism Focused Especially on the Conditions and Concerns of Black Women* (2016), video, 03:48 min., http://www.vtape.org /video?vi=8930.

13. Madelyne Beckles, *Theory of the Young Girl* (2017), video, 04:29 min., http://www .vtape.org/video?vi=8931; Tiqqun, *Preliminary Materials for a Theory of the Young-Girl* (New York: Semiotext(e), 2012 [1999]).

14. Sonia Fernández Pan, email exchange with the author, January 10, 2020.

15. Andrea Long Chu, "On Liking Women: The Society for Cutting Up Men Is a Rather Fabulous Name for a Transsexual Book Club," *n+1* 30 (2018), https://nplusonemag .com/issue-30/essays/on-liking-women.

16. To be a "meme" rather than an "image macro," the meme must be distributed virally through social media: in this way; wide circulation of the image-text pairing via online channels defines the meme as such.

17. The videos discussed in this section can be found on Youngman's YouTube channel, at https://www.youtube.com/user/HennesyYoungman/videos.

18. See especially the ART THOUGHTZ videos "How to Be a Successful Black Artist," "Relational Aesthetics," "The Sublime," and "Institutional "Critique."

19. See the videos "Damian Hirst," "Beuys-Z," "How to Be a Successful Artist," and "Bruce Nauman."

20. See the videos "The Studio Visit," "How to Make an Art," and "Louise Bourgeois."

21. Diana Stoll and Adrian Piper, "Adrian Piper: Goodbye to Easy Listening," *Aperture* 166 (2002): 40.

22. Stoll and Piper, "Adrian Piper," 40.

23. In Youngman's "ART THOUGHTZ: Grad School," the artist presents the video as an urgent "special message": "It has come to my attention that many artists nowadays think that it is essential to go to grad school. … But as any sane individual knows, paying tens of thousands or even a hundred thousand dollars for the privilege of making art in a university setting does not, and I mean *it does not,* guarantee that you will become a successful artist."

24. Genevieve Hudson, "An Interview with Maggie Nelson," Bookslut, July 2013, http://www.bookslut.com/features/2013_07_020156.php.

25. Helen Stuhr-Rommereim and Chris Kraus, "Interview: Chris Kraus," *Full Stop*, December 4, 2012, http://www.full-stop.net/2012/12/04/interviews/helen-stuhr -rommereim/chris-kraus.

CHAPTER 3

1. Jessica Weisberg, "Can Self-Exposure Be Private?," *New Yorker*, May 2, 2012, https://www.newyorker.com/culture/culture-desk/can-self-exposure-be-private.
2. Maggie Nelson, *The Argonauts* (Minneapolis: Graywolf Press, 2015).
3. Gloria E. Anzaldúa, *Borderlands/La Frontera: The New Mestiza*, 4th ed. (San Francisco: Aunt Lute Books, 2012); Nicole Brossard, *Picture Theory*, trans. Barbara Godard (Montreal: Guernica, 2006 [1982]).
4. Joanna Walsh, *Break.up: A Novel in Essays* (New York: Semiotext(e), 2018).
5. Still, when Gloria Anzaldúa uses endnotes in *Borderlands/La Frontera: The New Mestiza*, this is an experimental move in her context of writing. She incorporates endnotes—historically used in academic work—into her creative-critical work to engender a space for queer, feminist, Mestiza-becoming that engages citations as a reading list and a diverse, intertextual undergirding for her personal-poetic-theoretical narrations.
6. Chris Kraus, *I Love Dick* (New York: Semiotext(e), 1997), 113.
7. Eve Kosofsky Sedgwick, *Tendencies* (Durham, NC: Duke University Press, 1993).
8. Nelson, *The Argonauts*, 3–4.
9. Nelson, *The Argonauts*, 14.
10. Gayle Salamon, "*The Argonauts* by Maggie Nelson (Review)." *philoSOPHIA* 6, no. 2 (2016): 303.
11. Nelson, *The Argonauts*, 5.
12. Roland Barthes, *A Lover's Discourse: Fragments*, trans. by Richard Howard (New York: Hill and Wang, 1977), 5.
13. Roland Barthes, "The Death of the Author," in *Image Music Text*, trans. Stephen Heath (New York: Hill and Wang 1997 [1967]), 144.
14. Barthes, "Death of the Author," 146.
15. Barthes, *A Lover's Discourse*, 3.
16. Barthes, "The Death of the Author," 148.
17. Barthes, *A Lover's Discourse*, 8.
18. Barthes, "Death of the Author," 148.
19. Barthes, *A Lover's Discourse*, 3.
20. Bathes, *A Lover's Discourse*, 2.
21. Barthes, *A Lover's Discourse*, 4.
22. Barthes, *A Lover's Discourse*, 9.

23. Paul Ricoeur, *Freud and Philosophy: An Essay on Interpretation*, trans. Denis Savage (New Haven, CT: Yale University Press, 1970) 32.

24. Nelson, *The Argonauts*, 64.

25. Paul B. Preciado, *Testo Junkie: Sex, Drugs, and Biopolitics in the Pharmacoporno-graphic Era*, trans. Bruce Benderson (New York: Feminist Press, 2013 [2008]), 19.

26. Kathy Acker and McKenzie Wark, *I'm Very into You: Correspondence 1995–1996*, ed. Matias Viegener (New York: Semiotext(e), 2015).

27. Harry Dodge, *My Meteorite: Or, Without the Random There Can Be No New Thing* (New York: Penguin Books, 2020).

28. Alex Brostoff, "An Autotheory of Intertextual Kinship: The Touching Bodies of Maggie Nelson and Paul Preciado," paper presented at the American Comparative Literature Association conference, Los Angeles, March 30, 2018.

29. Anzaldúa, *Borderlands/La Frontera*, 99.

30. Audre Lorde, *A Burst of Light* (Ithaca, NY: Firebrand Books, 1988).

31. Moyra Davey, *Les Goddesses* (2011).

32. Chris Kraus, *Aliens and Anorexia* (New York: Semiotext(e), 2000), 119.

33. Nelson, *The Argonauts*, 57.

34. Nelson, *The Argonauts*, 5.

35. Barthes, *A Lover's Discourse*, 3.

36. Nelson, *The Argonauts*, 86.

37. Nelson, *The Argonauts*, 14.

38. Jane Gallop, *Anecdotal Theory* (Durham, NC: Duke University Press, 2002); Susan Fraiman, *Cool Men and the Second Sex* (New York: Columbia University Press, 2003), 69.

39. Nelson, *The Argonauts*, 47.

40. Nelson, *The Argonauts*, 46–47.

41. Nelson, *The Argonauts*, 129, 131, 133.

42. Sarah Nicole Prickett and Maggie Nelson, "Bookforum Talks with Maggie Nelson," *BookForum,* May 29, 2015, http://bookforum.com/interview/14663.

43. Rebecca Belmore and Florene Belmore, Something Between Us, keynote conversation at C Magazine Experiments in Criticism Symposium (Toronto: AGO and Toronto Media Arts Centre, TBD (postponed indefinitely from 2020).

44. Nelson, *The Argonauts*, 47.

45. Mira Mattar, Comments as panelist in "Subject to AUTO-" panel, *AUTO-* [conference], Royal College of Art, Battersea Campus, London, England, 24 May 2019.

46. Nelson, *The Argonauts*, 48.

47. Micah McCrary and Maggie Nelson, "Riding the Blinds: Micah McCrary Interviews Maggie Nelson," *Los Angeles Review of Books,* April 26, 2015. http://www.lareviewofbooks.org/article/riding-the-blinds.

48. Eve Kosofsky Sedgwick and Adam Frank, "Shame in the Cybernetic Fold: Reading Silvan Tomkins," *Critical Inquiry* 21, no. 2 (1995): 496.

49. Sedgwick and Frank, "Shame in the Cybernetic Fold," 494.

50. Katy Hawkins, "Woven Spaces: Eve Kosofksy Sedgwick's *Dialogue on Love*," *Women and Performance: A Journal of Feminist Theory* 16, no. 2 (2006): 251

51. Eve Kosofsky Sedgwick, *Epistemology of the Closet* (Berkeley: University of California Press, 1990); *Between Men: English Literature and Male Homosocial Desire* (New York: Columbia University Press, 1985).

52. Eve Kosofsky Sedgwick, *Tendencies* (Durham, NC: Duke University Press, 1993), 8.

53. *Transgender Studies Quarterly*, began in 2014, is a peer-reviewed journal published through Duke University Press that focuses on interdisciplinary scholarship on issues related to gender, sexuality, sex, identity, and the body that have not been sufficiently addressed by feminist or queer scholarship and theory. In "The Flourishing of Transgender Studies," published in the inaugural issue of the *TSQ*, Regina Kunzel names 2014 as a time in history when "transgender studies can boast several conferences, a number of edited collections and thematic journal issues, courses in some college curricula, and ... an academic journal with a premier university press" (285). Nearly a decade prior, Susan Stryker and Stephen Whittle co-edited *The Transgender Studies Reader* (2006).

54. There are, of course, exceptions. Trans theorist Jay Prosser considers what he calls transsexual autobiographies—which we might now refer to as transgender autobiographies, though the evolution of the discourse from "transsexual" to "transgender" is itself its own complicated history. Writing Eve Kosofsky Sedgwick into this project, Prosser maintains that Sedgwick "has revealed her personal transgendered investment lying at and as the great heart of her queer project." Jay Prosser, *Second Skinds: The Body Narratives of Transsexuality* (New York: Columbia University Press, 1998), 23.

55. Nelson, *The Argonauts*, 29–30.

56. Nelson, *The A rgonauts*, 30.

57. Alison Bechdel, *Are You My Mother? A Comic Drama* (New York: Houghton Mifflin, 2012).

58. Alison Bechdel, *Fun Home: A Family Tragicomic* (New York: Houghton Mifflin, 2007). *Fun Home* has prompted its own autotheoretical response text—Genevieve Hudson's *A Little in Love with Everyone: Alison Bechdel's Fun Home* (San Francisco: Fiction Advocate, 2018), as well a Tony Award–winning Broadway adaptation that opened in New York City in 2013.

59. See http://www.dykestowatchoutfor.com/dtwof.

60. Bechdel, *Are You My Mother?*, 152.

61. Bechdel, *Are You My Mother?*, 178, 200.

62. Nancy K. Miller, *Getting Personal: Feminist Occasions and Other Autobiographical Acts* (New York: Routledge, 1991), 22.

63. Nelson, *The Argonauts*, 60–61.

64. Eve Kosofsky Sedgwick, *Touching Feeling: Affect, Pedagogy, Performativity* (Durham, NC: Duke University Press, 2003), 144.

65. Nelson, *The Argonauts*, 6.

66. Sheila Heti, *How Should a Person Be?* (Toronto: House of Anansi, 2010).

67. Sheila Heti, *Motherhood: A Novel* (New York: Henry Holt, 2018).

68. Maggie Nelson, *The Art of Cruelty: A Reckoning* (New York: W. W. Norton, 2011), 6.

69. Jennifer Doyle, *Hold It Against Me: Difficulty and Emotion in Contemporary Art* (Durham, NC: Duke University Press, 2013), 1.

CHAPTER 4

1. In an interview in 2015, Mitchell stated: "When we opened FAG five years ago, we said that it was only going to be a five-year project. We took the model from LTTR, a collective of friends and artists from New York, who collapsed their project after five years because they didn't want to become institutionalized." Amber Christensen, Lauren Fournier, and Daniella Sanader, "A Speculative Manifesto for the Feminist Art Fair International: An Interview with Allyson Mitchell and Deirdre Logue of the Feminist Art Gallery," in *Desire Change: Contemporary Feminist Art in Canada,* ed. Heather Davis (Montreal: McGill-Queen's University Press, 2017), 257–270.

2. Lauren Berlant and Kathleen Stewart, *The Hundreds* (Durham, NC: Duke University Press, 2019); Hiromi Goto and David Bateman, *Wait until Late Afternoon* (Calgary: Frontenac House, 2009).

3. Allyson Mitchell and Deirdre Logue, *We Can't Compete,* exhibition, curated by Josephine Mills, University of Lethbridge Art Gallery, Lethbridge, AB, January 23–March 6, 2014.

4. Sarah E. K. Smith, "Bringing Queer Theory into Queer Practice," in *Deirdre Logue & Allyson Mitchell: I'm Not Myself At All,* ed. Meg Taylor (Kingston, ON: Agnes Etherington Art Centre, 2015), 30.

5. Allyson Mithcell and Deirdre Logue, *Hers Is Still a Dank Cave: Crawling towards a Queer Horizon,* (2016), video, 24:32 min., Vtape, http://www.vtape.org/video?vi=8423.

6. Heather Love theorizes Mitchell and Logue's use of a low-to-the-ground, view-from-the-floor perspective in their video, with its multispecies, cat-ally valences (as the artists crawl with the camera, they encounter their cats, on the same "level" as they) as being tied to what Jack Halberstam calls low theory: "The queer future as Logue and Mitchell picture it is low: low to the ground, low key, low culture, low down. You can't fly into this queer future: you have to crawl." "Low," in Tayor, ed., *Deirdre Logue & Allyson Mitchell: I'm Not Myself At All*, 41.

7. Monique Wittig, *The Straight Mind and Other Essays* (Boston: Beacon Press, 1992); José Esteban Muñoz, *Cruising Utopia: The Then and There of Queer Futurity* (New York: New York University Press, 2009).

8. R. M. Vaughan, "Nova Scotia College of Art and Design Was the Darling of the '70s Art World—We Think," *CBC Arts,* January 14, 2016, http://www.cbc.ca/arts/nova

-scotia-college-of-art-and-design-was-the-darling-of-the-70s-art-world-we-think-1
.3403927.

9. GF being short for gluten-free. I say "sick-woman-aligned" here, as there is a relationship between gluten intolerance and present-day autoimmune disorders.

10. Madelyne Beckles and Petra Collins, *In Search of Us* [performance], MoMA, New York, March 18, 2017.

11. Allyson Mitchell and Maedlyne Beckles, *What Motivates Her?,* exhibition, Thames Art Gallery, Chatham, ON, January 18–March 10, 2019.

12. Nancy K. Miller, *Getting Personal: Feminist Occasions and Other Autobiographical Acts* (New York: Routledge, 1991); Jane Gallop, *Feminist Accused of Sexual Harassment* (Durham, NC: Duke University Press, 1997).

13. Jane Gallop, *Anecdotal Theory* (Durham, NC: Duke University Press, 2002), 2.

14. Gallop, *Anecdotal Theory*, 11.

15. Gallop, *Anecdotal Theory*, 5.

16. Gallop, *Anecdotal Theory*, 2–5.

17. Shannon Bell, *Fast Feminism: Speed Philosophy, Pornography, and Politics* (New York: Autonomedia, 2010), 12.

18. Marie-Andrée Godin, *(Im)possible Labour,* exhibition, Diagonale Centre des arts et des fibres du Québec, Montreal, QB, April 11–June 8, 2019.

19. Sara Ahmed, *Living a Feminist Life* (Durham: Duke University Press, 2017).

20. Fred Armisen and Carrie Brownstein, "Did You Read It?," *Portlandia,* IFC, 2011, https://www.youtube.com/watch?v=6JLWQEuz2gA.

21. Love, "Low," 43–44

22. Love, "Low," 46.

23. Jessica Weisberg, "Can Self-Exposure Be Private?," *New Yorker*, May 2, 2012.

24. Maiko Tanaka, "Feminist Approaches to Citation," *C Magazine* 126 (2015), 47.

25. Jeanne Randolph, "Out of Psychoanalysis: A Ficto-Criticism Monologue," in *Canadian Cultural Poesis,* ed. Garry Sherbert et al. (Waterloo, ON: Wilfrid Laurier University Press, 2006), 232.

26. Frank O'Hara, *Lunch Poems* (San Francisco: City Lights, 1964); John Cage, *Empty Words: Writings '73–'78* (Middletown, CT: Wesleyan University Press, 1981), 79–98.

27. Joanna Walsh, *Break.up: A Novel in Essays* (New York: Semiotext(e), 2018).

28. Chelsea Rozansky, "Review: *Autotheory* Screening at Vtape," *C Magazine* 141 (2019): 72–74.

29. Rosalind Krauss, "Video: The Aesthetics of Narcissism," *October* 1 (Spring 1976): 50–64.

30. Martha Wilson, *Art Sucks*, (1972),video, 01:25 min., Vtape, http://www.vtape.org /video?vi=6874.

31. In this way, the work could be said to contain an exegesis of itself (as in *I Love Dick*, in which Kraus, in a chapter titled "Exegesis," theorizes her own work—and preempts critique—as part of an autotheoretical practice).

32. Kaye Mitchell, "Empathy, Intersubjectivity, and the Feminist Politics of the Auto," presentation at *AUTO-* conference, Royal College of Art, London, May 23, 2019.

33. Chris Kraus, *Aliens and Anorexia* (New York: Semiotext(e), 2000), 103.

34. Alanna Lynch, quoted in *Fermenting Feminism* catalogue, by Lauren Fournier (Vancouver: Access Gallery, 2019).

35. Kate Zambreno, *Heroines* (New York: Semiotext(e), 2012), 49.

36. Tanaka, "Feminist Approaches," 49.

37. Roland Barthes, "The Death of the Author," in *Image Music Text*, trans. Stephen Heath (New York: Hill and Wang 1997 [1967]), 142–149.

38. Zoe Todd, "An Indigenous Feminist's Take on the Ontological Turn: 'Ontology' Is Just Another Word for Colonialism," *Journal of Historical Sociology* 29, no. 1 (2016): 17.

39. Jackie T. Cuevas, "Tejana Writing, Scholarship, and Activism: Living in the Borderlands with—and without—Gloria Anzaldúa," in Gloria E. Anzaldúa, *Borderlands/ La Frontera: The New Mestiza*, 4th ed. (San Francisco: Aunt Lute Books, 2012), 243.

40. Bhanu Kapil (@Thisbanu), "Citation is feminist memory," Twitter, December 30, 2015, 9:25 a.m.

41. McKenzie Wark, "Review: I Love Dick," Public Seminar, August 25, 2016, http:// www.publicseminar.org/2016/08/ild.

42. Cauleen Smith, "Human_3.0 Reading List," *Human 3.0 Reading List* (blog), June 16, 2015, https://readinglisthumanthreepointo.wordpress.com/2015/06/15/june-16 -2015.

43. Cauleen Smith and Lorelie Stewart, "Human_3.0 Reading List Postcards," *Human_3.0 Reading List* (blog), June 16, 2015, https://readinglisthumanthreepointo .wordpress.com/human_3-0-reading-list-postcards.

44. There were fourteen books completed at the time Cauleen Smith wrote this entry, though there are now twenty-three books drawn by her and featured on her artist's website.

45. Smith, "Human_3.0 Reading List."

46. Carolyn Lazard, "How to Be a Person in the Age of Autoimmunity," *Cluster Magazine*, 2013.

47. Johanna Hedva, "Sick Woman Theory," *Mask Magazine,* January 2016, http:// maskmagazine.com/not-again/struggle/sick-woman-theory.

48. Annie Jael Kwan, "Curatorial Introduction to *Finding Fanon*," presentation at the Royal College of Art, London, England, May 24, 2019.

49. Frantz Fanon, *The Wretched of the Earth*, trans. Richard Philcox (New York: Grove Press, 2005 [1961]).

50. Larry Achiampong and David Blandy, *Finding Fanon Part 1* (2015), video, 15:22 min.

51. Smith, "Human_3.0 Reading List."

52. Larry Achiampong and David Blandy, *Finding Fanon Part 2* (2015), video, 9:13 min.

53. Christensen, Fournier, and Sanader, "Speculative Manifesto," 267.

54. See Ariel Levy, "Who's Afraid of the Lesbian Haunted House?," *New Yorker,* October 28, 2019, https://www.newyorker.com/magazine/2019/11/04/whos-afraid-of-the-lesbian-haunted-house; Tausif Noor, "Review of Killjoy's Kastle at Icebox Project," *Art Forum*, November 4, 2019, https://www.artforum.com/performance/tausif-noor-on-killjoy-s-kastle-at-icebox-project-space-81221.

55. Love, "Low," 40–41.

56. Judith Butler, "Performative Acts and Gender Constitution: An Essay in Phenomenology and Feminist Theory," *Theatre Journal* 40, no. 4 (1988), 519.

57. Allyson Mitchell and Deirdre Logue, "Female Voices with Lisa Steele," artist's talk, MOCA, Toronto, March 29, 2019).

58. Cait McKinney and Allyson Mitchell, *Inside Killjoy's Kastle: Dykey Ghosts, Feminist Monsters, and Other Lesbian Hauntings* (Vancouver: University of British Columbia Press, 2019); Nicole Brossard, *The Aerial Letter*, trans. Marlene Wildeman (Toronto: Women's Press, 1987 [1985]).

59. Mitchell and Logue, quoted in Taylor, ed., *Deirdre Logue & Allyson Mitchell: I'm Not Myself At All*, 32–33; Muñoz, *Cruising Utopia*, 49.

CHAPTER 5

1. Chris Kraus, *I Love Dick* (New York: Semiotext(e), 1997); Jill Soloway, dir., *I Love Dick* (Amazon, 2016), television series.

2. Hebdige's "initiation of legal action" against Kraus is one event that points to the fidelity between what Kraus half-heartedly frames as fictionalized and what happened in real life; it also brought about the widespread association of his name with Kraus's book. See Nic Zembla, "See Dick Sue: A Very Phallic Novel Gets a Rise out of a Beloved Professor," *New York Magazine* 30, no. 44 (1997): 20.

3. Rachel Blau DuPlessis and Ann Snitow, "Introduction," in *The Feminist Memoir Project*, ed. Ann Snitow (New York: Three Rivers Press, 1998), 7.

4. Joan Hawkins, "Afterword: Theoretical Fictions," in Kraus, *I Love Dick*, 263–276. "Sad girl phenomenology" is Kraus's own term and appears in the novel.

5. Claire Armitstead et al., "Maggie Nelson and Chris Kraus on Confessional Writing," *Guardian Podcast*, May 27, 2016, http://www.theguardian.com/books/audio/2016/may/27/maggie-nelson-and-chris-kraus-on-confessional-writing-books-podcast.

6. Kraus, *I Love Dick*, 227, 173.

7. Jill Soloway, *She Wants It: Desire, Power and Toppling the Patriarchy* (London: Ebury Press, 2018), 206.

8. Luce Irigaray, *This Sex Which Is Not One*, trans. Catherine Porter and Carolyn Burke (Ithaca, NY: Cornell University Press, 1985 [1977]), 151. See Lauren Fournier, "From Philosopher's Wife to Feminist Autotheorist: Performing Phallic Mimesis as Parody in Chris Kraus's *I Love Dick*," *ESC*, 45.2 (2020).

9. Virpi Lehtinen, *Luce Irigaray's Phenomenology of Feminine Being* (Albany: SUNY Press, 2014), 172.

10. Henry Schwarz and Anne Balsamo, "Under the Sign of *Semiotext(e)*: The Story According to Sylvère Lotringer and Chris Kraus," *Critique: Studies in Contemporary Fiction* 37, no. 3 (1996): 212.

11. Kraus, *I Love Dick*, 19.

12. Irigaray, *This Sex Which Is Not One*, 220.

13. Kraus, *I Love Dick*, 21.

14. Hélène Cixous, "The Laugh of the Medusa," trans. Keith Cohen and Paula Cohen, *Signs* 1, no. 4 (1976): 875.

15. Kraus, *I Love Dick*, 130.

16. Kraus, *I Love Dick*, 172.

17. Kraus, *I Love Dick*, 179.

18. Kraus, *I Love Dick*, 172.

19. The notion of an "identified disclosure" comes from VIDA: Women in Literary Arts' 2016 "Report from the Field: Statements against Silence," which discusses the "de-identified disclosures ... from women who have experienced traumatic interactions with a respected literary arts community member." VIDA, "Report from the Field: Statements against Silence," VIDA Women in Literary Arts, March 6, 2016, www.vidaweb.org/statements-against-silence.

20. See Isabella Smith, "Protesters Demand 'Where Is Ana Mendieta?' in Tate Modern Expansion," Hyperallergic, June 14, 2016, www.hyperallergic.com/305163 /protesters-demand-where-is-ana-mendieta-in-tate-modern-expansion.

21. Kraus, *I Love Dick*, 173.

22. Émile Zola, "I Accuse! Letter to the President of the Republic," *L'Aurore*, 1898, https://www.marxists.org/archive/zola/1898/jaccuse.htm.

23. Looking back on her younger self with an autotheoretical eye, Kraus understands how her younger years were characterized by a kind of gender failure: in spaces like Schechner's Aboriginal Dream Time Workshop, she was neither actually a boy (but was "acting like" one; *I Love* Dick, 173) nor properly a girl because she was no't foregrounding her sex appeal. While Kraus does not make mention of transgender discourse in *I Love Dick*, performatively reinscribing a cis-centric gender binary of male/female and boy/girl instead, Kraus seems to be seeking out a more capacious understanding of the gender spectrum in moments like this.

24. Kraus, *I Love Dick*, 174.

25. "Schizophrenia consists of placing the word 'therefore' between two non-sequiturs." Kraus, *I Love Dick*, 226.

26. Kraus, *I Love Dick*, 174.

27. Kraus, *I Love Dick*, 183.

28. Nina Power, *One Dimensional Woman* (New York: Zero Books, 2009), 27.

29. Kraus, *I Love Dick*, 173.

30. Kraus, *I Love Dick*, 54.

31. Richard Martin, "Andrea Fraser: *Official Welcome* (Hamburg Version) 2001–2003," Tate, December 2014, http://www.tate.org.uk/art/artworks/fraser-official-welcome-hamburg-version-t13716.

32. Chris Kraus, *Video Green: Los Angeles Art and the Triumph of Nothingness* (New York: Semiotext(e), 2004), 58.

33. Kraus, *Video Green*, 59–63. Alongside her foregrounding of the personal is Kraus's acknowledgment of the place of the impersonal in work by women. She politicizes the impersonal as that which is often disregarded, scorned, or censored, especially when it is wielded by women in the context of otherwise personal material: the impersonal therefore advances as a politically viable strategy for women to make use of alongside personal work.

34. Kraus, *Video Green*, 61.

35. Eileen Myles and Liz Kotz, eds., *The New Fuck You: Adventures in Lesbian Reading* (New York: Semiotext(e), 1995).

36. Ann Rower, *If You're a Girl* (New York: Semiotext(e) 1990). One of the texts in *If You're a Girl* is "LSD-Transcript," which became part of a Wooster Group play.

37. Kraus, *I Love Dick*, 39.

38. Rower, *If You're a Girl*, 176.

39. Virginie Despentes, *Baise-Moi (Rape Me)* (Paris: Éditions Florent Massot, 1994); *Baise-Moi (Rape Me)* (Pan-Européenne, 2000), film, dir. Virginie Despentes and Coralie Trinh Thi.

40. Chris Kraus, *Aliens and Anorexia* (New York: Semiotext(e), 2000); *Torpor* (New York: Semiotext(e), 2004).

41. Kraus, *I Love Dick*, 155.

42. Kraus, *I Love Dick*, 173.

43. Sara Ahmed, "Feminists at Work," *feministkilljoys*, January 10, 2020, https://feministkilljoys.com.

44. Kraus, *I Love Dick*, 173.

45. bell hooks, *Teaching to Transgress: Education as the Practice of Freedom* (New York: Routledge, 1994), 70.

46. Rebecca Walker, "Becoming the Third Wave," *Ms* 11, no. 2 (1992): 3.

47. Louis Althusser, "What Is Practice?," in *Philosophy for Non-Philosophers*, trans. and ed. G. M. Goshgarian (New York: Bloomsbury, 2017), 80–84.

48. Louis Althusser, *The Future Lasts a Long Time*, trans. Richard Veasey (London: Chatto, 1993).

49. Avital Ronell, "Kathy Goes to Hell," in *Lust for Life: On the Writings of Kathy Acker*, ed. Amy Scholder et al. (New York: Verso, 2006), 17.

50. Nina Power, *One-Dimensional Woman* (New York: Zero Books, 2009).

51. Judith Butler, confidential letter addressed to New York University president Andrew Hamilton and provost Katharine Fleming, May 11, 2018, published on *Leiter Reports: A Philosophy Blog*, https://leiterreports.typepad.com/blog/2018/08/the-infamous-butler-letter-on-ronell-revised.html.

52 Maija Kappler, "Margaret Atwood Takes to Twitter to Respond to Criticism of #MeToo Globe Op-Ed," *Globe and Mail*, January 14, 2018, https://www.theglobeandmail.com/news/national/margaret-atwood-takes-to-twitter-to-respond-to-criticism-of-metoo-globe-op-ed/article37599626.

53. Marsha Lederman, "Under a Cloud: How UBC's Steven Galloway Affair Has Haunted a Campus and Changed Lives," *Globe and Mail*, October 28, 2016, https://www.theglobeandmail.com/news/british-columbia/ubc-and-the-steven-galloway-affair/article32562653.

54. Margaret Atwood, "Am I a Bad Feminist?," *Globe and Mail,* 13 January 2018, https://www.theglobeandmail.com/opinion/am-i-a-bad-feminist/article37591823; Margaret Atwood, *The Edible Woman* (Toronto: McClelland & Stewart, 1969).

55. Atwood, "Am I a Bad Feminist?"

56. Avital Ronell, *The Telephone Book: Technology, Schizophrenia, Electric Speech* (Lincoln: University of Nebraska Press, 1989); Avital Ronell, *Crack Wars: Literature Addiction Mania* (Champaign: University of Illinois Press, 1992).

57. This is the argument that Maggie Nelson makes in her brilliant feminist art historiography that deconstructs twentieth-century avant-garde histories through the perspective of cruelty. Maggie Nelson, *The Art of Cruelty* (W. W. Norton, 2011).

58. Lisa Duggan, "THE FULL CATASTROPHE," *Bully Bloggers*, August, 2018, https://bullybloggers.wordpress.com/2018/08/18/the-full-catastrophe.

59. Keguro Macharia, "kburd: Caliban Responds," *New Inquiry*, August 22, 2018, https://thenewinquiry.com/blog/kburd-caliban-responds. The quotation is from Lisa Duggan, "The Trials of Alice Mitchell: Sensationalism, Sexology, and the Lesbian Subject in Turn-of-the-Century America," *Signs: Journal of Women in Culture and Society* 18, no. 4 (January 1993): 791–814.

60. Keguro Macharia, "kburd: Caliban Responds," *New Inquiry*, August 22, 2018, https://thenewinquiry.com/blog/kburd-caliban-responds.

61. Jane Gallop, *Feminist Accused of Sexual Harassment* (Durham, NC: Duke University Press, 1997).

62. Jane Gallop, *Anecdotal Theory* (Durham, NC: Duke University Press, 2002), 2–5.

63. Gallop, *Feminist Accused of Sexual Harassment*, 62.

64. Kraus, *Aliens and Anorexia*, 103.

65. Kraus, *I Love Dick*, 181.

66. Hannah Wilke, *Marxism and Art: Beware of Fascist Feminism* (1977), poster, Center for Feminist Art Historical Studies, Women's Building, Los Angeles.

67. Liv Wynter (@livwynter). "Fuck Nina Power. Said it since day. And don't be surprised that you find fascists in your institutions or fascists in your feminism.

Be more vigilant. Don't let stuff go unquestioned. F U C K Nina power," Twitter, March 12, 2019, 12:33 p.m., https://twitter.com/livwynter/status/1105552313463328769 ?lang=en.

68. Ben Quinn, "Tate Artist in Residence Quits, Claiming Gallery Is Failing Women," *Guardian*, March 7, 2018, https://www.theguardian.com/artanddesign/2018/mar/07 /tate-modern-artist-quits-saying-gallery-is-failing-women.

69. New Models (@newmodels_io), "Whether or not the recent Nina Power debate ... ," Twitter, March 14, 2019, 4:30 a.m., https://twitter.com/newmodels_io /status/1106155598683475968.

70. Kai Cheng Thom, "4 Ways That Call-Out Culture Fails Trans Women (and, Therefore, All of Us)," *Everyday Feminism*, October 8, 2016, https://everydayfeminism .com/author/kaict; jaye simpson, "A Conversation I Can't Have Yet: Why I Will Not Name My Indigenous Abusers," *GUTS: A Canadian Feminist Magazine*, January 17, 2019, http://gutsmagazine.ca/a-conversation-i-cant-have-yet-why-i-will-not-name -my-indigenous-abusers.

71. Cheng Thom, "4 Ways."

72. Dodie Bellamy and Kevin Killian, eds., *Writers Who Love Too Much: New Narrative 1977–1997* (New York: Nightboat, 2017), 505.

73. Mitch Speed, "The Ellipses of Eva Hesse: Reading Her Collected Diaries," *Momus,* September 29, 2016, http://www.momus.ca/the-ellipses-of-eva-hesse-reading-her -diaries, 3.

74. Hervé Guibert, *À l'ami qui ne m'a pas sauvé la vie (To the Friend Who Did Not Save My Life)*, trans. Linda Coverdale (New York: Atheneum, 1991 [1990]).

75. Kraus, *I Love Dick*, 230.

CONCLUSION

1. David Chariandy, *I've Been Meaning to Tell You: A Letter to My Daughter* (Toronto: McLelland & Stewart, 2018).

2. David Chariandy, "Theory: A Footnote," plenary talk at ACCUTE (Association of Canadian College and University Teachers of English) congress, Vancouver, June 2, 2019.

3. Dionne Brand, *Theory* (Toronto: Penguin Canada, 2018).

4. Christina Sharpe, *In the Wake: On Blackness and Being* (Durham: Duke University Press, 2016), 12–13. Quote from Patricia Saunders, "Defending the Dead, Confronting the Archive: A Conversation with M. NourbeSe Philip," *Small Axe* 12.2 (June 2008): 63–79.

5. David Chariandy, *Brother* (Toronto: McLelland & Stewart, 2017).

6. Chariandy, "Theory: A Footnote."

7. Aimé Césaire, *Notebook of a Return to My Native Land (Cahier d'un retour au pays natal)*, trans. Mireille Rosello and Annie Pritchard (Hexham, England: Bloodaxe

Books, 1995 [1939]); *Discourse on Colonialism*, trans. Joan Pinkham (New York: Monthly Review Press, 2001 [1955]).

8. Luce Irigaray, *This Sex Which Is Not One*, trans. Catherine Porter and Carolyn Burke (Ithaca, NY: Cornell University Press, 1985 [1977]), 149.

9. Alex Brostoff, "An Autotheory of Intertextual Kinship: The Touching Bodies of Maggie Nelson and Paul Preciado," paper presented at the American Comparative Literature Association conference, Los Angeles, March 30, 2018.

10. Kyla Wazana Tompkins, "We Aren't Here to Learn What We Already Know." *Los Angeles Review of Books,* September 13, 2016, http://avidly.lareviewofbooks.org/2016/09/13/we-arent-here-to-learn-what-we-know-we-already-know.

11. Mieke Bal, "Documenting What? Autotheory and Migratory Aesthetics," in *A Companion to Contemporary Documentary Film,* ed. Alexandra Juhasz and Alisa Lebow (New York: Wiley & Sons, 2015), 134.

12. Here I am indebted to the Métis artist, writer, and professor David Garneau, who articulated this divide between the globalized, cosmopolitan way of being—virtually disembodied, in a certain sense, in that one does not have a meaningful relationship with a certain land—and placed, land-based ways of living. Garneau noted, "For an Indigenous person it is inconceivable to not have a relationship with the land." David Garneau, "A Talking Circle about Indigenous Contemporary Art," artist's talk, Oboro, Montreal, September 28, 2017.

INDEX

Note: Page numbers in *italic* type indicate figures.